THE ARTS OF
TUSCANY

From the Etruscans to Ferragamo

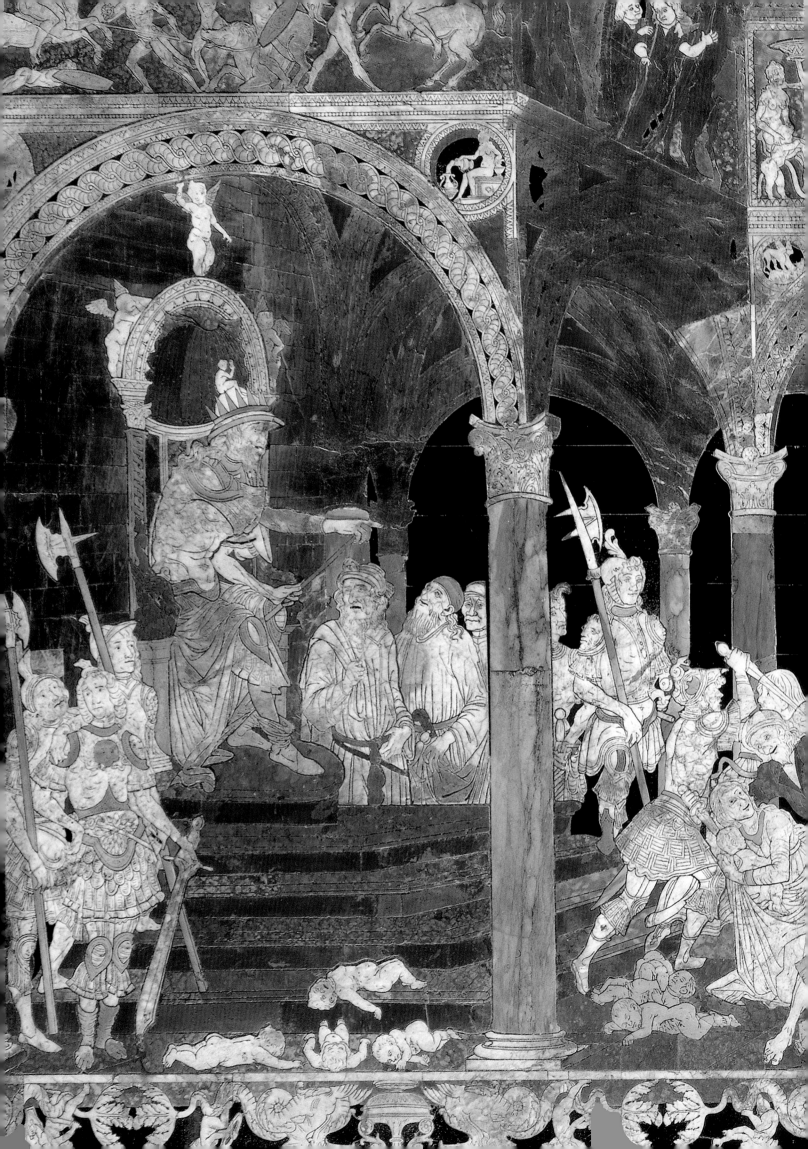

THE ARTS OF TUSCANY

From the Etruscans to Ferragamo

Marina Belozerskaya

ABRAMS, NEW YORK
IN ASSOCIATION WITH
SCALA GROUP, FLORENCE

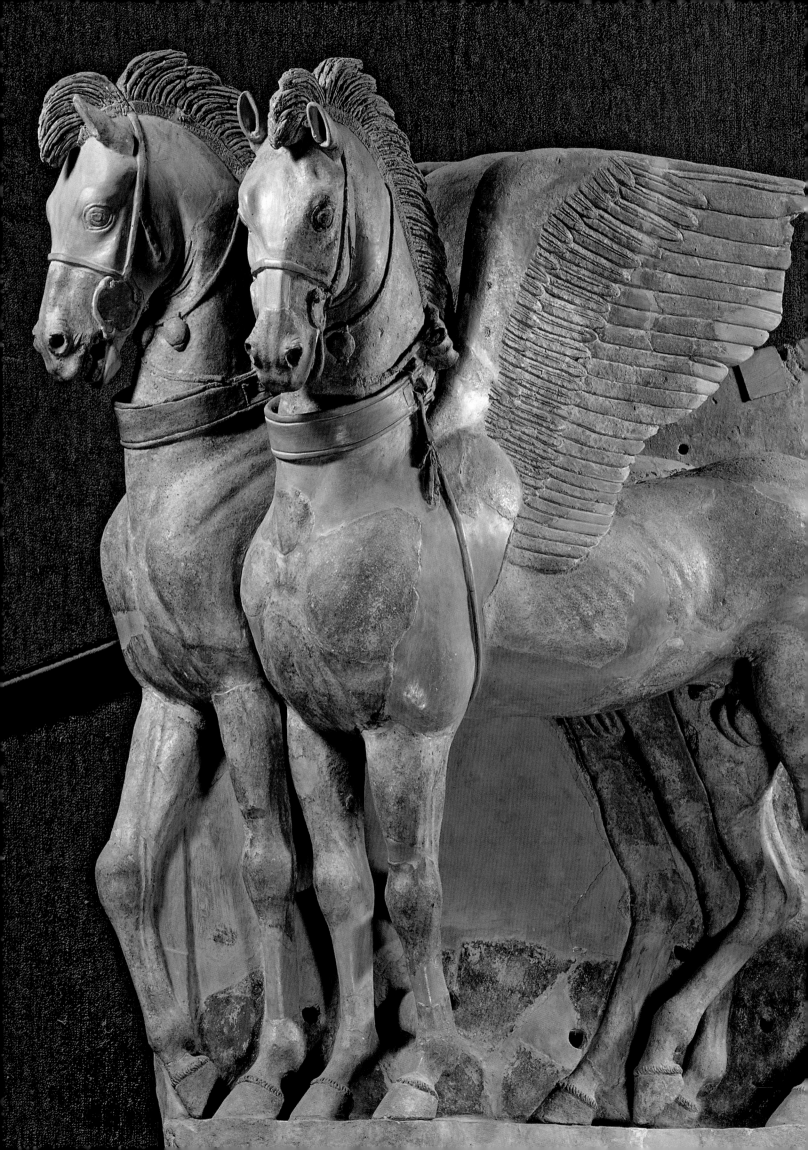

CONTENTS

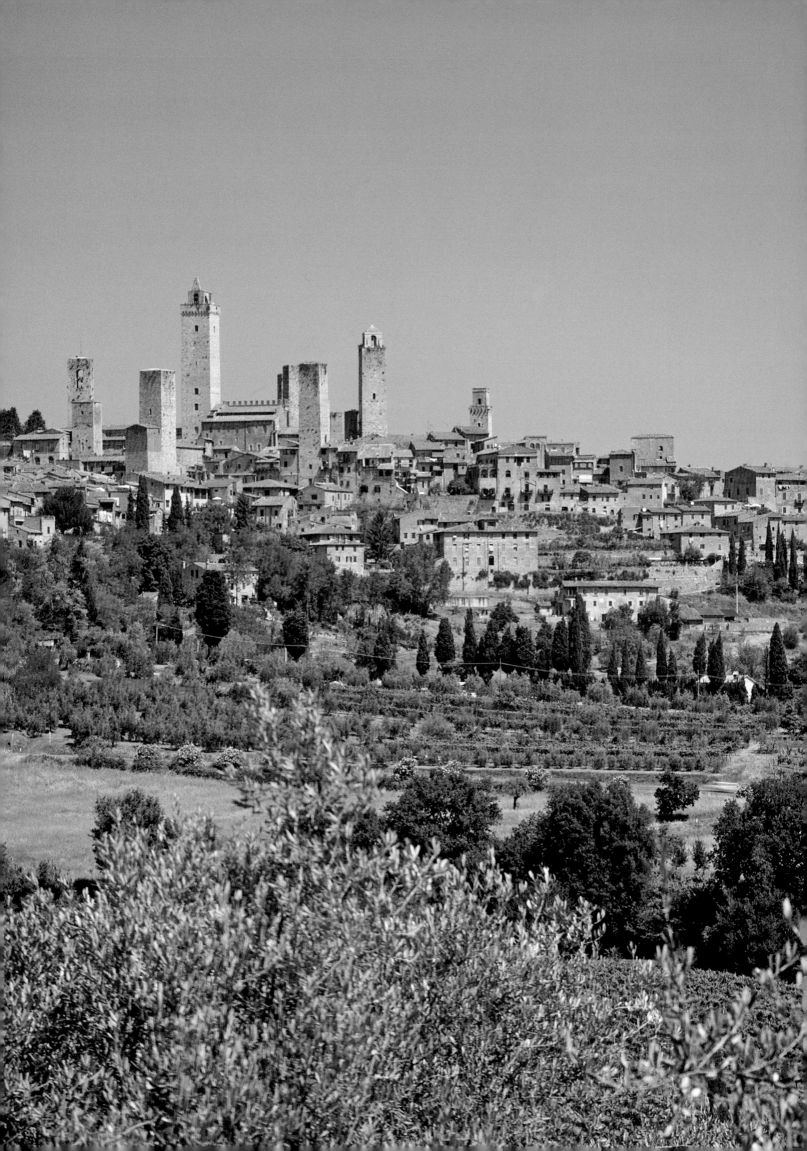

INTRODUCTION:

LANDSCAPE AND MAN

W E EMERGED FROM THE APENNINES AND SAW FLORENCE LYING IN A BROAD VALLEY, AMAZINGLY DENSELY CULTIVATED AND SCATTERED WITH VILLAS AND HOUSES AS FAR AS THE EYE COULD SEE. ONE LOOK IS SUFFICIENT TO SHOW THAT THE PEOPLE WHO BUILT IT WERE PROSPEROUS AND ENJOYED A LUCKY SUCCESSION OF GOOD GOVERNMENTS.

So wrote J. W. Goethe of his Italian journey in 1786, and so Tuscany appears to us today: rolling green hills dotted with terra-cotta towers and cream-colored villas, picturesque medieval towns perched high above the plains, and a bountiful countryside tended with diligent affection. Goethe was right to discern the affluence of the region, but credit for Tuscany's prosperity lies only partly with the wisdom of its inhabitants. The riches of the land and its superb location are the foundations of Tuscany's seemingly boundless creativity.

Tuscany's character, history, and art have all been greatly influenced by the natural environment. The region is blessed by a mild climate and fertile soil. The result is an array of valuable crops: grain and vines, olives and flax, not to mention all kinds of succulent produce. This agricultural wealth permitted cities to flourish and to develop outstanding crafts. This was the case in the days of the Etruscans, and Tuscany is still Italy's leading agricultural producer, famous for its wines, olive oil, mushrooms, cheese, cured meats, and leather industries (its lush river valleys are ideal for raising livestock). Although less plentiful today, abundant forests once supplied wood for building cities and ships, and fuel for kilns and furnaces. For Tuscany is also rich in clay for bricks and ceramics, and in metal ores. Stones such as marble and alabaster, quarried at Carrara and Volterra,

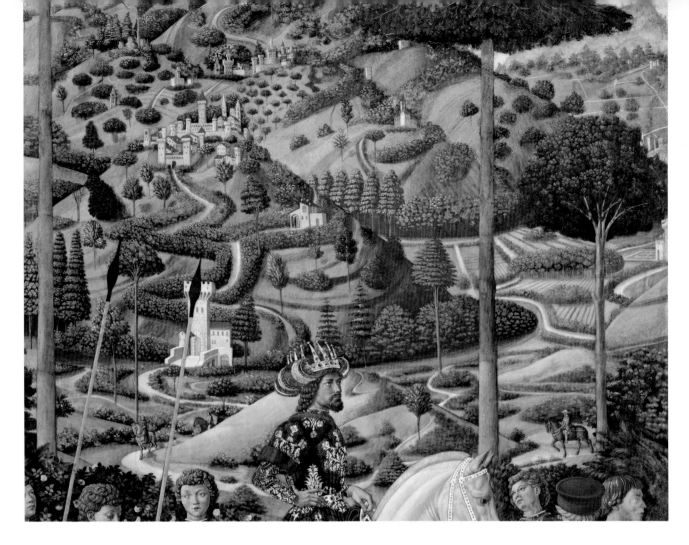

TUSCAN LANDSCAPE IN BENOZZO GOZZOLI'S *PROCESSION OF THE MAGI* IN THE PALAZZO
MEDICI-RICCARDI IN FLORENCE.

stimulated the development of architecture and sculpture, and naturally occurring pigments, like azurite and yellow ochre, fostered painting. Nor is this all.

Tuscany enjoys an incomparable situation: it stretches from the Apennines to the Tyrrhenian Sea, lies on major trade routes crossing Italy, its rivers Arno, Serchio, and Cécina flowing to the sea. Tuscans have long exploited these resources for international commerce, exporting what they grew and manufactured and importing foreign luxuries in return. The Etruscans shipped ores and metalwork, olive oil, and stylish shoes across the Mediterranean, and brought home Near-Eastern banqueting, the Phoenician writing system, and Greek vases and myths. Lucca rose to prominence by turning silkworms imported from the East by the crusaders into a thriving industry: Her opulent silks were among the most prized textiles in the wardrobes of medieval elites.

Because the location and its offerings could hardly be improved, Tuscany has been occupied continuously for millennia. Layers of history are palpable here, and have always provided inspiration. The extraordinary richness of Tuscan arts results from conscious cultivation of the past, and the desire to surpass what came before. Medieval towns claimed fanciful ancient pedigrees and erected their churches out of reused Roman blocks. Renaissance craftsmen learned from and competed with antiquity, which they met face-to-face in Roman ruins and artifacts found in Etruscan tombs. Baroque villas, gardens, theatrical productions, and hard-stone mosaics emulated ancient arts, but new masterpieces emerged from deft exploitation of local resources and far-flung commercial and diplomatic networks.

previous spread SKYLINE OF SAN GIMIGNANO, A MEDIEVAL TUSCAN TOWN.

2 THE ARTS *of* TUSCANY

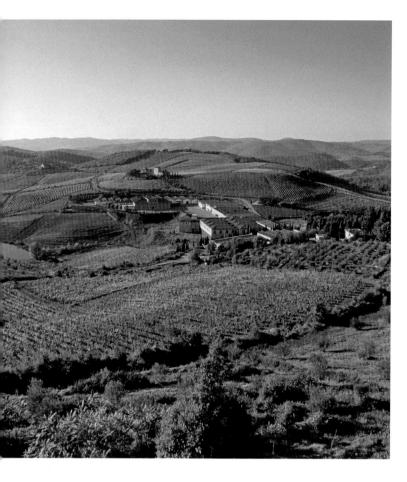

VINEYARD IN THE CHIANTI AREA OF SIENA, NEAR FLORENCE.
<⁓<⁓<⁓<⁓<⁓<⁓<⁓<⁓<⁓<⁓<⁓<⁓<⁓<⁓<⁓<⁓<⁓<⁓<⁓<⁓<⁓<⁓<⁓<⁓<⁓<⁓<⁓<⁓-

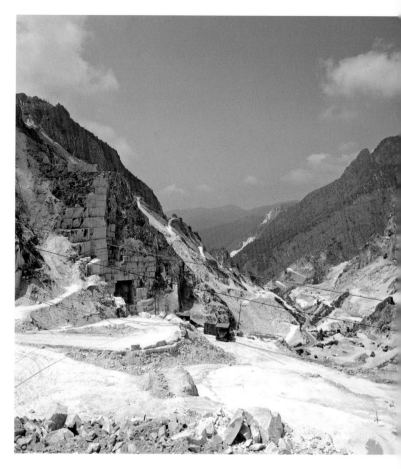

MARBLE QUARRY AT CARRARA.
<⁓<⁓<⁓<⁓<⁓<⁓<⁓<⁓<⁓<⁓<⁓<⁓<⁓<⁓<⁓<⁓<⁓<⁓<⁓<⁓<⁓<⁓<⁓<⁓<⁓-

The links between man and nature, city and countryside, natural and man-made creations have always remained intimate in Tuscany, and endlessly generative. The countryside is what Tuscans see just beyond their city walls, traverse as they go to the next town, or look forward to visiting on the weekend. The urbane Florentine designer Emilio Pucci became a vintner in his old age. Even at times when the region seemed spent, as was the case in the nineteenth century, the thermal springs of Montecatini and the seaside of Viareggio spurred local residents to develop their sleepy towns into major international resorts by marrying the offerings of the land with a hedonistic assembly of hotels and spas whose architecture, spanning styles from Neo-classical to Liberty (a version of Art Nouveau), playfully encapsulated the region's history and art.

This book is a journey through the arts of Tuscany as they grew and evolved over the centuries, each era providing substance for the next. Spanning time, geography, and a wide variety of materials—from Etruscan bronzes to Ferragamo shoes—the panorama I shall present is necessarily selective. By focusing on a few cities, I shall seek the roots of artistic developments in the sites that gave them birth. You may well find some of your favorite towns, artists, or artworks missing; but I hope that the broad chronological range of this book will introduce you to new treasures, and spur you to go to Tuscany, whether for the first time or the seventh, to experience its magic, and to compose another list of favorites that you will then return to again and again— as I have—to revise and expand.

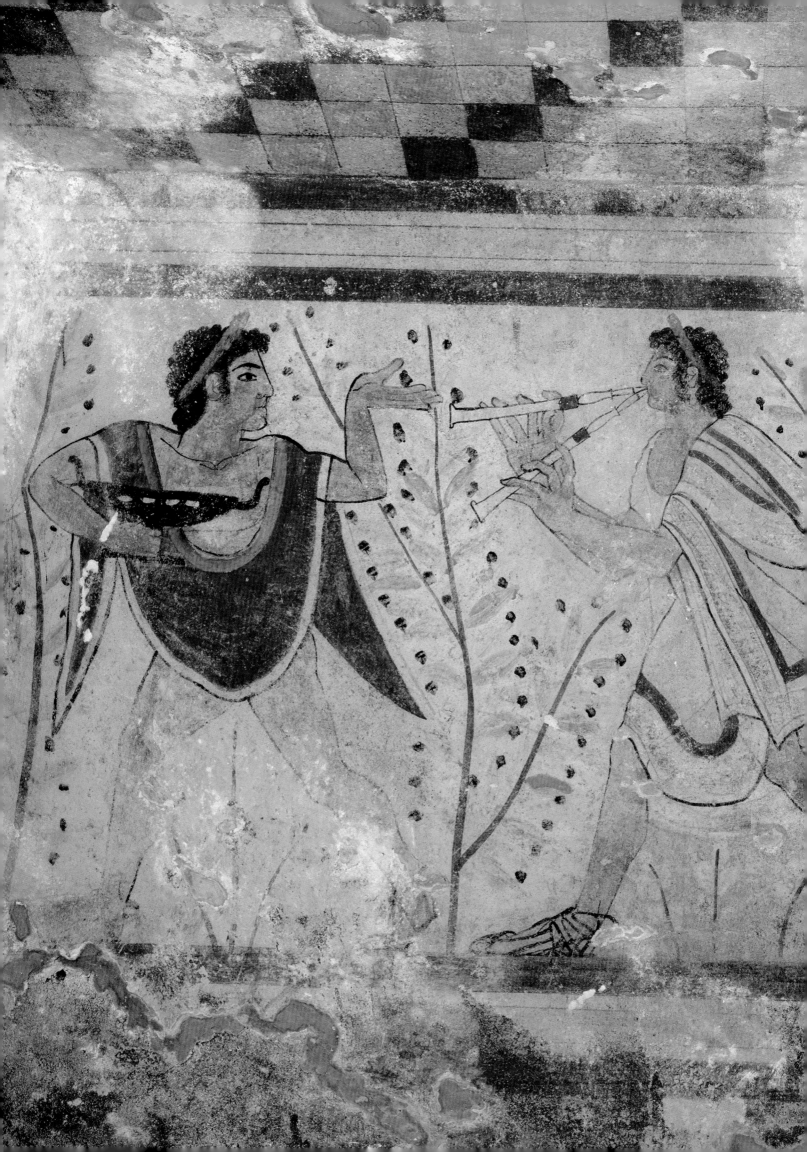

THE ETRUSCANS, SHAPERS OF TUSCANY: CERVETERI, TARQUINIA, VOLTERRA

THE TUSCANY WE KNOW AND ADMIRE TODAY BECAME A DISTINCTIVE AND CELEBRATED REGION THANKS TO THE ETRUSCANS. THESE RESOURCEFUL AND TALENTED PEOPLE RULED THE AREA FROM THE EIGHTH UNTIL THE FOURTH CENTURY BC, AND TRANSFORMED IT INTO A HOTHOUSE FOR ALL KINDS OF ARTS. THE ETRUSCANS WERE EVENTUALLY CONQUERED AND ABSORBED BY THE Romans, but they never vanished completely, and continued to haunt their land. Medieval hill-towns rose over Etruscan foundations. Renaissance architecture, sculpture, and painting drew inspiration from Etruscan remains. Eighteenth-century Europeans fell in love with ancient vases when they emerged from Etruscan tombs. And to this day, the Etruscan spirit lives in the Tuscan landscape, in the region's passion for cooking and wine, in the skills of local goldsmiths and fashion designers. The Tuscan genius for molding local resources into a beautiful life began with the Etruscans.

It is often said that the Etruscans are mysterious: mysterious in origin, in language, in beliefs. But in truth we know a great deal about them from their material remains and from ancient writers. We can envision their civilization in very rich detail. The Etruscans are fascinating precisely because of what we know about them: that they were mighty sailors and savvy merchants, great craftsmen and sensuous bon-vivants. That Etruscan women enjoyed a public life and economic opportunities denied to women in the

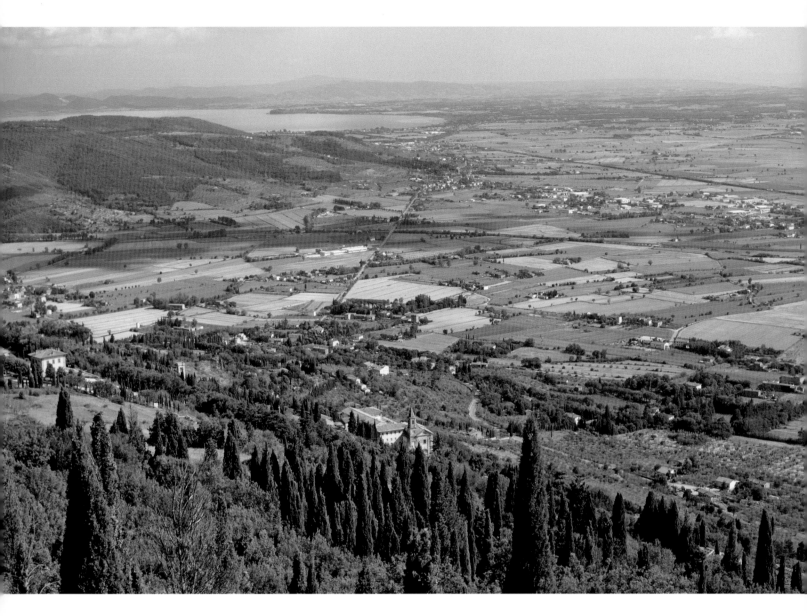

THE CHIANA VALLEY AND COUNTRYSIDE AS SEEN FROM CORTONA.

neighboring civilizations and were viewed as scandalous and dangerous by Greek and Roman men. That the Etruscans were the first to make Italian fashion, including shoes, hotly desired commodities, and clever enough to trade the riches of their land for the best luxuries the world had to offer. That the Romans did their best to vanquish Etruscan cities and culture, yet took pride in their Etruscan ancestry and greatly admired the Etruscan arts.

The Etruscans spoke a strange and singular language. They were unlike other inhabitants of the Mediterranean

in their practices and outlook. Greek and Roman authors debated their origins and imagined diverse routes by which they may have landed in Italy, but it seems most likely that the Etruscans evolved from local dwellers in the area. In any case, by the eighth century BC they emerged as a defined people who called themselves Rasna or Rasenna. The Greeks named them *Tyrrhenoi*, and the Romans called them *Tusci* and *Etrusci*. They lived in self-governing cities, but shared religion, language, and customs. Their territory stretched from the Tiber in the south to the Arno in the north, and was bordered by the

previous spread WALL FRESCO IN THE TOMB OF THE AUGURS DEPICTING A REVELER AND A MUSICIAN, C. 540–530 BC.

Apennines and the Tyrrhenian sea, which still bears their name. Through extensive maritime trade, their sphere of influence extended even further, from the Po Valley to Campania and beyond.

The ancestors of the Etruscans dwelled in small agrarian communities and lived modestly off the land. The Etruscans built the first cities and a lifestyle of unprecedented luxury by fully exploiting the fabulous natural resources right underneath them, and foreigners' desire for them. In the process, the Etruscans shaped the culture and landscape of central Italy. They preferred to set their cities on hilltops because that way they could best command and defend their domains. To get a sense of how majestically they surveyed their possessions from high perches, visit Cortona, a former Etruscan city and now a maze of steeply climbing medieval streets. At Cortona's feet stretches a stunning panorama of the Chiana Valley, Lake Trasimene, and Monte Amiata. The visibility is extraordinary. No one could sneak by undetected or undeterred.

The Etruscans were superb engineers who taught the Romans how to build. Etruscan city walls, or what remains of them, are striking in the huge size of the blocks and their tight fit. The monumental gate at Volterra, for example (right), is a marvel of construction and design, dwarfing the spectator standing before it, but also wonderful in its elegant lines. The Romans built to impose their will on the landscape: think of their cement vaults and theaters raised on level plains. The Etruscans worked with what they encountered, and perfected the natural assets in their possession. Lars Porsena, the sixth-century BC king of Chiusi, discovered that when water seeped through the ground of his city and collected in chance cavities in the bedrock, it became purified. The town stands on sedimentary rock that functions as a natural filtration system. Porsena lost no time in carving out of it a vast network of underground channels to collect as much of this clean water as possible. Additional tunnels allowed for regular maintenance and repair. As the visitor wanders through this labyrinth today, he marvels at the engineering of the Etruscans and their ecological wisdom. The locals still put the tunnels to good use. One restaurant transformed a portion of the labyrinth underneath it into a huge wine cellar, which one can visit after a delicious meal.

ETRUSCAN WALLS AND GATE, PORTA DELL' ARCO, IN VOLTERRA, FOURTH-THIRD CENTURY BC.

In the sixth century BC the Etruscans also built Rome. Originally a swampy pastoral village near vital salt deposits on the Tiber en route to Etruscan settlements in Campania, the Etruscans wanted it under their control. But they were accustomed to a certain standard of living, so they began to shape the primitive settlement into a civilized town. First they drained the surrounding marshes and built a great drain, the Cloaca Maxima, to carry excess water to the Tiber. Then they laid out the first forum, put up the first temples, and set on their roofs lively terra-cotta statues of the Etruscan gods. For entertainment they built a race course, the first Circus Maximus, and introduced to Rome competitive athletic games. They also gave Rome their religion based on augury, along with political insignia and ceremonies.

The Romans eventually subjugated the Etruscans and erased most of their buildings and civilization.

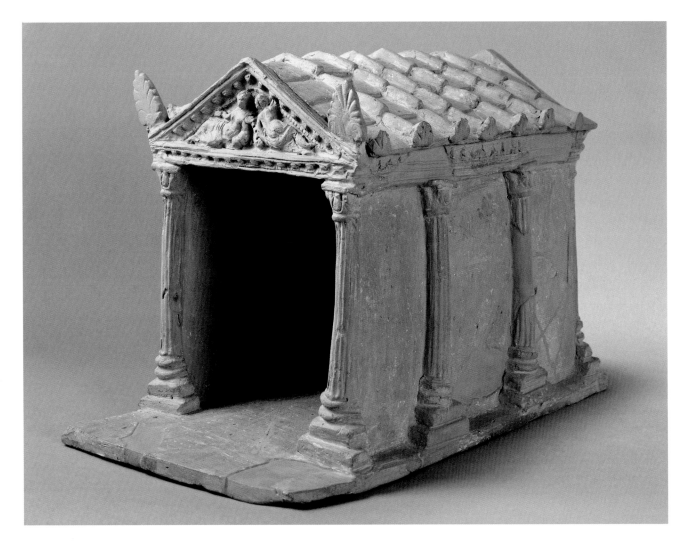

MODEL OF A TEMPLE FROM VULCI, THIRD CENTURY BC MUSEO DI VILLA GIULIA, ROME

Now we can only glimpse Etruscan architecture in scattered models and rock-cut tombs. A votive terra-cotta miniature of a temple from Vulci (above) looks rather like an ancient Greek temple, with large decorations on the roof. A painted terra-cotta statue of Apollo (opposite, right) was made for the roof of the Temple of Minerva at Veii in the late sixth century BC. It has been attributed to Vulca, the Veiian artist who made the cult statue of Jupiter in the Capitolium, the great temple on Rome's Capitoline Hill. Vulca is the only Etruscan master whose name is recorded, and the earliest Tuscan artist we know. His figure of Jupiter, the most important statue in Rome, was praised by Pliny—relying on earlier sources— in the first century BC.

The Roman author Marcus Varro, also writing in the first century BC, records further that the art of modeling in clay was well developed in Italy and especially in Etruria; that Vulca was summoned from Veii by Tarquinius Priscus; that the image of Jupiter for the Capitolinum was made of terra-cotta, for which reason, as was usual, it was colored red; that there were terra-cotta quadrigas on the peak of the temple; and that Vulca also sculpted a statue of Hercules. These were the most praiseworthy images of that era.

The life-size *Apollo* is a dynamic and majestic figure. So are the terra-cotta horses from Tarquinia (pp 4–5), and a head of a woman from Pyrgi (opposite, left) that also once decorated temple roofs. They are mere fragments, but so vivid and sensual with their capriciously turned necks. These sculptures are modeled in cheap local clay, but they are technically sophisticated and aesthetically refined far beyond their humble material.

The Romans were both fascinated and appalled by the Etruscans. They owed them so much of their culture,

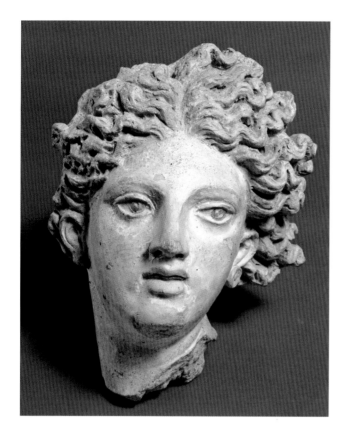

PAINTED TERRA-COTTA HEAD OF A WOMAN, LIKELY FROM THE PEDIMENT OF TEMPLE A IN THE SANCTUARY OF PYRGI, AT SANTA SEVERA, LATE FOURTH CENTURY BC. MUSEO DI VILLA GIULIA, ROME

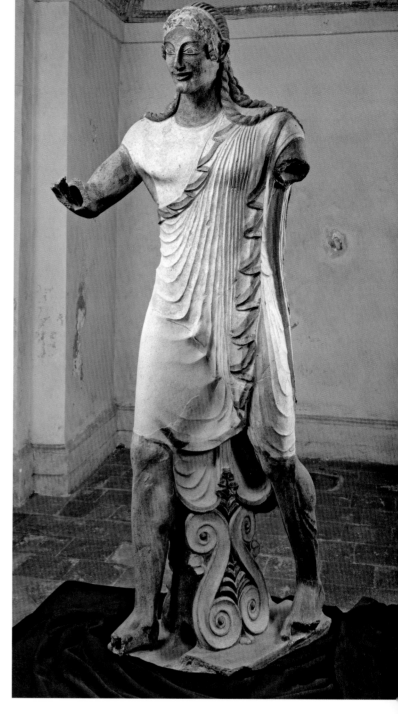

PAINTED TERRA-COTTA STATUE OF APOLLO FROM THE ROOF OF THE TEMPLE OF MINERVA AT VEII, LATE SIXTH CENTURY BC. MUSEO DI VILLA GIULIA, ROME

yet could not forgive their hedonistic and egalitarian ways. The Roman historian Livy described in lurid detail the reign of Rome's Etruscan kings, mesmerized by their opulence and opportunism and repelled by their domineering wives. Etruscan women played a much more active role in the public sphere than Roman matrons did, and they shared the pleasure-loving ways of their men. Livy's model of Roman womanhood was Lucretia, who stayed at home diligently spinning her wool. After being raped by Sextus, the son of the reigning Etruscan king, she killed herself to preserve her family's honor. An Etruscan woman would have probably killed her assailant instead. In fact, according to Livy, Sextus' mother, Tullia, hungry for power, despised her less ambitious sister for lacking "the daring proper to a woman."

Tullia modeled herself on Tanaquil, the wife of the first Etruscan king of Rome, Lucumo. It was Tanaquil who assured her husband's political success. Livy clearly disapproved of these two Etruscan women, and he spilled plenty of ink to paint them as darkly as he could.

Lucumo, Livy tells us, was born in Tarquinia. His mother was Etruscan, but his father was a Corinthian Greek who fled to Tarquinia to avoid political turmoil at home. He probably settled in Etruria because he had previous trade contacts there, as did many Greeks. Because of his Greek parentage Lucumo seems to have been unable to advance in his native city. His wife Tanaquil, "an aristocratic young woman who was not of a sort to put up with humbler circumstances in her married life than those she

TERRA-COTTA RELIEF FROM POGGIO CIVITATE,
C. 525 BC. ANTIQUARIUM, MURLO

had been previously accustomed to," says Livy, decided that Rome, a young and rising community, would be the place where Lucumo could come to power with her help. So south they went.

"The pair had reached Janiculum," writes Livy,

and were sitting together in their carriage [an honor denied to Roman matrons], when an eagle dropped gently down and snatched Lucumo's cap off his head. Up went the bird with a great clamor of wings until, a minute later, it swooped down again and, as if sent by heaven for that very purpose, neatly replaced the cap on Lucumo's head, and then vanished into the blue. Tanaquil, like most Etruscans, was skilled in reading celestial prodigies, and joyfully accepted the omen. Flinging her arms around her husband's neck, she told him that no future was too high to hope for. . . . Thus dreaming of greatness Lucumo and Tanaquil drove into Rome, where they bought a house, and Lucumo took the name of Lucius Tarquinius Priscus.

The prophecy eventually came true and Lucumo became a Roman king.

What of this story is truth, what malice or legend is difficult to sort out. Livy's spite for Tanaquil and Lucumo is clearly a Roman bias. But Etruscans did rule Rome for

a hundred years, and Etruscan women shared public life with their husbands. Hence Livy's emphasis on Tanaquil's brazen actions, whether in conceiving and carrying out plans for her husband's career, or riding alongside him as an equal partner and spiritual guide. Etruscan paintings and sculptures certainly show how visible women were in the civic sphere. A terra-cotta relief (left), roughly contemporary with Lucumo and Tanaquil's arrival in Rome, depicts a procession of chariots that carry noble women alongside men.

Roman women fared very differently. Plutarch, in his biography of Numa Pompilius, the city's second king, writes that "great modesty was enjoined upon women; all busy intermeddling forbidden, sobriety insisted on, and silence made habitual. Wine they were not to touch at all, nor to speak, except in their husband's company, even on the most ordinary subjects." Little wonder that Greek and Roman men were disgusted at Etruscan women appearing in public, reclining on couches at banquets, drinking wine, flirting, and flaunting their good looks. Etruscans were not only more egalitarian in regard to women, but more openly affectionate. Funerary urns frequently depict reclining couples enjoying a perpetual banquet together (opposite, top), or sleeping wrapped in each other's arms.

We can also see the high status of women in their individual funerary monuments. The sarcophagus of Larthia Seianti from Chiusi (opposite, bottom) shows a woman of privilege and pride. She wears an embroidered dress fastened with a gold belt studded with jewels, along with gold earrings, bracelets, rings, and a pendant shaped like a head of a girl. She reclines on a couch piled with fringed pillows; and an inscription underneath her records her name. Unlike contemporary Roman women, known merely as their fathers' daughters or their husbands' wives, Etruscan women had their own proper names.

In telling the story of Tanaquil and Lucumo, Livy also describes Etruscan augury. The Etruscans were regarded by their contemporaries as singularly religious people. They were especially skilled at reading omens in

opposite, top URN WITH FIGURES OF A MARRIED COUPLE, SIXTH CENTURY BC. MUSEO ETRUSCO GUARNACCI, VOLTERRA

opposite, bottom SARCOPHAGUS OF LARTHIA SEIANTI, FROM CHIUSI, SECOND CENTURY BC. MUSEO ARCHEOLOGICO, FLORENCE

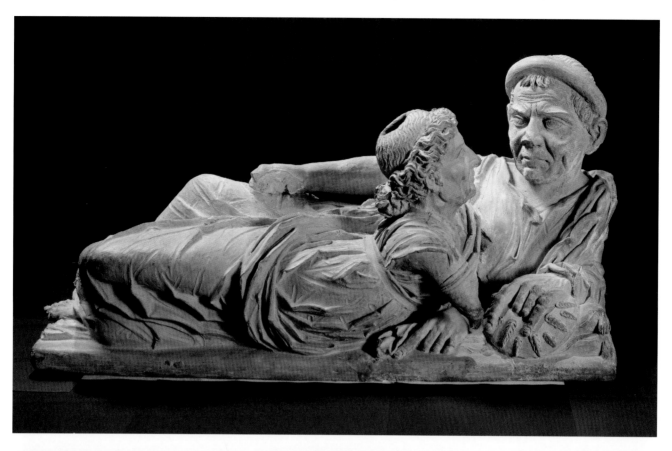

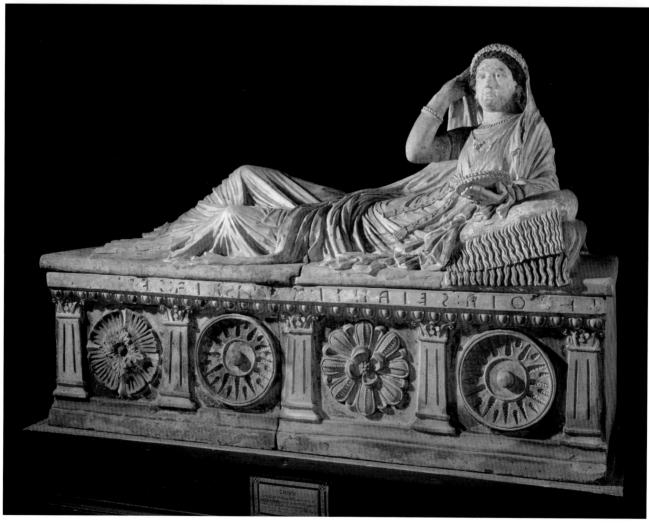

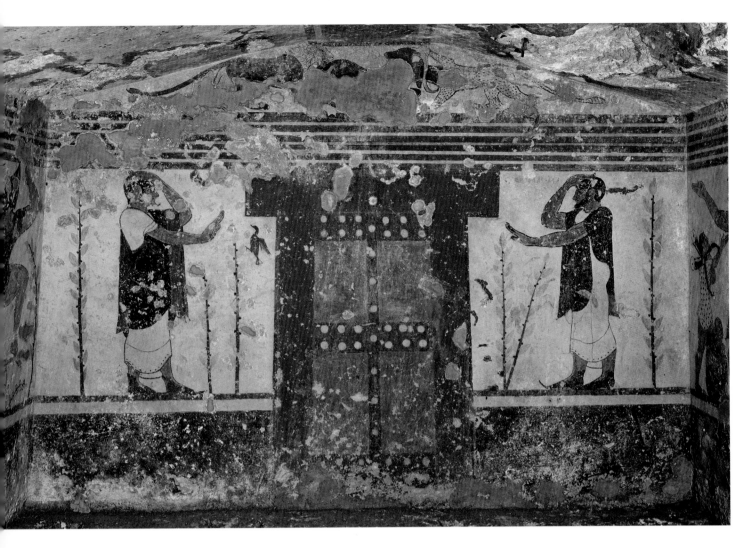

FRESCO OF AUGURS IN THE TOMB OF THE AUGURS IN TARQUINA, C. 540–530 BC.

thunder and lightning, the flight of birds, and livers of sacrificed animals. According to the Etruscans, the vault of heaven was divided into sixteen regions, each ruled by a particular god. The eastern part of the sky was inhabited by deities kind to mortals, the western by those who were obstreperous and hostile. To discern which god sent a particular message, or expressed his or her rage, Etruscan augurs read storm patterns and bird movements, as Tanaquil did on her approach to Rome. The *Tomb of the Augurs* in Tarquinia (above and p. 4) shows a male priest gesturing emphatically toward a flying bird. When the Etruscans used animal livers for divination, they saw on the steaming organ an imprint of the celestial map. A life-size bronze model of a sheep's liver found in Piacenza (opposite, right) seems to be a training tool. It is incised with compartments that name Etruscan gods and regions of the sky. To learn his craft, an augur's apprentice would

hold this model next to a freshly obtained organ and try to understand which region had a message for him.

Religion was so fundamental to the Etruscan worldview that early rulers of Etruscan cities were priests. The Romans, schooled by their Etruscans kings, continued to send their sons to study Etruscan augury in preparation for political office. Because Roman religion was closely bound to politics, generals and powerful magistrates had to be able to conduct sacrifices and other religious rites. And when in the early first century BC the Capitol was truck by lightning, soothsayers from all of Etruria were summoned to Rome to determine which gods needed to be appeased.

Etruscans ruled Rome only for a century. Most of their towns lay north of the Tiber and across Tuscany. Arezzo, Chiusi, Cortona, Fiesole, Pisa, Siena, and Volterra were all Etruscan foundations, loosely linked

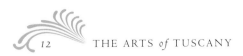

into a federation that met annually to affirm their common bonds. But each town functioned independently, even, unfortunately for them, when faced by a common enemy, such as Rome. Each had its own political and economic structures, its specialized crafts, its burial rituals. Medieval and Renaissance Tuscany would later inherit this network of autonomous city-states that proudly insisted on their distinct identities, civic and mercantile institutions, and artistic strengths.

Etruscan towns grew so prosperous and refined because their inhabitants exploited their natural resources with discernment and skill. Etruria's climate was favorable to all kinds of growth, and ancient authors sang the praises of its fine forests and rich agriculture. The forests provided materials for building temples and houses, bridges and ships. Grain, grapes, olives, and myriad fruits and vegetables, as well as game, fostered the development of a fine cuisine. Etruria also yielded abundant copper and tin for smelting bronze, along with lead, silver, and iron ore. It had more iron ore than any other region in the Mediterranean, which gave the Etruscans a great economic advantage. Even after they had used these assets to indulgence, there was still plenty available for international trade. So the Etruscans built an extensive navy and became extremely successful merchants, growing richer as each shipload left their ports.

Those less blessed with such bounties were exceedingly envious, and called the Etruscans pirates when they encountered them at sea. The Greeks, whose soil was far poorer, and who ventured into Etruscan waters to augment their more meager resources, were not short of disparaging remarks. Whether the Etruscans were in fact cut-throat brigands or clever businessmen is hard to tell; they were probably both. But they certainly were not fools, and jealously guarded their ships and shipping routes.

On a seventh-century BC Etruscan krater a heavy merchantman with a high prow encounters a slim, oared warship with a dolphin-shaped battering ram. Armed warriors stand ready for battle. It is hard to tell which vessel is Etruscan and which belongs to the enemy. The krater was almost certainly painted by a Greek artisan working in Etruria; what his allegiances or orders were we will never know. But on the opposite side of the pot the belligerent theme continues. There Odysseus, another

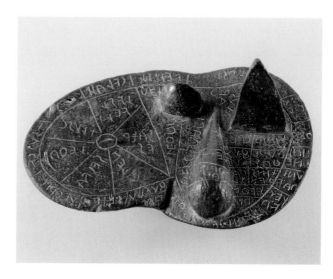

BRONZE LIVER OF PIACENZA, A MODEL OF A SHEEP'S LIVER WITH NAMES OF ETRUSCAN GODS INSCRIBED IN COMPARTMENTS ON ITS UPPER SURFACE. MUSEO CIVICO,

DRAWING OF ARISTONOTHOS' VASE SHOWING A NAVAL BATTLE AND ODYSSEUS BLINDING POLIPHEMUS PRODUCED IN CERVETERI IN LATE 7TH CENTURY BC. CAPITOLINE MUSEUM, ROME PIACENZA

wily sailor, blinds Polyphemos. Odysseus, when he had reached the land of the Cyclops, quickly assessed its fertility and disparaged its monstrous inhabitants for failing to establish viable agriculture and a fleet. The Etruscans excelled at both. So who here is a civilized traveler and who a barbarian? Like so many artworks, the krater generates more questions than answers.

In exchange for their agricultural and mineral wealth the Etruscans imported foreign luxuries and technologies, shaping them to their own aesthetics and needs. They took the Greek alphabet and altered it to express their own language: changing the Greek gamma into the "c"

they needed, they gave us our ABC. An elegant ceramic
inkwell has the newly acquired alphabet scratched into its
side (left).

The Etruscans were great metalsmiths because
metal was so plentiful in their soil. Through contacts
with the Near East, as well as Greece, they refined their
skills. Having learned from these trade partners the
techniques of filigree and granulation, they took them
to new heights. Granulation in particular is a remarkable
achievement. Even today, with sophisticated magnifiers,
precisely controlled temperatures and other superior
resources, granulation rarely approaches the quality of
Etruscan work. The process consists of soldering small
balls of gold onto a metal sheet to create a decorative
pattern, or a surface evenly covered with tiny gold
globules. Etruscans produced granules of 0.14 mm to
0.25 mm in diameter. They did this either by pouring
molten metal into water (which causes gold to break into
little balls) or by pouring it onto charcoal. Alternately,
they placed small cuttings of gold on charcoal and heated
them just to the melting point, so that they would turn
into granules but not fuse into a shapeless mass. They
then soldered the granules onto the surface they were
decorating by using a colloid hard-soldering process, in
which the binding medium melts faster than the gold,
leaving the granules attached to the surface but perfectly
intact. Some of the most spectacular pieces of Etruscan
gold jewelry, decorated with miniature sculptures, reliefs,
filigree, and granulation, came from the tomb of a very
rich lady in Cerveteri (opposite, top). She took with her
to the afterlife finely wrought gold pendants, bracelets,
and earrings adorned with marching lions, hand-holding
maidens, and ornamental designs of astounding delicacy.

Etruscans were no less proficient when working with
bronze, whether in miniatures or in life-size figures. One
of the most prized displays in the Medici art collection
in Florence and still an Italian national treasure, is a
bronze Chimera discovered in 1553 in Arezzo and
instantly appropriated by Grand Duke Cosimo I (p. 16).
The Chimera is a composite monster, with the body of
a lion, the tail of a serpent, and a goat growing out of its

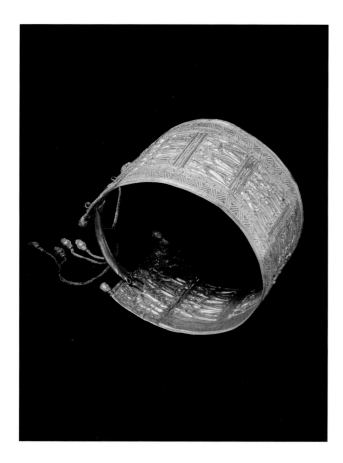

GOLD BRACELET FROM THE RIGOLINI-GALASSI TOMB AT CERVETERI, SEVENTH CENTURY BC. MUSEO GREGORIANO ETRUSCO, VATICAN

GOLD PECTORAL FROM THE RIGOLINI-GALASSI TOMB AT CERVETERI, SEVENTH CENTURY BC. MUSEO GREGORIANO ETRUSCO, VATICAN

back. Originally it formed part of a larger composition depicting its fabled combat with the hero Bellerophon. Bellerophon of Corinth was a man of remarkable beauty, valor, and uprightness. Propositioned by Anteia, wife of Proetus, king of the Argives, he refused her advances and was promptly accused by her in revenge. Proetus, hearing only his wife's side of the story, sent Bellerophon to Lycia with a letter to a king there, asking him to put Bellerophon to death. The king of Lycia ordered a fight with the Chimera among a series of trials intended to dispatch Bellerophon. Of course, since he was a hero, he won that and other contests, and eventually married the king's daughter. Although the Chimera is a mythical creature, the individual animal components of this Etruscan sculpture are rendered with such sensitivity to the anatomy and movement of animals that we instantly perceive a gravely endangered predator fighting for its life.

Etruscan craftsmen not only cast such vivid large bronze figures, they also hammered bronze sheets into

decorative and utilitarian objects. A mid-sixth-century parade chariot (at the Metropolitan Museum in New York) is a rare survival, made from embossed sheets of bronze enriched with ivory inlays. Given the imposing appearance of this vehicle, no wonder that the austere Romans decried Etruscan luxury and viewed it as a threat to their power and moral fiber.

In their clothing, too, the Etruscans were the envy of the Mediterranean. Just as modern Italians do, they took pride in elegant dress, fine hats, and stylish shoes. In tomb paintings and terra-cotta sculptures, on burial urns and bronze mirrors they are always dressed to show off their taste and wealth. Etruscan garments were bright with patterns and embroidered at necks, sleeves, and hems. Etruscan shoes stood apart from other contemporary footwear by their superior design and construction. Stylish lace-up boots with pointed toes brightened the cold season, and fancy sandals added flair when it was warm. Etruscan sandals had high wooden

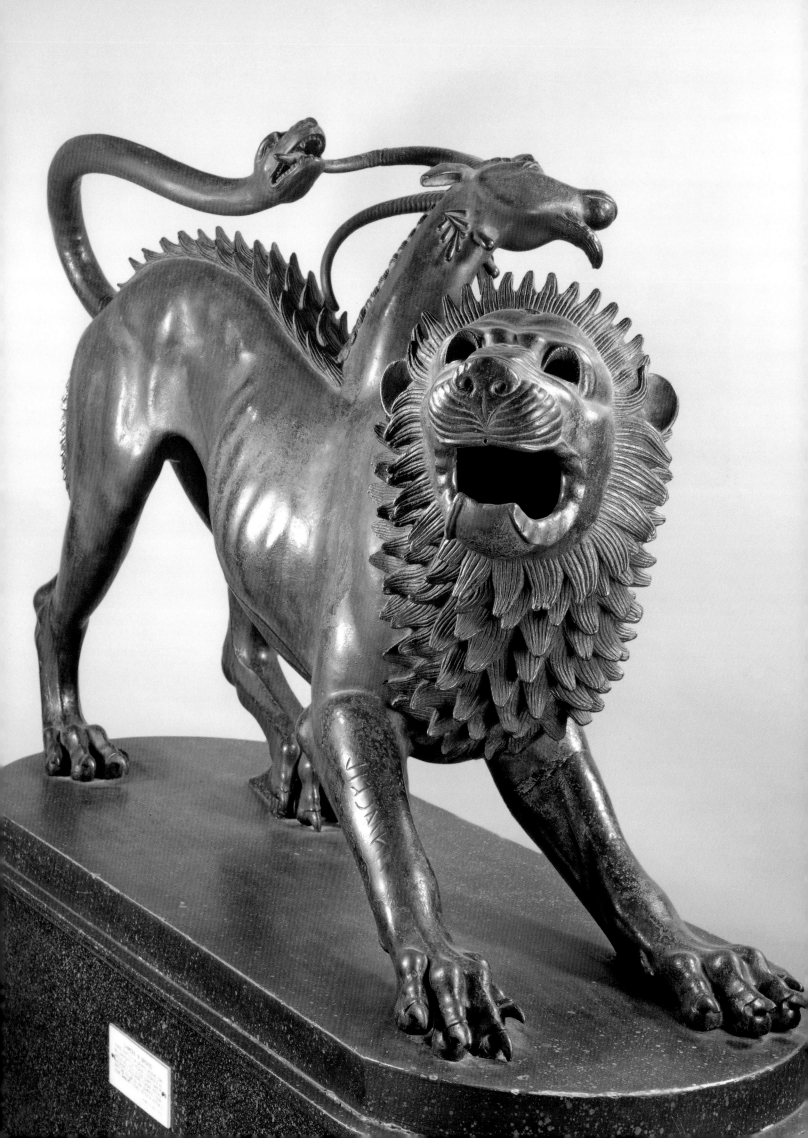

platforms hinged at the instep, so that the soles followed the natural movement of the foot—the lifting and lowering of the heel—with each step (top right). This made the sandals more pliable and comfortable than modern platform shoes, and their gold laces gave them particular chic. Etruscan shoes were so highly valued across the Mediterranean that even the most important lady in Athens—the colossal statue of Athena in the Parthenon—wore gold-embroidered Etruscan sandals. Indeed, they were the feature closest to the eye of any visitor standing before her towering forty-foot form.

Athena, as well as Hera and Aphrodite, show off Etruscan fashions on a mid-sixth-century BC amphora from Vulci (right, bottom). They are, after all, on their way to the most famous beauty pageant of antiquity, the Judgment of Paris. Their dresses are embroidered with patterns, and Aphrodite hikes up her skirt to display her shoes. The amphora was made by eastern Greek potters who set up business in Vulci and painted Greek stories for their Etruscan clients. Highly cosmopolitan, the Etruscans welcomed foreign contributions to their culture, including the mythology and literature of the Greeks, and luxury objects made abroad or created by immigrants.

As with so many ancient cultures, the Etruscans are most alive to us when they are dead. The Romans erased Etruscan towns, but whole cities of the dead survive. The cemeteries of Cerveteri (p. 18) and Tarquinia have carefully laid-out streets, with side-by-side house-like graves cut into stone, and owners' names inscribed over the doors. Inside, their multiple rooms are outfitted with everything necessary for living well, from elegant decorations to objects of everyday life. Men have been supplied with razors and bridles, weapons and armor. Women have with them their kitchen utensils and spindles, mirrors and jewelry of every sort. The *Tomb of Reliefs* (p. 19, top), belonging to the Matuna family, looks like a prosperous dwelling. Its beamed ceiling rests on pillars with carved capitals. Along the walls stand niches with couches and cushions piled high. The walls are hung with books and armor, drinking cups and cooking implements, a fancy feathered fan, a gaming board, and even pets: a dog plays with a lizard, a duck cleans its

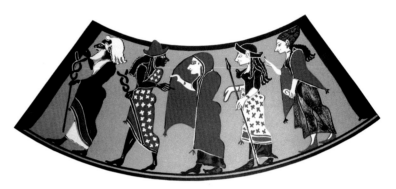

WOODEN ETRUSCAN SANDALS FROM BISENZIO OLMO BELLO TOMB XVIII, SIXTH CENTURY BC. MUSEO DI VILLA GIULIA, ROME

DRAWING OF AN AMPHORA DEPICTING THE *JUDGMENT OF PARIS*, PRODUCED IN VULCI IN MID-SIXTH CENTURY BC. AFTER A VASE IN STAATLICHE ANTIKENSAMMLUNGEN UND GLIPTOTHEK, MUNICH

feathers, a martin and a turtle are also to be seen. All this affluence is rendered in painted stucco reliefs.

Rich Etruscans dispatched their dead with lavish grave offerings and honored them with competitive games similar to the Greek Olympics. In the *Tomb of the Augurs* in Tarquinia wrestlers are shown in mid-contest (p. 19, bottom). Etruscans were extremely fond of music, since flutists often accompanied such games (p. 4). As one Roman source reports, Etruscans kneaded bread, wrestled and boxed, and whipped their slaves all to the

opposite BRONZE STATUE OF THE CHIMERA FROM AREZZO, FOURTH CENTURY BC. MUSEO ARCHEOLOGICO, FLORENCE

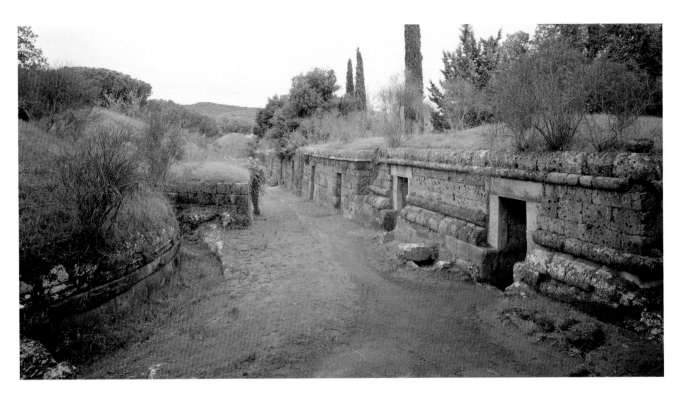

CERVETERI'S NECROPOLIS OF BANDITACCIA IN DEI MONTI DELLA TOLFA, MID SIXTH CENTURY BC.

music of the flute. And Aelian writes that

> It is said that in Etruria wild boars and stags are caught with nets and dogs in the usual manner but the hunters are more successful when they use music. Nets are stretched out, and all kinds of traps are set in position in a circle. A skilled flutist then plays the sweetest tunes the double flute can produce, avoiding the shriller notes. The quiet and the stillness carry the sounds, and the music floats up into all the lairs and resting places of the animals. At first the animals are terrified. But later they are irresistibly overcome by the enjoyment of the music. Spellbound, they are gradually attracted by the powerful music and, forgetting their young and their homes, they draw near, bewitched by the sounds, until they fall, overpowered by the melody, into the snares.

Etruscan women, like men, were often buried with sumptuous offerings. Particularly common were bronze *cistae*, or containers for toiletry articles. Made from sheet bronze, cistae were elaborately incised with scenes from myths and literature, theater and daily life. The range of subjects says a great deal about the wide interests of Etruscan women. The "Ficoroni" cista, one of the most beautiful of such vessels (p. 20), relates in elaborate detail the story of the Argonauts. Its handle consists of figures of drunken Dionysus held up by two satyrs, and its feet are lion paws standing on frogs. The maker of this box was clearly proud of his creation: he signed it with his name, Novios Plautios. So did the patron who ordered the cista. An inscription on the handle records that Dindia Macolinia, a lady from a leading Praenestine family, placed this offering in her daughter's tomb. Other common grave gifts were bronze mirrors, which their owners enjoyed during their lifetime. I especially love the mirror that shows a young couple playing a board game

opposite, top INTERIOR WALL OF THE TOMB OF RELIEFS SHOWING THE MATUNA FAMILY'S WELL-STOCKED AFTERWORLD CACHE, CERVETERI, LATE FOURTH EARLY THIRD CENTURY BC.

opposite, bottom FRESCO DEPICTING FUNERAL GAMES IN HONOR OF THE DECEASED IN THE TOMB OF THE AUGURS, TARQUINIA, C. 540–530 BC.

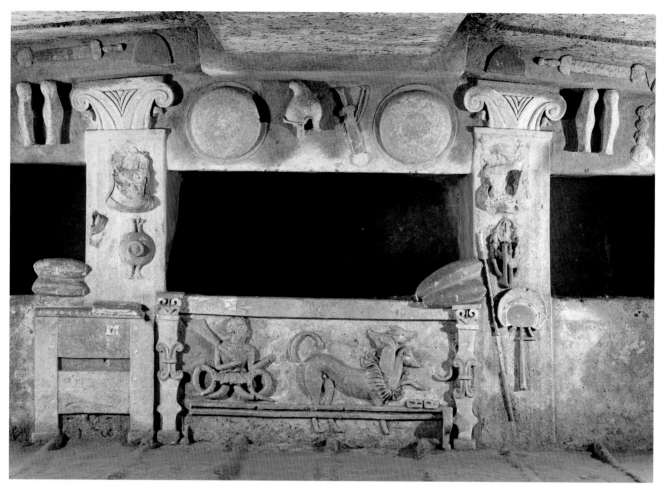

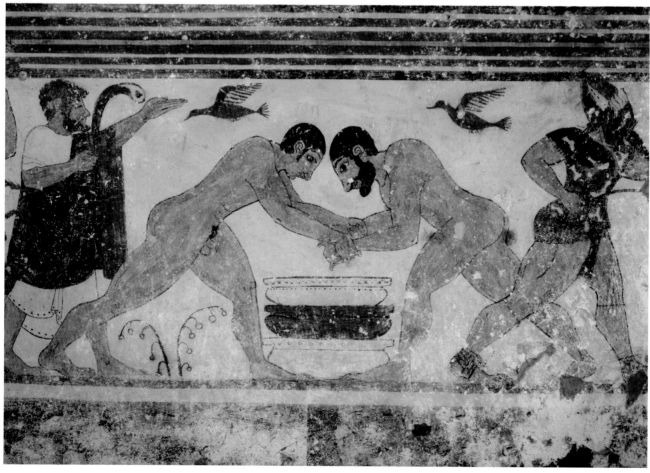

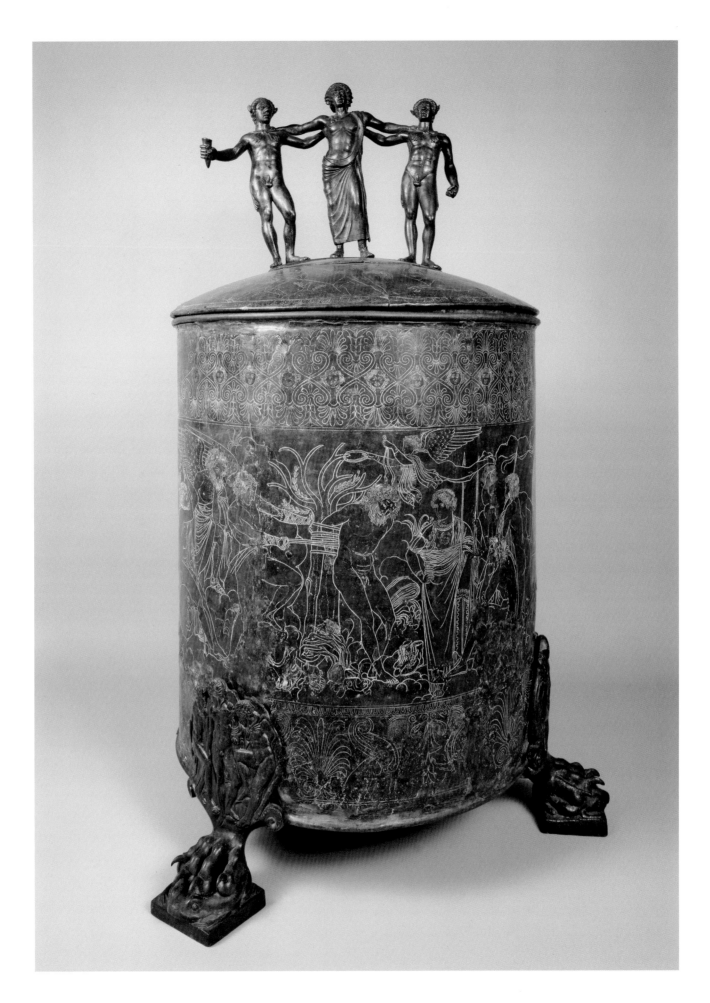

(right). She says to him, "I'm going to beat you." He replies, "I do believe you are."

Etruscans were a highly literate people, but their language remains a puzzle. It is not part of the Indo-European language group. Its grammar remains elusive, and surviving remnants of the vocabulary are too limited for us to bring the language back to life. Inscriptions on tombs and personal objects give only names and a few formulaic phrases. Yet in many funerary portraits men hold scrolls made of linen, and scenes shown on tomb walls, cistae, and mirrors indicate an extensive literary culture of myth, history, and drama. Many of these were Greek imports, but they were clearly adapted to the Etruscan pantheon, and to Etruscan interests and concerns.

Etruscans were certainly enthralled with Greek artifacts and stories. The best surviving Greek pottery comes from Etruscan tombs. The central scene in the mid-sixth-century BC *Tomb of the Bulls* depicts a Greek tale: Achilles waiting to ambush Troilus—an episode from the Trojan War (p. 22, top). The painted marble sarcophagus of Ramtha Huzcnai, a matron from Tarquinia, dramatically shows the *Battle of the Amazons* (p. 22, bottom). Was this subject of valiant female warriors chosen as an exemplum for a female owner of the urn? Etruscans were adept at enriching their culture through trade and diplomatic contacts with other countries, and transforming foreign imports into Etruscan arts. Their Tuscan descendants would do the same thing.

The custom of reclining on couches during banquets came to Etruria (and to Greece) from the Near East. In the East and in Greece women were excluded from such conviviality, unless they were prostitutes or entertainers. Etruscan women freely shared the couches and festivities with their men. The art of living well and joyously was an Etruscan specialty shared by both sexes and inherited by later inhabitants of the land. They loved to wear elegant clothes and jewels, to surround themselves with fine objects and music, to grow premium wines and cook delicious meals. "Plump Etruscans" is how Virgil

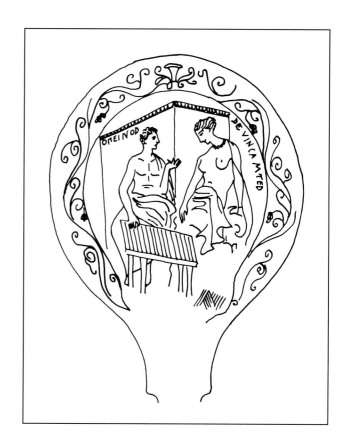

DRAWING OF A BRONZE MIRROR FROM PRAENESTE, THIRD CENTURY BC. AFTER A MIRROR IN THE BRITISH MUSEUM, LONDON.

characterized these hedonistic people. The Greek author Athenaeus wrote that they are "very good looking, because they live luxuriously and smooth their bodies. . . . They have many barber shops." Clean-shaven, well groomed, and contented, Etruscans eat, drink, and dance cheerfully on the walls of their tombs. These tombs, to be sure, belong to aristocrats, men and women of wealth and leisure; but no contemporary Greeks or Romans of this class seem to have as much fun.

Funerary banquets were, of course, ceremonial occasions rather than simple dinners, and many painted scenes of couples on couches show drinking parties rather than proper meals. Still, we know that the Etruscans were marvelous cooks and dedicated gourmands. The first-century-AD Roman satirist Martial,

opposite NOVIOS PLAUTIOS'S BRONZE "FICORONI" CISTA FROM PRAENESTE, LATE FOURTH CENTURY BC. MUSEO DI VILLA GIULIA, ROME

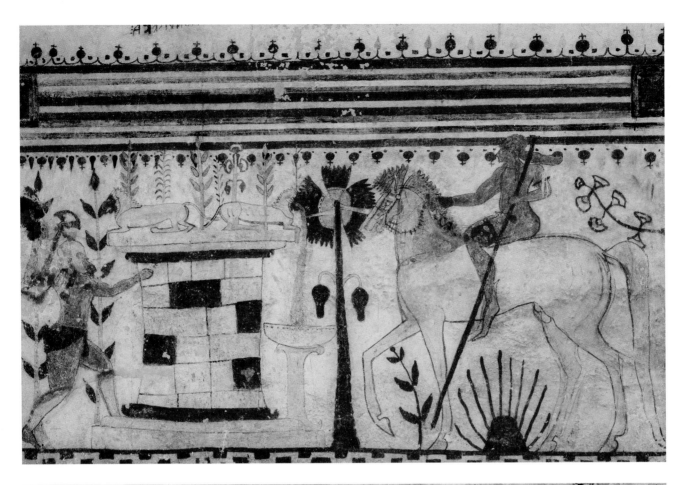

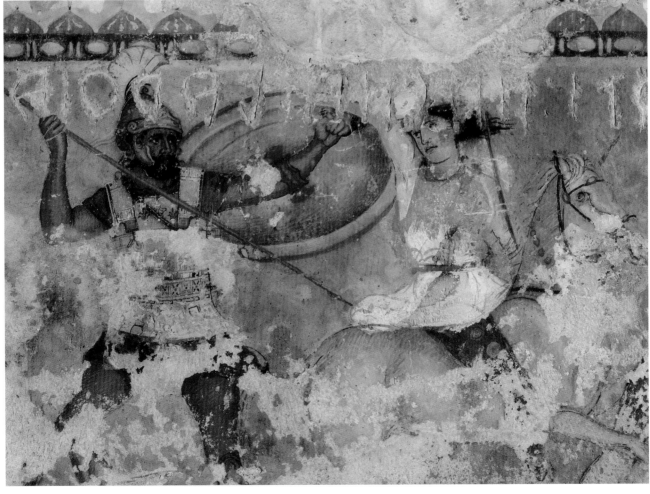

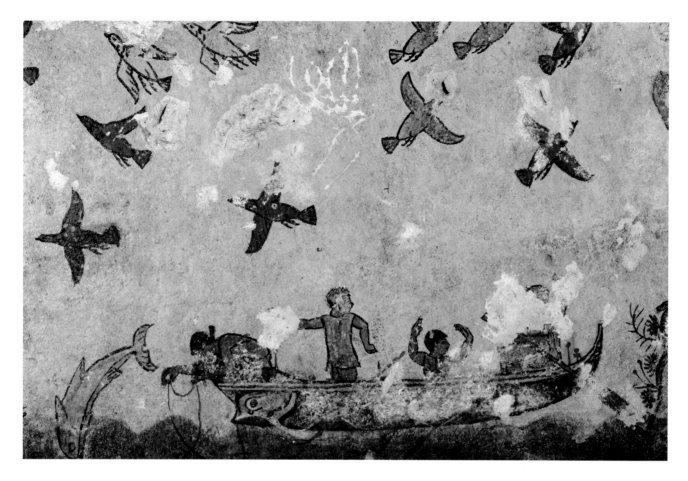

WALL FRESCO IN THE TOMB OF HUNTING AND FISHING, TARQUINIA, C. 540 BC.

in one of his poems, agonized whether to accept a Tuscan boar as a present, since to do it justice he would have to prepare it in the Etruscan manner. He would have to use a great deal of Falernian wine (grown in Campania, long part of greater Etruria) and costly spices blended into the sauce. According to another ancient writer, "The Tyrrhenians prepare sumptuous repasts twice a day [compared to the one meal enjoyed by the Greeks and the Romans] on carpets of many colors and with silver goblets of all kinds, and a crowd of beautiful slaves, dressed in precious garments." Etruscan tombs add to copious written descriptions of Etruria's almost unlimited fertility. The *Tomb of Hunting and Fishing* in Tarquinia (above) depicts one of the sources of this

abundance and the pleasures they ensure. Four men throw nets in the sea that teems with fish and leaping dolphins. A bird hunter on the seashore draws a slingshot. Above, a couple enjoys a banquet. The man lies on a couch draped with ornate fabric similar to one in another Tarquinian tomb. His wife, in an elegant dress and numerous jewels, listens to him attentively (p. 24). A table before them is piled with food.

The Etruscans' art of good living grew out of the fertility of their region, and their skillful use of the riches at their feet. Greek and Latin authors all commented that Etruria was famous for the high quality and quantity of its produce, compared to Greece and the rest of Italy, and that the Etruscans advanced agriculture with the

opposite, top FRESCO IN THE TOMB OF THE BULLS DEPICTING ACHILLES'S AMBUSH OF TROILUS, TARQUINIA, C. 550–540 BC.

opposite, bottom DETAIL OF A PAINTED MARBLE SARCOPHAGUS SHOWING COMBAT BETWEEN A WARRIOR AND AN AMAZON, LATE FOURTH CENTURY BC. MUSEO ARCHEOLOGICO, FLORENCE

 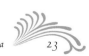

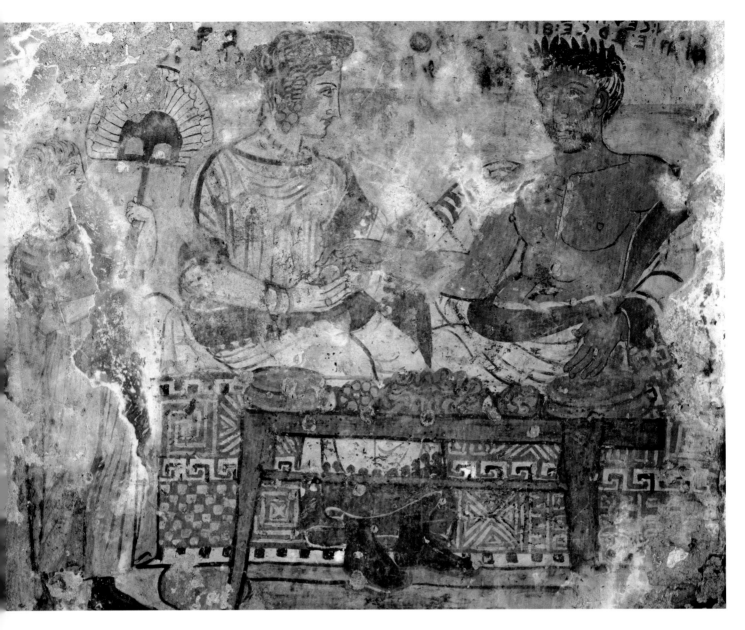

FRESCO IN THE TOMB OF SHIELDS SHOWING A FUNERAL BANQUET, TARQUINIA, LATE FOURTH CENTURY BC.

use of sophisticated tools and techniques. No wonder that the less fortunate and more staid Romans envied and denigrated the Etruscans for their decadence and self-indulgence. They were irritated by Etruscan culture dominating central Italy and permeating Roman life. Even after conquering and absorbing the Etruscans, the Romans still used gold "Etruscan crowns" to honor triumphant generals and Etruscan gold amulets to safeguard and distinguish noble Roman boys. They continued to admire Etruscan bronze work and to incorporate Etruscan religious rituals into their own. Maecenas, a close friend and advisor of the emperor

Augustus, felt honored to be of Etruscan blood. The emperor Claudius wrote a history of the Etruscans in twenty-one volumes, which are tragically lost. Even Roman dentistry was indebted to Etruscan examples. As early as 600 BC Etruscans made dental bridges by fitting gold bands with attached human or animal teeth over the patient's remaining ones. The Romans took care to exclude the gold of false teeth from their anti-luxury funerary laws: "But him whose teeth shall have been fastened together with gold, if a person shall bury or burn him along with that gold, it shall be with impunity."

Lest this picture of the Etruscans seems too rosy, we

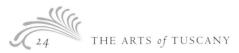

must acknowledge their darker side. Numerous Etruscan sarcophagi are decorated with scenes of bloody battles or beheadings. The history of Etruscan military conflicts with Rome shows that both sides were merciless and fierce. In 356 BC the warriors of Tarquinia sacrificed some 300 captured Roman soldiers in a public ritual in the city's forum. A year later the Romans slaughtered 358 noble Tarquinians in an equally grand and brutal display. In one early Etruscan tomb there is a painting of a violent contest between men and ferocious dogs. Could it be a foretaste of Roman gladiatorial games? Later Etruscan tombs abandon merry festivities to be haunted by evil demons, such as Vanth and Charon, with blue skin, crooked noses, and wings (right). Where they came from and why is a mystery. Do they somehow reflect the many threats and defeats suffered by the Etruscans from the fourth to the first century BC? In any case, they live on in the Last Judgment demons of medieval Tuscan churches, having switched allegiance from Etruscan to Christian afterworlds.

Despite these sinister aspects of their civilization, what is so winning about the Etruscans is their passionate attitude toward life: their ability to enjoy and multiply their bounty, to build a vibrant and fruitful culture, to create enduring models that would inspire those who would inherit their land. When the Romans took over the Etruscan territory, overbuilt their towns, and established their own outposts, they could not but be seduced by the beauty of the country that the Etruscans had developed with such creativity. From his estate in the vicinity of Arrezzo, Pliny the Younger wrote with delight:

> The countryside is very beautiful. Picture yourself a vast amphitheater such as could only be a work of nature; the great spreading plain is ringed by mountains, their summits crowned by ancient woods of tall trees, where there is a good deal of mixed hunting to be had. Below them the vineyards spreading down every slope weave their uniform pattern far and wide, their lower limit bordered by a belt of trees. Then come the meadows and cornfields, where the land can be broken up only by heavy oxen and the strongest ploughs. The meadows are bright with flowers, covered with clover and other delicate plants which always seem soft and fresh, for everything is fed by streams which never run dry.

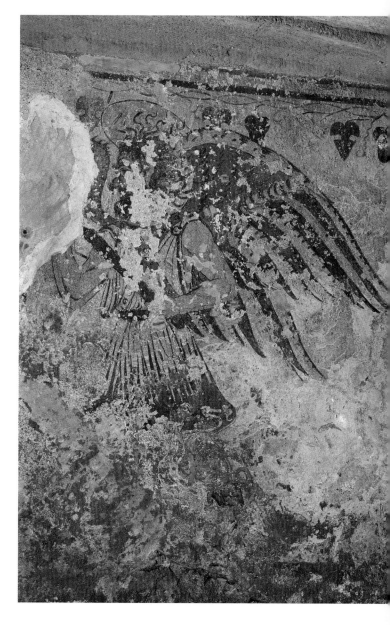

FRESCO IN THE TOMB OF THE OGRE DEPICTING A WINGED DEMON, TARQUINIA, SECOND CENTURY BC.

There is abundant water but no marshes, because of the downward slope: any water that the land does not absorb runs off into the Tiber, which flows through these fields. You would be in ecstasy at the view of this countryside from the mountains. It seems to be a painted scene of great beauty rather than real landscape.

This countryside, which we still admire and which seems so natural, was shaped by the labor and imagination of the Etruscans and their heirs.

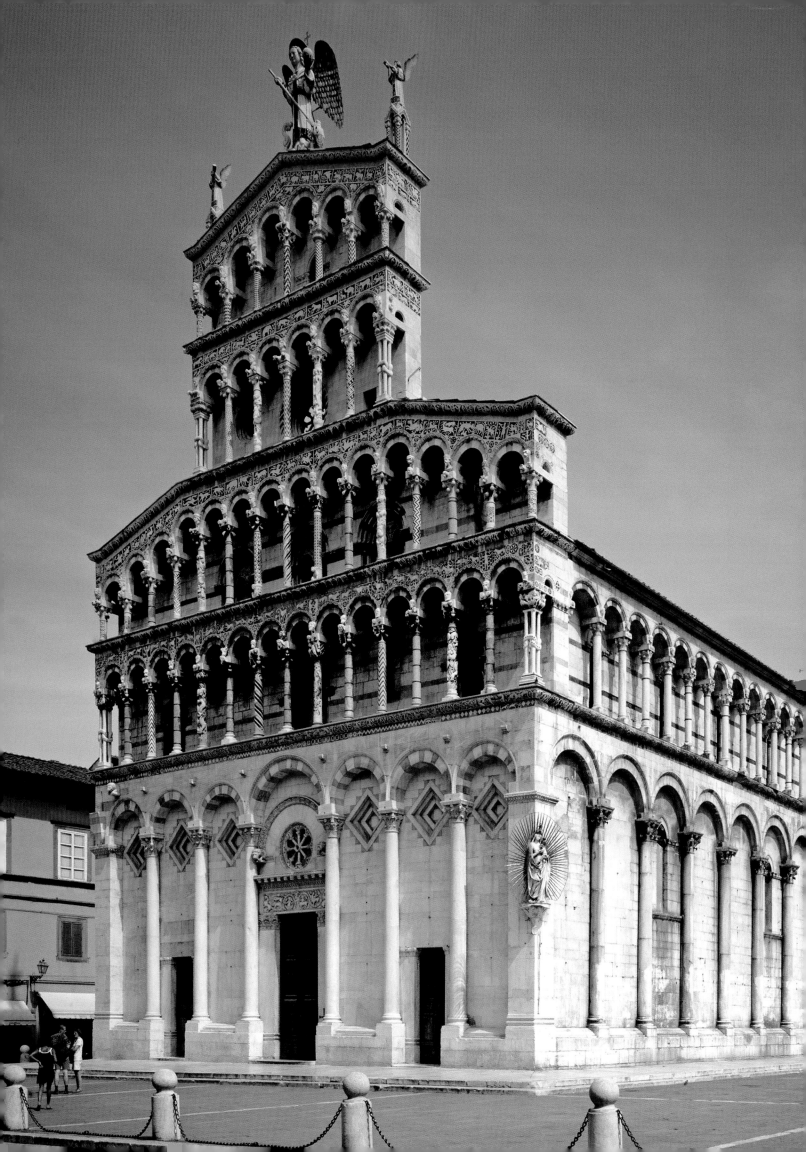

CHRISTIANITY AND PROSPERITY IN MEDIEVAL TUSCANY: LUCCA AND PISA

L IFE WAS TRANSFORMED IN ETRURIA WHEN ROMAN ARMIES CONQUERED THE ETRUSCAN CITIES, AND THOSE THAT WERE NOT DESTROYED BECAME ROMAN COLONIES. AS THEY TOOK OVER THE REGION, THE ROMANS ALSO ESTABLISHED NEW SETTLEMENTS, SUCH AS FLORENCE, LUCCA, AND PISA. BUT UNDER ROMAN RULE THIS VIBRANT AREA TURNED INTO A MERE PROVINCE WITHIN A MUCH LARGER empire: the emperor Augustus counted Tuscany as the seventh region of Italy.

You can recognize the Roman settlements by their standard grid layout: the *cardo* and *decumanus*, the main north-south and east-west avenues, cross at a right angle at the forum and set the pace for the surrounding streets. If you look at a map of Florence or Lucca, the old Roman core is clear. In Florence the Roman city center underlies the Piazza della Repubblica, and for a few blocks around it the streets form a regular network. Then they start veering off in all directions, reflecting haphazard medieval construction. In Lucca the Piazza of San Michele in Foro stands over the Roman forum. Just outside the orderly plan, an elliptical row of medieval houses traces the outline of the Roman arena where the populace was entertained with gladiatorial contests and other bloody sports (p. 28).

After the fall of Rome, Tuscany was overrun by waves of barbarians, and Roman structures gradually fell into ruin. But the region was even more decisively altered by the advent of Christianity. As the new religion took root, churches gave Tuscan cities a new aspect, and chapels and monasteries began to pepper the hilly countryside.

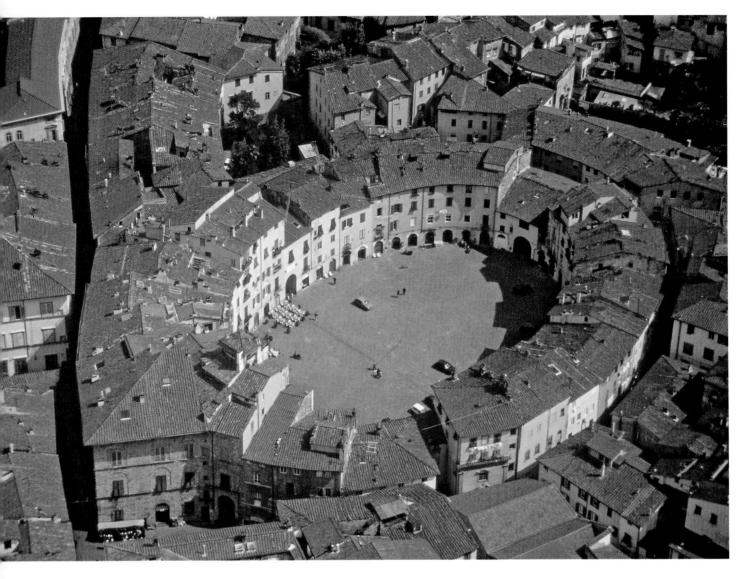

THE PIAZZA DEL MERCATO IN LUCCA OCCUPYING THE ANCIENT ROMAN AMPHITHEATER.

Lucca is reputed to have been the first place in Tuscany to accept Christianity. Paulinus, its first bishop, traced his spiritual lineage to St. Peter himself. According to tradition, Lucca once had one hundred churches. Gleaming white houses of God still stand on most piazzas. They are built of blocks quarried from the Roman walls and the arena that were Christianized by Romanesque carvings of monsters and saints.

Lucca has retained its medieval character virtually unchanged. The cobbled streets, paved with large, irregular gray stones, are narrow and slightly curving (opposite). They beckon visitors to explore what lies beyond each bend. The houses of four or five stories are somberly elegant, and overhung by heavy wooden cornices that add to the intimate atmosphere of the town.

The best way to get an overview of Lucca is to climb up the Guinigi tower, the stronghold of one of the city's medieval lords. From it, you can see that the Tuscan Apennines enclose Lucca in a horseshoe embrace (above). Between the mountains and the town stretch the fertile

previous spread THE CHURCH OF SAN MICHELE IN FORO, LUCCA, BUILT IN THE ELEVENTH TO FOURTEENTH CENTURIES.

opposite A MEDIEVAL FABRIC OF LUCCA, A VIEW OF THE CITY STREET.

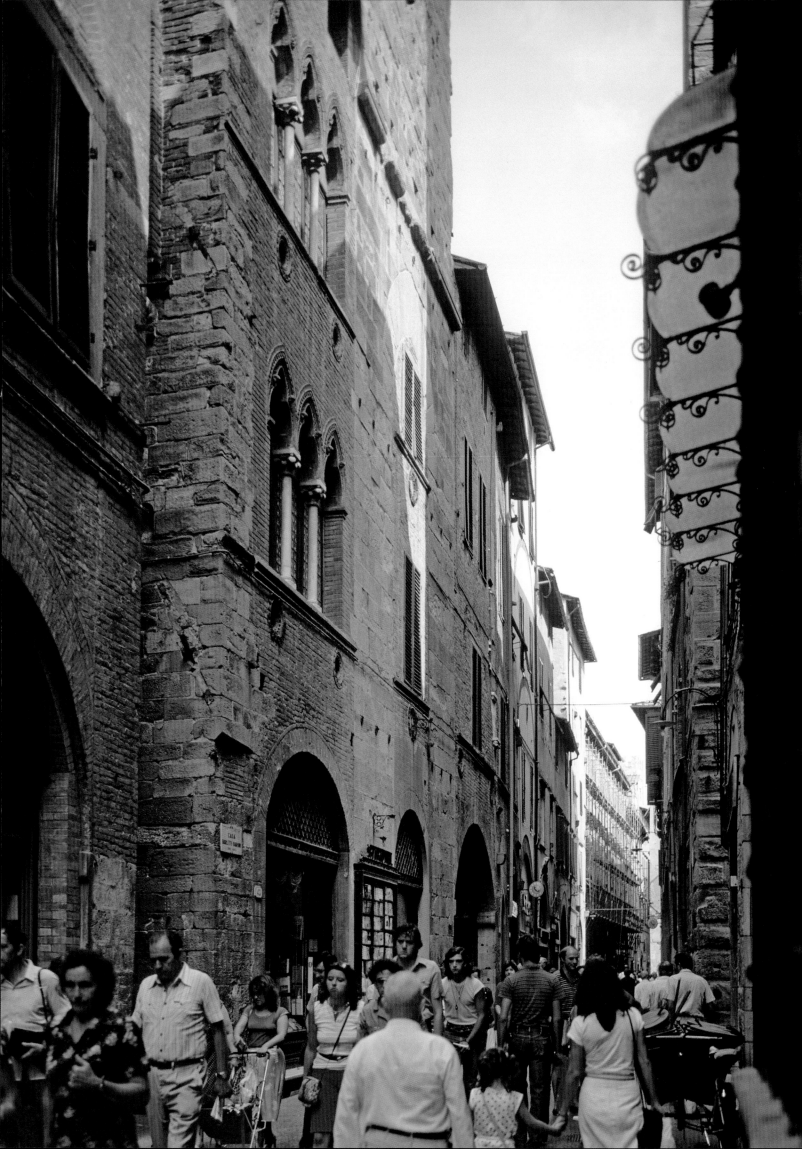

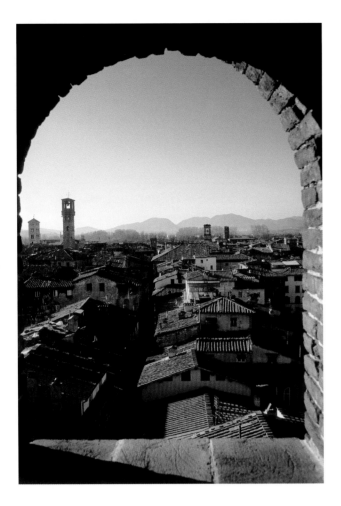

VIEW OF LUCCA FROM THE GUINIGI TOWER.

transit to the port of Luni on the Tyrrhenian Sea. These privileges helped Lucca to expand her nascent silk and banking industries and to gain independence later on.

In the mid-twelfth century the Lucchese merchants signed two treaties with Genoa. The first gave them a right to use Genoese ships to sail to the Levant to obtain the raw silk, dyestuffs, and metal threads necessary for weaving luxurious silk fabrics. The second permitted them duty-free passage through Genoese territory en route to and from the fairs of Champagne, the preeminent markets of medieval Europe where everyone came to shop. Another of Lucca's blessings was to be on the Via Francigena, the principal medieval trade and pilgrimage route between Rome and the lands beyond the Alps. This brought a constant flow of pilgrims to the city and strengthened its links with pan-European commerce.

As a result of her clever negotiations, fortuitous location, and talented craftsmen, Lucca developed into the leading center of silk weaving in Italy, and probably all of Western Europe. Lucchese weavers produced resplendent stuff, shimmering with gold and silver threads, decorated with floral patterns, animals, and birds. These silks, satins, and brocades filled royal wardrobes, papal treasuries, and the vestries of the greatest churches of Europe and England. They adorned the walls of cathedrals and palaces, altars and thrones, and the backs of popes and bishops, princes and noblemen. In an age when cloth defined people, luxurious textiles were of the utmost value and carefully scrutinized by all. The materials, colors, and designs of fabrics said a great deal about their owners and their place in the world.

The patterns woven into Lucca's cloth reflected the city's international relations. Through trade and war, Europeans were in constant contact with the East, and borrowed many of its craft traditions. Lucchese weavers drew inspiration from Eastern fabrics, but also unwittingly mirrored political events in those distant lands. In the thirteenth century, Lucchese silks were often decorated with symmetrical compositions of static animals that echoed textile designs of the ascendant Sassanian power in Persia. With the expansion of the Mongol Empire from China through Central Asia to

plains that helped assure Lucca's prosperity. And directly below lies the old city—the maze of twisting streets, the syncopated rhythm of red-tiled roofs and church towers, all contained by a thick circuit of walls.

The agricultural and mineral wealth of its countryside allowed Lucca to flourish, and its prosperity attracted a succession of overlords. In the late sixth century the Lombards made the city the capital of their Tuscan duchy. The Franks, who entered Italy in the late eighth century under Pepin III and Charlemagne, did the same. In the eleventh century, when the power struggle between the papacy and the Holy Roman Emperors tore the Italian peninsula into warring factions, Lucca sided with the Emperor Henry IV. He was generous in his reward. He gave the city freedom of navigation on the nearby river Serchio, abolished duties, and granted free

opposite THE CATHEDRAL OF SAN MARTINO IN LUCCA, BUILT IN THE ELEVENTH TO THIRTEENTH CENTURIES.

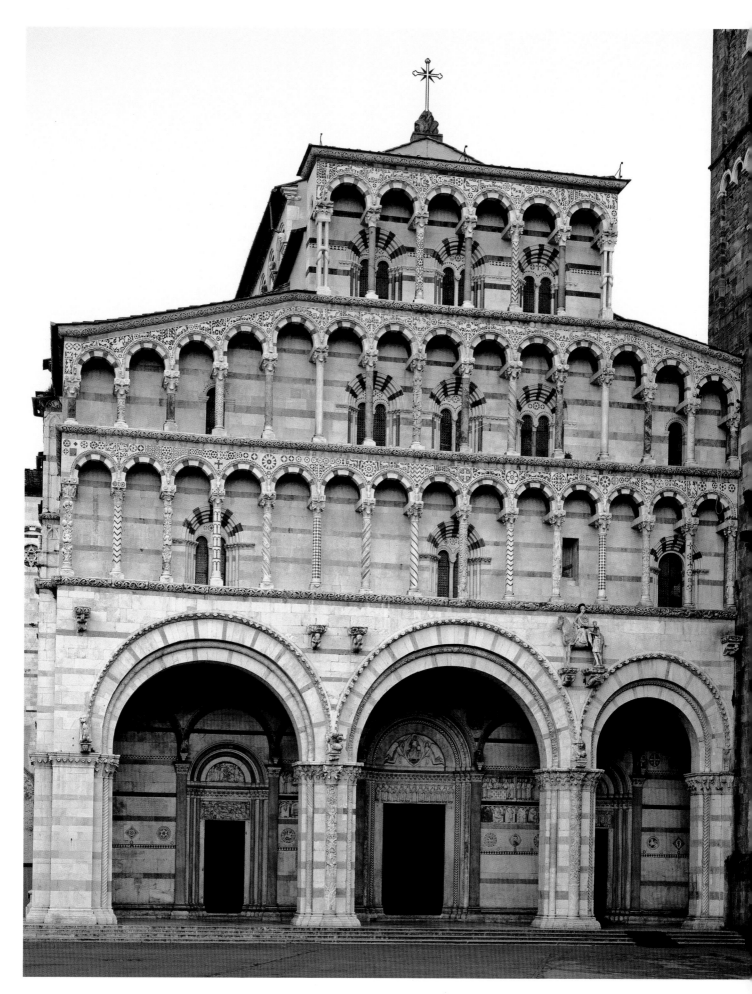

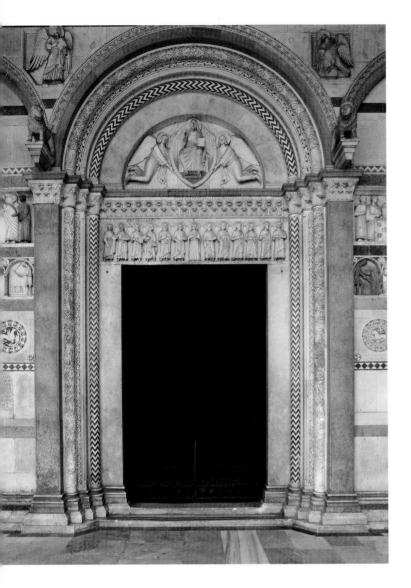

THE MAIN PORTICO OF SAN MARTINO IN LUCCA.

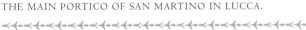

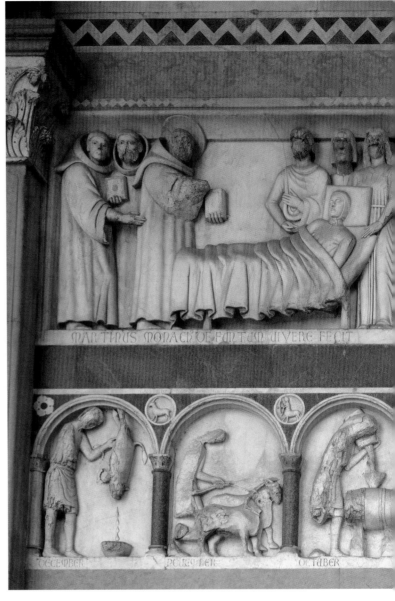

Persia in the fourteenth century, Italian weavers began to imitate dynamic and asymmetrical Chinese designs. Never before had communication with China been as easy as it was in the years after the Mongol conquest of Asia. A Florentine merchant, Francesco Pegolotti, commented in a 1340 handbook for merchants that the land route to Cathay was very safe. This ease of movement brought Chinese cloth to Lucca, and shaped the repertory of its weavers. Lucchese silks from this period depict vines among which animals cavort and little people busily hunt, court each other, or pray.

As Lucca grew rich through her silks and international banking, she expressed her pride and affluence through a construction boom. The greatest efforts went into making her churches splendid, in acknowledgment of God's favor that had brought Lucca success and in encouragement of further divine good will.

Lucca's Cathedral of San Martino was one of the beneficiaries. It had been founded in the sixth century and upgraded to an episcopal seat in the eighth. But it was considerably rebuilt in the 1060s, and embellished over the next two hundred years to reflect Lucca's piety and wealth. The cathedral's facade (p. 31) offers a wonderful introduction to Tuscan Romanesque architecture, which is more ornate than that of other regions thanks to the extensive use of white marble and colored stone inlays.

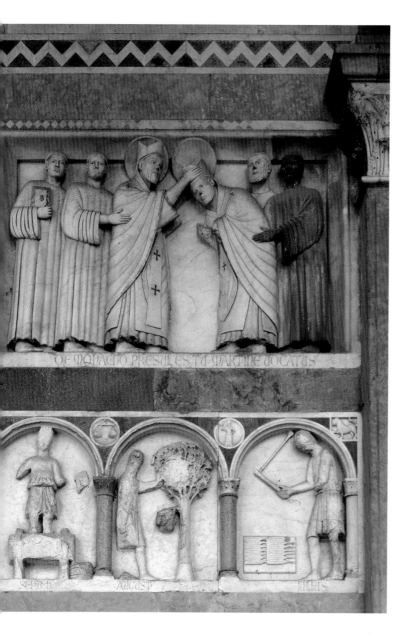

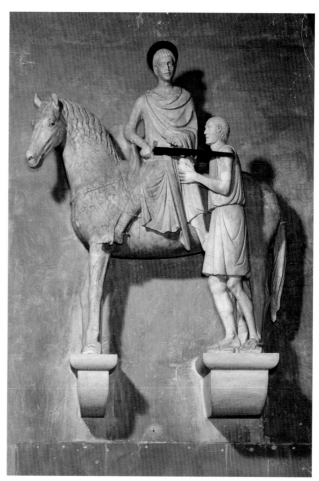

above STATUE OF SAINT MARTIN AND THE BEGGAR FROM THE FACADE OF THE SAN MARTINO.

left DETAIL OF SCULPTURES FROM THE MAIN PORTICO OF SAN MARTINO SHOWING STORIES FROM THE LIFE OF SAINT MARTIN AND THE WORKS OF THE MONTHS.

Different Tuscan towns developed their own look within this style, as we shall see in Pisa and in Florence. The Lucchese churches tend to have tiered arcades placed half-way up the facade and held up by intricately carved and ever-changing columns. Some columns are made from white or pink marble; others have elaborate green inlays along their shafts. Friezes of white animals cavorting on a dark green ground separate one gallery from the next. The overall effect is both harmonious and whimsical.

San Martino also has an ornate portico (left, and above center) with archways accentuated by pink marble and alive with the carved stories of St. Martin, St. Regulus, the Virgin, and Christ. The titular saint of the cathedral greets his visitors between the central and right doorways. He turns sideways on his horse and cuts off a piece of his cloak for a beggar—his most famous deed (above, right). The beggar, the saint, and the horse all seem to pause with a solemn demeanor, as if posing for a commemorative photograph. The sculptures of St. Martin and the beggar on the facade are copies. The original mid-thirteenth-century figures are mounted on the wall just inside the cathedral entrance, from which they bid farewell to visitors as they leave the church.

The most sacred object inside San Martino, and in all of Lucca, is the Volto Santo, the Holy Countenance— an over-lifesize, dark wooden sculpture of the crucified

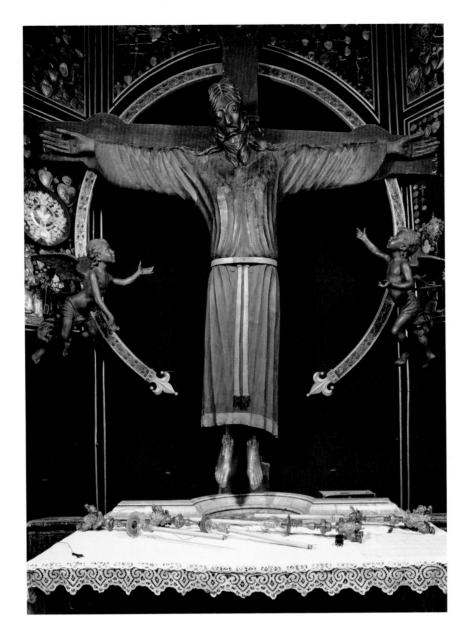

VOLTO SANTO INSIDE SAN MARTINO, C. 1170–1220.

⫷⫷⫷⫷⫷⫷⫷⫷⫷⫷⫷⫷⫷⫷⫷⫷⫷⫷⫷⫷⫷⫷⫷⫷⫷

Christ (above). It dwells in an ornate octagonal shrine constructed in the fifteenth century by Matteo Civitali. Every year, on September 13, it is honored by a feast called Luminaria, for the countless burning candles borne by the procession parading through town from San Frediano to San Martino to commemorate the miraculous transfer of the crucifix to its present place.

The Legend of the Volto Santo is delightfully colorful. The statue was reputedly begun by Nicodemus shortly after Jesus's death, and completed by divine intervention. Having kept a low profile for several centuries, it came to prominence in 742. In that year the statue made a journey from the Holy Land to Italy on a ship not manned by any crew; it docked just off the coast of Luni, an old Roman port in northern Tuscany. Apparently aware of the reputation of the Lunese as pirates, the ship kept moving away every time they drew near. Mystified, the Lunese sent word to the

⫷⫷

opposite AMICO ASPERTINI'S *TRANSPORT OF THE VOLTO SANTO FROM LUNI TO LUCCA* IN THE CHURCH OF SAN FREDIANO IN LUCCA, SIXTEENTH CENTURY.

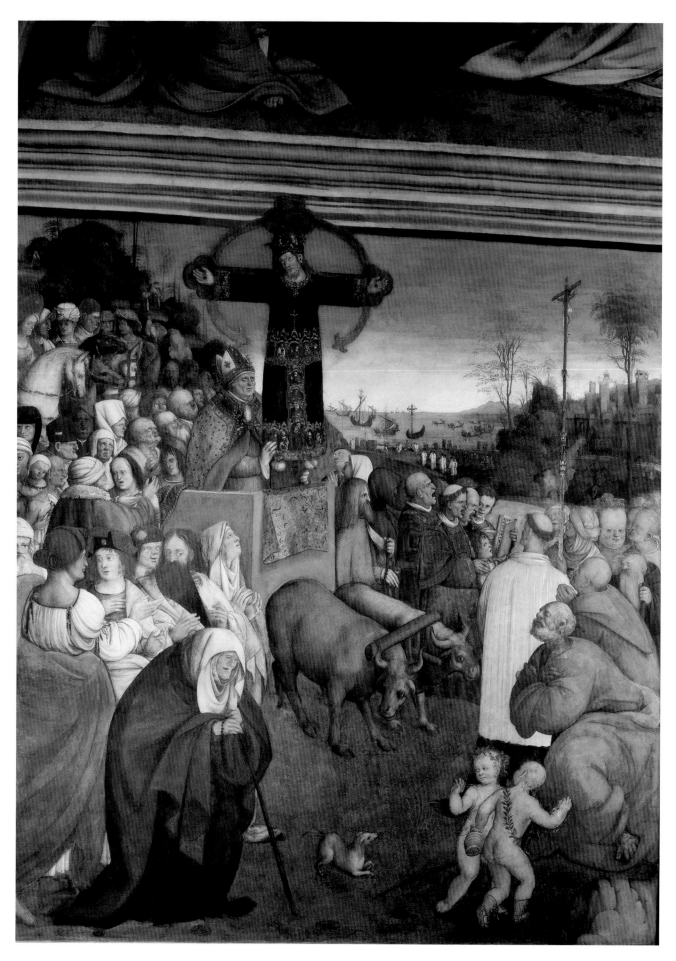

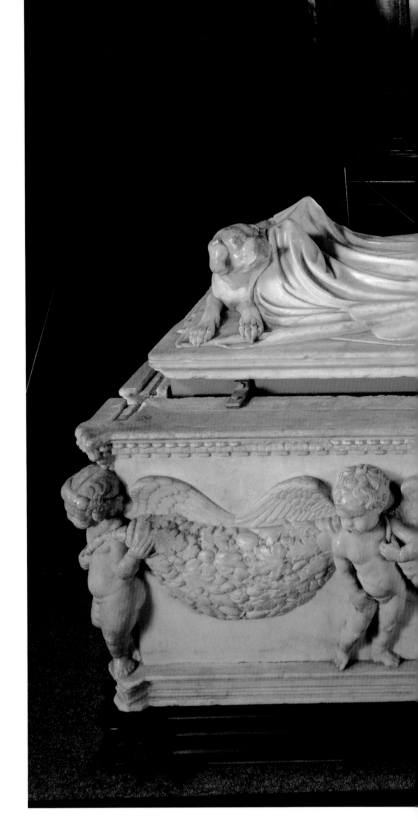

saintly and charismatic Bishop of Lucca, Giovanni I (or
he was advised of the arrival of the ship by a divinely
inspired dream). The bishop hurried to the coast. As he
approached, the boat stood still, allowing him to board
and to discover its sacred passenger. The bishop was a
faithful as well as an astute man. He instantly grasped
the significance of his find and began to plan for its
transport to Lucca. The Lunese objected. The relic had
come to their harbor, so it should remain their prize. To
resolve the dispute, the bishop asked the townspeople to
furnish him with two untrained oxen and to yoke them
in a cart on which he could place the Volto Santo. Then
he let the oxen decide where the cart would go. The
animals promptly set off for Lucca, all by themselves,
without a human driver. This scene is vividly portrayed
in an early sixteenth century fresco painted by Amico
Aspertini in the church of San Frediano (p. 35). The
bishop had ordered the sacred image to be taken to San
Frediano, which stood close to the city walls. There the
statue would rest for a night, while he would ponder what
to do next. In the morning, on September 13, Giovanni
returned to San Frediano and discovered with horror that
the crucifix was gone. In great alarm he ordered that the
city be searched. The statue turned up at San Martino,
where it remains to this day.

The Volto Santo is a twelfth-century sculpture
(although it may copy an earlier work), and no Bishop
Giovanni I lived in Lucca in 742, so the legend does not
quite stand up to historical record. But then, what relic
does? We can be certain, nonetheless, that by the eleventh
century the Volto Santo was a widely esteemed celebrity.
The abbot of Bury St. Edmunds, who had seen it on a
visit to Italy, ordered a copy for his church in 1050. The
English King, William Rufus (1080–1110), swore oaths
by invoking the Volto Santo. And a papal bull of 1107
indicates that pilgrims traveling along the Via Francigena
stopped to pray and make offerings to the famous relic.
The lure of the image contributed to Lucca's prosperity
and international repute.

San Martino houses another romantic relic as well:

the Tomb of Ilaria del Carretto, wife of Paolo Guinigi
(above), a member of the wealthiest family of silk
merchants and international bankers, and the lord of
Lucca from 1400 until 1430. Ilaria, Paolo's lovely second
wife, came from an illustrious family, and was a politically
advantageous match. They celebrated their wedding on
February 3, 1403. Ilaria was twenty-four years old. Two

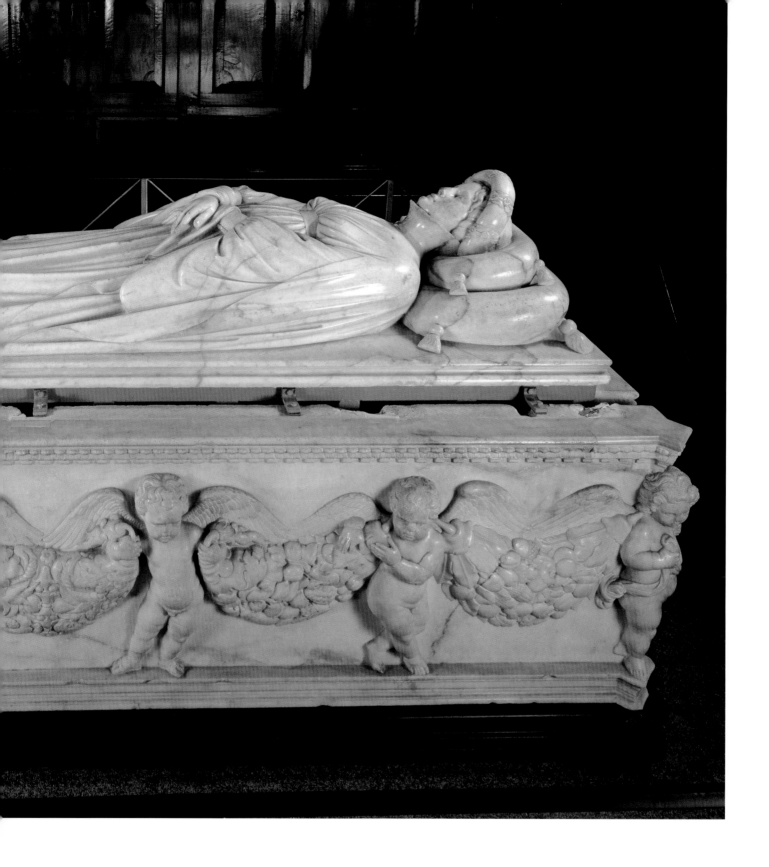

years later, on December 8, 1405, she died giving birth to her second child.

The Sienese sculptor Jacopo della Quercia immortalized Ilaria as a serene beauty. She wears a modish hat and a soft flowing robe, probably sewn from the luxurious fabrics that made the Guinigi rich and powerful. Ilaria lies still, her sleep guarded by a small alert dog at her feet, a traditional symbol of fidelity. But the charm of this image is bittersweet. Like so many portraits of young women that we admire in Italian churches and museums, it is a memorial to death in childbirth, an all too common fate in those days.

San Martino may be the most venerable church in Lucca, but to my eyes San Michele in Foro is the most

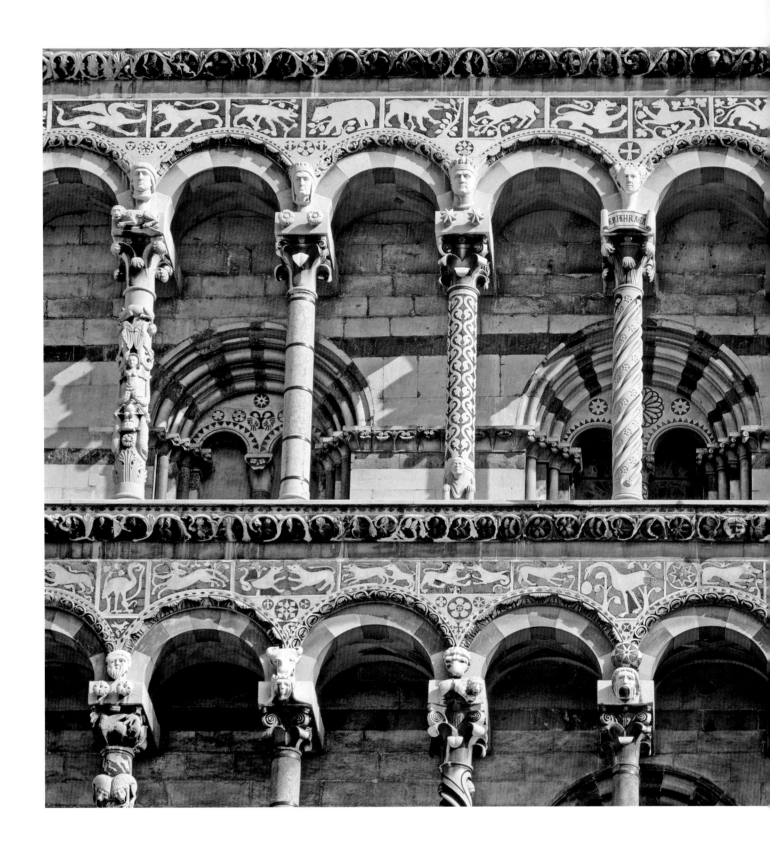

handsome and enchanting (p. 26, and detail above). It stands on the site of the Roman forum, to this day the lively heart of the city. Here the most tourists gather, pre-dinner strollers engage in the evening ritual of *passeggiata*, and politicians stage their rallies.

Like the cathedral, San Michele already existed in the eighth century, but it was rebuilt and embellished in the eleventh and twelfth centuries, at the time of Lucca's greatest prosperity. The construction continued for decades. The four-tiered ornamental arcade on the facade went up only in the fourteenth century. The rationale for it was to raise the height of the nave, and presumably to outshine the churches of Lucca's neighbors, particularly Pisa. Competition between Tuscan towns spurred much

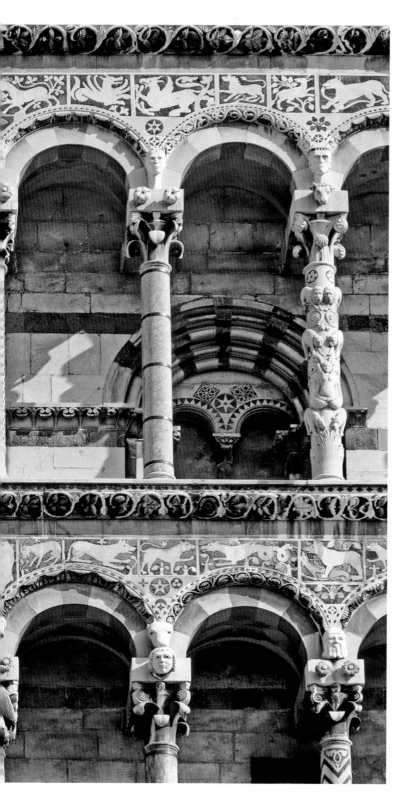

incongruity and to become absorbed in their world. Each patterned column differs from the next. Some are covered with floral patterns, others with geometric inlays; some are twisted, others tied in knots. The columns are crowned by intricate capitals and sculpted heads. A number of them were restored in the nineteenth century and replaced with portraits of such celebrities as Dante and King Vittorio Emmanuele II. The arcades are divided by dark green friezes. On them white hunters ride along with their falcons; stags, boars, and rabbits graze among leafy greens; there are also elephants and camels, as well as exotic and mythical creatures. Alighting on the pinnacle of the roof, the almost four-meter-high Archangel Michael thrusts his bronze spear into the mouth of a dragon while trumpeting angels serenade him from either side.

San Michele is an irresistible magnet for many visitors to Lucca. John Ruskin could not take his eyes off the church for years. In letters and notes from Lucca written in the 1840s, he described it with intimacy and affection:

> It is white marble inlaid with figures cut an inch deep in green porphyry, and framed with carved, rich, hollow marble tracery. I have been up all over it and on the roof to examine it in detail. Such marvelous variety & invention in the ornaments, and strange character. Hunting is the principal subject—little Nimrods with short legs and long lances—blowing tremendous trumpets—and with dogs which appear running up and down the round arches like flies, heads uppermost—and game of all description— boars chiefly, but stags, tapirs, griffins & dragons— and indescribably innumerable, all cut out in hard green porphyry, & inlaid in the marble.

of their public art. However, in Lucca funds ran out and the nave was never raised. If you look at the church from the side, you may be disconcerted to discover that the upper portion of the facade is a mere screen, unattached to any structure behind.

The arcades on the facade are such a riot of imagination that it is easy to forget their structural

In the northern part of the city the august church of San Frediano has a different personality. It is named after a sixth-century bishop of Irish decent who came to be revered as a patron saint of Lucca. He built the first church on this site during his lifetime. At the height of the city's glory in the twelfth century, the Lucchese

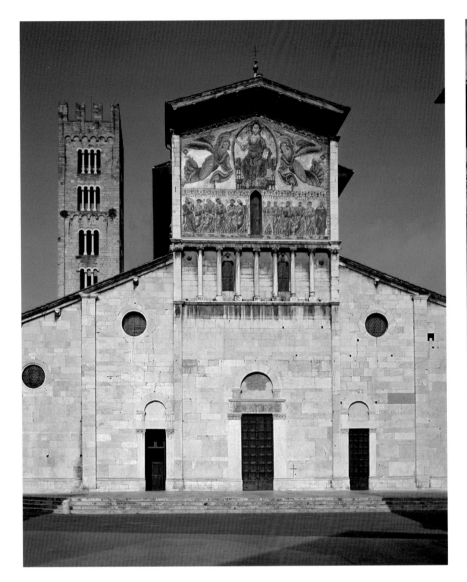

THE CHURCH OF SAN FREDIANO IN LUCCA.

decided to refurbish the church that must have, by then, looked outmoded and too humble for their self-image. A century later, they set it apart from all other churches by dressing its facade with a glowing mosaic instead of the usual galleries of carved stone (above, left). The massive *Ascension of Christ* is readable even from the distance of the Guinigi Tower and all the more impressive from close-up. The enthroned Christ is colossal. So are the two angels who bear him heavenward. The twelve apostles below tilt their heads and gesture in wonder, inviting the same response from the visitors to the church. The interior of San Frediano manages to combine sobriety and rich decoration. Its nave is composed of two rows of ancient columns that support austere walls (above, right). Here calm prevails, until you step into the aisles. These open

onto sumptuously adorned chapels built by the Lucchese nobility keen to display their wealth to one another, and their piety to God. In the south aisle, close to the entrance, stands a mid-twelfth-century baptismal font (opposite). The sculpted reliefs that encircle it tell the stories of Moses, the Good Shepherd, and the Apostles, but the Biblical actors are dressed like the twelfth-century Lucchese.

Lucca's churches proclaimed her success and the divine favor that enabled her to grow and flourish. The superimposed arcades, intricately carved columns, and multicolored marbles of the city's shrines transformed these imposing structures into shimmering heavenly visions. Christianity triumphant gave old Tuscany a splendid new face.

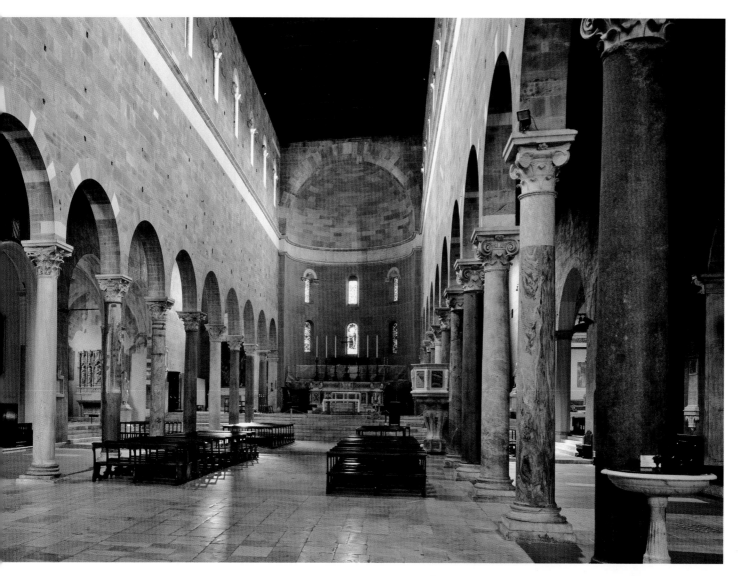

Alas, Lucca's days of glory did not last long. Throughout the fourteenth century internal struggles, a rapid succession of foreign rulers, and conflicts with neighbors wreaked havoc in the city and sapped its strength. Political unrest and warfare within and between Tuscan towns was a perennial problem. Both the cities

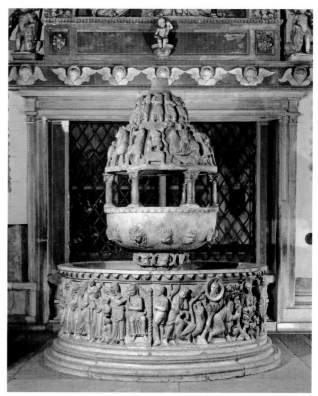

◄-

above BASILICAN INTERIOR OF SAN FREDIANO WITH REUSED ANCIENT COLUMNS AND CAPITALS, TWELFTH CENTURY.

right MASTER ROBERTO'S BAPTISMAL FONT DEPICTING STORIES OF MOSES, THE GOOD SHEPHERD, AND THE APOSTLES, IN THE CHURCH OF SAN FREDIANO, TWELFTH CENTURY.

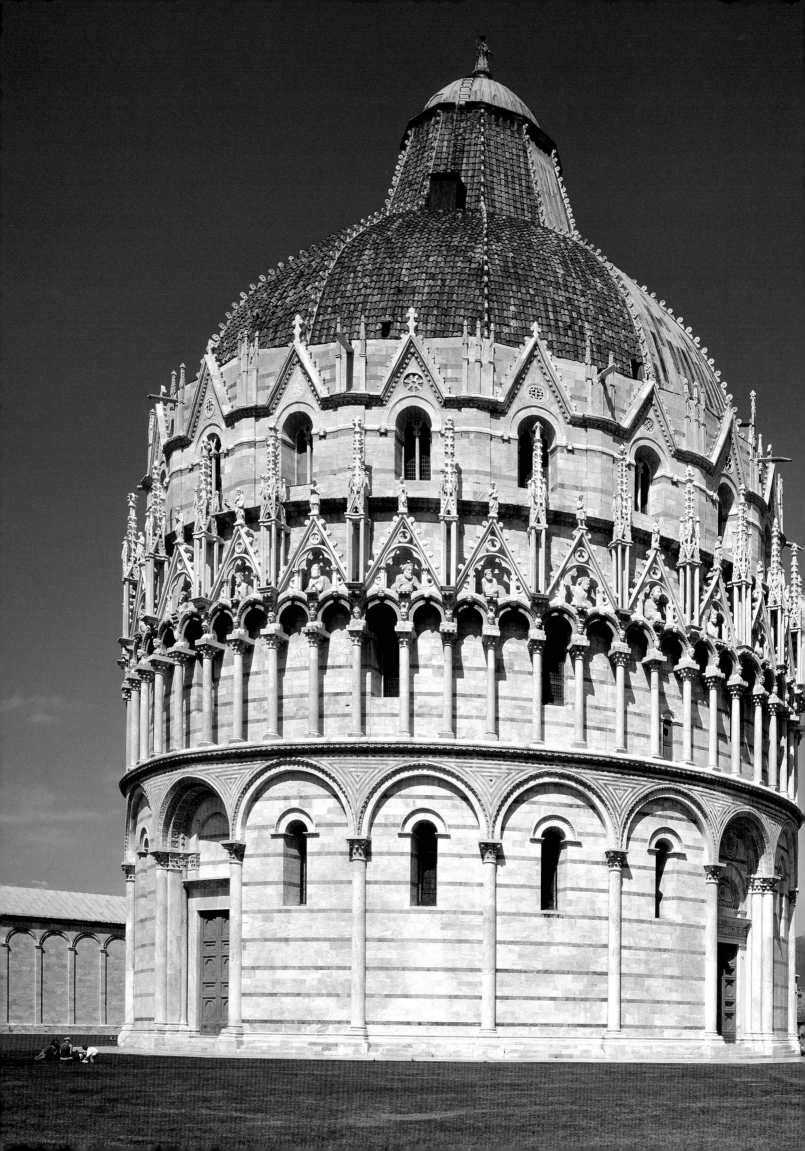

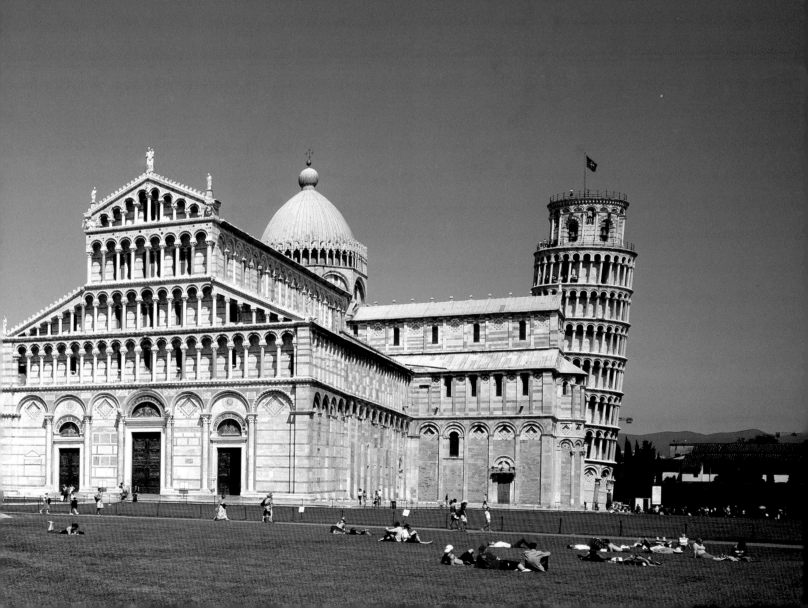

and the region were too small to accommodate powerful personalities with ideological differences and territorial ambitions.

Among Lucca's major foes was Pisa. Today we associate Pisa chiefly with the exquisite constellation of the cathedral, the baptistery, and the leaning tower floating as radiant apparitions over a carpet of lush green (pp. 42–43). Her medieval contemporaries perceived her through the lens of her fierce navy and mighty merchant fleet. Pisa attained preeminence by taking an active role in the Christian crusades in the eastern Mediterranean in the tenth and eleventh centuries. Through her geographic position and militant spirit, she nimbly turned defensive warfare against the Saracen's into overseas expansion. She made Corsica, Sardinia, and the Balearic islands her colonies, and in the eleventh and twelfth centuries competed with Genoa, Venice, and Amalfi for dominion over the Mediterranean trade. Having grown immensely rich and proud, Pisans decided to build an opulent cathedral that would celebrate their role in Christian victories over the infidels, and their spectacular ascent.

The funds and the direct stimulus for building came in 1063, in the aftermath of Pisa's involvement in the sack of Muslim-held Palermo. During the sack, Pisan ships flying red flags embroidered with a white cross broke the chains protecting Palermo's harbor and dealt a decisive blow to the Infidel. Flushed with success and a vast booty, the Pisans returned home and promptly channeled their gains into the new church complex. The very stones of the cathedral, the baptistery, and the bell tower conveyed Pisan power in Tuscany and in her subject territories. Local and Carrara marble, San Giuliano and Verruca limestone, granite from the islands of Elba, Giglio, and Sardinia, and tufa from Livorno were all assembled to clad her edifices in sumptuous mantles.

The scale of the new structures left no doubt as to Pisa's self-image. The cathedral was planned and begun by the architect Buschetto. When he died in mid-project, and was buried in the left-most arch of the facade, the commemorative inscription lauded him for designing a building comparable to the greatest churches

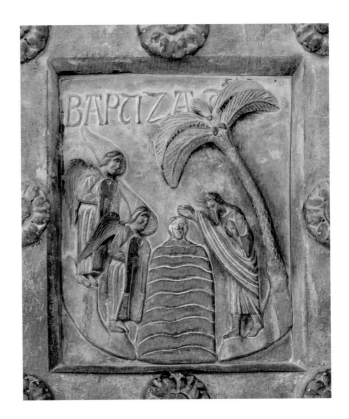

above THE BAPTISM OF CHRIST, FROM THE DOOR OF SAN RANIERI.

opposite BONANUS OF PISA'S DOOR OF SAN RANIERI, CATHEDRAL OF PISA, CAST IN 1180.

of Christendom. Italians have always loved to boast how their monuments surpassed famous predecessors. The central nave of St. Peter's Basilica in the Vatican is punctuated by inlaid markers showing the size of the largest churches of the world that could easily fit inside.

Pisa's cathedral was vast for its era (p. 43). Its gleaming white exterior seems to lighten the structure somewhat. The tiers of arches encircling the building weave a lace curtain over its massive walls. Jigsaw-like pieces of colored stone set between the columns and pilasters help the eye to skip lightly from one pattern to the next. Yet compared to Lucca's churches, Pisa's cathedral is more solemn. No whimsical columns here, nor playful beasts frolicking in the friezes. Opulence and authority were what Pisans wished to express.

The interior of the church is deliberately

previous spread THE BAPTISTRY, CATHEDRAL, AND LEANING TOWER OF PISA, BUILT IN THE ELEVENTH AND TWELFTH CENTURIES.

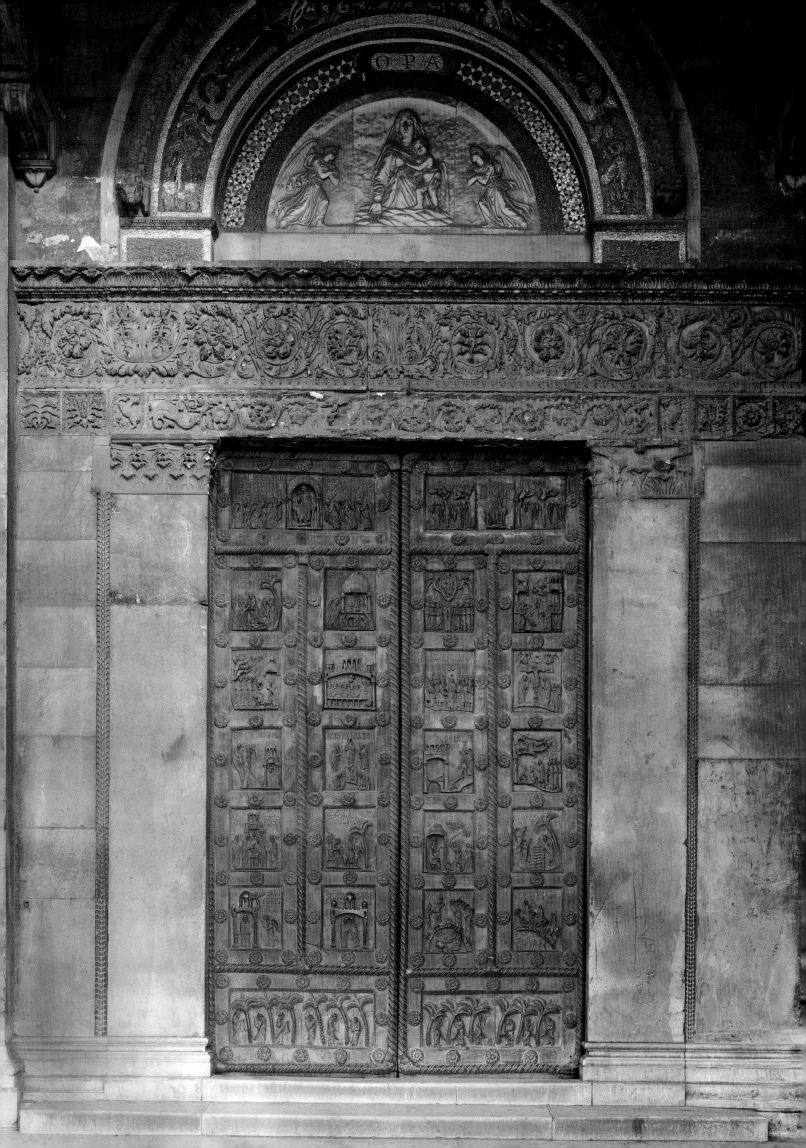

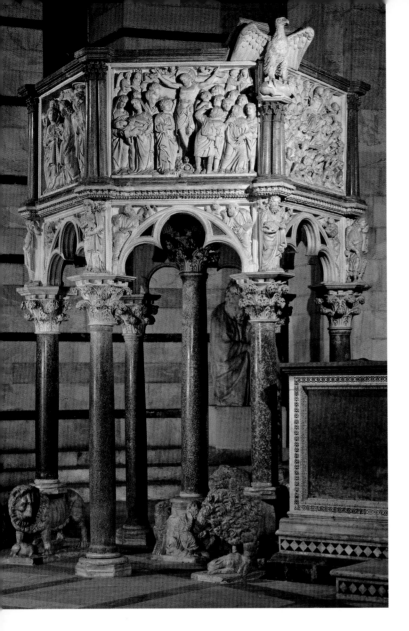

NICOLA PISANO'S PULPIT IN THE BAPTISTERY OF PISA, 1260.

⊰⊱⊰⊱⊰⊱⊰⊱⊰⊱⊰⊱⊰⊱⊰⊱⊰⊱⊰⊱⊰⊱⊰⊱⊰⊱⊰⊱

overpowering. A colossal mosaic of Christ Pantocrator orders you into submission over the apse. The nave is ninety-six meters long. The space expands further into four aisles flanking the nave, and two, the transept. And the church is crammed with painted, sculpted, and cast dedications accumulated over centuries of worship. Should you somehow still harbor doubts about Pisa's supremacy, a visit to the cathedral dispels them for good.

Two particular dedications reflect the fine taste of the Pisans: the bronze doors of Bonanus (p. 45) and Giovanni Pisano's carved marble pulpit (opposite). Bronze doors were always an ostentatious undertaking, as only the richest churches could afford them. Bonanus of Pisa cast four doors for the Pisan cathedral in the

1180s. They remained in place until the fire of 1595 damaged the west end of the building, and the one rescued pair of doors was moved to the south transept. Today the southern portal is the main entrance to the building, and the cramped entryway makes Bonano's doors difficult to view as the masses of tourists push past them. But it is worth the discomfort to pause and examine the narrative panels, which illustrate the lives of the Virgin and Christ in an engagingly expressive and naïve style. I especially enjoy the *Baptism of Christ,* in the lower right corner (p. 44). The river Jordan wraps around Jesus like a voluminous cloak; and the palm bending over him from the river bank looks like a giant dragonfly. Large captions clarify each episode should you be unclear.

The pulpit of Giovanni Pisano is one of a pair. The other one was carved by his father, Nicola, for the baptistery next door (left). The father and son were the most famous masters working on the cathedral complex, and subsequently in demand in other Tuscan cities that wanted to keep up with the most avant-garde arts of the day. Nicola was an attentive pupil of ancient sculpture, studying diligently the surviving Etruscan and Roman sarcophagi. In carving the baptistery pulpit he translated pagan figures and compositions into Christian subjects: his Virgin giving birth to baby Jesus looks very much like a Roman matron reclining on a bed as an Etruscan woman would recline on her tomb (p. 47). But Nicola's interests were not confined to antiquity. He also drew on the new French Gothic sculpture and on South Italian tradition, since he himself came from Apulia, in the heel of Italy. His cosmopolitan orientation harmonized with the spirit of Pisa, whose wide network of contacts nurtured her coffers and her outlook. It is not coincidental that the city came to host a great university, established by Pope Clement VI in 1343. To this day it is Italy's preeminent institution of higher learning.

In the opening decade of the fourteenth century Nicola Pisano's son, Giovanni, sculpted the pulpit for the cathedral (p. 48). He took further the complex inheritance of his father, and added a psychological intensity that Nicola's work lacked. Giovanni undercut his figures and their architectural settings much more deeply, which gave his compositions an animating play of light and shade. He also paid greater attention to facial expressions and vivid gestures in order to convey ardor

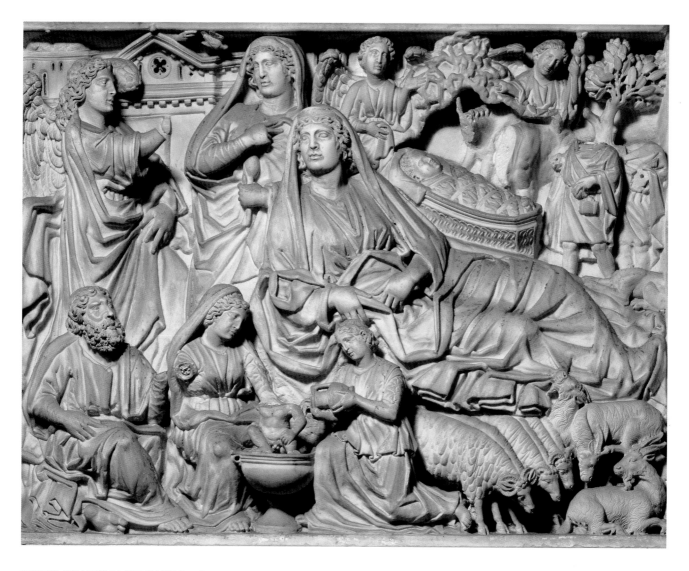

DETAIL OF NICOLA PISANO'S PULPIT SHOWING THE *NATIVITY OF CHRIST.*

or pathos, and turned formulaic scenes into affecting dramas. In his depiction of *Herod Ordering the Massacre of the Innocents*, the king's fiery eyes and outstretched arm generate a sea of slaughter and misery; and each mother mourns her dead baby in an individual and heartbreaking way (p. 49).

Whereas the cathedral is packed with artworks of every description, the baptistery opposite it is now almost empty. Aside from Nicola's pulpit and a sculpted and inlaid baptismal font in the center, its decorations are all on the outside. The exterior is a contradiction of mass and airiness (p. 42). The baptistery is huge, yet its bulk is dissolved by a delicate wrap of columns, pointed Gothic arches, and a gallery of sculpted half-length saints and prophets who twist and turn in their fictive windows as they survey the piazza and ponder the wisdom of God.

The baptistery was begun in 1153 under the supervision of the architect with the marvelous name of Diotisalvi, or May God Save You. He took as his model the church of the Holy Sepulcher in Jerusalem. But the scale of his building was so ambitious, and the ongoing work on the cathedral so financially draining, that funds quickly fell short. In the first half of the thirteenth century a special tax was levied on 14,000 Pisan families to give the construction a much-needed boost. Still, the hat-like, Oriental dome was raised only in the fourteenth century. It made the baptistery almost as tall as the leaning tower, with which it seems to carry on a conversation over the cathedral's roof.

The tower is, of course, the most famous monument on the piazza (p. 50). Begun in 1173, it started to tilt by the time the first floor was done, as the alluvial ground

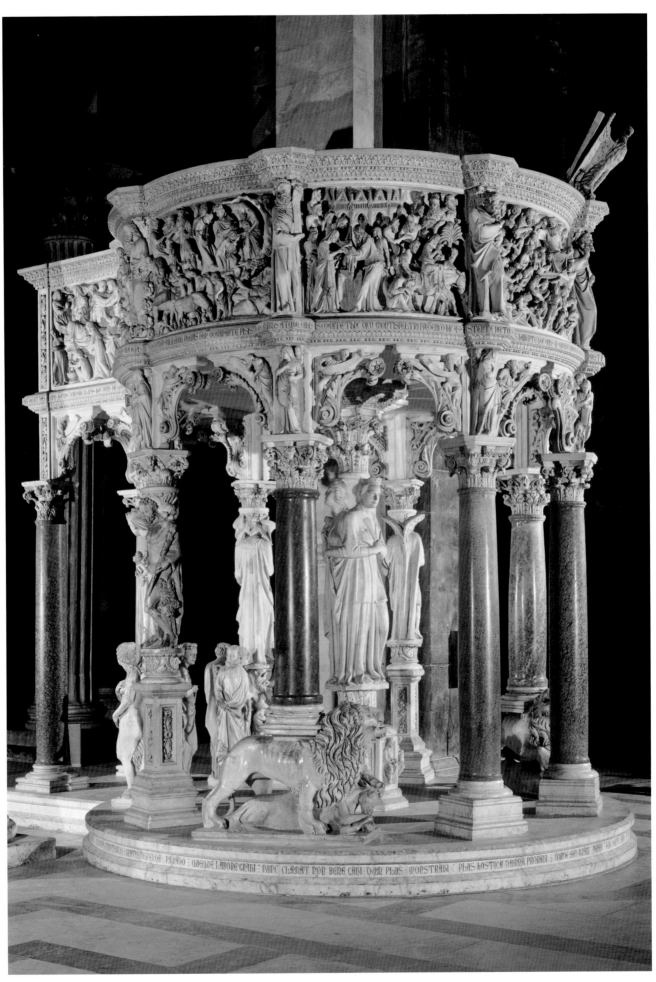

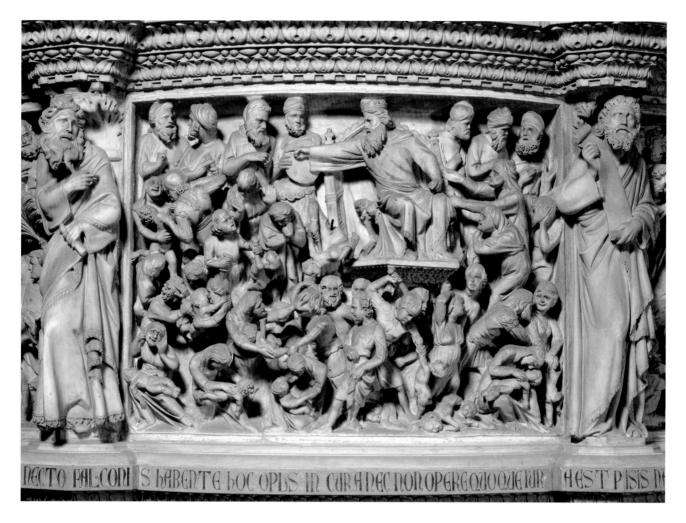

DETAIL OF GIOVANNI PISANO'S PULPIT SHOWING HEROD ORDERING THE MASSACRE OF THE INNOCENTS.

beneath it gave way under the piling weight. Ignoring the problem, the builders pushed the project forward and two more floors went up. With more weight pressing on the unstable soil, the tower keeled some more. Unsure what to do next, the builders stopped all work for about a century, a state of affairs one can easily imagine in Italy to this day. When work resumed in the thirteenth century, the architect Giovanni di Simone tried to ameliorate the problem by placing less weight on the sinking south side and introducing a slight counter-curve on the north. Thus, even if the building were to be set upright, it would have something of a wave along its vertical axis.

But, frankly, the lean is the tower's, and Pisa's, greatest asset. Galileo, Pisa's native son, used it to conduct experiments on the velocity of falling bodies by dropping objects of different weight from its top. And for centuries the building has drawn international crowds, generating steady revenue after Pisa's power declined. Remarkably, the tower's magic is undiminished by exposure and expectations. No matter how many times I have seen it in person, or in countless photographs, I am astonished each time by its elegant beauty and its precarious angle. And so are the crowds who flock to see it every day.

Amid the bustle of the cathedral square, there is one spot of great tranquility and contemplative calm: the Camposanto, an enclosed cemetery opposite the cathedral (pp. 50–51). It derives its name from the Holy Earth said to have been brought here from Jerusalem by Bishop

opposite GIOVANNI PISANO'S PULPIT IN THE CATHEDRAL OF PISA, EARLY FOURTEENTH CENTURY.

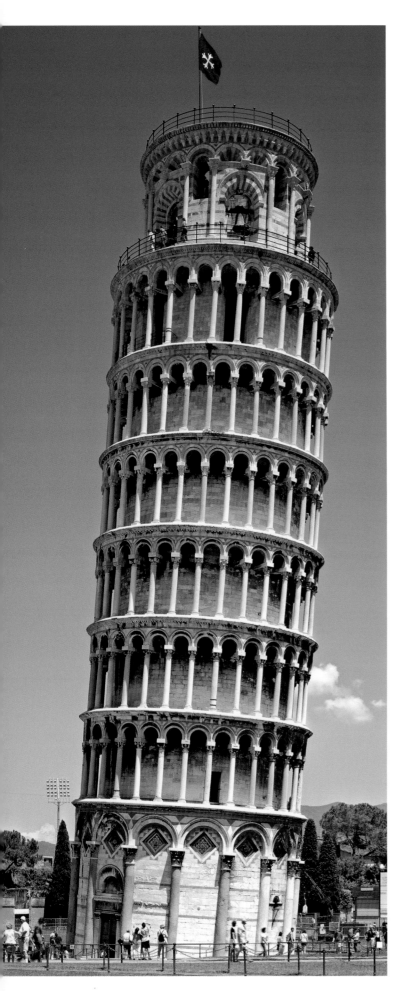

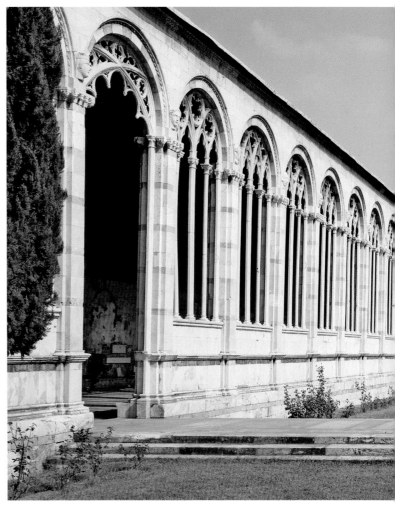

Ubaldo Lanfranchi in 1188. The exterior of Camposanto is very simple: a long white wall punctuated by a blind arcade. But inside, the vast, rectangular cloister is majestic, framed by a membrane of tall traceried windows open to the air. As you walk along the soaring galleries surrounding the cloister, your feet further wear down the tombstones of the medieval Pisans set into the floor. Along the walls stands an extensive collection of ancient sarcophagi, a showcase of Pisa's Roman legacy, gathered here since the Middle Ages and serving as a Mecca for students of ancient art.

The upper walls of the Camposanto were originally covered with elaborate frescoes. But on the evening of July 27, 1944 an incendiary bomb fell on the building. The huge conflagration melted down the lead sheathing of the roof and ravaged the paintings below. It is a miracle how much has been recovered and restored.

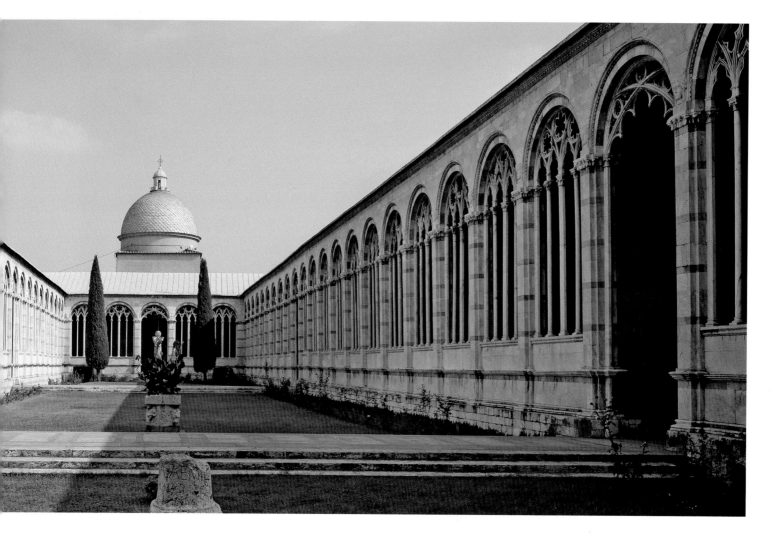

CAMPOSANTO CLOISTER WITH TRACERY WINDOWS, PISA, THIRTEENTH CENTURY.

Even though fragmented, darkened, and battered, the *Last Judgment* fresco still strikes the heart (p. 52). Its Hell is a multi-tiered world, teeming with suffering human beings and ferocious devils. The colossal carnivorous Satan who presides here stares hungrily at the viewer with his wild eyes.

More poignant still is *The Triumph of Death* fresco. Like any work of such complexity, it has been a subject of many interpretations and debates. Was it painted between 1360 and 1380 to mourn the devastation of the Black Death that ravaged Tuscany in 1348? Was it produced just before, in response to the moralizing climate prevalent in the city in those days? The transitory nature of life, in any case, was not only part of the Church teachings, but a familiar reality for dwellers of medieval towns, where crowding and poor

sanitation fueled epidemics and disease. No one was immune.

In the left portion of the fresco a party of noblemen and women ride through a forest on a leisurely hunt (p. 53). Suddenly they stumble upon three open graves with bodies in various stages of decomposition. What they encounter is their own impending death. A banner unfurled over the tombs speaks for the corpses: "What you are, we were once; what we are, you too will be." On the right side of the fresco demons swarm down from the sky to spear everyone within reach. Below them the pile of victims grows thick. The scene captures the horror of the indiscriminate demise of rich and poor alike, be it the general human condition or the result of the plague. The adjacent *Last Judgment* warns the faithful to be ready to account for their deeds.

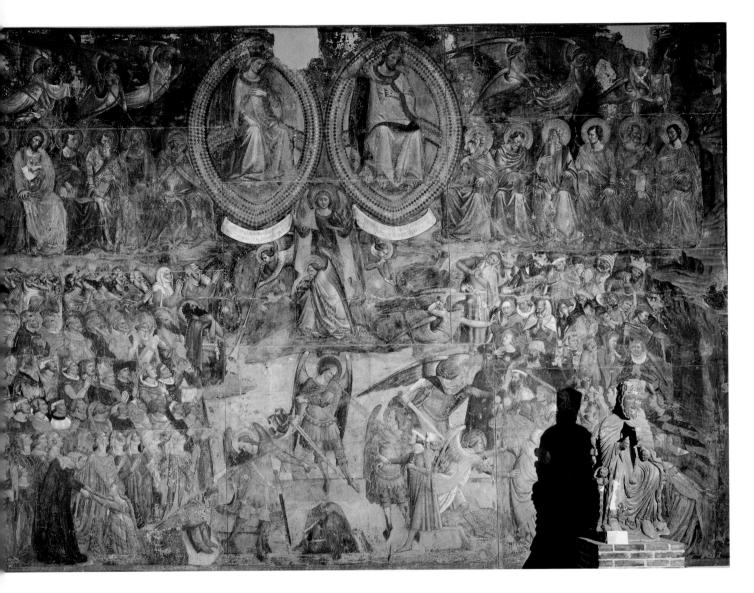

DETAIL OF FRANCESCO TRAINI'S *LAST JUDGMENT* FRESCO IN THE CAMPOSANTO, C. 1360.

The cathedral piazza is so infinitely rich in things to see and layers of religious and political meaning that visitors to Pisa may be forgiven for seldom exploring other vestiges of her past. It is true that not much remains of the medieval city, given the eventual Florentine takeover and transformation of Pisa, and the devastations of World War II. Yet there are small treasures here and there. A few narrow streets curve from the river bank to the cathedral, framed by old houses raised on squat colonnades. The St. Matthew Museum holds an astonishing collection of paintings and sculptures: mournful thirteenth-century crucifixes, charming capitals carved with the Evangelists or monsters, altarpieces of great passion and beauty, all gathered from churches now gone.

Of the few that remain, the most dazzling is the jewellike Santa Maria della Spina, perched on the southern bank of the Arno, right on the sidewalk (p. 54). Originally built in the thirteenth century as an oratory for the newly constructed Ponte Novo, the New Bridge, it used to stand much lower down, by the water it meant to placate. Over the centuries the river threatened its survival. In 1871 it was dismantled and rebuilt, block by block, higher up on the bank. The church's name, St. Mary of the Thorn, derives from the precious relic it houses. In the early fourteenth century a Pisan merchant returning home from the East presented the oratory with a thorn from the crown of Christ. To honor this gift, the church was enlarged and embellished, and given the appearance of a reliquary. It is a porcupine of Gothic

DETAIL OF FRANCESCO TRAINI'S *TRIUMPH OF DEATH* FRESCO IN THE CAMPOSANTO, C.1360.

⊰⊹⊰

turrets and arches, and a showcase of sculptures by fourteenth-century Pisan craftsmen.

Pisa's ascendancy proved as temporary as Lucca's. In 1284 she was decisively defeated by Genoa in the naval battle at Meloria, and soon lost her maritime supremacy and political might. In the course of the fourteenth century she also lost most of her colonies. In 1406 Florence, long covetous of a harbor from which to carry out its own commercial operations, laid a long siege to Pisa, defeated her, and annexed her port.

Yet the memory of Pisa's heyday lingers, not only in the old monuments, but in more recent creations. In the 1950s the former Italian maritime super-powers—Pisa, Genoa, Amalfi, and Venice—founded an annual river race conducted in period costumes and boats, and hosted by each city in turn. The Venetians, who remain most intimate with the sea, win most of these regattas. But more fascinating than the boat contest is the historic procession that leads up to it (p. 55).

Representatives of each town, in medieval and Renaissance dress, march behind standard-bearers, trumpeters, and drummers, who herald their approach. Watching the pageantry can capture the most jaded imagination, exciting visitor and locals alike. Marching in the procession are rugged Amalfitani, fierce Genoese, regal Venetians, and militant Pisani. The Amalfitani appear resolute and serious, game to take anyone on. The tall Genoese, in chain mail, look dangerous. The Venetians parade their wealth: the opulently clad Doge walks underneath his ceremonial umbrella, and Venetian

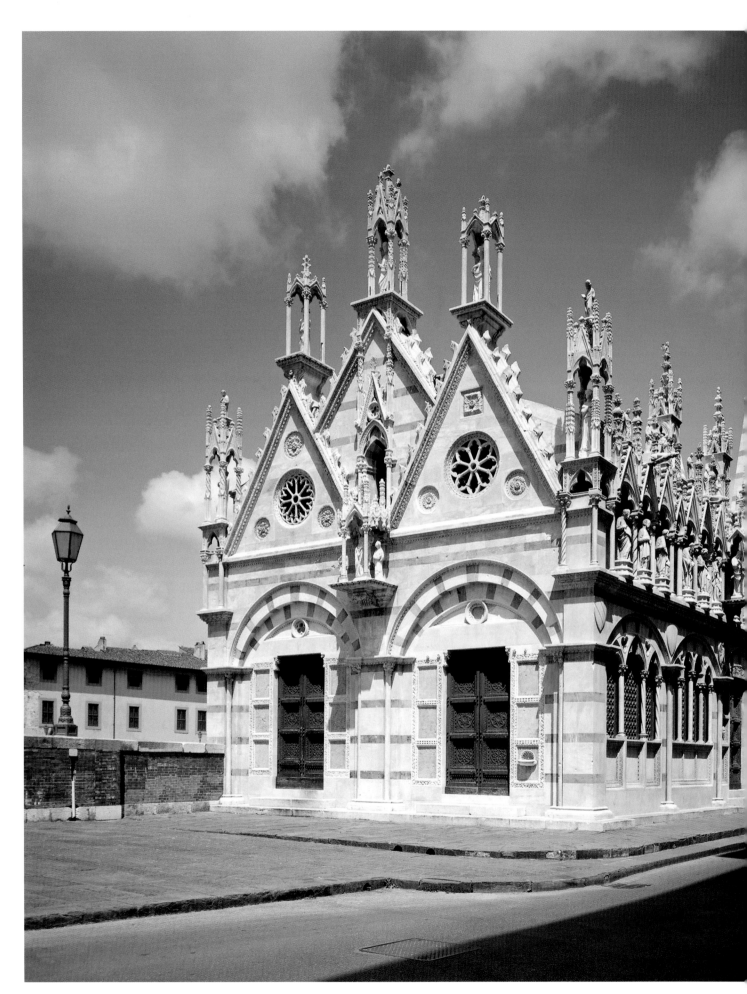

REGATA STORICA'S COSTUMED PARADE IN PISA.

senators stroll in full-length purple robes and wigs.
The luxuriously decked-out Venetian ladies smile at the
spectators, bringing to mind their Renaissance reputation
as prized courtesans. The Pisans march under their
crusading banner, the red cross of medieval knights
prominently sewn on their chests and backs. Observing
this parade on the riverbanks of Pisa, one is reminded
that the red cross was once not a mere ornament, but
a war cry motivated in part by religion, but also by
economic gain through conquest of rich infidel lands.

THE CHURCH OF SANTA MARIA DELLA SPINA IN
PISA, BUILT IN THE FIRST HALF OF THE THIRTEENTH
CENTURY AND ENLARGED A CENTURY LATER.

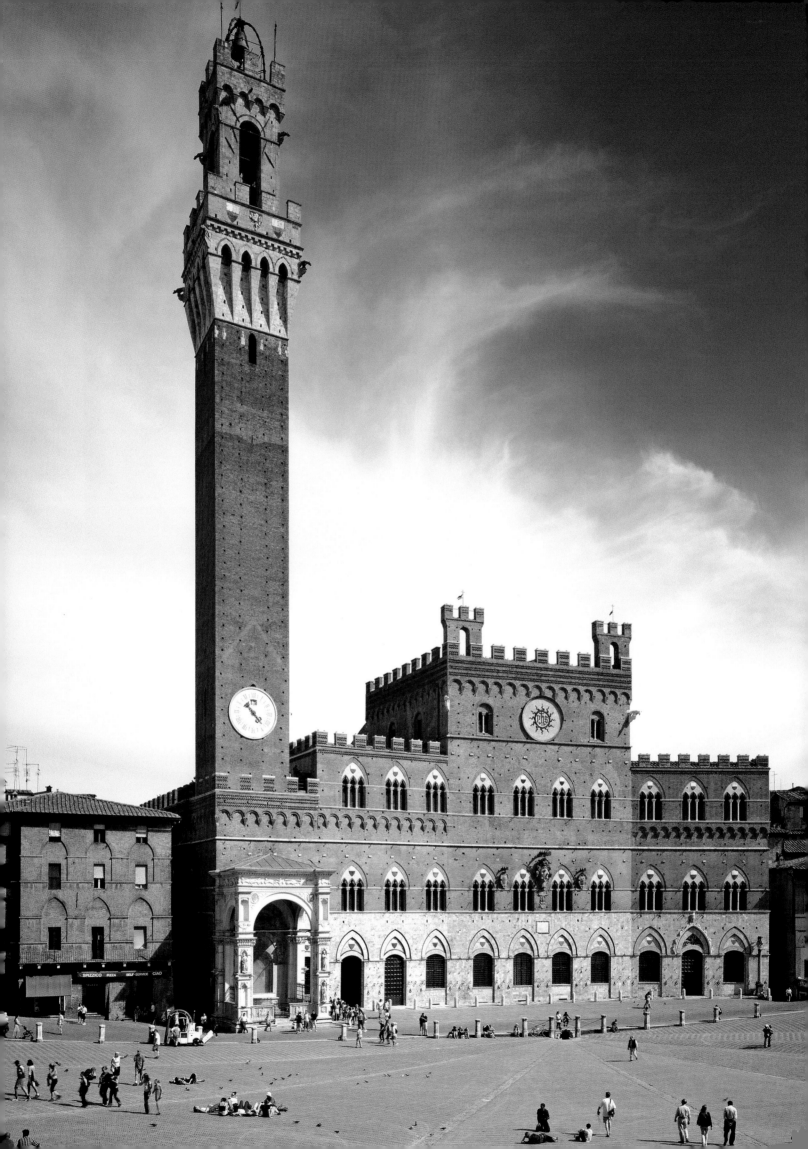

CHAPTER 3

THE CIVILIZATION OF SPACE: SIENA

S IENA IS ONE OF THE FIRST PLACES IN THE WESTERN WORLD
WHERE ARTISTS BEGAN TO DEPICT RECOGNIZABLE PLACES IN
THEIR PICTURES. IT IS HAZARDOUS TO VENTURE EXPLANATIONS
FOR SUCH MAJOR SHIFTS, BUT IT COULD BE THAT BECAUSE SIENA IS MADE
UP OF A CHAIN OF WELL-DEFINED AND INTENSELY CHARGED SPACES, THE
SIENESE FELT INSPIRED TO TRANSLATE THEIR LIVED WORLD INTO ART.

The most famous spot in Siena is the Campo, one of the most enchanting places in
all of Tuscany (left). The scallop-shaped piazza, anchored by the town hall, or Palazzo
Pubblico, and surrounded by a semicircle of medieval and Renaissance buildings, is a
remarkably inviting and intimate place, cozy and contained, like a huge living room.
Its contour embraces everyone and folds them into the bosom of the city. A gracious
host, the Campo seems to bid locals and visitors alike to borrow a piece of its red brick
pavement, settle on it, and observe how it generates and channels life. As, in the course
of the day, the light shifts, the sun rises and sets, and the clouds play across the sky, the
Campo whispers stories of Siena's past.

The piazza slants upward from its base at the Palazzo Pubblico to the curve of palaces
at its crest. Every alleyway that radiates from it either descends or climbs. This is the first
lesson in the town's topography. Siena lies on three hills, and her twisting and angled
streets swell and tumble underfoot. Like Lucca, Siena hardly seems changed since her

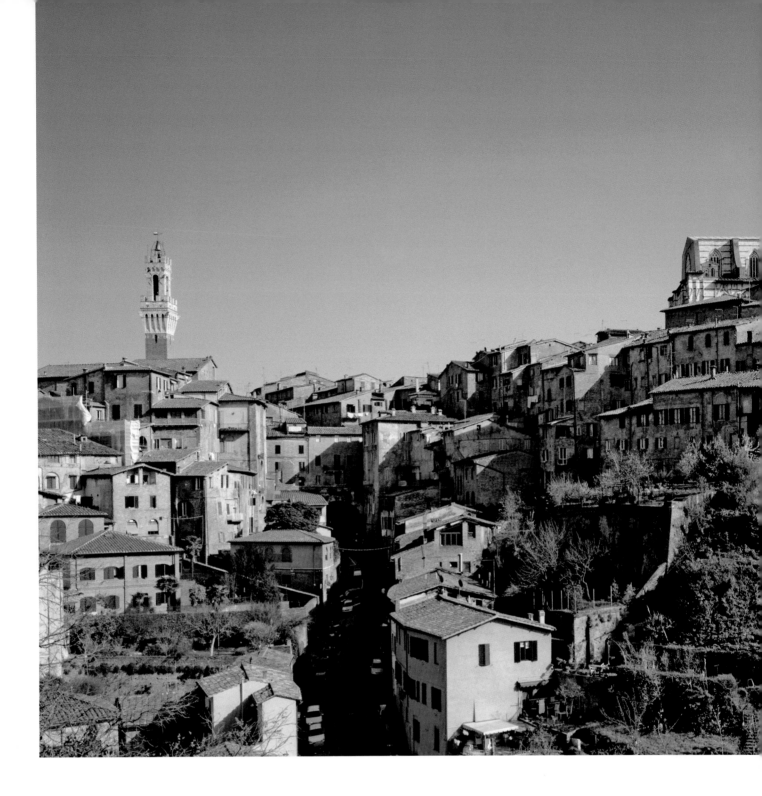

medieval days, but it took time and effort to achieve this aesthetic perfection.

The city's founding legend holds that it was established in the eighth century BC by Ascius and Senius, sons of Remus, when they fled Rome after their uncle Romulus killed their father. To maintain this dignified myth, the Roman she-wolf crops up throughout the city: in bronze statues on columns, in frescoes, in illuminated books. The monogram SPQS on the city's public buildings co-opts the SPQR emblem of ancient Rome. More plausibly, the settlement should be credited to the Etruscans: the city's name seems to derive from that of the powerful Etruscan Saina clan. The Romans, of course, eventually wrested the town from the Etruscans, and in 29 BC Augustus turned it into a Roman military colony. But it was the passage by Siena of the Via

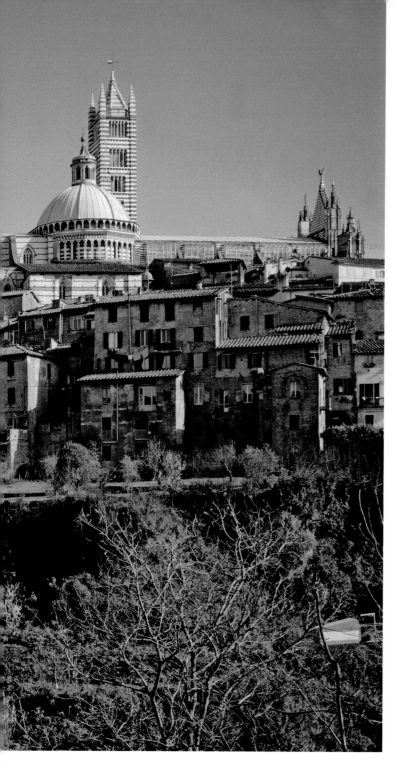

next to the Palazzo Pubblico (p. 56), all the way to the bell itself, and look around from that dizzying height. From here you can readily grasp the chief parts of the city: the Campo and the town hall at your feet; the white- and green-striped cathedral rising on its own hill to the left; and snaking around in various directions, big and small streets grouped into the seventeen *contrade* (neighborhoods) that famously compete in the Palio horse race. All around the city stretches her fertile countryside: vineyards and olive groves, wheat fields and woods, small farmhouses and villas in a picture-perfect Tuscan landscape.

All these features, the urban and the rural, jelled together in the thirteenth and fourteenth centuries. At that time the Sienese erected their most imposing public and private buildings, and expanded their *contado*, the outlying subject territories that supplied the city with food, raw materials, manpower, and political influence. The opening page from a fifteenth-century *Book of Census* (p. 60) sums up Siena's self-image in those decades. At the bottom of the page—at its foundations, as it were—the Roman she-wolf suckles Romulus and Remus. The Christian patron saints of the city—Ansanus, Sabinus, Crescentius, and Victor—peek out from the foliage in the side borders. A cityscape of Siena, with its circuit of walls, town hall, and striped cathedral, crowns the page and serves as an ornate initial for the text that spells out the annual tribute Siena expected from her dependents.

Siena reached the height of her affluence and pride under the leadership of the Council of Nine, a kind of coordinating committee and executive board that governed the general council of 300 members, as well as commissions of tax officials, merchants, and knights. The Nine were elected by cast lots from the most prosperous and well-established merchants and bankers of the city, and served for a two-month term. Other government officers ruled for six months or less. With so much turn-around, plus the typically rancorous dynamics of Tuscan civic politics, it is astonishing how much they got done.

The Nine and other government officials inhabited the Palazzo Pubblico, the Nine quite literally. To avoid

Francigena, the economic and pilgrimage highway of Europe, that brought her prosperity and fame.

Siena became an independent republic in the twelfth century, and blossomed under a lay communal regime that ruled with sufficient wisdom to turn the city into a commanding and prosperous state. Sienese merchants and bankers, actively involved in international finance and commerce, brought in much of the wealth with which the city was built.

To get a sense of the vision and achievement of these generations, climb to the top of the bell tower

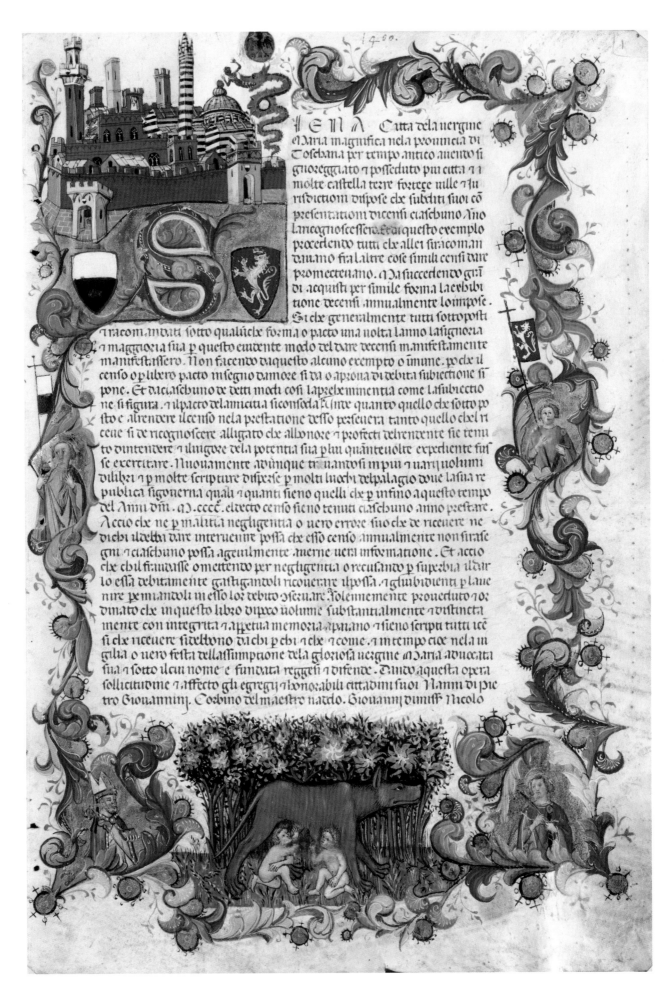

being lobbied, they had to live there for the duration of their term. Most town halls in medieval Tuscany tower over surrounding buildings and are richly decorated. Siena's, built between 1297 and 1326, is, arguably, the most beautiful of all (p. 56). A massive edifice, it seems deceptively light. Its lower course is built of soft gray stone, and has pointed arches over windows and portals that seem to lift the building off the ground. Two rows of triforate windows, divided by slim columns and crowned by white gables, dissolve the brick walls. The stepped upper stories give dynamism to the structure, and roof crenellations add to the ornate look. The bell tower, added between 1325 and 1344, also makes the eye soar. Its name, Torre del Mangia, derives from the word *mangiaguadagni*, "eat all you earn," which is, apparently, what the first bell-ringer, Giovanni di Balduccio, did. The tower's brick shaft blossoms into a crenellated stone platform from which the ringing bell alerted citizens to dawn and dusk curfews, marked the passage of time throughout the day, and summoned the councilmen to meetings.

The Palazzo Pubblico was more than the seat of government offices (with a prison in its bowels). It defined citizenship both conceptually and physically, and set the architectural standard for the whole of Siena. A law passed just as the town hall was going up stipulated that any subsequent building on the Campo must have biforate or triforate windows with columns, to match its facade. This aesthetic and civic norm served to express social harmony. So when the Palazzo Sansedoni was built just opposite the Palazzo Pubblico, it faithfully adhered to the new regulation. Even the Florentines, Siena's chief competitors, modeled their town hall on that of Siena (right). In those days public monuments were powerful weapons with which Tuscan cities fought each other for preeminence.

The appearance of the city expressed the dignity of its inhabitants. Under the rule of the Nine all principal streets of Siena were paved with brick. Each citizen was responsible for keeping clean the space in front of his house or shop. He had to sweep it every Saturday or pay a fine of twelve denari. Many blind alleys and narrow

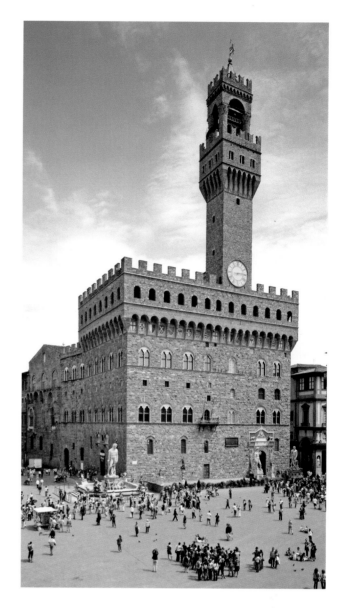

THE PALAZZO VECCHIO IN FLORENCE.

lanes were closed off by locked gates because "many sins are committed therein, and many stinking things are thrown there."

The Campo, being the most visible and charged space in the city, received the greatest attention. Its very pavement—red brick subdivided by marble inlays into nine sections—symbolized the Council of the Nine. The piazza hosted all the major Sienese celebrations. Here politicians read their proclamations, and preachers gave fiery sermons. In 1427 the local religious leader Saint Bernardino delivered a riveting address that was

opposite OPENING PAGE OF *LIBRO DEI CENSI*, FIFTEENTH CENTURY. ARCHIVIO DI STATO, SIENA

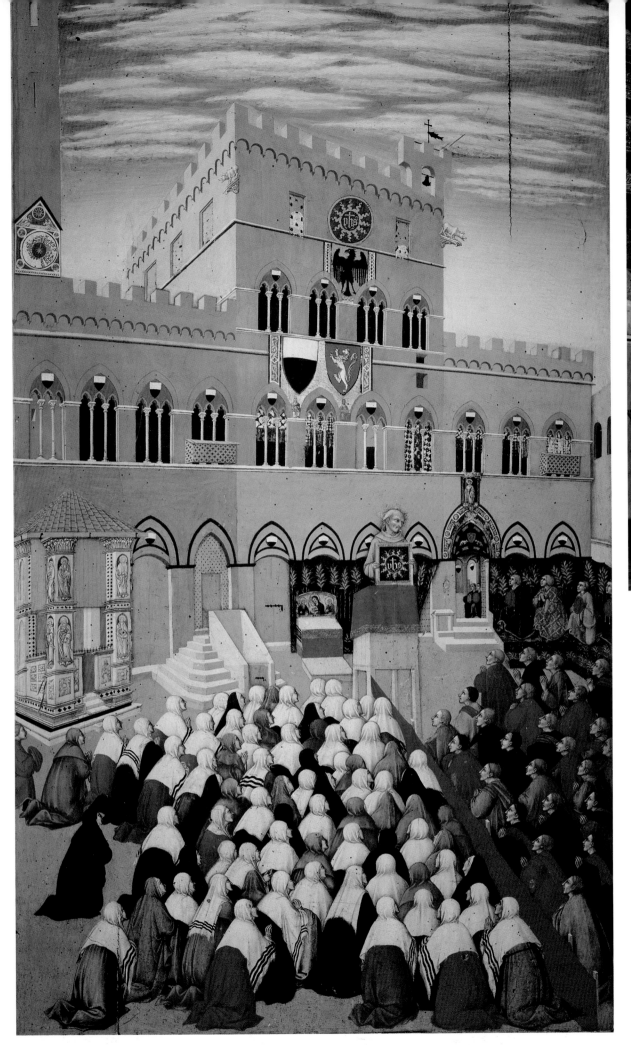

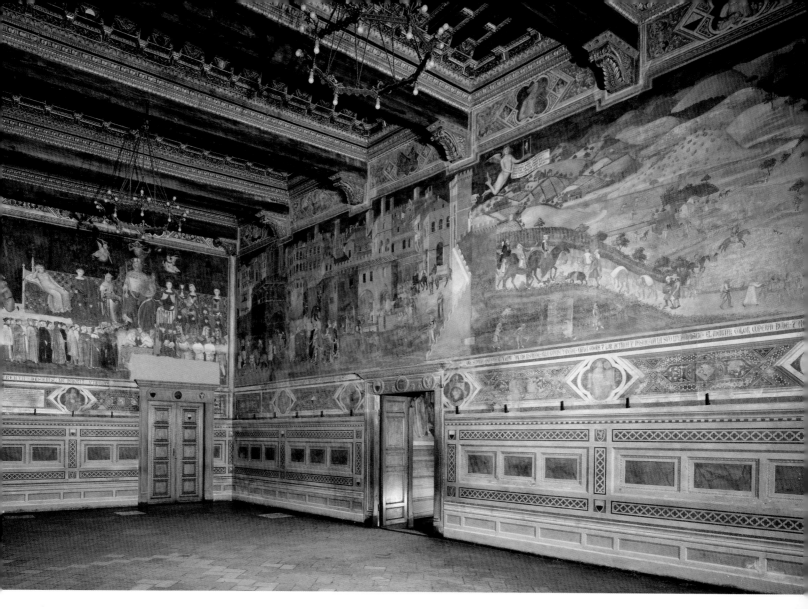

GENERAL VIEW OF THE ROOM OF THE NINE IN THE PALAZZO PUBBLICO OF SIENA, WITH FRESCOES BY AMBROGIO LORENZETTI, FOURTEENTH CENTURY.

commemorated in a painting, whose artist took pains to reproduce faithfully the Campo and the Palazzo Pubblico (opposite).

To penetrate the hearts of his listeners as deeply as possible, Saint Bernardino grounded his sermon in the city's most vital spots. As he addressed the Sienese in front of the town hall, he referred specifically to the chambers of state inside the building, particularly to the frescoes in the Room of the Nine (above). In 1338 Ambrogio Lorenzetti had been commissioned to decorate this meeting hall of the councilors with an *Allegory of Good and Bad Government*, a programmatic statement of

wise rule that was to inspire and guide them. On the north wall he painted a personification of the Sienese Commune—an old man with Remus and Romulus at his feet (p. 64). He shares his throne with six virtues: Justice, Temperance, Magnanimity, Prudence, Fortitude, and a dreamy maiden, Peace, who reclines on a pile of armor covered with a cushion. She holds an olive branch in her hand. To the left of the Commune presides the figure of Justice, meting out punishments and rewards. Below her, Concordia holds a carpenter's plane on her lap, to even out civic discord. Concordia passes two cords that stretch from the scales of Justice to a procession of

opposite SANO DI PIETRO'S *SAN BERNARDINO PREACHING IN THE PIAZZA DEL CAMPO*, FIFTEENTH CENTURY. OPERA DELLA METROPOLITANA, SIENA

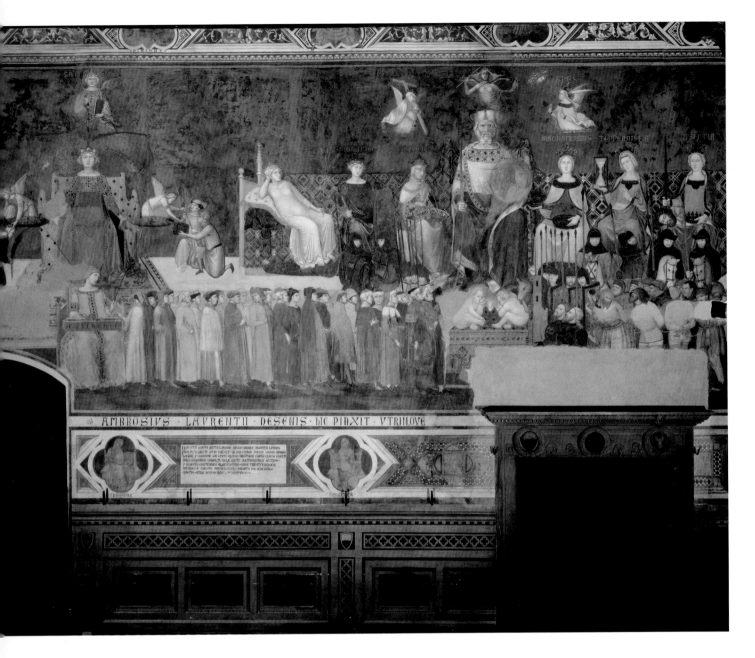

AMBROGIO LORENZETTI'S *ALLEGORY OF GOOD GOVERNMENT* FRESCO IN THE *ROOM OF THE NINE*.

Sienese citizens who carry them back to the Commune. Judicial and executive branches of the government, the painting shows, ran separately, but were linked by threads of mutual interest and public good.

The west wall admonished the Nine about the perils of bad government (opposite). Here a devilish Tyranny rules in the company of vices—Cruelty, Treason, Fraud, Fury, and Divisiveness, who is dressed in a half-black, half-white tunic embroidered with the words SI and NO (Yes and No). She wields a huge saw with jagged teeth. Avarice, Pride, and Vainglory are Tyranny's muses, fluttering over his head. Bound and humiliated, Justice

slumps below his throne, her scales broken and scattered. She looks utterly forlorn. To the left a panorama of a badly ruled city shows a town in disorder and decay (p. 66, left). Buildings crumble and are being torn down; shops stand abandoned; citizens loot, fight, and are arrested by soldiers on the spot. Beyond city walls, villages burn in a desolate countryside. Terror—a skeleton-like figure in tattered robes—flies over this miserable land, brandishing a sword and a scroll that spells out the effects of misrule.

Opposite this scene of disaster, on the east wall, rises the well-governed city—the one onto which the

AMBROGIO LORENZETTI'S *ALLEGORY OF BAD GOVERNMENT FRESCO* IN THE *ROOM OF THE NINE.*

Sienese projected themselves (pp. 66–67). To hint that this may be Siena, the painter placed the striped cathedral tower in the top left corner of the picture. This city is a model of harmony and industry. The houses are well maintained; new construction is underway on the rooftop in the center of the view. Businesses are plentiful and productive. A cloth shop is busy in the pink house just in from a piazza. On the main street a cobbler's stall employs three men plus a young apprentice whose head just peeks out from behind the countertop. Next door, in a schoolroom, pupils listen attentively to a teacher lecturing from a raised podium. In the middle of the

main square ten richly dressed maidens sing and dance, evoking concord and joy. Noblemen ride out the gate on a hunting party, while heavily loaded donkeys bring goods from the countryside. Life is so peaceful and easygoing in this city that a woman leisurely waters her plants on the balcony of the gray palazzo on the left, and below her a cat stalks a bird in a cage.

Midway along the fresco a gate opens onto the well-cultivated landscape dotted with farms and castles, fields and groves (p. 68). It looks just like the view from the Torre del Mangia today. A flying figure of Security makes sure that no trouble brews: she holds an admonitory

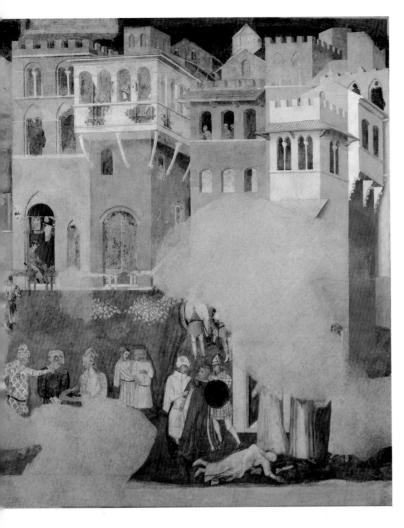

AMBROGIO LORENZETTI'S *EFFECTS OF BAD GOVERNMENT* FRESCO IN THE *ROOM OF THE NINE.*

gallows from which the body of a criminal dangles in the wind. The fresco reproduces a recognizable world of Siena, but omits any underlying tensions and discords.

The aspiration toward wise and harmonious rule, preached so eloquently by Lorenzetti's frescoes, was still more ideal than reality. In fact Siena remained frequently torn by feuds between powerful families and political factions, and by disaffections with the governing regime. The Sienese constitution of 1309–10 had declared "This city and all its people, its countryside and all its jurisdictions are to be conserved in perpetual peace, pure justice and unity." But clearly, if Siena had been untroubled, it would not have needed such pictorial sermons, no matter how beautiful to behold.

The *Well-Governed City* is an idealized portrait of Siena, with her stately buildings climbing up the hills and the cathedral gleaming from its perch. What sets it

AMBROGIO LORENZETTI'S *EFFECTS OF GOOD GOVERNMENT* IN THE CITY FRESCO IN THE *ROOM OF THE NINE.*

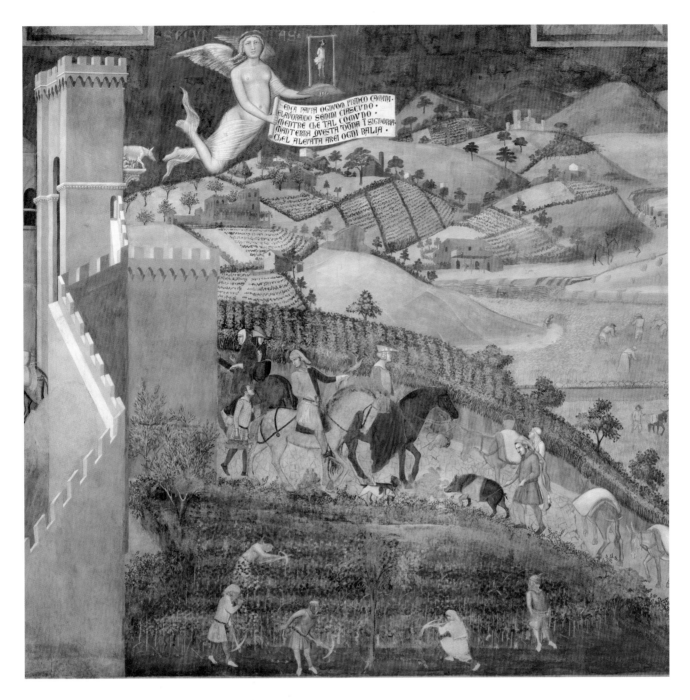

DETAIL OF AMBROGIO LORENZETTI'S *EFFECTS OF GOOD GOVERNMENT IN THE COUNTRY.*

apart from the city we know, aside from its bickering politics, are the brightly colored houses and the tall towers that give the skyline something of an aggressive, bristling look. Today Siena's dominant color is orange-brown, because the painted plaster that once coated its walls has worn away, and what we see is the exposed underlying brick. We find this hue and texture charming; to the fourteenth-century Sienese, buildings without paint would have seemed nude. As for the towers attached to the dwellings of powerful families, a few of them

still stand. But only nearby San Gimignano (opposite) preserves them in sufficient number to convey how medieval Tuscan towns looked with a profusion of such stern bodyguards. In the days when clan strife swiftly erupted into warfare, towers provided their owners with a stronghold to which they could retreat and from which they could defend their family, property, and pride.

The Sienese credited their relative order and well-being partly to the intelligent rule of their legislators and partly to divine guardianship, especially to the

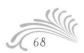

benevolence of the Virgin. They had dedicated the city to her in 1260, on the eve of a bloody battle with Florence. They lost the battle, but kept their faith. Separation of church and state was not a Tuscan political ideal; co-opting divine favor was. Given this attitude, it is only logical that the Meeting Hall of the General Council of Siena (p. 71), next door to the Room of the Nine, is dominated by a monumental fresco of the Virgin and Child, seated under a canopy on a splendid gilded throne in the company of angels and saints. The fresco is so deteriorated that you can hardly make out that the celestial assembly gathers outdoors (p. 70). When the picture was fresh, it would have given an impression that the wall of the room had miraculously dissolved and the fortunate Sienese legislators were blessed with a glimpse of heaven. The miracle was all the more impressive because Simone Martini, its author, used the finest ground lapis

lazuli, azurite, and malachite to paint the clothing and the setting of the divine aristocracy. He made their haloes from elaborately tooled gold and even added pieces of glass to the Virgin's throne, the brooch that closes her mantle, and to Christ's halo, so that they would shimmer when struck by light. During council meetings Siena's legislators presided directly below the Virgin, who seemed to back their decisions and to keep them honest. The Christ child in her lap held up a parchment that ordered: "Love justice, you who judge the earth."

Peaceful and divinely sanctioned rule was certainly part of Siena's ambition. But territorial acquisition was indisputably her other major goal, which she pursued with relentless determination throughout the thirteenth and fourteenth centuries. Her expansionist policy was commemorated on the other walls of the Council Hall. Adjacent and opposite the majestic vision of the Virgin

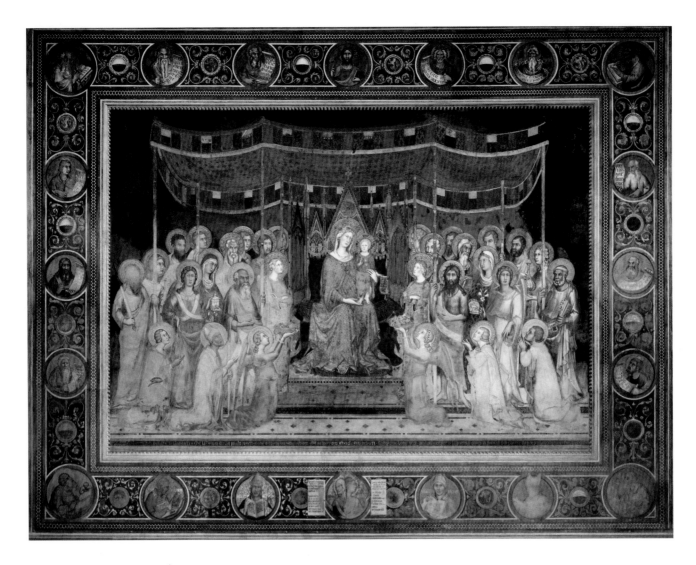

SIMONE MARTINI'S *MAESTÀ* IN THE PALAZZO PUBBLICO, SIENA, C. 1315-21.

appear scenes of Siena's military conquests. In progress on one wall is the battle of the Val di Chiana, which the Sienese fought against English mercenaries in 1363. On another, Guidoriccio da Fogliano, captain of the Sienese army, prances across the countryside between two fortresses he had seized in 1328 (p. 72). As always in medieval Tuscany, one city's gain was its neighbors' loss.

A series of circular scratches in the wall below Guidoriccio trace the vanished motion of a giant rotating map of the world. Siena clearly saw herself within a much larger frame than Tuscany and Italy. Without the lost map, the room is a contained world, the political universe of medieval Siena.

The city's spiritual core is its cathedral (pp. 74–75), dedicated to the Virgin of the Assumption, the

celebration of which was Siena's principal holiday. Siena's reverence and affection for the Virgin were intertwined with a sense of civic pride. By richly embellishing their cathedral the Sienese honored both the Virgin and the city that thrived under her benevolent gaze. White marble of Carrara, green stone of Prato, and local Sienese pink give the cathedral facade its festive air; however, the sculptural decoration is almost oppressively profuse. Giovanni Pisano, previously engaged in Pisa, supervised and contributed to this riot of carving from 1284 until about 1300. Then, criticized for the disorder reigning on the site and the scatter of sculpted pieces lying about with no known destination, he was forced out of the job and out of the city. But in a few years he returned and resumed work. Perhaps he was better than

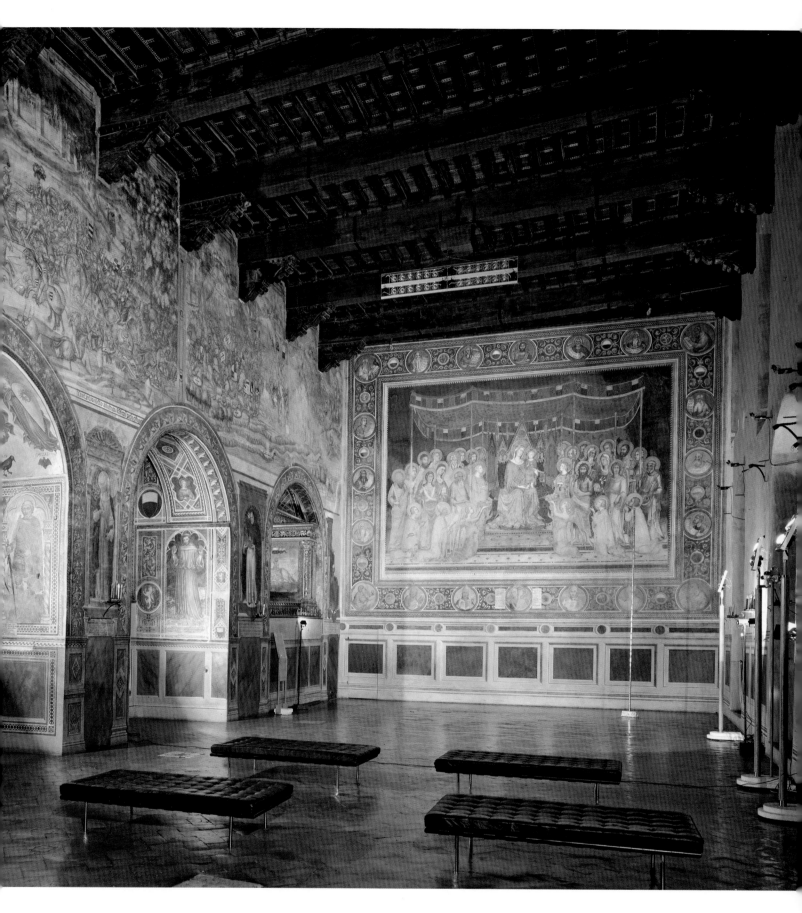

THE SALA DEL CONSIGLIO IN THE PALAZZO PUBBLICO OF SIENA WITH SIMONE MARTINI'S
MAESTÀ, C. 1315–21.

his replacement. In the 1370s Giovanni di Cecco added Gothic elements to Pisano's lower arches over pillars and doorways. The mosaics in the gables went up only in the nineteenth century. The marriage of Pisan Romanesque style with Gothic and nineteenth-century elements is not felicitous.

Modesty and restraint, however, were far from Sienese minds, and their over-ambitiousness was not limited to the facade. Unsatisfied with the already monumental size of the cathedral, they decided to enlarge it to truly colossal proportions. Excited and impatient, they jumped into the project in 1339 and proceeded with great speed. According to the plan, the nave would become a mere transept, and the rest of the building, reoriented by ninety degrees, would expand accordingly. Reverence for the Virgin may have spurred the Sienese in their efforts. But they were clearly keen to outstrip the cathedrals of rival Pisa and Florence. In 1348 the Black Death struck Siena, wiped out a third of its population, and put a stop to the cathedral works. The scale of the scheme

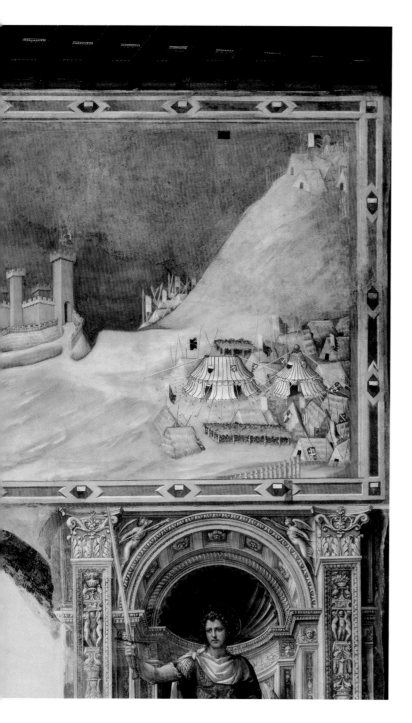

left SIMONE MARTINI'S *GUIDORICCIO DA FOGLIANO SETTING OFF ON THE SIEGE OF MONTEMASSI* FRESCO IN THE SALA DEL CONSIGLIO, FOURTEENTH CENTURY.

along a narrow bridge over the arch. Immediately before you is the south side of the cathedral and its exquisite bell tower. Midway up its striped shaft are open rows of windows. The one at the very bottom is a plain rectangle; the next has a single column that divides the window in two; then the number of columns increases by one with each story. This gradual but visible build-up of openings gives a tremendous dynamism to the tower, as if its windows were rocket boosters, propelling it into the sky. Looking off in the opposite direction, you see the Torre del Mangia, the top of the Palazzo Pubblico, and the Campo intimated by its buildings joining shoulders for their circular dance. Off into the sun-drenched distance stretch the gently rolling hills and meadows of Siena's countryside.

The interior of the cathedral is as opulent as the exterior, but in a different key (p. 76). Whereas the outside is bright and lacy, inside the grandeur is more severe. Alternating bands of white and dark green marble line the walls; more densely packed stripes form the columns. The solemn splendor is enlivened by the ever-changing views through the thickly planted forest of pillars, which pull you into a kind of stately dance around the church. The floor comes alive with fifty-six inlaid pictorial panels (pp. 76–77; title spread). Here sit prophets and sibyls, allegories of virtues and the Seven Ages of Man. Moses strikes the rock to bring forth water; Samson battles the Philistines; David slays Goliath; an old man sings psalms. Some forty-six artists, including Matteo di Giovanni, Pinturicchio, and Beccafumi, poured their efforts and passion for nearly two centuries into this carpet of stories (work started in 1369 and continued until 1547). Only Siena's cathedral has such an extensive pictorial pavement. And this is just the floor.

The striped columns of the nave lead the eye up to two rows of portraits of popes who look down unflinchingly, and make one feel like a small child reproachfully watched by stern adults. Under the arc of the dome, a circle of illusionistic statues of prophets

also doomed it to extinction. The ground had been insufficiently prepared to take the massive weight of the new building; what had already gone up turned out to be unstable, and had to be demolished and carted away. Thus the expansion was ingloriously abandoned. Yet an uncanny memorial to it remains. A few arches of the projected nave and facade soar over the present Cathedral Museum. You can climb on top and receive another aerial lesson on Siena from this precarious height. There are no barriers or wide viewing platforms as you walk

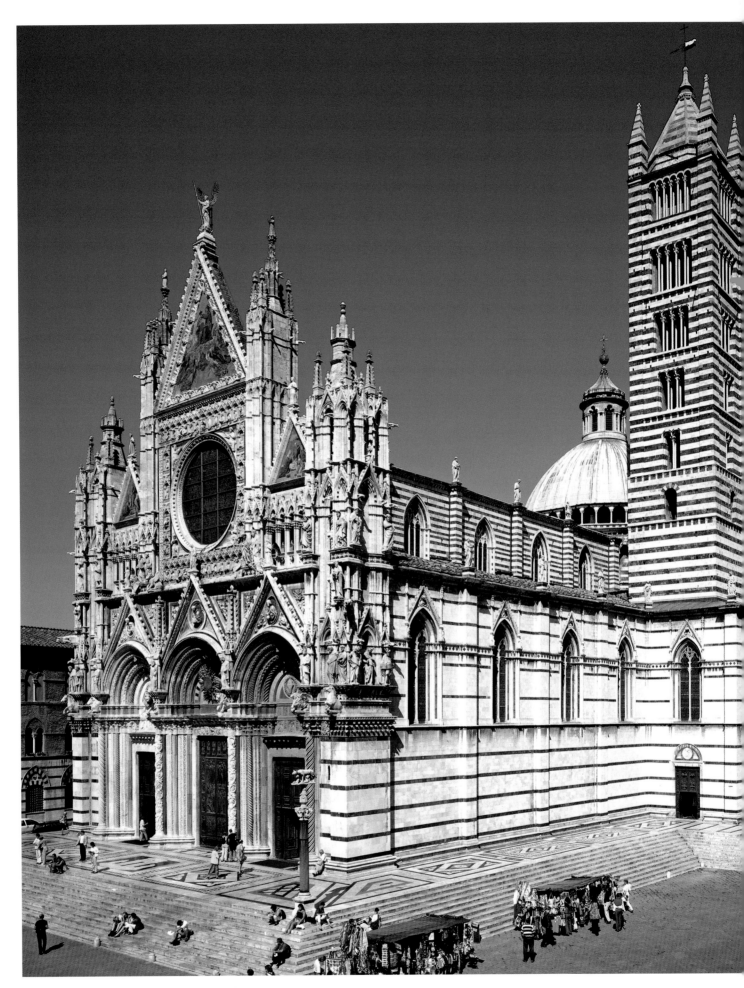

looms with scrolls in their hands. Below them four monumental bronze saints guard their flock. A great stained-glass rose window over the high altar celebrates the Virgin with scenes of her *Dormition*, *Assumption*, and *Coronation* (p. 77, top right). And between the sanctuary and the transept stands Nicola Pisano's ornate pulpit, carved in 1265–68, after he had completed his Pisan work (p. 78). The pulpit is supported by columns set upon lions that barely pause from devouring their prey.

Perhaps the greatest gem in the cathedral is the Piccolomini Library, a small world onto itself (p. 79). A statement of homage and family pride, it was built at the turn of the sixteenth century by Cardinal Francesco Piccolomini, Archbishop of Siena, to house the books of his illustrious uncle, Enea Silvia Piccolomini, Pope Pius II. Enea had been born to impoverished Sienese aristocrats, and achieved fame and fortune by his intellect and diplomatic skills. He studied hard, pursued numerous amorous affairs, and courted the favor of influential men. One way to make a career for a man of broad humanist interests but limited means was to obtain a post as a private secretary or an envoy to some important person. Enea served in the chancery of the Habsburg Emperor of Austria and Germany, Frederick III. Eventually he took holy orders, became an apostolic secretary, then bishop of Trieste in 1447, archbishop of Siena in 1450, cardinal in 1456, and pope in 1458. In those days a well-trained humanist could rise from being a scholar and orator to the papacy itself because his learning, as well as ambition, were tickets to success. Thus, a library was a particularly fitting monument to Enea. As Pius II, he did make a crusade against the Turks in the Balkans his most ardent business, but his other great passion was books. He was an avid reader of ancient authors and a prolific writer. Never losing the verve of his youth, he composed learned treatises on public affairs alongside anecdotal private letters and an amatory novella *The Tale of Two Lovers, Eurialus and Lucretia*—a bestseller about the seduction of a young Sienese matron by a handsome German courtier. Enea's *Commentaries*, detailing his eventful life and career, served as a source for the library's decorative scheme.

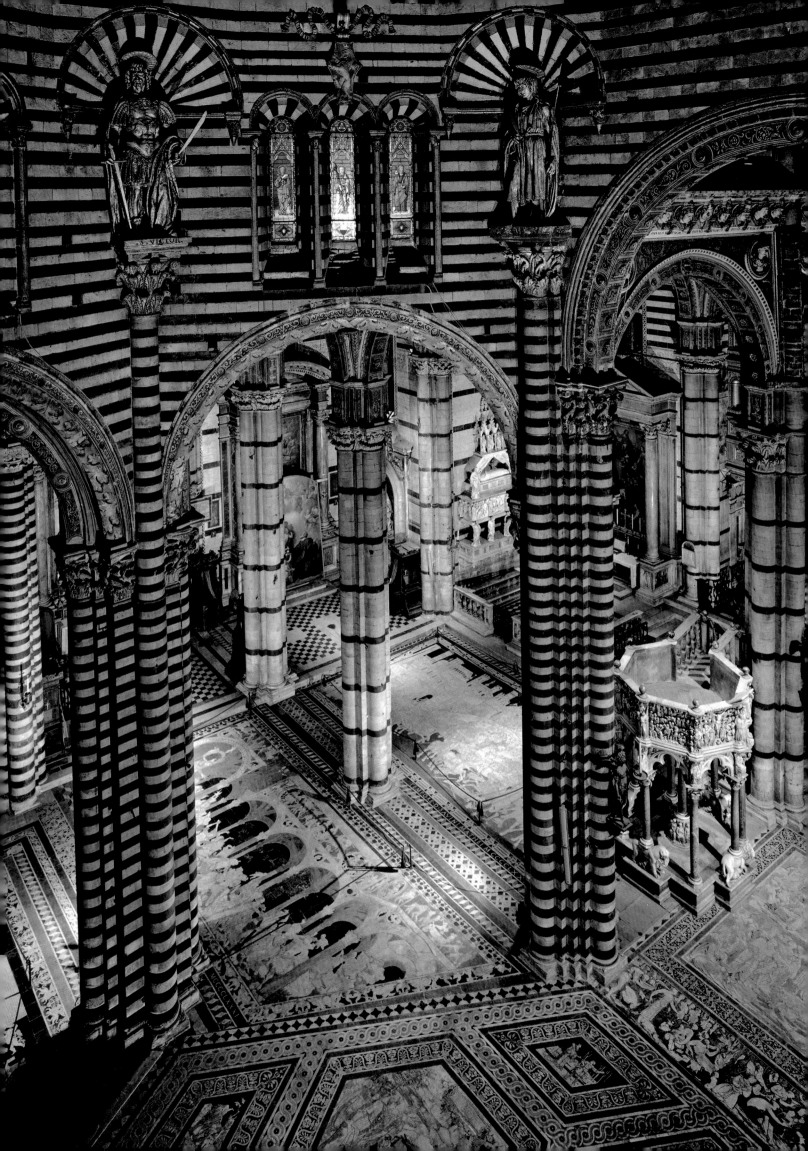

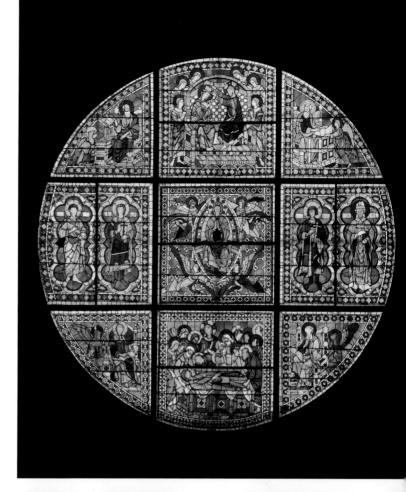

The library is a kind of intellectual mausoleum, and
its frescoes are windows onto the notable episodes of
Enea's life. Painted in meticulous detail by Pinturicchio
and his assistants, the scenes begin in the year 1432,
when the twenty-seven-year-old Enea went to Basel as
a secretary to the Bishop of Fermo, Domenico Capranica
(p. 80). The voyage was plagued by disaster from the
start. First the party's departure from Piombino, a port
midway up the Tuscan coast, was hindered by the city's
lord, Jacopo Appiano. After they finally embarked, a
huge storm broke out, and the violent wind carried the
ship so far south that it came within sight of Africa,
or at least so Enea claimed. Then, the wind changed
direction and the vessel was forced back to Italian waters,
somewhere between Corsica and Sardinia. At last it
managed to land in Porto Venere, on the Ligurian coast,
and the travelers caught their breath. What is most
astonishing is that this whole wild ride took place over
only one day and one night. Worn out, but not deterred,
the travelers embarked again at Genoa and at last sailed
north. The fresco depicts the cortege between the land
and the sea. Enea is the stylish youth on a white stallion
in the center of the picture. The bishop rides immediately
in front of him, on a sorrel horse. In the background
on the left a huge storm erupts over the water, filling the
galleys' sails and scattering them over the waves. On the
right the good weather returns, and a rainbow aches over
the hills.

Other scenes depict Enea's meeting with King James I
of Scotland. In the service of Frederick III he receives the
crown of poet laureate from the emperor himself. Later
he is made a cardinal, and subsequently crowned Pope. As
pontiff he canonizes Catherine of Siena, another great

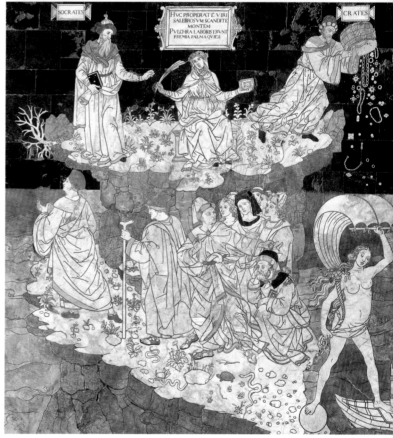

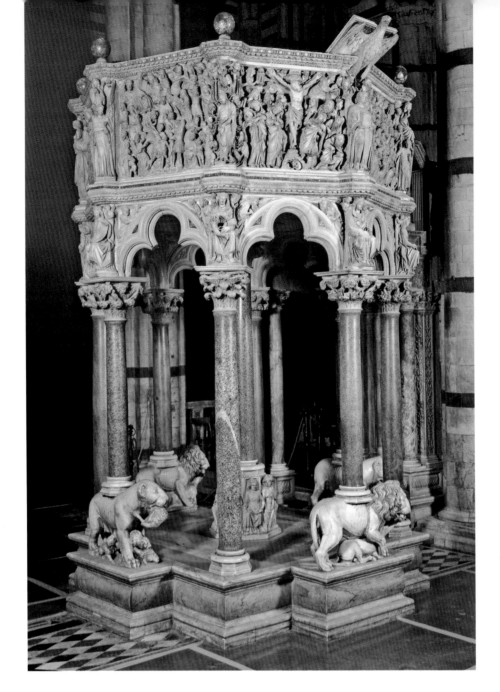

NICOLA PISANO'S PULPIT IN THE CATHEDRAL OF SIENA, 1265–68.

Sienese religious figure who had died in 1380. In the last picture of the cycle the gravely ill pope arrives in Ancona to launch his long cherished crusade, but he is forced to witness the failure of the expedition. He died there on August 14, 1464. All these episodes, shown in such a lively and anecdotal manner and explained by helpful captions over each scene, create an effect of an entire lifetime being played out before us, as if it were a silent movie.

As rich as it is, the library does not complete the offerings of the cathedral, but complements all that it contains. What is remarkable about the duomo is how harmoniously its decorations coexist with each other, and how well they are preserved. Unlike so many other contemporary churches, whether the Cathedral of Florence, largely denuded of its old layers, or San Michele in Foro in Lucca, altered to conform to later tastes, Siena's main church retains its original

opposite PICCOLOMINI LIBRARY IN THE CATHEDRAL OF SIENA, WITH FRESCOES BY PINTURICCHIO, 1502–1509.

THE ARTS *of* TUSCANY

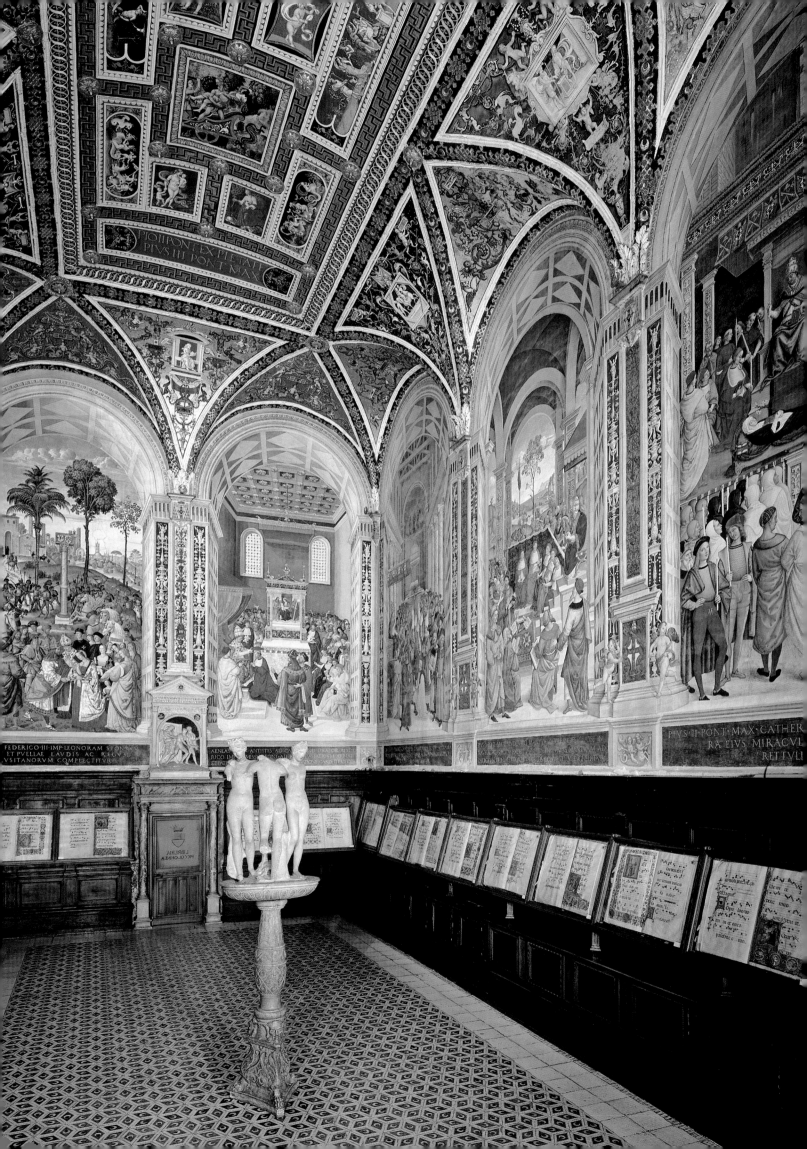

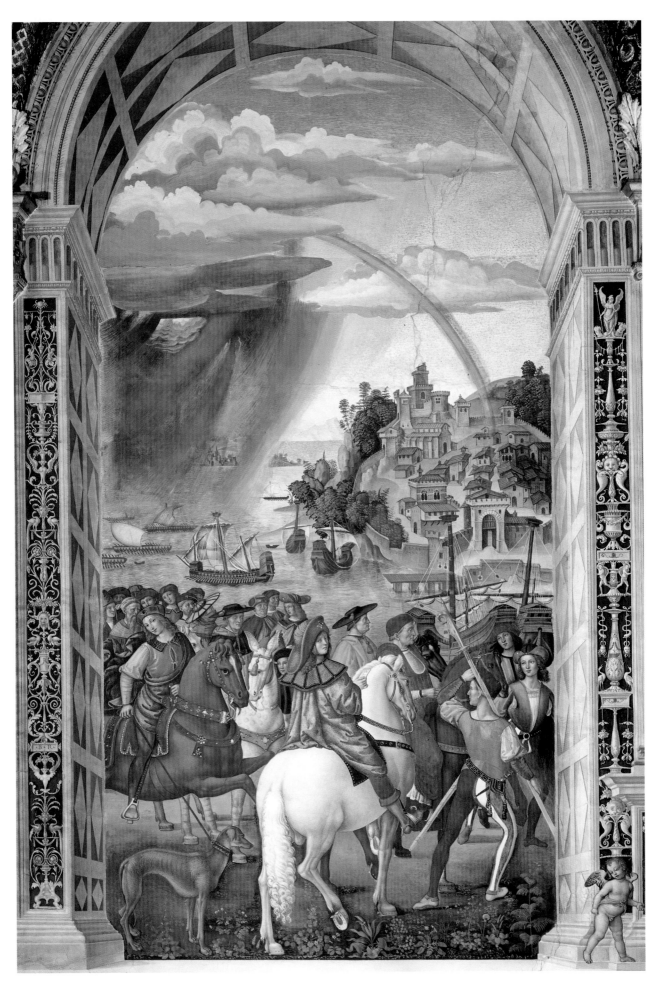

embellishments and later additions. Together they give it historical depth.

The one vital object missing from today's cathedral is the main altarpiece that was its glory in Siena's heyday. The huge double-sided altarpiece with the Virgin enthroned on its face, and scenes from the life of Christ on the reverse, was painted by Duccio di Buoninsegna and his workshop between 1308 and 1311 (pp. 82–83). Its transfer from the artist's studio to the high altar of the cathedral on June 9, 1311 was a momentous civic and religious event, recorded by an anonymous local chronicler:

> The shops were locked up and the Bishop ordered a great and devout company of priests and friars with a solemn procession, accompanied by the Signori of the Nine and all the officials of the Commune, and all the populace. All the most worthy were hand in hand next to the said panel with lights lit in their hands; and then behind were the women and children with much devotion; and they accompanied it right to the Duomo making procession round the Campo, as was the custom, sounding all the bells in glory, out of devotion for such a noble panel.

Unfortunately, over the centuries the majestic altarpiece was not only taken down from its lofty place, but dismantled, sawn into dozens of individual scenes, and sold off piecemeal. Most of the panels have been painstakingly reunited, and now reside in the cathedral museum. Set up in this sterile environment, out of time and context, the *Maestá* has become a mere work of art. We stand before it in hushed silence and admire it aesthetically, for breaking away from the stylized and stilted Byzantine pictorial conventions and infusing painting with human feeling and coherent, lived-in space. But to the fourteenth-century Sienese approaching it on the high altar, the *Maestá* was, first of all, an awe-inspiring devotional experience. For them it was a commanding heavenly apparition, surrounded by the rich golden halo of its elaborate frame and coming to life in the flickering candlelight.

The *Maestá* is shown in its original position in a fifteenth-century painted wooden cover for a ledger of financial records (p. 83, right). It can be seen at the far end of the nave, on the left of the picture, under the stained-glass oculus in the apse. Nicola Pisano's pulpit is shown to the right of the high altar, while along the aisle a row of chapels each has its own altarpiece. In the foreground the leading magistrates solemnly rededicate Siena to the Virgin and offer her the keys to the city gates. The Virgin emerges from the altarpiece to accept the tribute, graphically demonstrating how the faithful perceived such images in the church: as permeable windows onto the realm of the divine.

The most significant and fine altarpieces stood at the eastern end of the cathedral, over the altars of Siena's four patron saints. Pietro Lorenzetti, the brother of Ambrogio who painted the *Allegories of Good and Bad Government*, produced and signed the *Birth of the Virgin* in 1342 (p. 84). Departing from the usual representations that set holy scenes against a plain gold backdrop, Pietro expanded the story by putting it into a contemporary Sienese home. In the central panel St. Anne recovers from giving birth to baby Mary. She rests on a bed covered with a characteristic Sienese checkered cloth and watches placidly as two maids prepare the infant for her first bath. The maid holding little Mary tests the water temperature with her hand. Alongside the bed stands a handsome wooden chest of the type Tuscans typically used to store their clothes and valuables. Women bearing gifts enter the house in the right wing, stepping on colorful, patterned tiles. In the left wing Anne's husband, Joachim, leans in to listen to the happy tidings delivered by a young boy. By casting the Biblical event in terms of familiar Sienese realities, Pietro makes holy figures more human and approachable, and thus more sympathetic guardians of their earthly charges.

Simone Martini, the author of the Virgin fresco in the Palazzo Pubblico, and his brother-in-law Lippo Memmi, the designer of the Torre del Mangia, together furnished another altarpiece for the east end of the cathedral (p. 85). The *Annunciation* is flanked by Saints Ansanus and Massima, and adheres to the tradition

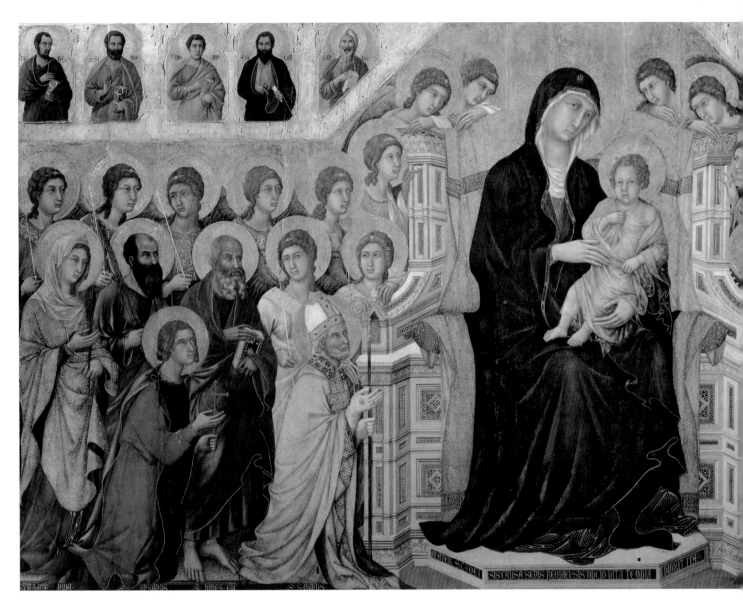

of placing holy figures against a timeless, radiant gold ground, but not because Martini and Memmi lacked more advanced vision or subtler skill. The veined marble floor, the inlaid throne of the Virgin, the golden vase with lilies are all pictured with the utmost precision; and Mary, interrupted at her reading, keeps her page open with her thumb. A gentle undulation of the two bodies conducts the dialogue between the angel and the Virgin. The divine messenger kneels and bends slightly toward Mary to communicate his message, while she swoons in dismay at her newly revealed fate. The empty space between them is filled with a line of angelic salutation floating in relief from his mouth to her ear. It is one of the most poetic pictures of pre-Renaissance Italy, more of a love story than a somber religious event.

Simone Martini was a marvelously versatile painter, and in demand not only in his city, but in Assisi and San Gimignano, Pisa and Avignon. In the lower church of San Francesco in Assisi he frescoed scenes from the life of Saint Martin, an officer in the Roman army who converted to Christianity in 344 (p. 86). This subject was rare in Italian art, and offered much scope for imagination. Since Martin had begun his life as a nobleman, Simone presented in rich detail the pomp and pageantry of courtly life. Scenes from Martin's later religious career gave the artist a chance to show solemn

ecclesiastical rituals and deep faith. He clearly loved painting this cycle. You can see how he lavished his brush on different facial types and costumes, expressive gestures and emotions. My favorite scene is *St. Martin Being Invested as a Knight.* Here a striking group of court musicians solemnizes the proceedings. A man with laughing eyes plays two flutes, while his melancholy companion strums a lute. Both wear bright parti-colored tunics and fancy hats. Two singers behind them round their lips in a song. A savvy older courtier, holding the emperor's hat and sword, watches from the doorway alongside a wide-eyed young page with a napping falcon on his hand. The emperor owes his face to the ancient Roman coins that

have always inspired Italian artists, whether in the Middle Ages or in the Renaissance.

In 1336 Simone went to Avignon, where the French-born Pope Clement V had transferred his court in 1309 during the Great Schism. Simone may have been invited there by one of the Italian cardinals, Giacomo Gaetani Stefaneschi, for whom he painted several frescoes in the Avignon cathedral.

In the papal entourage Simone met the great Tuscan poet Petrarch, and in a tribute to his new friend painted the frontispiece of a manuscript of works by Virgil that Petrarch owned (p. 87). At the top of the page Virgil sits on a hillock composing his famous masterpieces. His

PIETRO LORENZETTI'S *NATIVITY OF THE VIRGIN*, 1342. OPERA DELLA METROPOLITANA, SIENA.

commentator, Servius, uncovers his secrets by literally pulling back a diaphonous curtain behind which the poet writes. The hero of Virgil's epic, Aeneas, with a lance in hand, proudly arches his back on the far left of the picture. At the bottom a farmer from the *Eclogues* and a rustic from the *Georgics* engage in productive rural labors extolled by the Roman bard. As one chops a tree and the other milks his goats, they look up to Virgil, who gave dignity and honor to their simple work.

Before we leave Siena altogether, we must return to the Campo as a place of Siena's greatest festival, the Palio. Although it has some medieval roots, the Palio is as much a product of historical reconstruction as a genuine tradition. Versions of it existed in the thirteenth and fourteenth centuries, but they were straight-line horse races that began outside the city gates and ended before the cathedral. Such races were part of a series of public games that took place in the course of the liturgical year. Ball and boxing matches were also popular, as were bullfights and wild animal hunts. A vivid sixteenth-century painting depicts a bull hunt in the Campo (p. 88). District teams enter the field in wooden carts shaped

SIMONE MARTINI AND LIPPO MEMMI' *ANNUNCIATION WITH SAINTS ANSANUS AND MASSIMA,* 1333. GALLERIA DEGLI UFFIZI, FLORENCE

like birds and animals—an elephant, a unicorn, an ostrich, a snail. When a bull gets particularly enraged, or contestants need a break, they climb inside their carts to catch a breath. These animal carts seem to have inspired the symbols by which the *contrade* identify themselves to this day.

All games were held on a religious feast day, because these were official holidays. The Palio of August 16, which goes back to the Middle Ages, was dedicated to the Virgin of the Assumption; that of July 2, to the miracle-working Virgin of Provenzano. This Virgin was originally

a modest terra-cotta image that sat in a niche between two houses on the Via de' Provenzani, in one of the city's dicier neighborhoods. It came to prominence in the late sixteenth century, when as a result of the bad policies of Francesco I de' Medici Tuscany was going through hard times, and Siena in particular was suffering from famine and pestilence. In 1594, the Sienese, worn out and desperate from prolonged suffering, decided to appeal to the Virgin. But even their piety was stumped by a feud between the Archbishop of Siena, Ascanio Piccolomini, and the rector of the Cathedral Fabric, Giugurta Tommani.

SIMONE MARTINI'S TITLE-PAGE OF PETRARCH'S VIRGIL, 1338.
BIBLIOTECA AMBROSIANA, MILAN

Because of the furious conflict between these two men, the people could not go and properly pray to the Virgin in the Cathedral. So they prostrated themselves instead before Our Lady of Provenzano, known to work miracles.

One day, on July 1, the Vigil of the Feast of the Visitation, a group of workmen were decorating the shrine of the Virgin of Provenzano. Sitting on the street and watching them was a certain Giulia di Orazio, a woman known for her evil life, who was tormented by an incurable illness. After a while, Giulia began to scoff at the preparations, and at the Blessed Virgin. Later that day, at dusk, she felt a strange force compelling her to go and kneel before the sacred image, and beg the Virgin to forgive her and give her health. The next day she returned to pray again, which was quite out of her character. A few hours later, when a doctor stopped by to treat her sores

opposite SIMONE MARTINI'S *INVESTITURE OF SAINT MARTIN* FROM THE *LIFE OF SAINT MARTIN* CYCLE IN THE LOWER CHURCH OF SAINT FRANCIS AT ASSISI, C. 1312–1330.

VINCENZO RUSTICI'S *CACCIA DEI TORI*, C. 1590. MONE DEI PASCHI, SIENA

and reapply her bandages, he was amazed to find that Giulia was perfectly cured. The repentant sinner rushed to the little shrine, offered passionate thanks to the Virgin, and told all assembled with great emotion how she had been forgiven and made whole by the miraculous image. The shrine became a site of great many offerings and much veneration. By the following year a new church was under way to house the marvelous image with greater care and pomp. By the early seventeenth century the Feast of Our Lady of Provenzano became a major Sienese holiday, celebrated on July 2.

But the neighborhood was still a shady one. If a man did some ill deed, it was commonly said, "You would

do well in Provenzano." Even the Feast of the Virgin would give rise to much disorderly conduct. To channel the energies of the unruly people, the superintendents of the feast decided, in the mid-seventeenth century, to inaugurate an annual horse race in the Campo, as a contest among the various *contrade*. This way, they could direct the questionable impulses of the populace into an organized competition. And so the modern Palio was born—or at least this is one version of the story. Since the festival evolved over time, and was altered up to the twentieth century to conform to various notions of historical accuracy, many more stories can be told.

The word *Palio* itself comes from the *pallium*—a swath

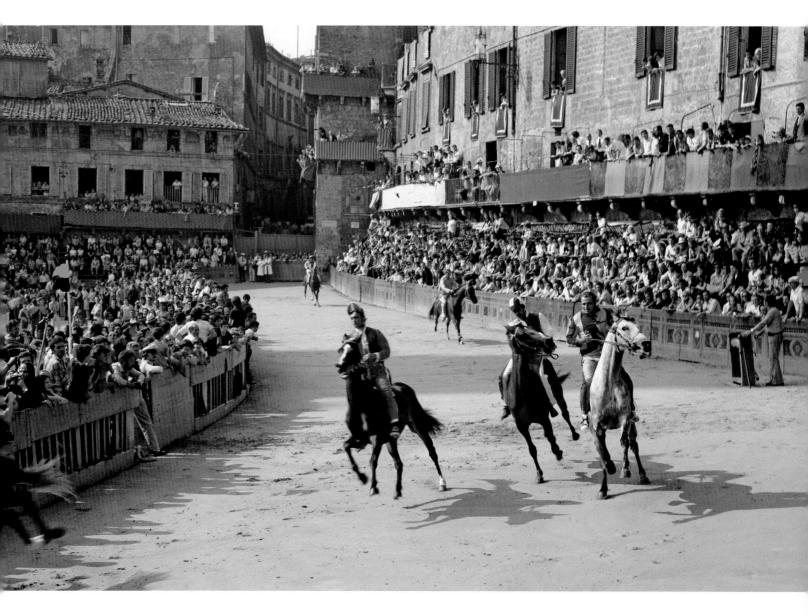

PALIO RACE IN SIENA.

of rich cloth awarded to the winner. Initially it was a piece of silk or damask, since in the Middle Ages and the Renaissance costly fabrics functioned as a kind of currency, and were often presented as special gifts. Over time, the *pallium* became a banner with the image of the Virgin. Now a new one is produced every year.

Of the seventeen *contrade*, ten participate in each race. Those who did not get a chance to run in July compete in August. Most years there are two races, but special occasions have prompted additional Palios. In 1809 a Palio held on June 4 celebrated Napoleon's victorious return to Paris. On October 23, 1849 a Palio honored the opening of the Siena-Empoli railroad line. An

extraordinary Palio marked the end of World War II in 1945, and another commemorated the first lunar landing in 1969.

The charge of horses around the Campo lasts only a minute and some seconds (above). But the festival is really a yearlong affair. As soon as the August Palio is over, preparations for the following season begin. And the passions surrounding the Palio are genuine and intense. Before the race, horses and jockeys are closely guarded, lest they come to some harm at the hands of opponents, or the riders be bribed. On the day of the race the animals and their riders are solemnly blessed in their respective parish churches. Profuse horse droppings

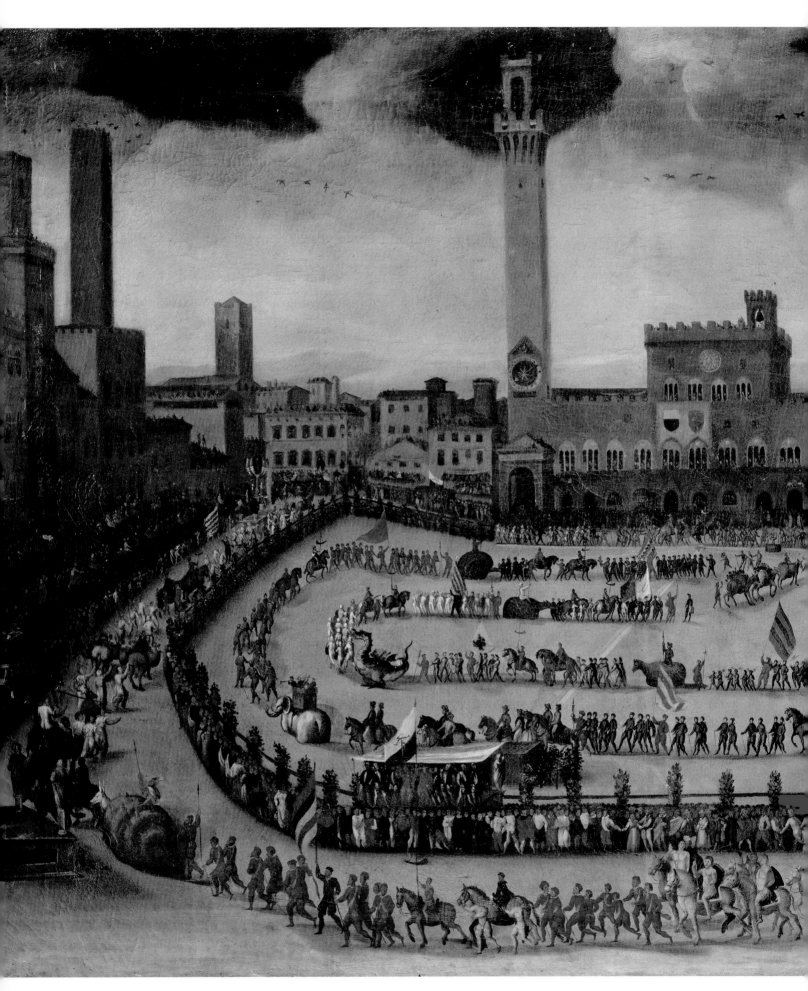

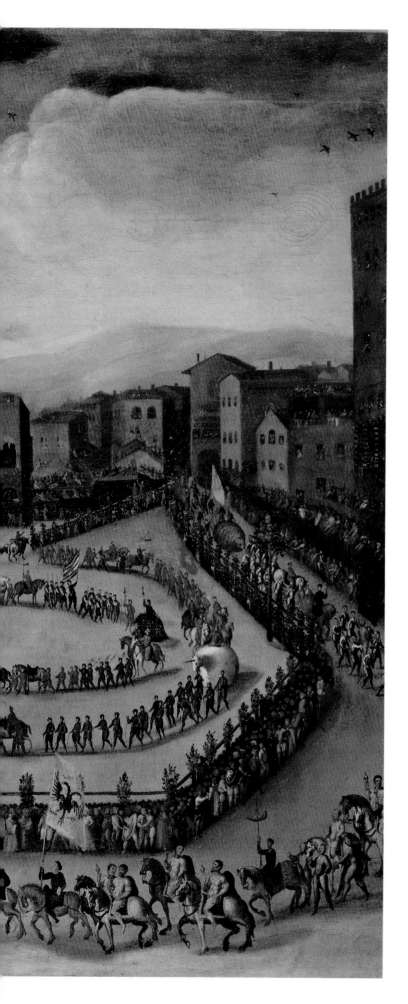

at that moment are deemed good luck. When the horse wins—there is only one winner, everybody else loses—members of the winning *contrada* weep for joy and party for weeks. A celebratory mass is held in the cathedral. The Palio, in other words, combines all the characteristics of Siena: civic pride, devotion, and close neighborhood ties.

Before the race itself a historic procession circles the Campo (left). In addition to the representatives of the *contrade*, envoys of all the towns, villages, castles, and small principalities that once owed allegiance to Siena march in turn. The Palio is the celebration of Siena at the moment of her greatest glory. It remains the high point of the year not for its tourist allure, but because the Sienese, like all Tuscans, feel passionately about their past and devoutly maintain their historic roots.

VINCENZO RUSTICI'S *PRESENTATION OF THE CONTRADE IN PIAZZA DEL CAMPO*, C. 1590. MONTE DEI PASCHI, SIENA

 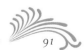

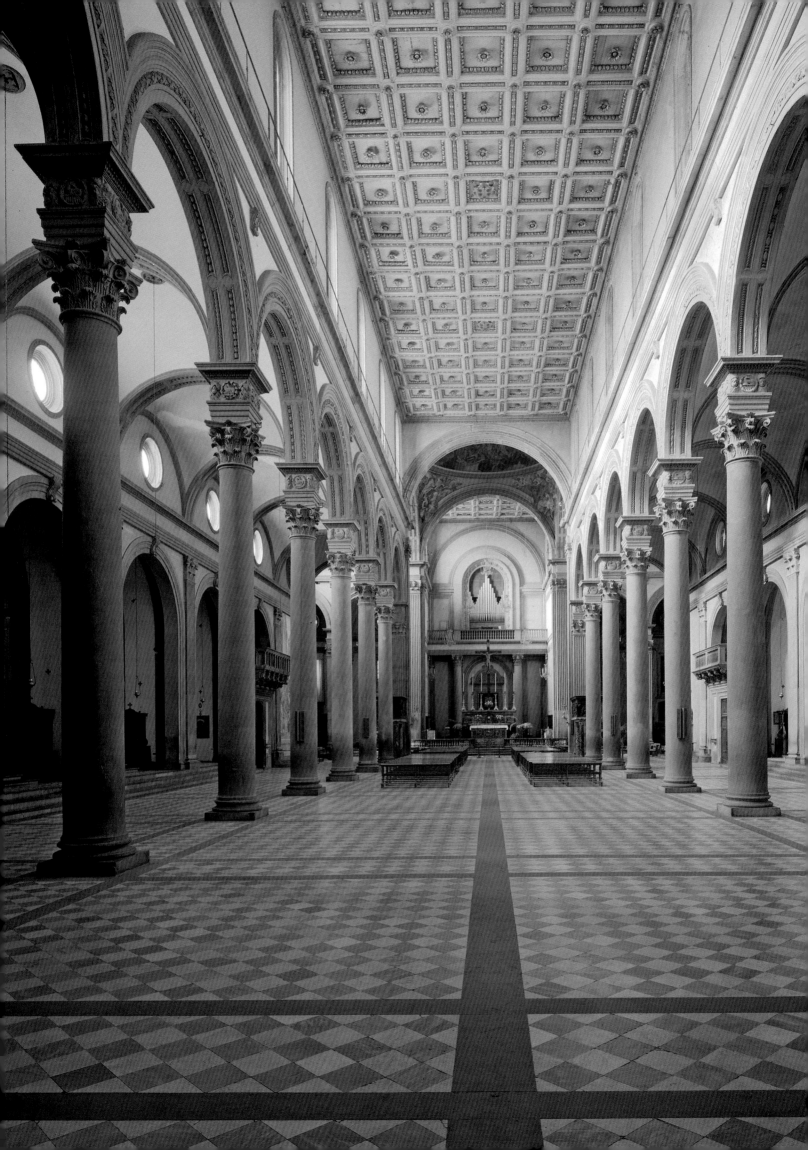

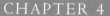

SURPASSING THE ANCIENTS
AND ONE ANOTHER:
QUATTROCENTO FLORENCE

T HE FLORENTINES, IN THE PAST AS TODAY, LOVE THEIR CITY

PASSIONATELY. THE GREAT FIFTEENTH-CENTURY FLORENTINE

LANDOWNER AND BANKER, GIOVANNI RUCCELLAI, EXPRESSED

HIS PLEASURE IN THE MONUMENTS HE HAD CONTRIBUTED TO HIS HOME

TOWN IN THIS WAY: "THEY SERVE THE GLORY OF GOD, THE HONOR OF

THE CITY, AND THE COMMEMORATION OF MYSELF." FLORENCE WAS BUILT

with an equal measure of religious devotion, civic pride, and personal honor. One can
sense these complementary ambitions walking around the city, down streets lined with
massive private palazzi, across piazzas dominated by grandiose churches, past public
buildings and statues, and through museums stuffed with artifacts. Perhaps the greatest
catalyst of the fifteenth-century building boom, to which we largely owe the appearance of
Florence that we see today, was competition—with antiquity and with other cities, among
patrons and among the artists themselves. Of course, Florence was fortunate to give
birth to a constellation of remarkable craftsmen—Lorenzo Ghiberti, Donatello, Filippo
Brunelleschi, and many others—who vied with the Etruscans and the Romans, and with
each other, for the most accomplished works. Yet equal credit is due to their ambitious
patrons, the leading merchants and bankers of Florence, who engaged in one-upmanship
through the arts.

Consider the Orsanmichele, the state granary and home of a miracle-working image
of the Virgin (p. 95). It stands on a block of the Via dei Calzaioli, half-way between the

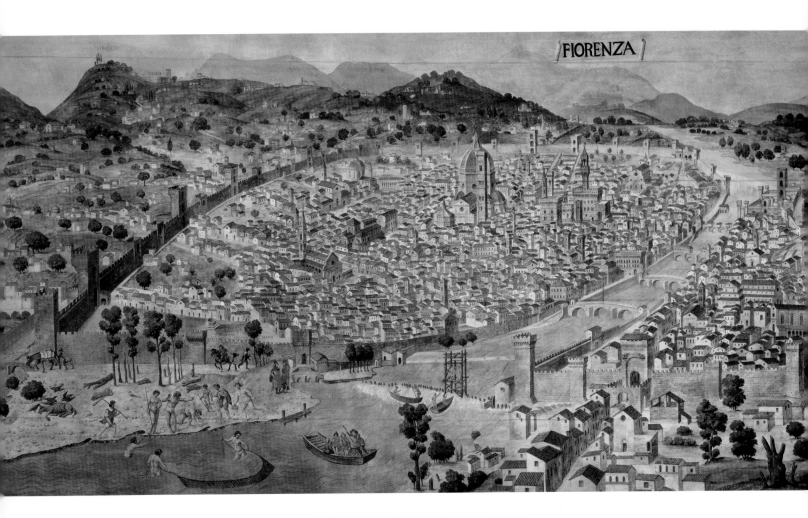

CARTA DELLA CATENA: FLORENCE, C. 1470. MUSEO DI FIRENZE COM'ERA, FLORENCE

cathedral and the Piazza della Signoria. The building is a primer in Florentine piety, public works, society, and the development of Renaissance art. In speaking of Florentine arts, let us not forget one at which the Florentines excelled and without which no other kinds would flourish: the art of making and managing money, an enduring Tuscan talent. Florence was built on the foundations of banking (the "florin" was a European monetary standard), the cloth industry, and international trade. Those who engaged in professional activities organized themselves into guilds. Unlike modern trade unions, Florentine guilds served to safeguard mercantile interests against interference by the aristocracy, and guild membership included both employers and employees.

Most important for us, guild membership conferred the right to participate in Florentine politics, and in the process to dictate the course of Florentine public arts. Seven major guilds—wool and silk merchants, cloth-finishers, furriers, spice dealers, bankers, and lawyers—occupied three-quarters of the seats on all government committees. Shopkeepers and artisans belonged to fourteen minor guilds. Part of the guilds' responsibilities entailed the management of public structures. The wool merchants oversaw all works at the cathedral. The cloth-finishers administered the baptistery. The silk merchants supervised the Ospedale degli Innocenti, the public orphanage of Florence, hiring Brunelleschi to design its new facade in classical style, and Luca della Robbia to

previous spread INTERIOR OF SAN LORENZO IN FLORENCE, DESIGNED BY FILIPPO BRUNELLESCHI FROM 1421–28, OTHERS AFTER 1442.

opposite THE ORSANMICHELE, FLORENCE, BUILT FROM 1337 TO 1380.

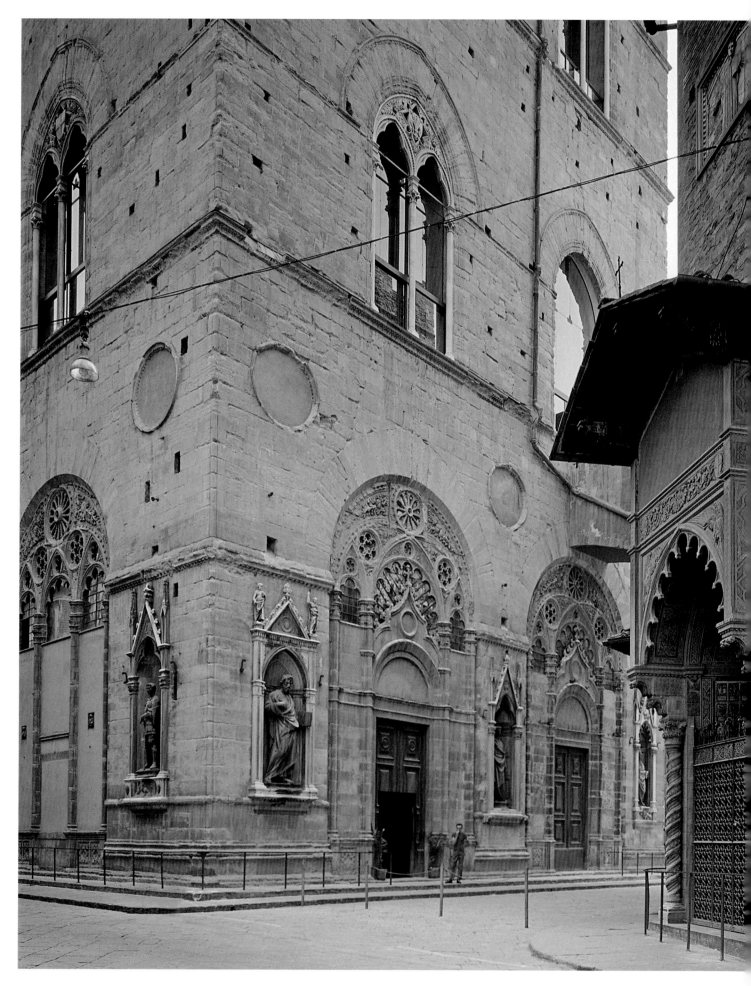

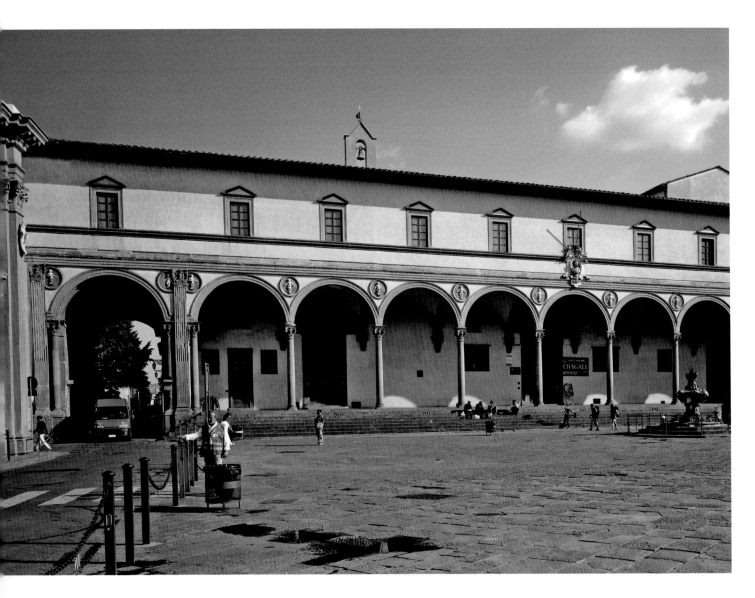

FILIPPO BRUNELLESCHI'S *OSPEDALE DEGLI INNOCENTI* IN FLORENCE, C. 1419–1440.

ornament it with terra-cotta medallions of swaddled babies (above). The same silk merchants also took care of Orsanmichele. In the 1330s they sponsored construction of a new building with grain storage on the upper story and the shrine of the Virgin on the ground floor. Ten other guilds were asked to embellish the exterior walls by putting up statues of their respective patron saints in ornamental niches.

In 1348 the Black Death arrived in Florence, killing half of the city's population and putting aside any thought of public works. After the plague came economic depression and political upheaval. Only in the opening years of the fifteenth century did Florence recover and turn to refurbishing the city with new zeal. The guilds sprang into action, hiring the best masters to fashion sculptures for the Orsanmichele to demonstrate their civic pride and piety, as well as their prestige.

The richest guilds ordered bronze statues. Need we be surprised that the bankers put up a dignified bronze St. Matthew, cast by Lorenzo Ghiberti, the leading sculptor of the day? They paid 945 florins for this image. A marble statue of the same size cost 100–150 florins. Bronze was a clear sign of status. The wool merchants, who had already ordered a marble statue, realized that they better replace it with a bronze so as not to lose face. A document recording their deliberations notes that the old statue was deemed inferior to the bronzes sponsored by the bankers and the cloth merchants. So Ghiberti was hired to make a new bronze statue of St. Stephen instead. Meanwhile, the cloth-finishers had funded a bronze St.

LORENZO GHIBERTI'S *SAINT JOHN THE BAPTIST*, C. 1412–16. ORSANMICHELE, FLORENCE

DONATELLO'S *SAINT GEORGE*, C. 1415–17. ORIGINAL IN THE MUSEO NAZIONALE DEL BARGELLO, FLORENCE

‹‹

John the Baptist, patron saint of Florence. At more than eight feet tall, it was the largest bronze statue made in Italy for centuries, and, astonishingly, it was cast in one piece. The guild was so skeptical about the feasibility of this project that its contract with Ghiberti absolved it of any obligation if he failed. But Ghiberti succeeded admirably (above, left). The stately figure of the saint, dressed in ample drapery that falls in soft, heavy waves, advertised both the wealth of the guild and the cloth that enabled it to finance such a majestic work.

In casting the Orsanmichele figures, Ghiberti set out to compete with the techniques of ancient metalworkers and to revive the dynamic poses of classical statues. At the same time Donatello, who carved the marble St. George for the armorers and sword makers (above, right), gave his figure a new psychological depth. For the benefit of his patrons, he carefully detailed the arms and armor of the warrior saint, including the now lost metal helmet, sword, and sheath. But he also captured the youth at a moment of suspended action and brewing emotion. St. George stands at rest, his legs wide apart, his arm posed on the shield. Yet his face is vigilant. He furrows his

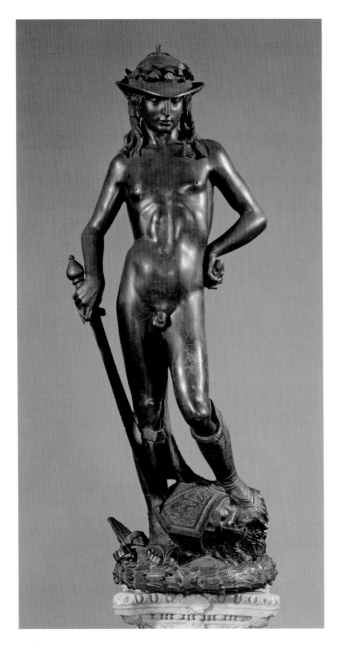

DONATELLO'S *DAVID*, FROM THE MEDICI PALACE COURTYARD, C. 1440. MUSEO NAZIONALE DEL BARGELLO, FLORENCE

DONATELLO'S *MARY MAGDALENE*, C. 1450. MUSEO DELL'OPERA DEL DUOMO. FLORENCE

brow and looks out of his niche into the distance, ready to take on any enemy that might come his, or Florence's, way. For its own protection, the figure of St. George has been moved to the Bargello Museum. In a room full of Renaissance masterpieces he still is a powerful presence, but bereft of his valiant role.

Donatello was a sculptor of extraordinary technical and emotional range. He could cast the sensual bronze nude David with a smooth, adolescent body and a large, modish hat, standing with one foot resting nonchalantly on the head of the defeated Goliath (above, left). He

could also carve a gruesome wooden Magdalene, gaunt and disfigured after thirty years of penitence in the desert (above, right). He pioneered shallow yet illusionistically deep relief in both marble and bronze. In his *Feast of Herod*, a panel on Siena's baptistery font, the space recedes far into Herod's palace (opposite). We see room after room layered into less than an inch of relief. In the foreground Salome performs her deadly dance, by which she obtains the head of St. John the Baptist. As the severed head is brought to the king on a platter, it sends a ripple of horror through the diners, and makes

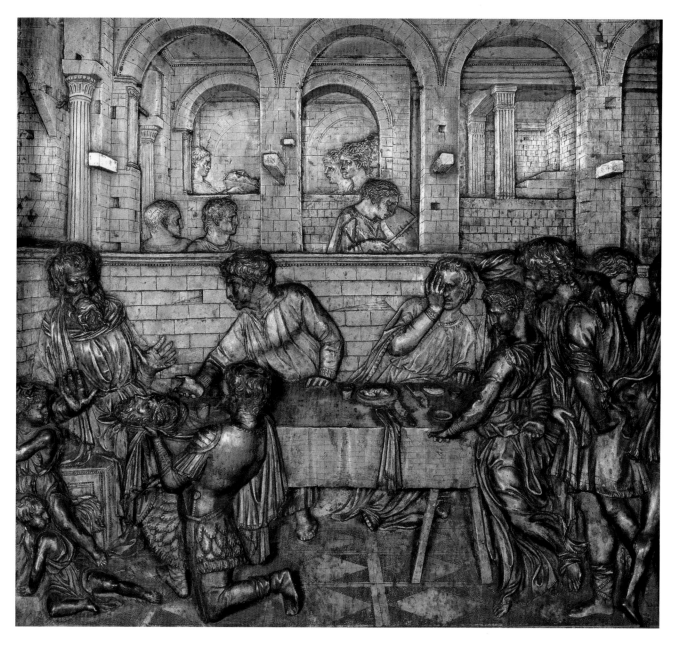

DONATELLO'S *FEAST OF HEROD*, A RELIEF ON THE BAPTISMAL FONT IN THE BAPTISTERY
OF SIENA, 1423–7.

servants stumble and run in fright. Later Donatello cast
a monumental bronze equestrian portrait of the *condottiere*
Erasmo da Narni, nicknamed Gattamelata, or "honeyed
cat," in Padua (p. 100). Inspired by the famous ancient
bronze statue of Marcus Aurelius in Rome, Donatello
presented Narni as a man of tremendous authority and
determination. His lips are pressed together, his jaw
tense, body erect. The massive horse underneath him is a
perfect match for its rider.

The sculptural program of Orsanmichele was typical
of Renaissance Florence. Similar statues of saints stand

in niches on the nearby cathedral and its campanile. The
campanile (p. 101), in fact, was designed and partially
built by Giotto at the same time that Orsanmichele was
being constructed, and over several decades some of
the same artists contributed sculptures to both. Work
on these and other public projects reached a high point
in the opening years of the fifteenth century. In 1402
Florence barely escaped being defeated by Milan, saved
only because the duke of Milan suddenly dropped dead.
In 1406 Florence vanquished Pisa and seized its long-
coveted port. The fight for her own independence did not

DONATELLO'S *GATTAMELATA* IN THE PIAZZA DEL SANTO, PADUA, C. 1445–53.

preclude Florence from subjugating rivals and expanding into their territories. Both written eulogies and major public works were employed to celebrate such victories.

Even within Florence liberty and republicanism had a less than rosy underside. The city's politics were dominated by strife among powerful clans and political parties. Those who lost fled into exile. As they waited out the moment of danger in some town friendly to their faction, they fermented rebellion long-distance and plotted revenge. In 1434 Cosimo de' Medici returned from his exile and promptly took control of Florence. A savvy politician, he put on a show of republicanism, but effectively ruled the city from behind the scenes. By and large, he, his son Piero the Gouty, and his grandson, Lorenzo the Magnificent, exercised authority by

manipulating electoral commissions and stacking political offices with their supporters.

When Lorenzo inherited power in 1469 at age twenty, he made little pretense of being first among equals. He got his epithet by acting like a prince. As he wrote in his *Ricordi*, he accepted the position of leadership "for the conservation of our friends and wealth, since in Florence you live badly if you are rich but do not control the state."

Lorenzo was a man of many gifts and contradictions. A statesman and a poet, he loved classical literature as well as bawdy songs. He was pious yet skeptical, mixed easily with simple folk, yet behaved like a prince, even though he came from merchant stock. As a boy he received a superb education, an early training in

opposite GIOTTO'S CAMPANILE IN FLORENCE, C. 1330, MODIFIED BY HIS SUCCESSORS ANDREA PISANO AND FRANCESCO TALENTI BETWEEN 1349 AND 1360.

diplomacy, and introduction at foreign courts. As a young man he was riotous and chased women. As he was being groomed for political leadership, he was taken in hand by the elders of the Medici party and admonished to follow in the wise and measured footsteps of his grandfather Cosimo. He was sent to study moral philosophy with the celebrated humanist Marsilio Ficino, and under his tutelage wrote a complex philosophical poem on the Supreme Good. But he also loved to compose rude carnival songs and to stage opulent chivalric tournaments, in which, naturally, he was the star.

As a ruler, Lorenzo masterfully resolved complex and dangerous political situations. The perception that the Medici acted like lords rather than citizens of a republic irked many Florentines, and boiled over into a conspiracy headed by the rival Pazzi clan. On April 26, 1478, while Lorenzo and his brother Giuliano were attending Mass in the cathedral, they were attacked and stabbed. Giuliano died; Lorenzo was wounded, but survived by escaping into the sacristy. The conspirators were swiftly caught, and Botticelli was ordered to paint gruesome scenes of their deaths for public admonition. (Many artists painted executed criminals on the walls of public buildings, but they were temporary murals, and do not survive.)

A man of exquisite taste, Lorenzo wanted to make Florence into a new Athens. He also wanted to raise his and his family's status on the international arena, to put behind his bourgeois origins and to be viewed as a true prince. He avidly collected books, ancient coins, gems, and cameos, which Florentine artists exploited as models of Roman compositions and figure types. His prized possession was an ancient sardonyx bowl

probably carved in Alexandria, which was valued at 10,000 florins (opposite, left). Lorenzo also passionately amassed vessels carved from rock crystal, jasper, amethyst, sardonyx, chalcedony, and agate, which he knew the ancient Romans greatly prized (opposite, right). Such pieces were so precious that they were carefully preserved over the centuries, passed from ruler to ruler, from antiquity to the Renaissance. Many of Lorenzo's vases were ancient, although he encouraged contemporary stone workers to revive the art of hard-stone carving. To make sure that his treasures would never go astray, he had them engraved with his initials: LAV. R. MED, with R standing for "Rex paterque," Horace's title for the great Roman art patron Maecenas. In addition, Lorenzo erected public and private buildings, and sponsored humanists and musicians. Altogether, he immeasurably enriched Florentine cultural life. Unfortunately, he lacked the business acumen of his ancestors and managed to run the once mighty Medici bank into the ground through a series of risky loans and poor oversight. He died young, at age forty-two, of the hereditary Medici curse of gout. His death mask is now in the Palazzo Pitti (right), alongside the remains of his collection of precious artifacts. It is a strange experience to contemplate it. Here the once powerful man is but a plaster shadow. His face is broad, with high cheek bones, his nose broken and askew, his jaw protruding slightly forward; he looks like a thug. Standing before him, one struggles to discern what in his features speaks of his refinement and humor, subtle intelligence and great sensitivity to art.

But let us return to the pre-Laurentian monuments of Florence. The most revered building in the city was the baptistery (p. 105). It had been constructed between the eleventh and the thirteenth centuries over a fifth-century structure that the Florentines believed had been a Roman temple of Mars. Thus, they saw it as a testimony to their Roman heritage. Every child born in the city was baptized here, to become a Christian and a Florentine. The opulent adornments of the baptistery emphasized its importance. The building is dressed in white and green marble from Prato assembled into rich patterns. While in Pisa and Lucca colored marbles serve to create an effect of opulence superimposed on the structure, in an Oriental style—owing to the Eastern contacts of those two states—in Florence the decoration functions

LORENZO DE' MEDICI'S DEATH MASK. MUSEO DEGLI ARGENTI, FLORENCE

in harmony with the building. Dark stone highlights its architectural elements—windows, doors, stories, and bays—a treatment that gives the building a geometric look, inspired by ancient Roman remains.

Inside the baptistery colored stones cover the floor and the walls, while the high domed ceiling is radiant with mosaics (p. 106, top). They were created by specially imported Venetian masters who excelled at this technique, having learned it from the Byzantines. The Old and the New Testament mosaic scenes are so detailed and vivid that you could spend hours "reading" them and getting fully absorbed in their world. Unfortunately, to do that you really need to line the baptistery with couches. Otherwise, the pain in your sharply bent neck cuts this pleasure short.

Today the baptistery is rather denuded of its fittings, although it hardly seems barren. Most of its furnishings have been removed to the Cathedral Museum nearby. The

silver altar dossal, a kind of apron for the baptistery's high altar, was created by the Florentine goldsmiths Betto di Geri and Leonardo di Ser Giovanni in 1367 (p. 107, left). Twice a year, on the feast of the Baptism of Christ and the Birthday of St. John the Baptist, the dossal was mounted on a mobile altar set in the middle of the building, and piled high with the church's treasure to awe the Florentines and foreign visitors. As always, ambition spurred expansion. In 1441 Ghiberti's workshop was asked to make a central aedicule for the dossal, and a few years later Micchelozzo di Bartolomeo supplied for it the statue of St. John. In 1477 the cloth-finishers, who oversaw the baptistery, decided to transform the dossal into a free-standing altar, and engaged several major artists to fashion narrative reliefs for the two flanks. Altogether some 400 kilograms (approximately 880 pounds) of silver went into the altar, along with enamels and gold.

Another magnificent offering to the baptistery was a set of liturgical vestments embroidered with scenes from the life of St. John the Baptist (p. 107, right). When officiating priests said Masses on major holidays, they had to be dressed with suitable pomp, so the cloth-finishers commissioned Antonio del Pollaiuolo to design appropriately opulent vestments. A team of Florentine, Flemish, and French masters translated his patterns into fabric, laying down rows of fine gold threads and stitching the designs over them in colored silks. The enormously labor-intensive project stretched over twenty-two years (1466–1488). When the vestments became too fragile to wear, they were simply displayed on the silver altar. In the eighteenth century the frayed garments were taken apart and the embroideries mounted onto wooden panels, to be preserved as individual pictures. And so they appear in the Cathedral Museum today. In these remarkable works, the scenes are set in spacious and coherent interiors and outdoor settings, and the figures convey volume, movement, and emotions. All this is achieved with needles and thread.

The most famous decorations of the baptistery are its bronze doors. The first pair was completed by Andrea Pisano in 1336. It shows key moments in the life of St. John in a series of quatrefoils that give the scenes elegant frames and a certain rhythm. In 1401, to boost Florentine morale at a moment of Milanese threat, the cloth-finishers commissioned a second set of doors. It was customary then, as now, to select an artist for a big public project through an open competition. Seven masters submitted designs.

Lorenzo Ghiberti and Filippo Brunelleschi emerged as the two leading contenders, but the story of how and why Ghiberti won depends on who tells it. Half a century later he claimed in his *Commentaries* that he won the contest with universal support. But Brunelleschi's biographer, Antonio Manetti, differed. He described how Ghiberti, as he was preparing his model, went around Florence consulting all the important members of the voting committee and building up their good will. Whenever an influential person offered suggestions, Ghiberti changed his model to follow them. In the meantime, Brunelleschi worked quietly and competently without any lobbying, and finished much before the deadline. When the judges assembled to vote, they were prepared to favor Ghiberti. But as Brunelleschi presented his model, they saw that it was very different, but equally good. So the judges recommended that both artists be hired to complete the doors together. Hearing their verdict, Ghiberti kept quiet; but Brunelleschi flatly refused to share the project. If he could not be the sole author, he wanted nothing to do with it at all. Whatever the truth of the story, the committee of thirty-four judges faced a difficult choice. Brunelleschi's composition was more innovative, dynamic, and realistic (p. 109, right), Ghiberti's more elegant and courtly, and more economical to produce (p. 109, left). Brunelleschi's panels would be cast in more pieces, Ghiberti's in fewer, thus using less time and one-quarter less bronze. (If you wish to cast your own vote, you can compare the two panels now displayed in the Cathedral Museum.) In the end, Ghiberti was entrusted with the whole commission: a set of New Testament scenes, set into quatrofoils, to match Pisano's doors (p. 108).

This story is the clearest example of a competition between Florentine artists. But in fact, masters often

opposite THE BAPTISTERY OF FLORENCE, BUILT IN THE LATE ELEVENTH TO EARLY TWELFTH CENTURIES.

104 THE ARTS *of* TUSCANY

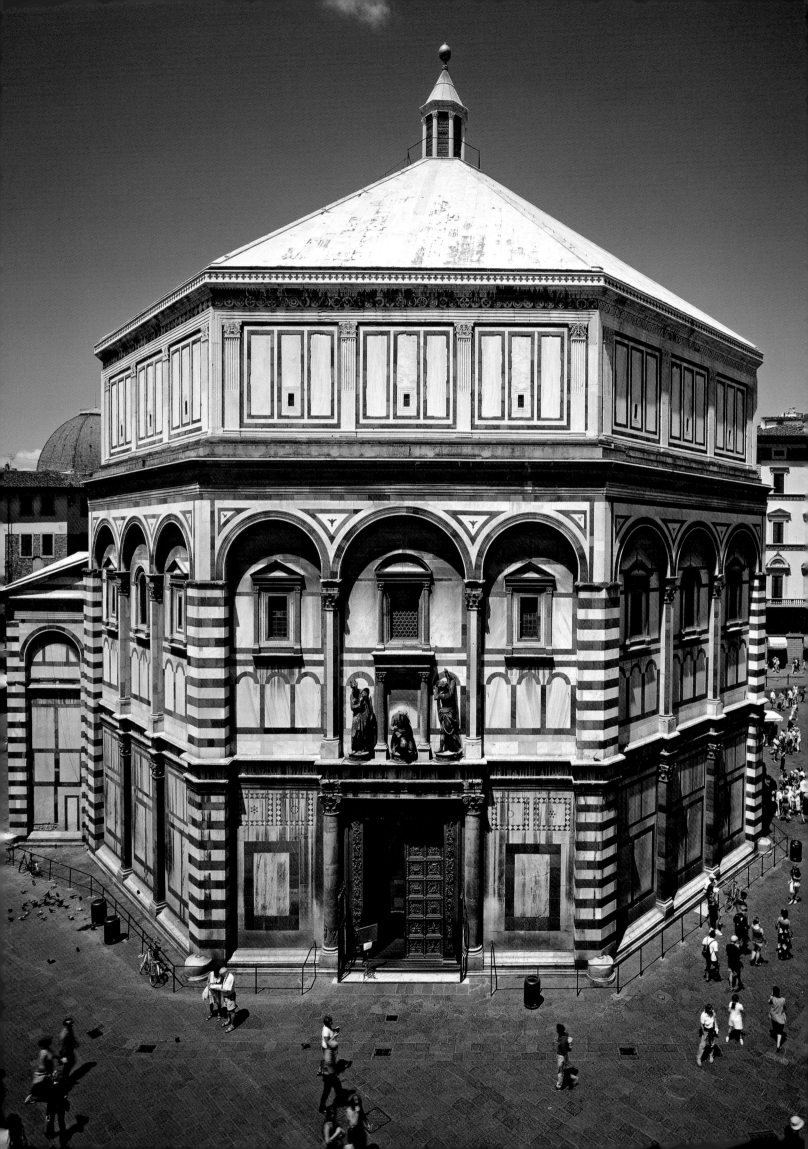

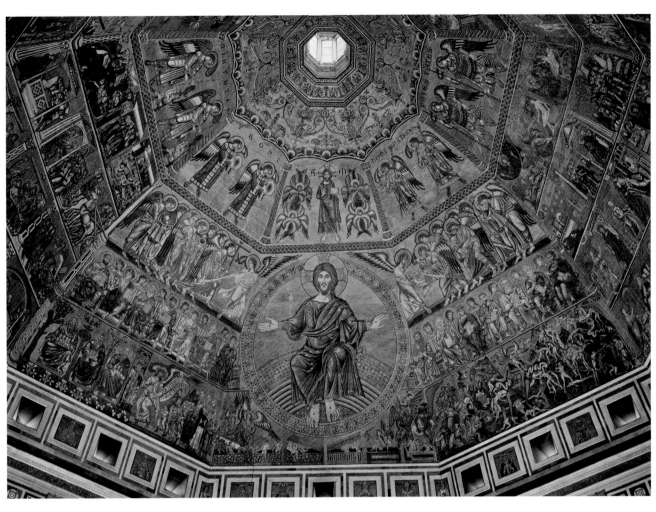

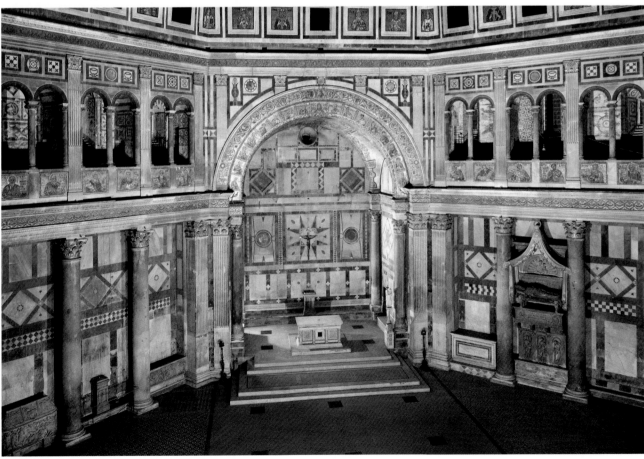

cooperated, especially on large projects. When he came to manufacture the doors, Ghiberti was assisted by Masolino, Donatello, Michelozzo, and Paolo Uccello, among others. The doors were simply too large and technically demanding for one man to make. Each panel had to be designed, modeled in wax, cast in bronze, chased, gilded, and burnished to a smooth and radiant finish. The team worked for two decades. At the same time Ghiberti had other projects going, including the statues for Orsanmichele.

The completed doors were such a success that the cloth merchants asked Ghiberti immediately for another set—with Old Testament scenes—for the baptistery's third entrance. This time there was no competition. As Ghiberti later wrote, he was encouraged to proceed in a way that would make it "most perfect and most splendid and most rich." Again, the result was magnificent (p. 110). The doors came to be called the *Gates of Paradise*—partly because they faced the area between the baptistery and the cathedral called Paradisium, and partly because Michelangelo was said to have pronounced that they were worthy to be the Gates of Heaven itself.

As he pondered his new commission, Ghiberti decided to depart from the format of the previous doors. Instead of twenty-eight small scenes, he created extensive worlds in ten large panels. Within each he set apart distinct episodes by differences in the depth of relief (p. 111, left). The stories unfold in complex architectural

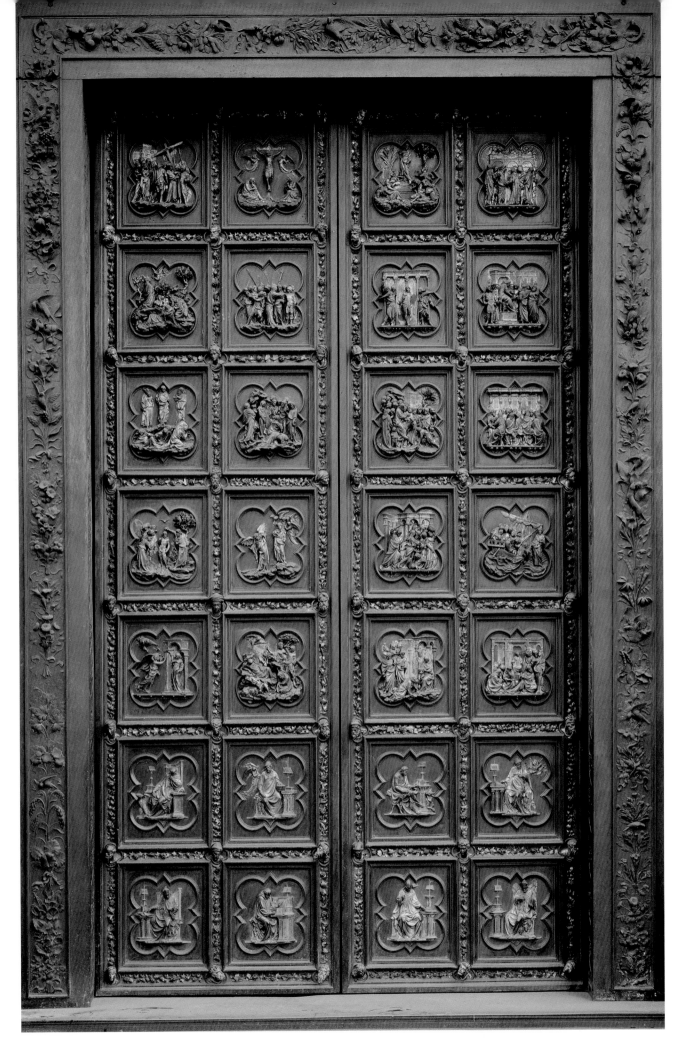

LORENZO GHIBERTI'S COMPETITION PANEL WITH *SACRIFICE OF ISAAC*, 1401. MUSEO NAZIONALE DEL BARGELLO, FLORENCE

FILIPPO BRUNELLESCHI'S COMPETITION PANEL WITH *SACRIFICE OF ISAAC*, 1401, MUSEO NAZIONALE DI BARGELLO, FLORENCE

and landscape spaces. As the action recedes into distance, it pulls the viewer into its own universe. Ghiberti was immensely, and justifiably, proud of his achievement. He added his portrait head to the frame (p. 111, right), and eventually wrote that there were few things in the city worthy of note that he had not either made or inspired. And indeed, it is true that the next generation of leading Florentine artists was trained in his workshop.

The Gates of Paradise were removed during World War II, but re-hung in 1948. They remained in place until the catastrophic flood of 1966. As the waters of the Arno swept through the city, they ripped six out of the ten panels out of their frame. Today gilded bronze replicas decorate the baptistery, while the original panels are housed across the street in the Cathedral Museum.

It is a blessing that Brunelleschi was not assigned the commission for the baptistery doors, for the dome he raised over Florence's cathedral proved vastly more important. As Leon Battista Alberti described it, the

"structure was so enormous, as high as the heavens, big enough to cover all the people of Tuscany with its shadow." It became the symbol of Florence, proclaiming her power and glory far beyond her walls.

Even before the dome began to take shape, the Cathedral of Santa Maria del Fiore was the city's most imposing landmark (p. 112–113). Intended to hold the entire Florentine population, it is the fourth largest church in the world—after St. Peter's in Rome, St. Paul's in London, and the Cathedral of Milan. The building was begun in 1296, in competition with Pisa and Siena, and envisioned as "the most beautiful and honorable church in Tuscany." Its exterior is dressed in white marble from Carrara, green from Prato, and pink from the Maremma, in southern Tuscany. As on the baptistery, colored stones form geometric patterns that work in concert with the underlying structure (the facade went up only in the late nineteenth century). By the 1360s a vast octagonal opening was built over the crossing, but how

opposite LORENZO GHIBERTI'S NEW TESTAMENT BRONZE DOORS TO THE BAPTISTERY, 1403–24.

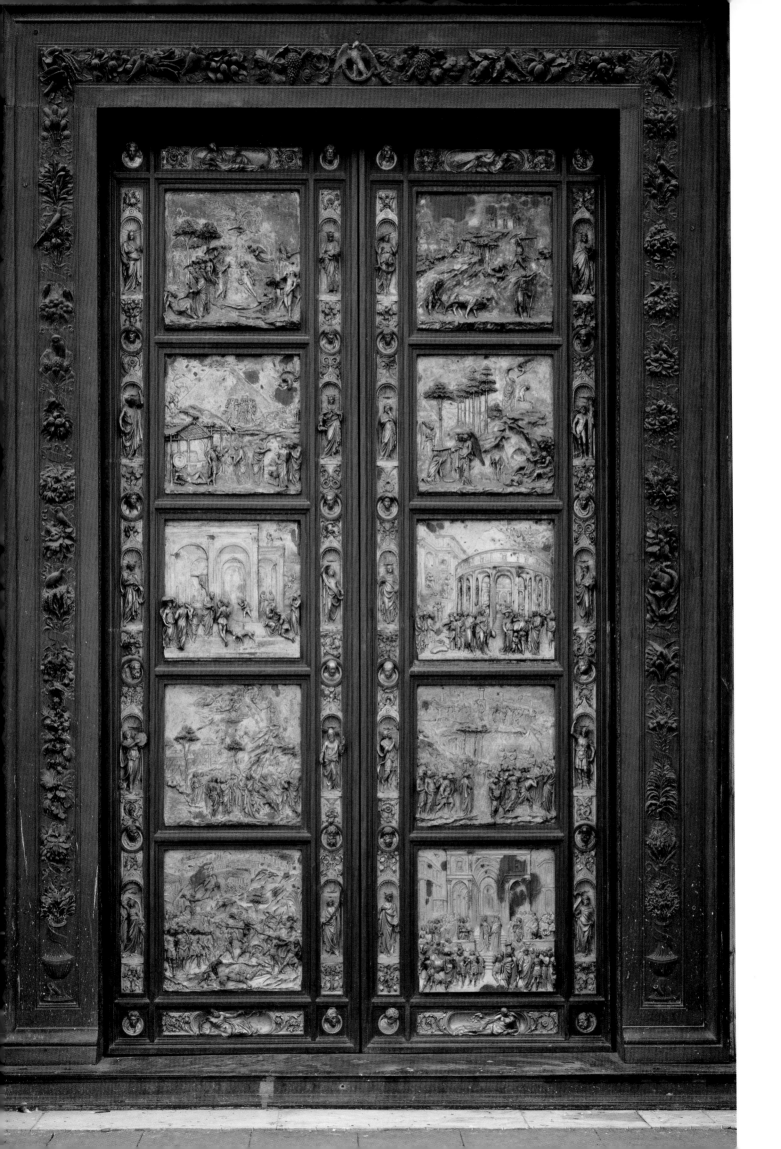

STORY OF ESAU AND JACOB, A PANEL FROM LORENZO GHIBERTI'S *GATES OF PARADISE*, 1425–52.

SELF-PORTRAIT OF LORENZO GHIBERTI FROM THE *GATES OF PARADISE*.

to crown the 140-foot-wide space, nobody knew. It was Brunelleschi who, several decades later, finally proposed a feasible plan.

Brunelleschi was a highly versatile and talented artist. He had trained as a goldsmith and practiced as a sculptor, engineer, and architect. After he failed to win the commission for the baptistery doors, he went to Rome and immersed himself in the study of ancient Roman architecture. When he came to ponder how to build the cathedral's dome, he would have loved to replicate the hemisphere of the Roman Pantheon. But he was restricted by the existing octagonal opening. The only solution was a ribbed Gothic-style vault. Gothic vaults typically relied on external buttresses to counter their outward thrust, but Brunelleschi did not want ungainly buttresses to mar the contours of his dome. To distribute the tension and weight of the structure he devised instead

inner and outer shells with a hollow space between them. He anchored the shells to the eight vertical ribs visible on the surface of the dome. Between the two shells he placed sixteen smaller ribs linked to one another and to the larger ones by horizontal arched bands of stone. He reinforced this interlocking system further at the spring of the dome with an encircling chain of huge oak beams held fast by iron links. Four semicircular exedras on the outside, at the rise of the dome, buttressed it at the base, while the tall lantern crowning the structure bound together the eight outer ribs.

Since all work would proceed high off the ground, Brunelleschi had to devise special scaffolding suspended from the completed portions of the dome. He also invented hoisting apparatuses for lifting materials to the work site. Secretive about his ideas and methods, he left very little by way of plans or explanations of his designs.

opposite LORENZO GHIBERTI'S *GATES OF PARADISE* FOR THE BAPTISTERY, 1425–52. ORIGINAL PANELS IN THE MUSEO DELL'OPERA DEL DUOMO, FLORENCE

But what really matters is the awe-inspiring result. When Brunelleschi died in May 1466, he was entombed in the cathedral, a rare honor for a craftsman. Andrea di Lazzaro Cavalcanti carved his monument (p. 114), and the chancellor of the Republic, Carlo Marsupini, composed a commemorative inscription in which he called Brunelleschi "a divine genius."

Brunelleschi was not the only hero of the city memorialized in the cathedral. In the left aisle, closer to the high altar, a fresco honors Dante and his *Divine Comedy* (p. 115). It was painted to celebrate the poet's two hundredth birthday, when the city tried to make up for the insult of having exiled him. Dante was driven from Florence in 1302, in one of the city's typical political purges, and never returned to his native town. In the fresco he is shown standing outside the city, although rays of light emanating from his book flow toward it. To his left is the cathedral, already domed, but not yet covered with marble revetments. To his right opens the gate of the Inferno, where devils herd wailing humans into its fiery bowls. Behind him rises the stepped mountain that represents Purgatory. The Earthly Paradise, with Adam and Eve, sits at its top.

Another cathedral fresco honors a respected civic leader, Sir John Hawkwood (p. 116). This English commander moved to Italy with his mercenary troops and served the Florentine Signoria from 1377 until his death in 1394. Originally the Florentines intended to celebrate him with a real bronze statue, but funds, as usual, ran out. They cleverly found a solution: a painting of a monumental metal likeness, for a fraction of the cost. Paolo Uccello, who had assisted Ghiberti on the first set of baptistery doors, was hired to produce the fresco, and it is an odd vision: the horse and rider appear in straight profile, while the pedestal is shown in perspective, as if receding from view. Uccello was obsessed with perspective. He was said to murmur its sweet name late into the night instead of going to bed with his wife. Ironically, the painting celebrates the loyalty of a mercenary.

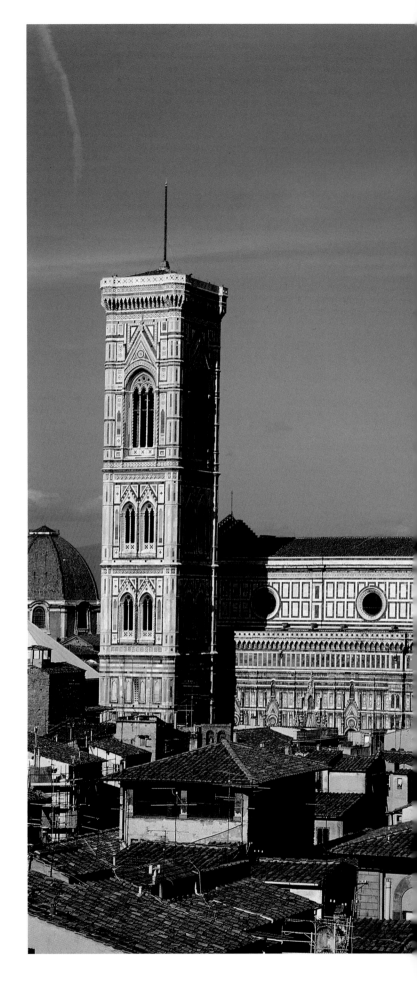

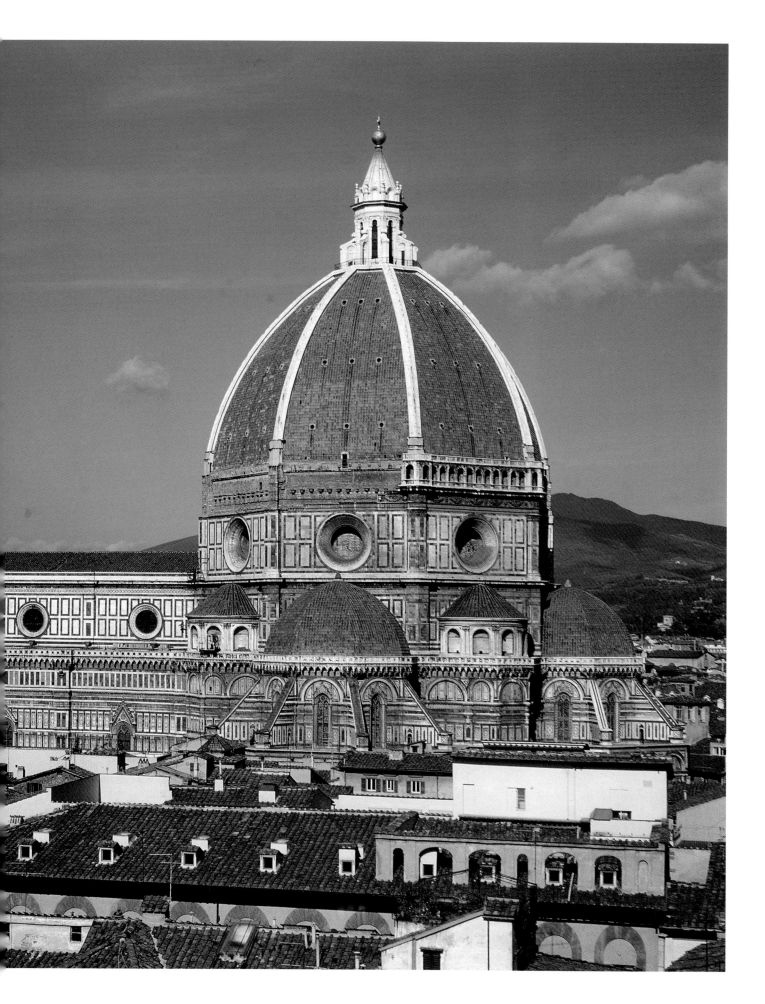

DETAIL OF ANDREA DI LAZARO CAVALCANTI'S TOMB OF BRUNELLESCHI IN THE
CATHEDRAL OF FLORENCE, 1446.

While many Florentine public buildings and
their decorations came into being owing to pride and
competition among guilds, patricians, eager to outdo
each other, also embellished the city to no small extent.
The Medici rebuilt the Dominican monastery of San
Marco as well as the church of San Lorenzo. According
to Vispasiano de' Bisticci, a biographer of great fifteenth-
century men, Cosimo patronized San Marco (p. 117) to
atone for his dubious financial dealings. Given that the
Medici were bankers and merchants, that might well have
been the case.

Cosimo hired Michelozzo di Bartolommeo, another
former Ghiberti assistant, to design the building. Fra
Angelico, a Dominican monk and a highly esteemed
painter, was engaged to fresco the chapter house,
corridors, and monks' cells. The architecture and
paintings match to perfection, producing a harmonious
environment for peace and contemplation. At the top
of the stairs that lead to the private realm of the monks
is Fra Angelico's *Annunciation* (p. 118), its action set in a
loggia that echoes the newly rebuilt cloister. Each monk's
cell has a fresco of its own: a Nativity, a Crucifixion,

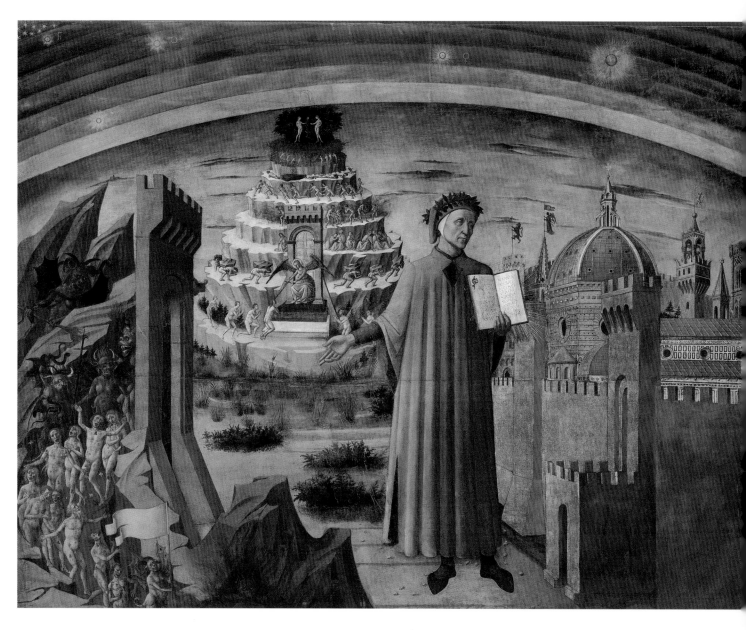

DOMENICO DI MICHELINE'S *DANTE AND THE DIVINE COMEDY*, A FRESCO IN THE CATHEDRAL
OF FLORENCE, 1465.

<+<+<+<+<+<+<+<+<+<+<+<+<+<+<+<+<+<+<+<+<+<+<+<+<+<+<+<+<+<+

a Resurrection, or a Coronation of the Virgin. One
of the most poetic is his *Noli Me Tangere* (p. 119). In a
lush garden Christ appears to the Magdalene after his
resurrection; she stretches her arms toward him, but he
bids her not to touch him, as he is passing from this
world. The paintings gave each room and each monk a
focus for prayer. Since Cosimo paid for all this work, he
reserved for his private use a double cell in the part of
the monastery set aside for lay brothers, and chose an
Adoration of the Magi for his wall. The Medici belonged
to the religious confraternity called the Company of the
Magi, and they used this biblical episode as something

of a personal imagery. It certainly flattered them to be
associated with rich and wise kings.

Like the Sienese, the Florentines identified strongly
with their neighborhoods and parish churches. The
Medici made their devotion to the church of San
Lorenzo, kitty-cornered from their palazzo, into another
opportunity for one-upmanship. They asked Brunelleschi
to renovate and extend the earlier building in the newly
fashionable style inspired by ancient Roman architecture.
The interior of the church imitates Roman and early
Christian basilicas with three wide aisles and a flat roof
(p. 92). All its components follow a system of modules

MICHELOZZO DI BARTOLOMMEO'S CLOISTER OF SAINT ANTONIUS IN THE CHURCH AND CONVENT OF SAN MARCO, FLORENCE, 1437–40.

and are highlighted with a local gray stone, *pietra serena*. As we have seen in the baptistery and the cathedral, the Florentines liked to use colored stones to emphasize structural elements. But the interior of San Lorenzo is more crisp and elegant than earlier buildings. It has few frills to distract the eye from the simplicity and harmony of the space.

Off the left transept Brunelleschi rebuilt the Old Sacristy as a burial chapel for the Medici (p. 120). A classic example of the architect's rational design, the cubical room is crowned by a semicircular, webbed dome;

pietra serena articulates the architectural details. Only Donatello's stucco reliefs in the lunettes and pendentives, and his bronze doors with animated figures of saints and apostles, enliven this otherwise somber place.

Seeing how Cosimo had augmented his prestige by rebuilding San Lorenzo and San Marco, Giovanni Ruccellai resolved to do the same for himself through similar work in his quarter of the city. He was the third richest man in Florence, and, like Cosimo, a landowner, textile merchant, and banker of international standing. With Cosimo's new buildings arousing admiration,

opposite PAOLO UCCELLO'S *PAINTING OF THE EQUESTRIAN STATUE OF SIR JOHN HAWKWOOD*, A FRESCO IN THE CATHEDRAL OF FLORENCE, 1436.

FRA ANGELICO'S *ANNUNCIATION*, C. 1450, IN SAN MARCO, FLORENCE.

Giovanni's reputation was at stake. He decided to sponsor the long-overdue facade on the church of Santa Maria Novella (p. 121), the most important Dominican house in Italy, which had hosted popes when they visited Florence.

Today the church stands near Florence's main train and bus stations. The piazza before it teems with a transient crowd of travelers, tourists, and the shady characters one sees near central stations everywhere in the world. The church facade is dirty from dust and pollution, and no longer at its best. Yet, if you sit on a bench in the park before it, block out the commotion of people, scooters, and cars, and immerse yourself in its contemplation, you will discover that Santa Maria Novella's facade is the most beautiful in the city. If one could only enjoy it in peace!

Facades of Renaissance churches were often left

unfinished. Intentions were good, but since patrons, whether corporate or private, were eager to furnish the most imposing frontage, they often fell short of funds. Despite repeated Medici efforts, the facade of San Lorenzo never materialized, and to this day the church's front remains a bare, brick wall. The facade of Santa Maria Novella was begun in the late thirteenth century, but only the level of the arched niches was finished before all work ceased. Spurred by rivalry with Cosimo, Giovanni Ruccellai decided finally to give the church a proper face. He hired for this task Leon Battista Alberti, the leading theoretician of several of the arts.

Leon Battista was the illegitimate son of Lorenzo Alberti, a Florentine banker whose family had been exiled as a result of the Ciompi Revolt in 1378. The boy was born in Genoa and named Battista after Florence's

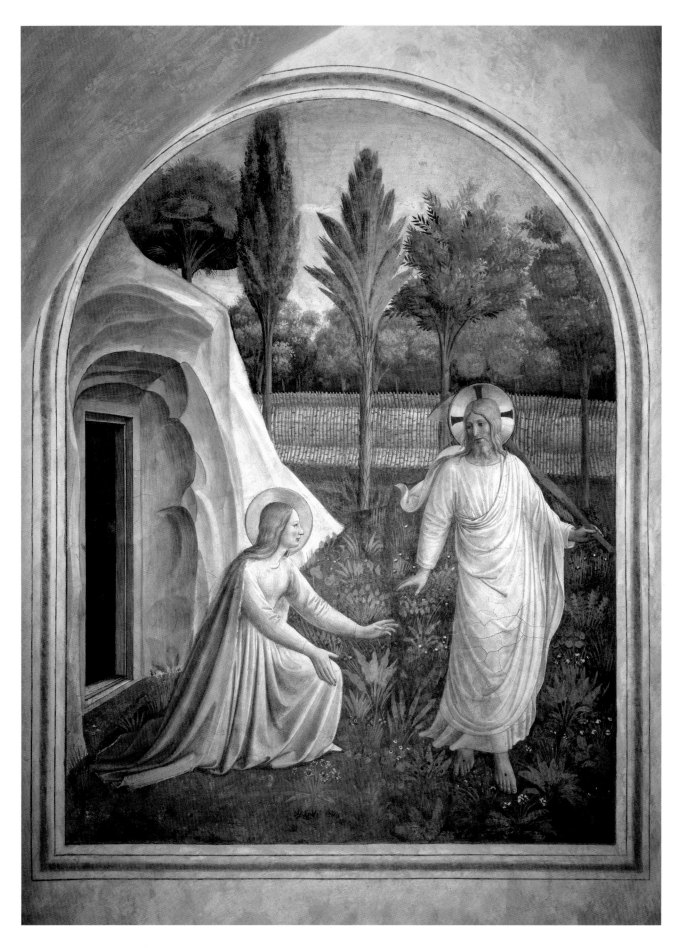

FRA ANGELICO'S *NOLI ME TANGERE*, 1438–45, IN SAN MARCO, FLORENCE.

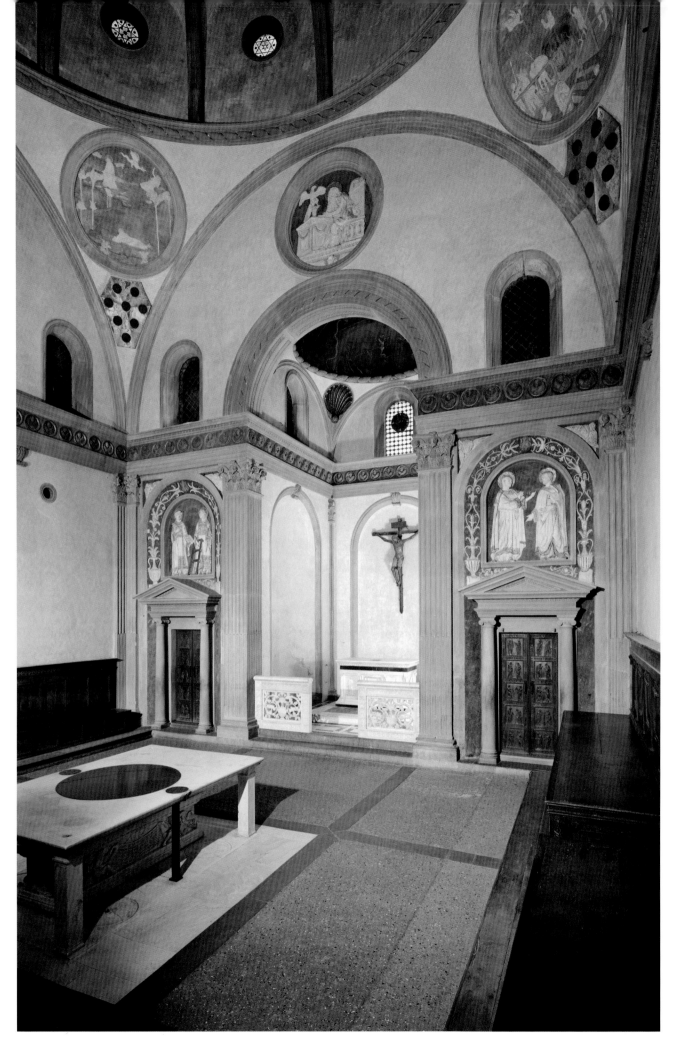

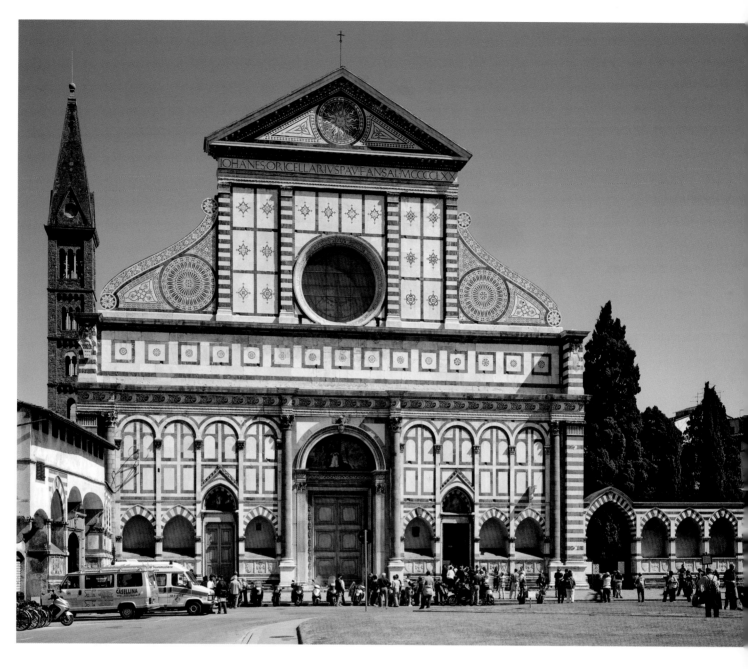

LEON BATTISTA ALBERTI'S FAÇADE OF SANTA MARIA NOVELLA, FLORENCE, 1456–78.

patron saint. He studied in Padua, then attended the venerable University of Bologna, and there received his doctorate in law at twenty-four. When his father died in 1421, Battista was cheated out of his inheritance by his cousins and left to earn his living by his wits. Of those he was never short. While still a twenty-year-old university student, he composed a Latin comedy called *The Lover of Glory*, which he passed around as an authentic ancient

play. Upon completing his law degree Alberti took holy orders, intending to make a career in the papal Curia—a solid living for a man of learning without independent means.

Alberti's interests ranged far beyond law and ancient literature. He wrote the treatises *On Painting* (1435), which he dedicated to Brunelleschi, *On Sculpture* (ca. 1433), *On Architecture* (ca. 1450), and *On the Family* (by

opposite FILIPPO BRUNELLESCHI'S OLD SACRISTY IN SAN LORENZO, 1421–25.

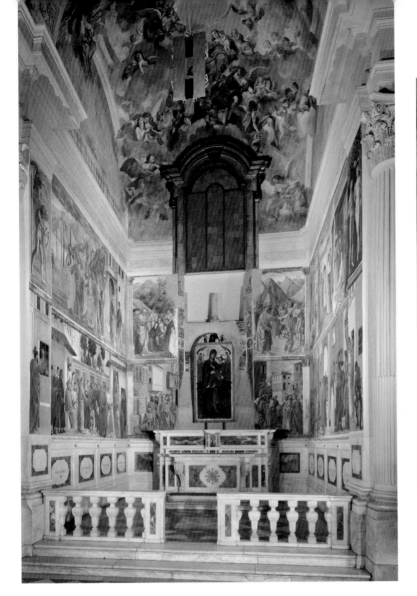

BRANCACCI CHAPEL WITH FRESCOES BY MASACCIO, MASOLINO, AND FILIPPINO LIPPI IN
SANTA MARIA DEL CARMINE, FLORENCE, MID-1420S TO 1480S.

≺+

1434), as well as others on law, on cryptology, on the
horse, and on love. During the pre-Christmas week of
December 1437 he composed a hundred Aesopic fables.
On another occasion he wrote *Mathematical Recreations*,
twenty exercises in surveying and applied geometry. At a
time when all serious writing was accomplished in Latin,
in which Alberti was fluent, he also championed the
vernacular, compiling the first grammar of the Italian
language. After 1450 he increasingly devoted himself to
architectural projects. So Giovanni Ruccellai asked him
to work on the facade of Santa Maria Novella. Unlike
Brunelleschi or Michelozzo, Alberti did not participate
in the construction proper, but instead supplied ideas for
others to execute.

Alberti's design combined ancient architectural
vocabulary and Florence's native tradition. Echoing the

beloved baptistery, he used white, green, and red stone
to create ordered patterns that both organize and enliven
the facade. In his treatise *On Architecture*, he called the
baptistery and other similar Florentine buildings "a
concert of all their parts, arranged with moderation,
thought and discourse." The upper story of Santa Maria
Novella's facade, meanwhile, emulates the appearance
of a Roman temple. An elegant mezzanine separates the
two levels, and ornamental volutes mask the transition
between the high nave and the much lower side aisles.
This element, invented by Alberti, would become a
prominent feature of Italian churches for the next two
centuries. Alberti also incorporated the pre-existing
circular window into his design. He mirrored it in the
curve of the entrance arch, in the sun medallion in the
pediment, and in the rosettes in the volutes. It is a delight

MASACCIO'S *TRIBUTE MONEY* AND *EXPULSION OF ADAM AND EVE* FRESCOES IN THE
BRANCACCI CHAPEL.

━◄━◄┥━

to hunt for such plays of shapes throughout the facade.

Giovanni Ruccellai was exceedingly pleased with what
he accomplished, and took full credit for it. This was
a common practice in Renaissance Italy. After all, the
patron thought up the project and paid a great deal for
it. Giovanni's personal device, a billowing sail, runs the
length of the frieze just over the doorways. Under the
pediment, above Alberti's graceful composition in marble
geometry, large capital letters loudly proclaim: "Giovanni
Ruccellai, son of Paolo, 1470."

Only a few outstandingly rich and ambitious
Florentines could immortalize themselves through such
major creations. Many more honored God, showed off
status, and competed with each other by building chapels
inside Florentine churches where Masses would be said
perpetually for their souls. Every Florentine church

is lined with these private memorials. A Who's Who
itinerary can profitably occupy and enlighten a visitor
to the city for weeks. Today we know these chapels best
for their fresco cycles. The most famous is the Brancacci
Chapel in Santa Maria del Carmine (opposite). It
was decorated by Masaccio and Masolino in the mid-
1420s with scenes from the life of St. Peter. Masaccio's
muscular and volumetric figures were utterly new in
Florentine art of his day. They seem to occupy real space,
and even to shape the space around them. Their emotions
are also uncommonly profound and intense. In the
Tribute Money a semicircle of toga-clad apostles surrounds
Christ by the shores of the Sea of Galilee (above). Christ
commands Peter to fetch the money out of a fish's mouth
and pay it to the Roman tax collector, who demands it as
a tribute for a local temple. The interlocking looks and

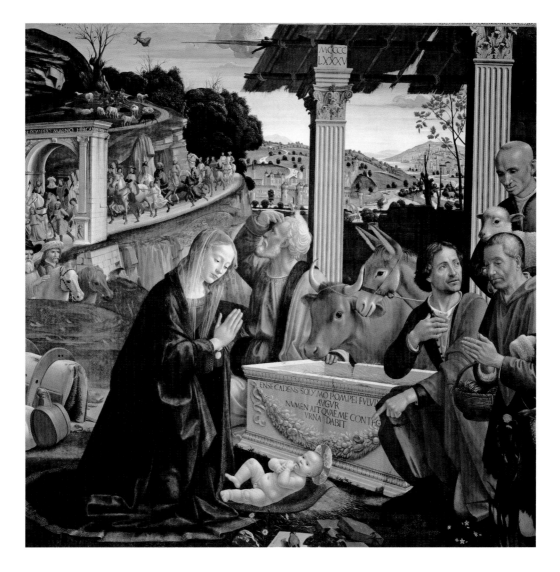

DOMENICO GHIRLANDO'S *ADORATION OF THE SHEPHERDS* ALTARPIECE IN THE SASSETTI CHAPEL IN SANTA TRINITÀ.

gestures produce a psychological drama that lingers in your memory long after you leave the church.

The subject of the *Tribute Money* was apparently a commentary on Florentine politics. At the very time the fresco was painted, city officials were hotly debating a tax increase to balance the municipal budget and finance costly military campaigns. The measure was introduced in 1427 and the burden fell in particular on the richest families, so the fresco likely evoked more than religious sentiments. Another unforgettable image in the chapel is the *Expulsion of Adam and Eve from Paradise* (p. 123). The remorse and anguish of the first parents is palpable

and deeply human, although Eve's pose derives from an ancient statue of *Venus Pudica* type.

For the Florentines, chapel frescoes were less about the accomplishments of painters than about the saints whose lives they narrated and the owners who dedicated these spaces. Francesco Sassetti, a manager of the Geneva branch of the Medici bank, commissioned Domenico Ghirlandaio to create one of the more personalized fresco cycles. No one in contemporary Florence could paint more accurate portraits than Ghirlandaio, or depict with such precision the daily world of Florentine elites.

Sassetti's chapel in the church of Santa Trinità

opposite SASSETTI CHAPEL IN SANTA TRINITÀ IN FLORENCE, FRESCOED BY DOMENICO GHIRLANDAIO IN 1482–1486.

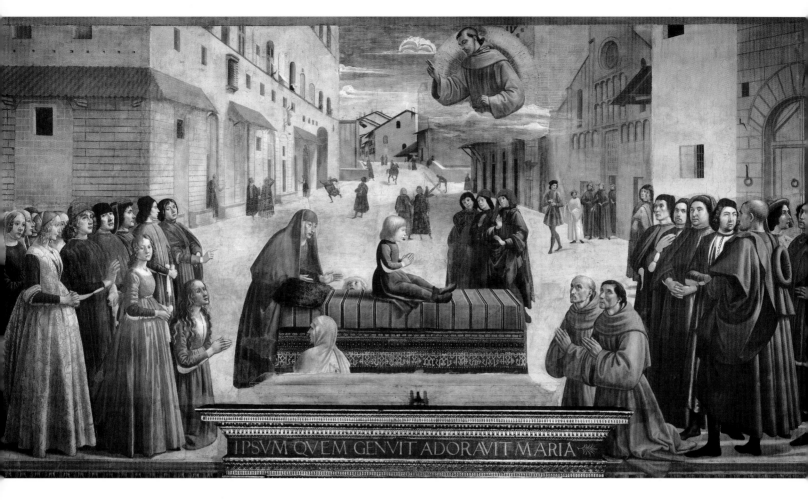

IPSVM QVEM GENVIT ADORAVIT MARIA

DOMENICO GHIRLANDAIO'S *SAINT FRANCIS RESURRECTING THE SON OF THE ROMAN NOTARY* FRESCO IN THE SASSETTI CHAPEL.

(p. 124) served to fulfill a vow of thanksgiving. Francesco had lost his young son Theodoro, but was soon blessed with another boy. On the chapel's central wall three paintings directly relate to Francesco's life. Over the altar stands a Nativity altarpiece (p. 125). On either side of it, frescoed portraits of Francesco and his wife pray to be granted another son. This altarpiece is particularly interesting because it reflects two current fashions: for ancient architecture and sculpture, and for Flemish painting. In the very years when Sassetti was decorating his chapel, another Medici employee, Tommaso Portinari, made a stir in the city by bringing from Bruges for his chapel a monumental altarpiece by the Flemish master Hugo van der Goes. It showed the *Adoration of the Shepherds*. Ghirlandaio, possibly on order from Sassetti, who was keen not to be outdone by his colleagues, painted shepherds very similar to those by van der Goes. Thus Sassetti could

"keep up with the Joneses" without the cost and trouble of importing an actual Flemish altarpiece.

The fresco in the middle register depicts Francesco's reversal of fortune. Ostensibly it shows an episode from the life of St. Francis of Assisi, Francesco's patron saint: the saint appears from the sky to miraculously resurrect the son of a Roman notary (above). But the event that took place in Rome is staged in Florence, in the Piazza Santa Trinità, before the very church that contained Francesco's chapel. The boy is Francesco's new son, and the onlookers, members of his clan.

Equally autobiographical is the *Confirmation of the Franciscan Order by Honorius III* in the upper tier (opposite). Again the event is transported from Rome to Florence, to the Piazza della Signoria, visible behind the screen. On the right stands the dark-haired Lorenzo de' Medici. Francesco is to his left. Lorenzo's young sons ascend the

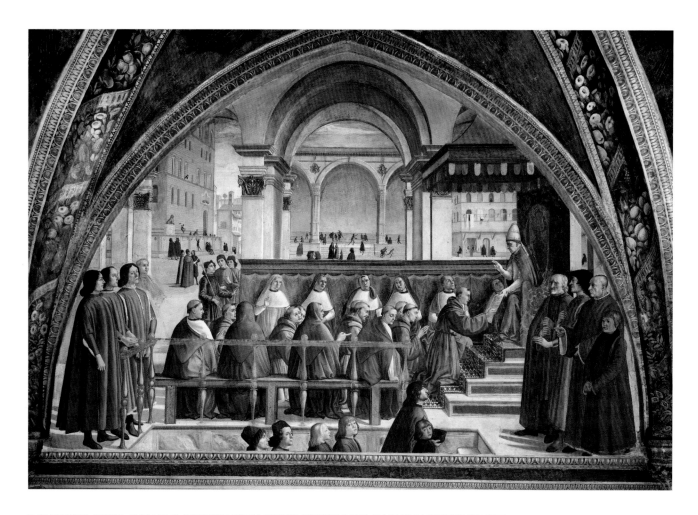

DOMENICO GHIRLANDAIO'S *CONFIRMATION OF THE RULE* FRESCO IN THE SASSETTI CHAPEL.

stairs, led by their tutor, the poet Angelo Poliziano. Three of Sassetti's grown sons pose on the far left. The painting honors Francesco's holy patron, his illustrious employer, and the good fortune he owed to his heavenly and earthly benefactors.

In addition to chapels, wealthy Florentines also vied with each other through home-building. The most impressive and trend-setting urban palazzi were, of course, put up by the richest bankers and merchants: the Medici, Pitti, Ruccellai, and Strozzi. Seeing the remains of Roman buildings, they realized that architecture could assure their fame for centuries. Giovanni Ruccellai noted in his diary that he viewed his palazzo, designed by Alberti, as his major achievement. Building such palaces typically consumed one-half to two-thirds of a man's financial worth. To justify this extravagance, Florentines cited ancient sources, such as Aristotle, who advocated

lavish expenditure as a virtue befitting a patrician, especially one actively involved in civic life. Leon Battista Alberti argued in his treatise *On Architecture* that the wealth of magnates was the sign of God's favor. This was a great excuse for ostentatious display.

The Florentine palace-building boom took off in the 1440s, soon after the Medici had returned from exile and set new trends. Cosimo first asked Brunelleschi to design his palazzo, but Brunelleschi's proposal seemed too grandiose to a man careful to maintain the appearance of being first among equals. Cosimo turned it down. The architect was reputedly enraged, but there was little he could do. Cosimo hired Michelozzo di Bartolommeo instead.

Michelozzo proposed a structure that combined traditional Florentine architecture with features derived from ancient Roman buildings (p. 128, top left). His

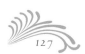

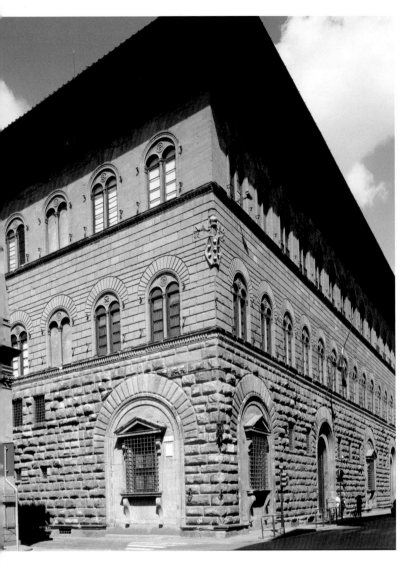

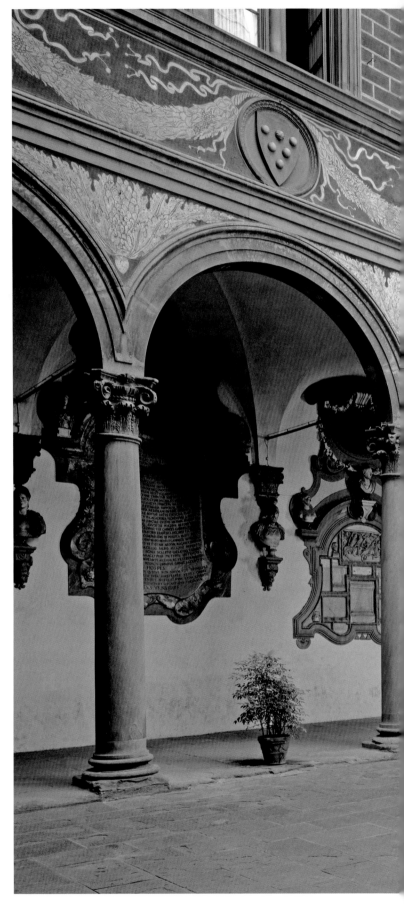

MICHELOZZO DI BARTOLOMMEO'S EXTERIOR OF THE
PALAZZO MEDICI-RICCARDI, FLORENCE, 1444–1450S.
PEDIMENTS WERE ADDED TO THE GROUND FLOOR
WINDOWS IN THE SIXTEENTH CENTURY; THE BUILDING
WAS LENGTHENED AND A LOGGIA AT THE CORNER WAS
ENCLOSED IN THE SEVENTEENTH CENTURY.

three-story structure with shops and storage on the
ground level, a piano nobile with grand rooms for
receiving guests on the second floor, and living quarters
above was not too different from palazzi built in the
thirteenth and fourteenth centuries. New elements were
the round-arched windows framed by rusticated stonework
and heavily rusticated walls that, actually, represented
a misunderstanding of surviving Roman structures.
Renaissance architects interpreted the rough, exposed
foundation blocks of Roman buildings, or their weathered
masonry, originally covered with marble revetments,
as the intended final look. The heavy cornice capping

MICHELOZZO DI BARTOLOMMEO'S COURTYARD OF THE
PALAZZO MEDICI-RICCARDI, 1444–1450S.

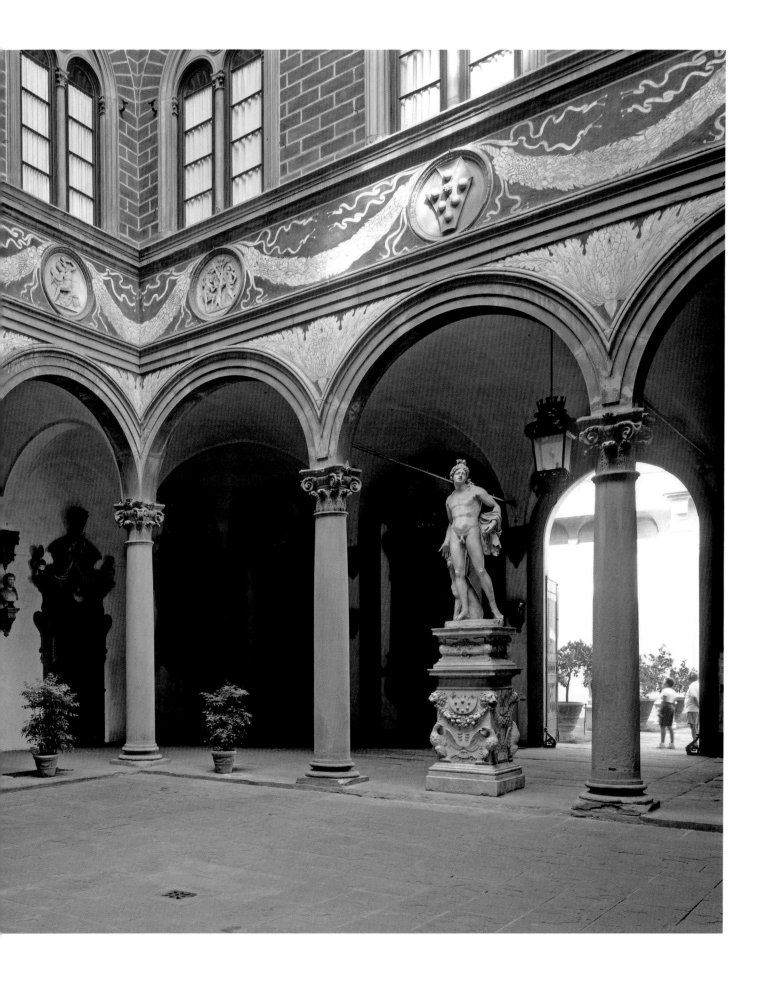

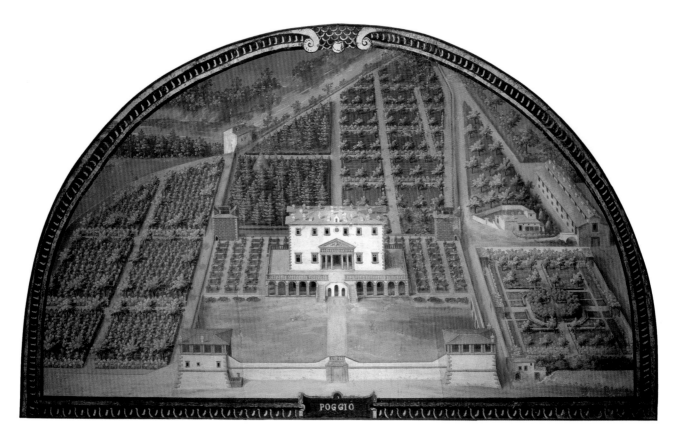

GIUSTO UTENS' 1599 PAINTING OF THE VILLA DI POGGIO A CAIANO DESIGNED BY
GUILIANO DA SANGALLO IN THE MID-1480S. MUSEO DI FIRENZE COM'ERA, FLORENCE

Michelozzo's palazzo was also influenced by Roman examples, but it had a practical function: to shield both the building and the passers-by from rain. The main entryway led into an elegant courtyard open to the sky and designed to let more air and light into the back rooms (pp. 128–29). The Medici device of balls on a shield was to be seen throughout the external corner of the palazzo, over the windows on the facade, and above the arches in the courtyard. The elegant proportions and classical vocabulary of the Medici residence made it a prototype for patrician dwellings for the next few centuries, not only in Florence, but throughout Tuscany, Italy, and beyond.

Once the precedent was set, other great Florentine families followed the Medici example, and strove to surpass it. Their ever more stately, large, and ostentatious homes immeasurably transformed and ennobled the city. As you stroll through its streets, you can find palazzi everywhere. Some still belong to ancient families; others have been acquired by new magnates. In 1937 the shoe

designer Salvatore Ferragamo bought the Palazzo Spini-Feroni, first built by the papal banker Geri Spini in 1289 and remodeled by many owners over the centuries. Ferragamo made it the headquarters for his company, and today it also houses a museum of the shoes he designed for twentieth-century elites.

Florentines also built numerous country estates, since agriculture was indispensable to their economy, and pastoral dwellings provided respite from the crowded, noisy, dirty, and epidemic-prone cities. Under the influence of ancient texts, especially Virgil's *Georgics*, which extolled the virtues of rural labors and life, and Pliny the Younger's letters about his Tuscan villa, Florentine patricians began to construct ever more architecturally distinguished and sumptuously appointed suburban homes. The Medici eventually built seventeen of them. The most elegant fifteenth-century Medicean villa, at Poggio a Caiano, was designed by Giuliano da Sangallo for Lorenzo de' Medici (above). Lorenzo loved to retreat there to hunt and fish, and composed affectionate verses

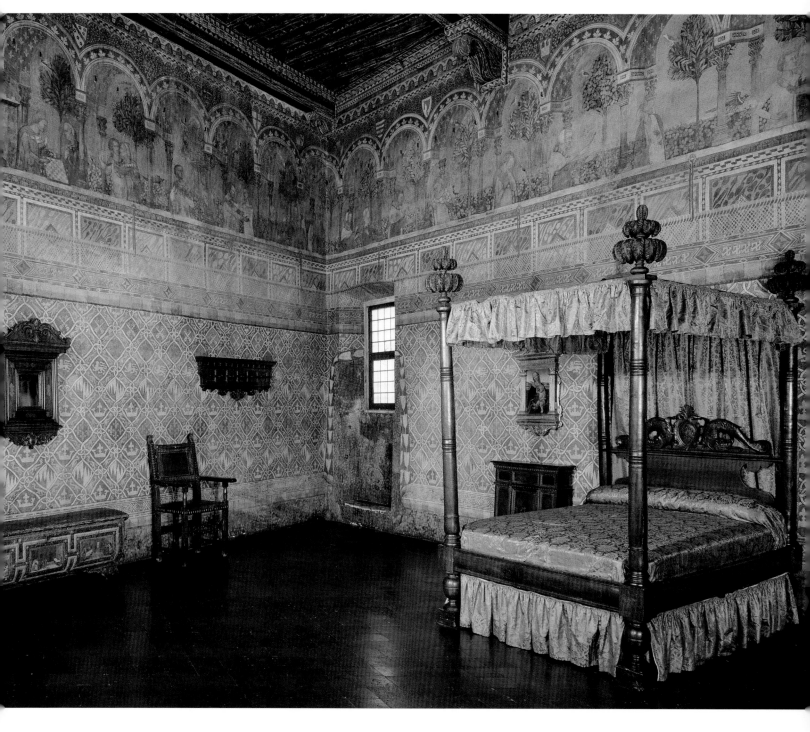

THE SECOND-FLOOR BEDROOM IN THE PALAZZO DAVANZATI, FLORENCE, 1390S.

praising the estate. The main building is a rectangular block raised on a colonnaded platform and enhanced by a Roman-style portico—a row of Ionic columns supporting a sculpted frieze and a pediment bearing the Medici arms. In keeping with Florentine architectural fashion, Sangallo highlighted the moldings, doors, and windows with *pietra serena*. Since all Renaissance villas have

been significantly remodeled, we must gauge the original appearance of Lorenzo's building and its grounds from a late-sixteenth-century painting. In its early days the villa was surrounded by herb and flower beds, multiple orchards, and a formal decorative garden in which Lorenzo and his guests strolled, read, pondered, and conversed.

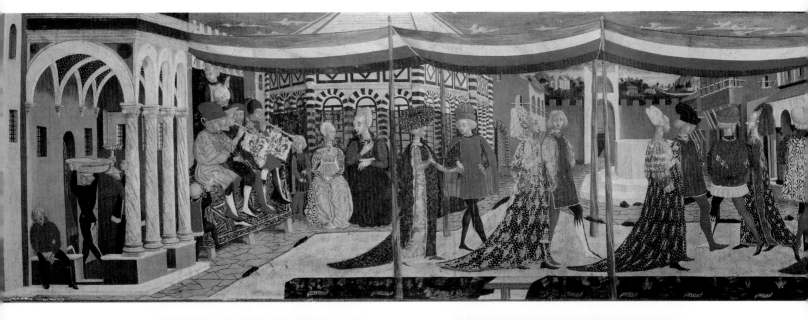

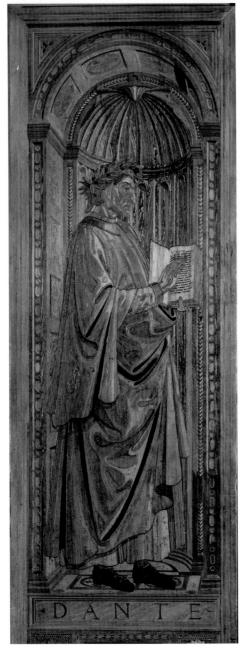

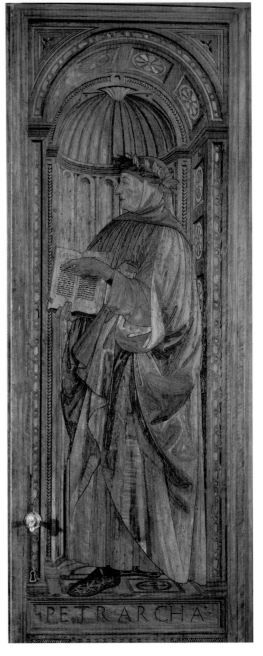

·DANTE· ·PETRARCHA·

above GIOVANNI DI SER GIOVANNI, CALLED LO SCHEGGIA'S *ADIMARI CASSONE*. GALLERIA DEL ACCADEMIA, FLORENCE

opposite, left PORTRAIT OF DANTE FROM GIULIANO DA MAIANO AND FRANCIONE'S INTARSIA DOOR TO THE SALA DE' GIGLI IN THE PALAZZO DELLA SIGNORIA, FLORENCE.

opposite, right PORTRAIT OF PETRARCH FROM GIULIANO DA MAIANO AND FRANCIONE'S INTARSIA DOOR TO THE SALA DE' GIGLI IN THE PALAZZO DELLA SIGNORIA, FLORENCE.

The Florentine building boom spurred the development of a variety of arts because new palaces and villas had to be furnished with suitable splendor, and thus offered opportunities for further competition and the display of status. In 1459 a counselor of the Duke of Milan visited the Medici palace and was awed by "the studies, chapels, salons, chambers, and garden . . . decorated on every side with gold and fine marbles, with carvings and sculptures in relief, with pictures and inlays, tapestries and household ornaments of gold and silk, silverware and bookcases that are endless and without number." The Medici had clearly achieved the desired effect.

Sadly, their palace no longer preserves its Renaissance adornments. To catch a partial glimpse of how it may have looked, visit the late-fourteenth-century palace of a rich wool merchant, Palazzo Davanzati. Most of the rooms retain their frescoes: some of them imitate textiles,

others depict popular romances of the day. Those in the bedchamber are particularly enchanting (p. 131). They tell a story of the trials of chastity and fidelity, perfectly suited to the room. The furniture does not all belong to this palazzo, but it is more or less in keeping with the period style.

More luxurious than fresco decorations were pictorial wood inlays, called *intarsia*. They were a Florentine specialty, and made the spaces they embellished both opulent and warm. They are not nearly as well known as paintings, but once you become aware of them, you notice them all over the city. You can see a set of intarsia doors up close in the "Lily Chamber" of the Palazzo della Signoria (so called for the lily pattern of its walls). The inlaid panels depict Petrarch and Dante, with their famous books stacked underneath their feet (opposite, left and opposite, right).

The most versatile adornments in Renaissance palazzi were *cassoni*—wooden chests in which the bride brought her trousseau and stored it in her husband's home. Cassoni were often made in pairs and painted with scenes from ancient history, literature, mythology, chivalric tournaments, or courtly romances. The Adimari *cassone* shows a more contemporary scene, probably a Florentine wedding (opposite, above). Sumptuously dressed couples dance with stately steps before the baptistery (seen on the left) to the accompaniment of four wind instruments.

Many oblong Florentine paintings were originally parts of cassoni, benches, or *spalliere*—inset decorative panels placed under the ceiling. Sandro Botticelli's languid *Venus and Mars*, as well as his *Primavera*, probably served such a function. Botticelli's elegant lines, flowing garments, and mannered gestures perfectly suited the atmosphere of courtly refinement his patrons wanted in their homes. A particularly beguiling painting by Botticelli is the less frequently reproduced *Return of Judith* (p. 134), which, together with the *Discovery of the Beheaded Body of Holofernes*, formed a diptych set in a gilded walnut frame. It was passed down through generations of the Medici family. Botticelli's Judith is a delicate teenage beauty, almost too young and dainty to have slain a grown male enemy. I love the way the painter captured the bond between her and her servant, two women amid the male world of war. The color composition is deeply poetic: the saffron yellow of the servant's dress, the

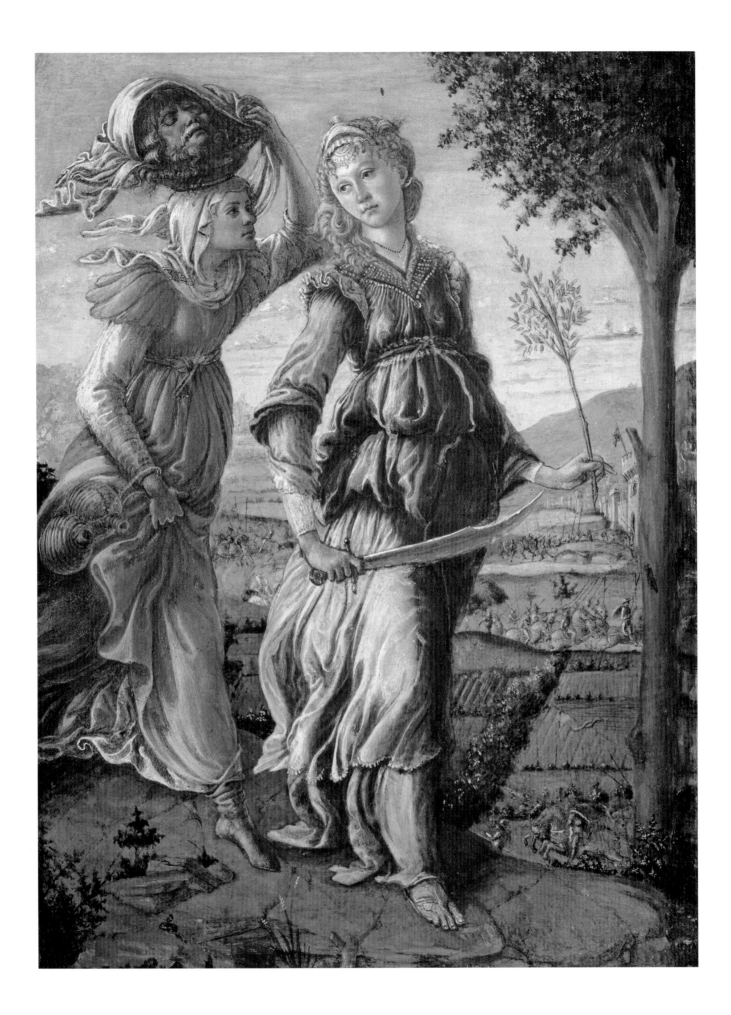

above, left ANTONIO DEL POLLAIUOLO'S *HERCULES AND THE HYDRA*, C. 1460. GALLERIA DEGLI UFFIZI, FLORENCE

above, right ANTONIO DEL POLLAIUOLO'S *HERCULES AND ANTAEUS*, 1470S. MUSEO NAZIONALE DEL BARGELLO, FLORENCE

translucent violet of Judith's clothes, and the muted green of the landscape.

Florence was at once a profoundly religious city and a devoted student of pagan antiquity, with which it engaged in an ongoing contest. Leon Battista Alberti, in the preface to his treatise *On Painting*, declared that Florentine artists surpassed the ancients because these forebears had many precedents from which to learn and therefore less difficulty in mastering "those noble arts which for us today prove arduous; but it follows that our fame [and he particularly credited Brunelleschi,

Donatello, Ghiberti, della Robbia, and Masaccio] should be all the greater if without preceptors and without any model to imitate we discover arts and sciences hitherto unheard of and unseen."

The return to classical art and literature had a practical purpose. It set apart the elites who had time, access, and money for such pursuits. Painting and sculpture of subjects drawn from Antiquity made manifest the learning and refinement of those who commissioned and displayed them. In this the Medici, again, led the way. They particularly liked the creations of

opposite SANDRO BOTTICELLI'S *THE RETURN OF JUDITH*, C. 1472. GALLERIA DEGLI UFFIZI, FLORENCE.

DOMENICO GHIRLANDAIO'S *BIRTH OF THE VIRGIN* FRESCO IN TORNABUONI CHAPEL IN
SANTA MARIA NOVELLA IN FLORENCE, 1486–90.

≺≺≺≺≺≺≺≺≺≺≺≺≺≺≺≺≺≺≺≺≺≺≺≺≺≺≺≺≺≺

the brothers Antonio and Piero del Pollaiuolo. Around
1460 Antonio Pollaiuolo painted for the Palazzo Medici
three large canvases depicting the *Labors of Hercules* (p. 135,
left). The hero was an ideal subject for the Medici. A
defender of order and justice, he had been adopted by the
Florentines as a civic symbol and then appropriated by
the Medici in their role as the guardians of the Republic.
The original canvases have disappeared, but Pollaiuolo's
own small-scale copies survive, showing the Greek
strongman in poses clearly inspired by ancient gems and
sarcophagi.

Antonio Pollaiuolo was not only a painter and
graphic artist, but also a goldsmith and sculptor. In
addition to the Hercules paintings, he also made for the
Medici bronze statuettes, such as his *Hercules and Antaeus*
(p. 135, right). Fifteenth-century small bronzes revived
an ancient art genre prized by Roman collectors. The
Latin poets Martial and Statius wrote eloquent praises
of a little bronze Hercules owned by a certain Novius
Vindex. At one of Novius's dinner parties, Statius fell
"deeply in love" with this statuette: "such majesty despite
its narrow limits. A god was he . . . small to the eye, a

≺≺≺≺≺≺≺≺≺≺≺≺≺≺≺≺≺≺≺≺≺≺≺≺≺≺≺≺≺≺

opposite DOMENICO GHIRLANDAIO'S *PORTRAIT OF GIOVANNA DEGLI ALBIZZI TORNABUONI*, C. 1488–90. MUSEO THYSSEN-
BORNEMISZA, MADRID

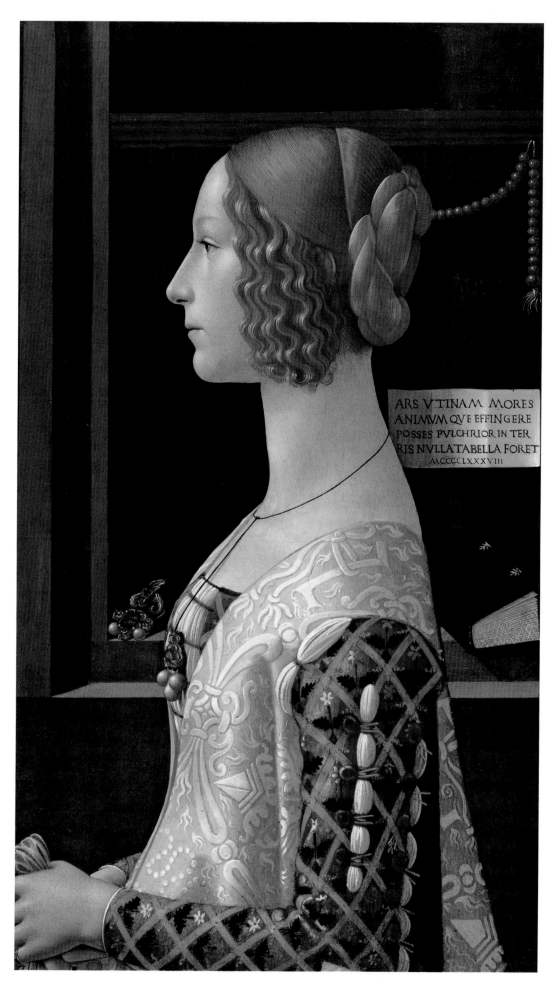

ARS VTINAM MORES
ANIMVMQVE EFFINGERE
POSSES PVLCHRIOR IN TER
RIS NVLLA TABELLA FORET
MCCCCLXXXVIII

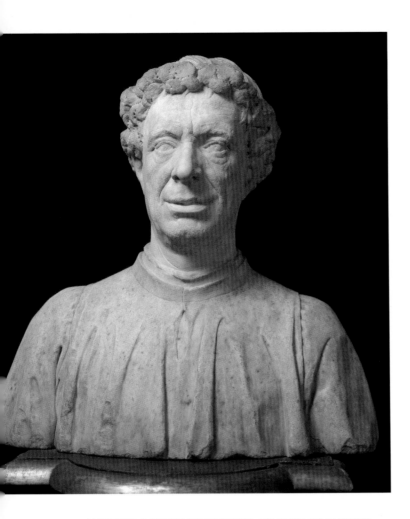

ANTONIO ROSSELLINO'S PORTRAIT BUST OF MATTEO PALMIERI, 1468. MUSEO NAZIONALE DEL BARGELLO, FLORENCE

statuettes, and encouraged artists like Pollaiuolo to create more such works.

Renaissance portraits were also partly inspired by Roman examples, and partly by the vanity of their sitters and their desire for commemoration. Whether painted or sculpted, free-standing portraits frequently graced patrician homes; and chapel owners liked to see themselves in frescoes honoring their patron saints. Sitters requested to be depicted in the most sumptuous attire allowed by their social station. After all, the Florentines manufactured, and sold across Europe, some of the finest fabrics of the day: silk and taffeta, velvet and gold brocade, lampas and damask. They also excelled at gold-work. Despite the periodic passage of sumptuary laws aimed at curtailing excessive private spending, the Florentines sported opulent fabrics and fine jewels whenever they could. And whether in paintings or in life, they paid careful attention to one another's appearance, as they do to this day.

As we have seen in the Sassetti chapel, Domenico Ghirlandaio was perfectly attuned to the interests of his clients. He was a great portraitist, not only of their faces, but of their dress. For Giovanni Tornabuoni, an uncle of Lorenzo de' Medici, he painted a chapel with a cycle narrating the lives of St. John the Baptist and of the Virgin. He filled the frescoes with minute details of his patron's life. The scene of the *Birth of the Virgin* (p. 136) takes place in a richly appointed Florentine home. Intarsia panels line the walls; a sculpted frieze of putti runs under the ceiling. The women who come to congratulate St. Anne on the birth of little Mary are Ludovica, Giovanni Tornabuoni's only daughter, and her ladies in waiting. Ludovica's luxurious brocade dress sets her apart as the most important person in the room, seemingly more important than St. Anne and the Virgin. But her depiction is actually heartbreaking. She died in childbirth at fifteen, and the painting is a posthumous commemoration of her brief, if privileged, life.

Ghirlandaio's free-standing portrait of Giovanna degli Albizzi, wife of Giovanni Tornabuoni's son Lorenzo, is one of the most beautiful Florentine paintings (p. 137). The young woman is decked out in the finery that speaks of her husband's wealth and status. She wears a brocaded sleeveless dress over an elaborately

giant to the mind. To think that so tiny a body should create the illusion of so great a frame. What precision of touch, what daring imagination the cunning master had, to model a table ornament, yet to conceive such mighty forms." Statius went on to recite the statuette's illustrious pedigree. A masterpiece by Lysippus, it must have presided over Alexander the Great's banquets, aroused the admiration of the Carthaginian general Hannibal, and adorned the table of the Roman dictator Sulla before finding its way into Novius's house. Whether the statuette did have this lineage, or copied (or even forged) a Greek work, will remain a mystery. What matters is that fifteenth-century Florentines were aware of such ancient raptures over small bronzes, and wanted to imitate Roman taste. To be like the Romans, the Medici greedily collected surviving Etruscan and Roman bronze

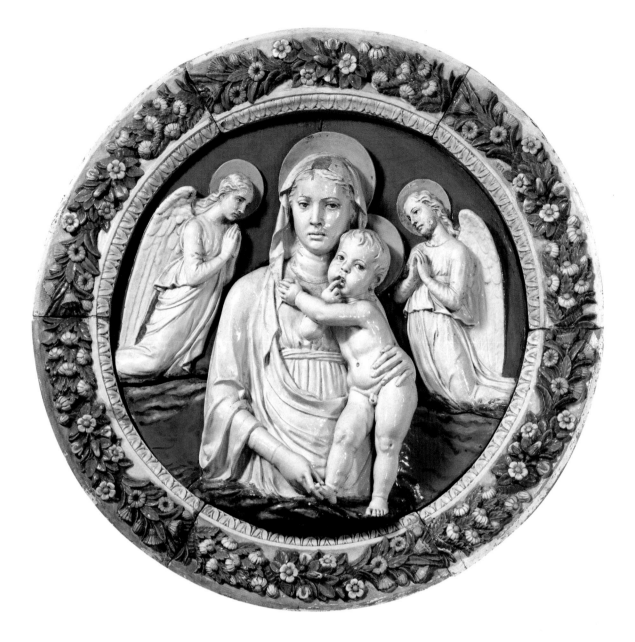

LUCA DELLA ROBBIA'S *TONDO WITH MADONNA AND CHILD*, C. 1460. MUSEO NAZIONALE DEL BARGELLO, FLORENCE

embroidered blouse. A gold pendant with a ruby and three pearls is suspended from a delicate cord around her neck. Keeping one's wife in appropriate form was so costly that fifteenth-century Florentine men married in their thirties, when they had accumulated enough money to afford it. The brides were usually much younger, often mere teenagers. And marriage was not about love, but an alliance between powerful clans. Giovanna is still a girl, radiant and lively. Yet appearances are deceptive. This, too, is a posthumous likeness. She died in childbirth at age nineteen. A piece of paper pinned up in a niche

behind her wistfully declares, "Art, would that you could represent character and mind. There would be no more beautiful painting on earth."

Female portraits, then as now, emphasized the attractiveness of their subjects. Men's faces expressed strength and wisdom, and sought to evoke ancient prototypes. When the humanist Matteo Palmieri commissioned a marble bust from Antonio Rossellino, he wanted a representation that would recall Roman Republican portraits in which signs of age and wear connoted a life of virtuous service to the state (opposite).

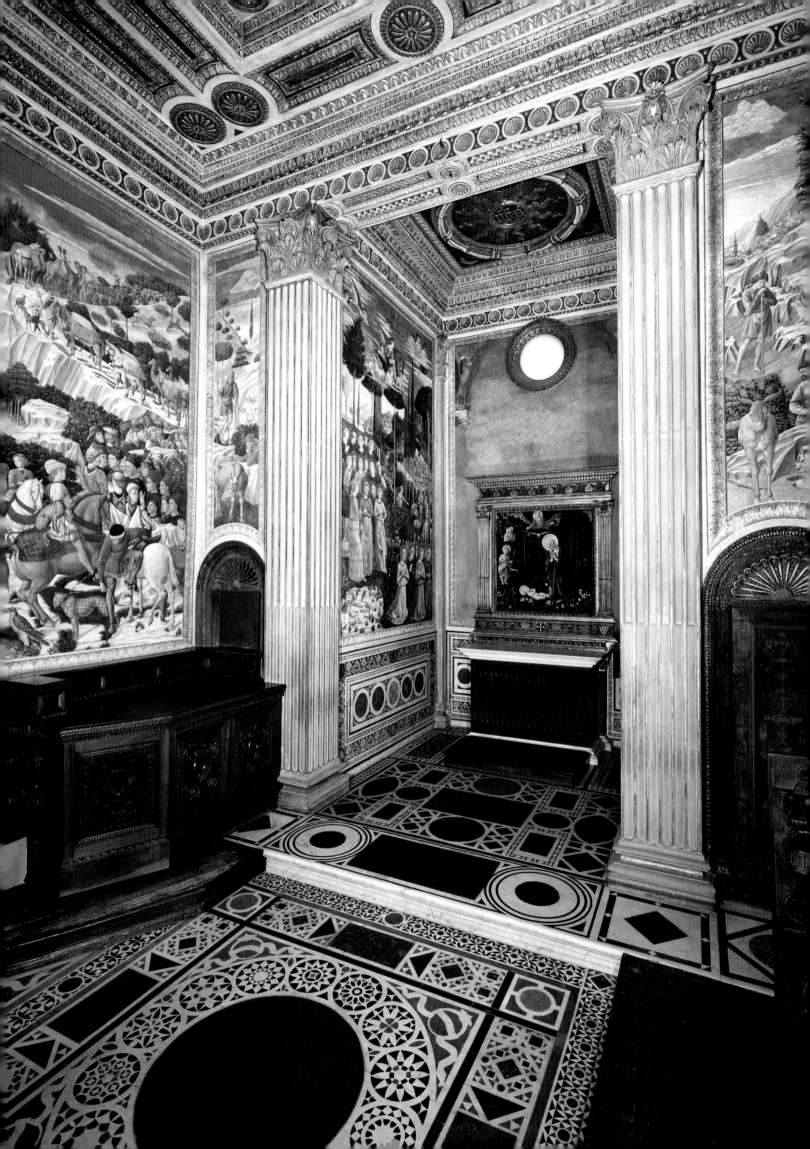

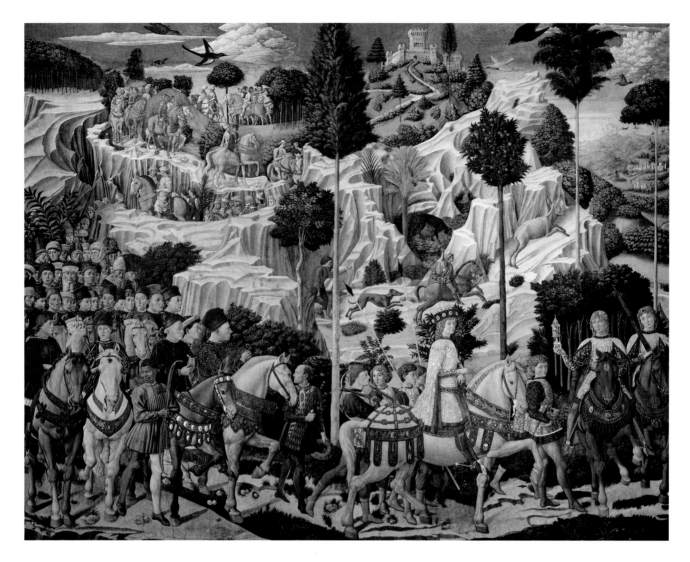

DETAIL OF BENOZZO GOZZOLI'S *PROCESSION OF THE MAGI* FRESCO IN THE MEDICI CHAPEL.

Palmieri also adopted Roman practice in placing his portrait: following Pliny's recommendation, he set it up above the door of his house.

Classical stories and portraits graced the homes of rich and self-consciously enlightened Florentines, but by far the most common household images were the Madonna and Child and the saints. These icons were protectors as well as guides to virtuous behavior for children and young wives. They came in every form, painted on cloth or panel, carved in wood or stone, or modeled in terra-cotta and glazed. Luca della Robbia invented glazed terra-cotta reliefs—with primarily religious subjects—which gained immediate and lasting popularity (p. 139). Eye-catching and extremely durable, his compositions were equally appealing indoors and outside. They came to adorn buildings throughout Florence and around Tuscany, from little outdoor shrines to the swaddled babies on the Ospedale degli Innocenti. Luca's heirs carried on his tradition for several generations, closely guarding the secret of his technique.

The most magical manifestation of private devotion in fifteenth-century Florence is the Medici chapel in the family's palazzo. To reach it today, you ascend a wide and somber seventeenth-century staircase. Whether

opposite ARCHITECT MICHELOZZO DI BARTOLOMEO AND PAINTER BENOZZO GOZZOLI'S INTERIOR OF THE MEDICI CHAPEL IN THE PALAZZO MEDICI-RICCARDI, 1459–1463.

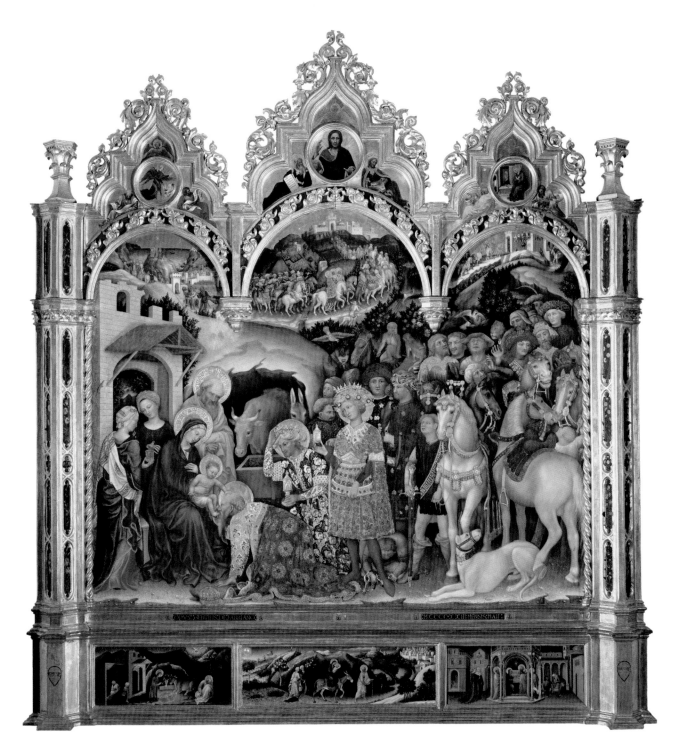

you have seen the chapel before, or visit it for the first time, the minute you enter it you are transported to an enchanted realm. The tiny, two-room chapel is a jewel-box (p. 140). Its floor is inlaid with an ancient-style colored stone mosaic; along the walls stand richly carved wooded seats. Over the visitor's head the ceiling bursts with elaborately pieced and gilded paneling. But the most

spectacular feature is the panoramic fresco encircling the entire space.

The fresco, painted by Benozzo Gozzoli, another of Ghiberti's assistants on the *Gates of Paradise*, details the procession of the magi (p. 141). The travelers wind their way through a craggy countryside to worship the Virgin and Child, depicted in a separate panel over the altar.

The cult of the Magi had taken root in Florence in the last decades of the fourteenth century. The feast of the Epiphany was celebrated by a procession of costumed actors that made its way through the city. According to a contemporary chronicler, "the Magi processed all over the city, beautifully dressed and mounted, with a large retinue and many novelties." Starting from the monastery of San Marco, they arrived at the Baptistery, which represented the Temple in Jerusalem. Before it the actors performed a sacred play. One act represented the encounter of the three wise kings with Herod; another, the Magi offering gifts to the baby Jesus; and a third the Massacre of the Innocents enacted with "imitation babies."

From the beginning of the fifteenth century the members of the Company of the Magi who planned and prepared these festivities every three years met at the church of San Marco. When Cosimo de' Medici became unofficial ruler of Florence, he assumed the leadership of this organization. As we have seen, Cosimo had connected himself to San Marco by rebuilding and embellishing the monastery. He was partly moved by guilt and devotion, and partly by competition with his rivals and by his political instincts. Cosimo wanted to make San Marco into a cultural center, complete with a humanist library, that would outshine a similar institution founded by his adversary, Palla Strozzi, at the Vallombrosan monastery of Santa Trinità. In fact, Palla Strozzi had linked himself with the Magi before the Medici had, for in 1423 he had commissioned Gentile da Fabriano to paint an opulent panel on this subject for his chapel in Santa Trinità (opposite). Cosimo sought to outstrip his rival and to make the Magi into an image of his control of Florence. By making himself leader and benefactor of the Company of the Magi, he accomplished this conceptual link.

Benozzo's frescoes are full of details that bind the painted story to the Medici. One wall is occupied by a group portrait of their clan. Cosimo is a man in his sixties with gray hair and red beret, dressed in a black brocade doublet. He rides on a russet horse behind his son and successor, Piero the Gouty, shown in profile and dressed in green brocade with gold embroidery. A gorgeous youth in gold brocade and red hose posed on a white horse is an idealized likeness of the young Lorenzo. A crowd of retainers behind the Medici is full of individualized faces, including that of Benozzo himself: he wears a red hat embroidered with the gold letters OPUS BENOTII, the work of Benozzo. Even the hilly landscape, cultivated with great care, is a slightly fictionalized portrait of the Florentine countryside and the Medicean villas scattered through it.

The Medici followed the progress of the chapel with keen attention. In a surviving letter from Benozzo to Piero de' Medici written in July 1459, the painter responds to his patron's displeasure: "This morning I received a letter from your Magnificence . . . and I understand that the seraphims I have done do not seem appropriate to you. . . I will do whatever you command me to do; two clouds will make them vanish. . ." Benozzo clearly worked hard to please his masters. In bright and costly pigments he created a lush world that engulfs and absorbs the visitor to the chapel. Standing in the tiny space the visitor is immersed completely in the fairy tale before him, his eyes feasting on the lively faces and dazzling costumes. The saturated blues, greens, reds, and yellows are more intense, through both preservation and restoration, than in almost any other Renaissance frescoes. The effect of the Medicean power and splendor is overpowering. One can well imagine what their progress through the city looked like in real life.

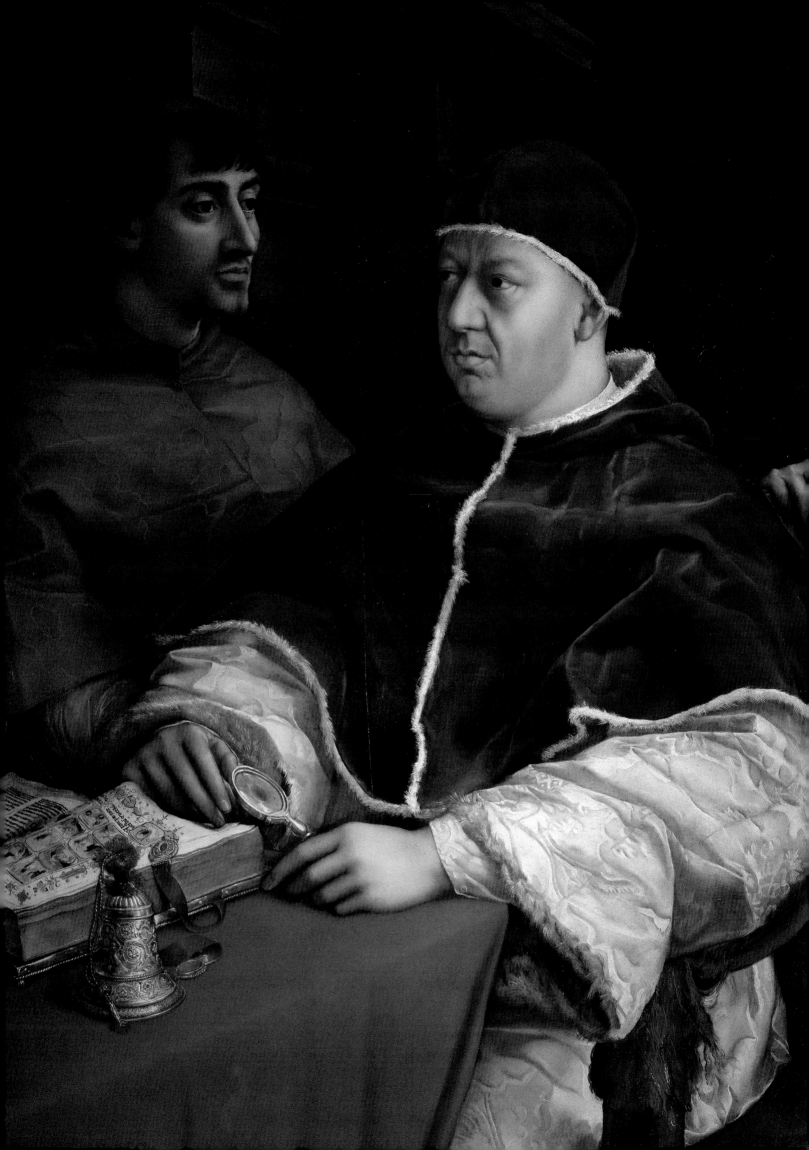

FLORENCE OF THE POPES AND THE GRAND DUKES

IFTEENTH-CENTURY FLORENCE WAS LIKE A CROWDED HOME
WITH LOUD AND COMPETITIVE SIBLINGS JOSTLING FOR
ATTENTION AND RANK. THE SIXTEENTH-CENTURY CITY, IN
CONTRAST, WAS LIKE AN IMPOSING MANSION INHABITED BY A GRAND
SIGNOR AND HIS ATTENTIVE SUITE. IN THE SIXTEENTH CENTURY THE
MEDICI BECAME GRAND DUKES OF TUSCANY, PRODUCING TWO POPES

and two queens of France. As they grew powerful, ambitious, and refined, they harnessed
great artists to make them shine on the international stage. To do this, they fostered the
traditional Florentine crafts of sculpture, painting, architecture, *intarsia*, and textiles. But
like good heirs to the Etruscans, they also imported foreign arts—especially tapestries
and hard-stone carving—and made them their own. Through these and other efforts,
the astute and erudite Medici family outgrew its mercantile origins and became a truly
princely house.

After the death of Lorenzo the Magnificent in 1492, Florence plunged into political
turmoil. Lorenzo's son, Piero, made such disastrous alliances that Florence was nearly
invaded by the French king, Charles VIII, in 1494, as he marched south to claim the
kingdom of Naples. Enraged, the Florentines expelled the Medici. For the next few
years the city was under the sway of a fiery and charismatic Dominican preacher,
Domenico Savonarola. These were the years leading up to the turn of a century and

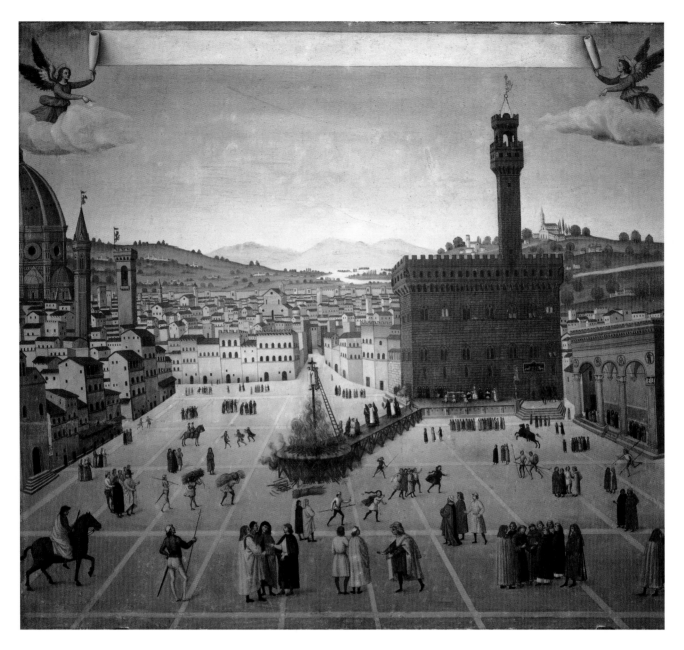

BURNING OF SAVANAROLA IN THE PIAZZA DELLA SIGNORIA, C. 1498. MUSEO DI SAN MARCO, FLORENCE

the half-millennium. At such times people often seem to become frantic and fanatic. Savonarola aroused the religious fervor of the Florentine populace by thundering against the extravagance of the rich, the tyranny of the powerful, and the decay of morality, and threatened them with imminent divine punishment if they did not instantly mend their ways. In February 1497 he ordered a bonfire of vanities. From all parts of the city people dragged to the Piazza della Signoria signs of their vices: wigs, perfumes, and mirrors; musical instruments that supposedly stirred the soul in overly sensual ways; books by vernacular authors, including Boccaccio and Petrarch; and works of art that Savonarola decreed to be impious. Many great creations went up in smoke. When news of these events reached Pope Alexander VI, whom Savonarola had already antagonized to the

previous spread RAPHAEL'S *LEO X (1513–21) WITH CARDINALS GIULIO DE'MEDICI, FUTURE CLEMENT VII (1523–34), AND LUIGI DE'ROSSI*, 1518. GALLERIA DEGLI UFFIZI, FLORENCE

breaking point, the pope excommunicated the preacher. This usually terrifying punishment made little impression on Savonarola. He continued his blistering sermons, even though the pope had ordered him to desist. In 1498 he staged another, even bigger bonfire. The pope finally lost patience. Savonarola was arrested, tried, and condemned to death—to be burnt at the stake at the very place where he had only recently ignited his own fires. Mercifully, he was hanged beforehand, and spared a more harrowing end. His ashes were scattered in the Arno to prevent relic-hunting. A painting by an unknown artist depicts Savonarola's execution in careful detail (opposite). Here is the Piazza della Signoria with the cathedral visible on the left and the Palazzo Vecchio on the right. Just before it presides the tribunal, and from the judges a walkway stretches to the fire in the middle of the piazza. A couple of men bring in more straw, while groups of Florentines gather to observe the execution. Savonarola and his companions are being led to the pyre, and then dangle, lifeless, above it, as flames lick their feet.

After Savonarola's death, republican rule returned to Florence for a few years, but the Medici were biding their time and scheming to come back. They managed to do so in 1512; were forced to flee again in 1527; and installed themselves for good in 1532.

The Medici remained devoted to their family and city whether at home, in exile, or abroad. Pope Leo X, son of Lorenzo the Magnificent, and later his cousin, Pope Clement VII, essentially governed Florence from Rome (p. 144). To make sure that the Medici presence and preeminence remained unmistakable, they initiated a series of new works at the church of San Lorenzo. This time the chosen architect was Michelangelo Buonarroti.

Michelangelo claimed descent from the medieval counts of Canossa, and all his life emphasized his nobility through his bearing and dress. As was customary among the upper classes, while a baby he was placed under the care of a wet-nurse. The nurse came from a family of stonecutters living in Settignano, a village of masons and stone workers near Florence. As a grown man, Michelangelo claimed that he had absorbed his love of marble with his nurse's milk.

Contrary to his father's wishes, Michelangelo desired to become an artist. Painting and sculpture were manual labors and thus considered lowly occupations.

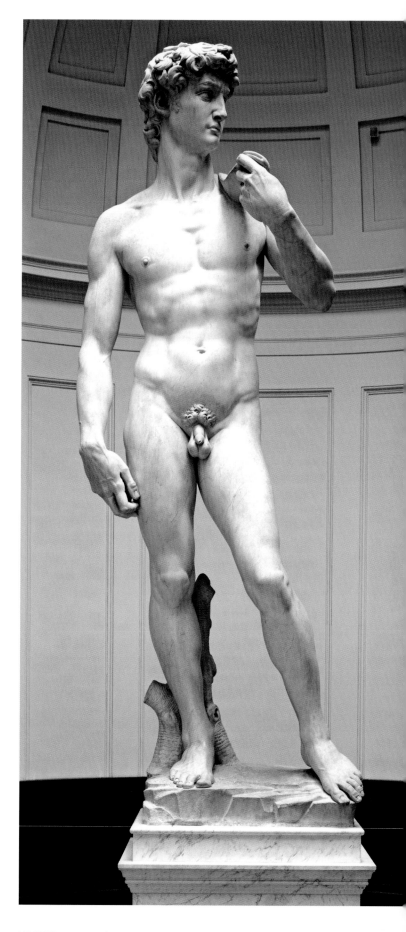

MICHELANGELO'S *DAVID*, 1501–03. MOVED TO THE ACCADEMIA, FLORENCE, IN 1873.

But Michelangelo had made up his mind, so he was sent to train under Domenico Ghirlandaio, the most fashionable master in Florence. He stayed only two years, did not finish his apprenticeship, and later wrote to his nephew Lionardo, "I was never a painter or sculptor like those who run workshops." Instead, he obtained an introduction to the entourage of Lorenzo the Magnificent, probably thanks to his father, who claimed a distant kinship to the Medici. In Lorenzo's garden Michelangelo studied ancient sculptures, and he received some humanist education alongside two of his future patrons, Giovanni, Lorenzo's son (the future Pope Leo X), and Giulio, the son of Giuliano who had been killed in the Pazzi conspiracy (the future Clement VII).

Michelangelo was a talented pupil, and his early lessons and contacts served him well. His biographer, Ascanio Condivi, reports that in the winter of 1495–96 he carved a marble figure of Cupid in the ancient style for his own amusement. Lorenzo di Pierfrancesco de' Medici (a cousin of Lorenzo the Magnificent) suggested that Michelangelo bury the statue in the ground, age it, and sell it as an antique. Once the Cupid had been sufficiently doctored, the merchant Baldassarre del Milanese took it to Rome and sold it to Cardinal Riario, nephew of Pope Sixtus IV and one of the richest men in Rome, for a hefty sum of 200 ducats. Baldassarre told Michelangelo that he had received only thirty ducats. Somehow both Michelangelo and Riario got wind of the deception. Riario demanded that the merchant return the money and remove the forgery. Michelangelo set off from Florence to Rome to reclaim his earnings and to see the eternal city for the first time. Condivi concludes that the real loser in the affair was Riario. By making a fuss about the fake Cupid he had deprived himself of an original Michelangelo. Not surprisingly, Michelangelo was the winner. He gained instant celebrity and launched his career.

Michelangelo was enthralled by Rome's ancient remains, and began working for important patrons there, but he also traveled frequently back to Florence, partly to see his family and partly to execute commissions for the Florentine government and private clients. His most famous civic work is, of course, the *David*, carved at the behest of the board of directors of Florence's cathedral. The commission was actually half a century old. In the 1460s Agostino di Duccio had been hired to shape a

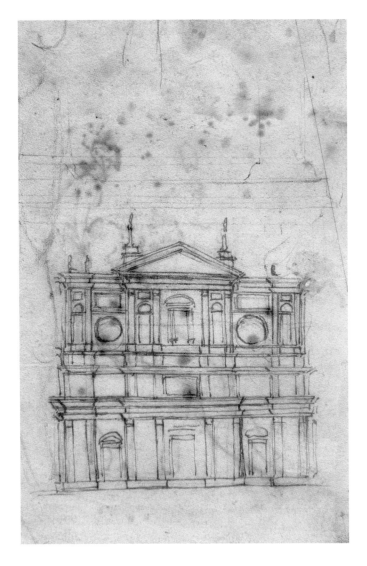

MICHELANGELO AND BACCIO D'AGNOLO'S DESIGN FOR SAN LORENZO'S FAÇADE. CASA BUONARROTI, FLORENCE

massive marble block into a statue of David for one of the niches on the exterior of the cathedral. But he never completed it, and the partially carved stone lay abandoned for decades. In 1501 Michelangelo was asked to finish the job.

Michelangelo's *David* was inspired in part by the other statues on the cathedral and Orsanmichele (p. 147). Like its predecessors, *David* emulates ancient statuary in his *contrapposto* stance, with one leg straight, bearing the body's weight, the other slightly bent and in repose. This gives the figure an internal dynamism. *David*'s face, similar to that of Donatello's *St. George*, is tense with apprehension as he stands ready to battle for Florence. But, unlike its precursors, *David* is the first fully nude figure carved since antiquity, and on a colossal scale to boot.

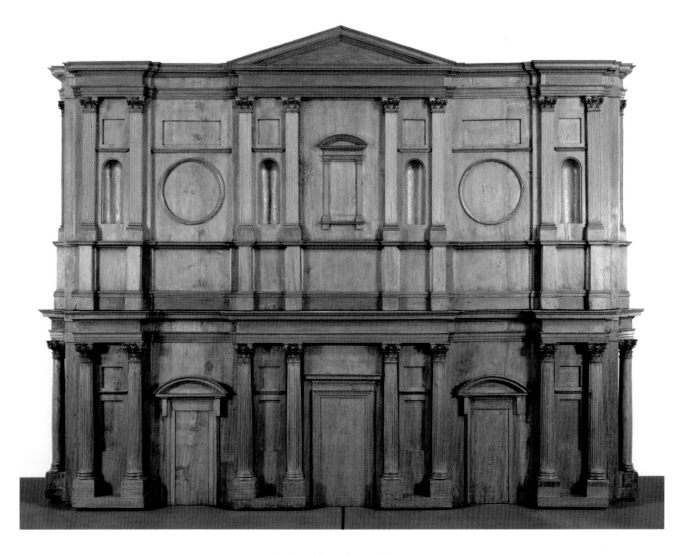

MICHELANGELO'S WOODEN MODEL FOR SAN LORENZO'S FAÇADE, C. 1518.
CASA BUONARROTI, FLORENCE

David's right hand is bigger than his left. It seems to allude to his appellation, *manu fortis*, strong of hand—that is, the hand with which he hurled the stone that slew Goliath. Other distortions, such as the overly large upper body and head, were intended to compensate for the statue's projected placement high off the ground, where distance would right these imbalances and prevent the figure from looking pin-headed.

When Michelangelo finished *David*, it became clear that the statue was too exceptional to be dispatched to a distant niche high up on the cathedral, so a large committee of artists and citizens assembled to debate where it should be placed. The surviving minutes of this historic meeting make fascinating reading. Among those present were Botticelli and Leonardo da Vinci. Opinions varied widely. Some advocated putting the statue on the cathedral, as intended, or on a pedestal at the entrance to the church. Others thought that the loggia opposite the Palazzo Vecchio would be more suitable: it would make *David* visible, but shelter it from the elements, since the marble had already been compromised by sitting out in the open air for forty years. Still others suggested the courtyard of the Palazzo Vecchio, or even the Council Hall inside as the best location. After a long deliberation, it was decided to set up the Giant, as the Florentines called it, by the main entrance to the Palazzo Vecchio, a location of the highest honor.

Luca Landucci, a dealer in spices and medicines, left a vivid description of how the statue was put into place:

On May 14, 1504, the marble Giant was taken from the *Opera*. It came out at 24 o'clock, and they broke the wall above the gateway enough to let it pass. That night some stones were thrown at the colossus to harm it. Watch had to be kept at night; and it made way very slowly, bound as it was upright, suspended in the air with enormous beams and a complicated mechanism of ropes. It took four days to reach the Piazza, arriving on the 18th at the hour of 12. More than forty men were employed to move it; and there were fourteen rollers joined beneath it, which were progressively transferred.

In its highly charged spot, and in the years when the Medici were exiled, *David* became a symbol of the republic's liberation from its oppressors. To this day he is Florence's most famous citizen. His face, body, and portions of his anatomy appear in reproductions throughout the city, and the lines to see him at the Academia are notoriously long.

David may be the most famous of Michelangelo's Florentine works. But more impressive is his achievement at San Lorenzo, a project conceived by the Medici after they returned to power in 1512. Giovanni de' Medici, son of Lorenzo, became Pope Leo X in 1513, and he made it his business to restore the prestige of his family in his native city. Although he resided in Rome, he was, in effect, ruling Florence by guiding the decisions of his kin whom he had placed in control.

Like his father, Leo was a complex and talented man, with refined tastes and grand ambitions. He had received a superb education and was passionate about learning and art. He loved poetry and music, hunting and buffoonery, lavish festivities and gourmet foods. Fat and hedonistic, he is said to have declared, "God gave us the Papacy, let us enjoy it!" Even if these words were only attributed to him, they are certainly in keeping with his princely ways. Through his unbridled consumption and nepotism Leo precipitated the Protestant Reformation; he made his cousin, Giulio, archbishop of Florence and then a cardinal. But he also returned a "golden age" to Rome, assembling a splendid musical choir in the Sistine Chapel; reviving ancient Roman theater; and employing Raphael to catalogue the city's ancient remains. Raphael also decorated

Leo's apartments in the Vatican, and designed for the Sistine Chapel a series of opulent tapestries that honored St. Peter, St. Paul, and Leo himself.

As Leo set out to rebuild the Medici authority in Florence, he embarked on a project that would bring him and his family immediate and enduring glory. He decided to give the church of San Lorenzo a long-overdue and magnificent facade and called the foremost artists to submit suitable models. Among the contenders was Michelangelo, whom Leo knew from the artist's days in the Medici household. Never modest about his talents, Michelangelo proposed what he called a "mirror of architecture and sculpture of all Italy": a two-story facade built of solid marble, as opposed to the usual facing of marble veneers. The structure would be decorated with twelve standing marble statues, six seated bronze ones, and nineteen reliefs. His presentation was convincing and he won the contract—together with Baccio d'Agnolo, Florence's leading architect, since Michelangelo himself had never overseen the construction of a building before (p. 148).

The two men set out to work up more detailed models, but as Michelangelo watched what Baccio planned, he became more and more disappointed. Baccio's design was, in his view, unsuitable for his own grand scheme. He had in mind a unity of sculpture and architecture, a structure that would rival the greatest monuments of antiquity. In December 1516 he set off for Rome to persuade Leo X and his cousin Giulio to grant him greater control over the project. By 1518 he had completed a large wooden model and won sole leadership (p. 149).

Later in life Michelangelo promoted an image of himself as a solitary genius. By vehemently and frequently complaining about his family, friends, and associates, he perpetuated a notion that he was an unsociable and mistrustful man. In reality he hardly ever worked alone: he spent much of his professional life in close and friendly cooperation with large crews of craftsmen. While painting the Sistine Chapel ceiling he relied on at least thirteen assistants. He took more than a dozen men with him to the quarries to procure marble for the facade

opposite THE CARRARA MARBLE QUARRIES IN THE APUAN ALPS.

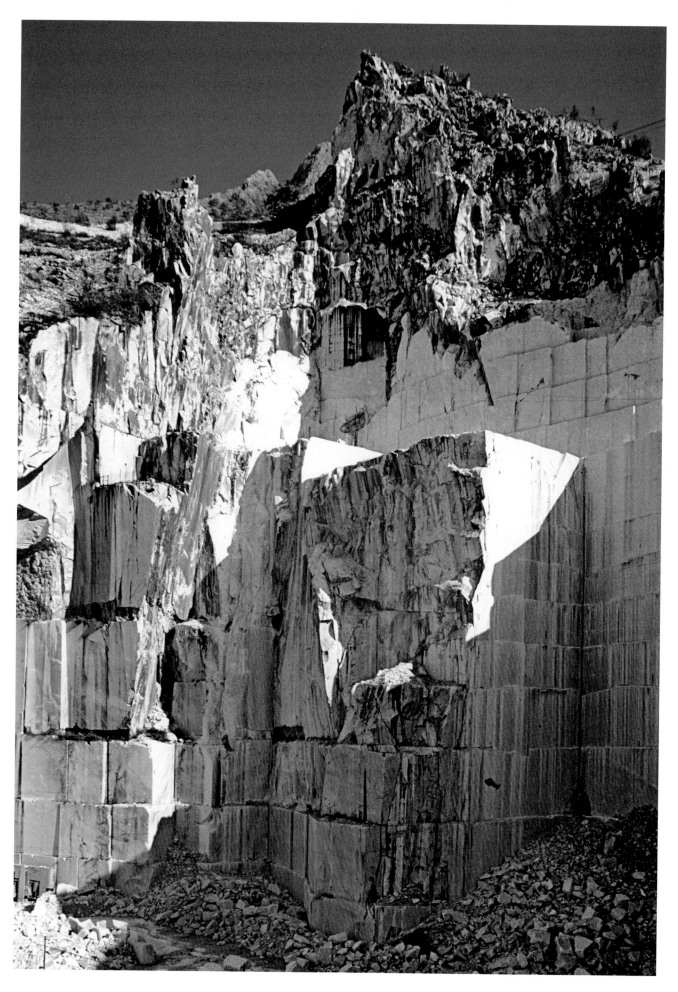

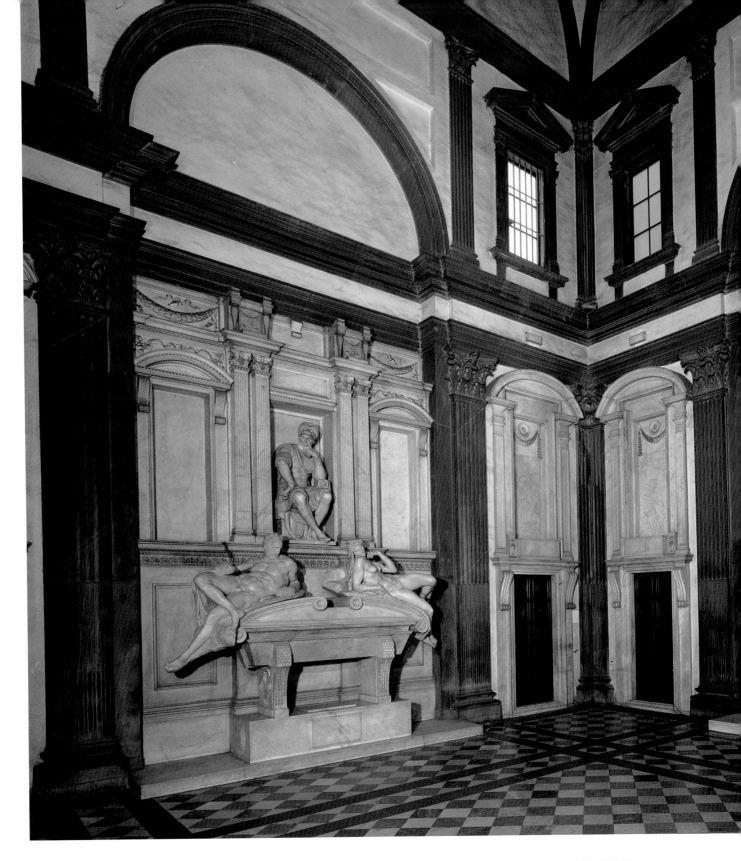

MICHELANGELO'S MEDICI CHAPEL IN SAN LORENZO, FLORENCE, SHOWING THE TOMB OF LORENZO DE' MEDICI.

of San Lorenzo. In 1525, when he was building both the new Medici mausoleum and the library at San Lorenzo, he had more than 100 people on his weekly payroll. In an age when labor was notoriously unreliable, Michelangelo employed many of the same men for ten, fifteen, and even twenty years. His commissions changed, but many of his assistants remained the same, providing cohesion to his projects and ensuring a consistently high quality in his final products.

In a wonderful book, *Michelangelo at San Lorenzo:*

shuttled between the work site and the quarries, between Rome and Florence, ordered materials, took deliveries, provided models for his carvers, and did his own creative work all at the same time. He also took care of his men: he sent them to doctors when they were ill, tided them over at times of financial difficulties, and treated them as part of his extended clan.

As he prepared to carve the facade of San Lorenzo, Michelangelo spent many months quarrying marble at Carrara and Seravezza in northwestern Tuscany (p. 151). He was exceptional among Renaissance sculptors in the amount of time he spent in the quarries. He loved marble, personally selected the veins he wanted extracted, and remembered from past trips the locations of particular stones. He left the quarrying itself to experienced locals, but sent his trusted assistants to supervise the work so that all would be done to his specifications.

The facade of San Lorenzo called for vast quantities of marble. Michelangelo envisioned a structure with a dozen monolithic columns that would outshine the most imposing ancient buildings. Working tirelessly and passionately from late 1516 until March 1520, he built at least two different models, quarried and delivered much of the marble, and dug the foundations. The site was the major workplace in Florence. Then, suddenly, without explanation, the pope canceled the contract.

Michelangelo was bitterly disappointed. In a letter enumerating his expenditures, both monetary and emotional, he wrote: "I am not charging to his [the pope's] account the fact that I have been ruined over the said work for San Lorenzo; I am not charging to his account the enormous insult of having been brought here to execute the said work and then having it taken away from me." Michelangelo's long career was full of frustrations and sorrows as his powerful patrons truncated or canceled commissions after he had poured so many thoughts, dreams, and efforts into them.

But the popes and princes who employed him never fell short of ambitions. Although Leo called off the project for the San Lorenzo facade, he and his cousin had already put Michelangelo to his next task. They wanted a new Medici chapel inside the church, mirroring Brunelleschi's Old Sacristy, to house the tombs

The Genius as Entrepreneur, William Wallace shows that Michelangelo was not only a superb artist, but a gifted manager. He selected his helpers with care, trained them well, and encouraged them to do their best by giving them pay raises and more challenging assignments. He

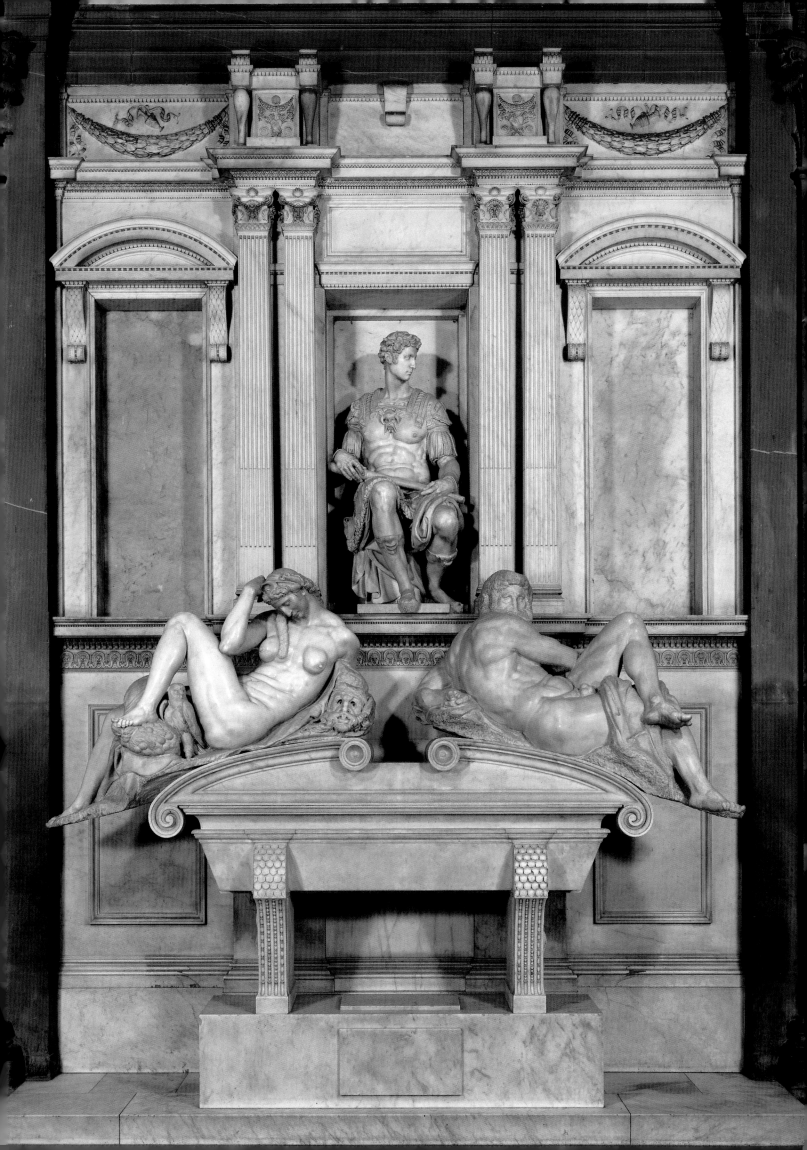

of Lorenzo the Magnificent; his murdered brother Giuliano (these tombs were never completed); Lorenzo's son Giuliano, the Duke of Nemours; and his grandson Lorenzo, the Duke of Urbino.

Since Michelangelo had already assembled a team of trusted masons and carvers, he redirected his energy and inspiration to the new chapel. This elegant space repeats Brunelleschi's use of gray stone to highlight the architectural elements in the Old Sacristy, but it is more austere. The Old Sacristy has wooden cabinetry, glazed terra-cotta reliefs, and bronze doors. Michelangelo's New Sacristy is all gray and white, starkly juxtaposed; the space is cold and formidable (p. 152). Much of the actual carving was done by skilled craftsmen supervised by experienced *capomaestri*. Michelangelo made precise drawings and templates to guide them, and trusted them to do the job well. He was the guiding spirit of the project, but they, too, deserve credit.

Michelangelo, and his craftsmen, completed only two of the projected four tombs, flattering the two inconsequential dukes by portraying them as noble Romans. Giuliano appears in the guise of a Roman general, in a muscled cuirass, holding the baton of command over his knees (opposite). He was, in life, commander of the papal troops in Rome. Giuliano's legs are relaxed, but his torso twists slightly to the left, while his head turns to the right. He is like a coil, full of imminent motion. He embodies the ancient concept of the *vita activa*, or active life. Meanwhile, Lorenzo represents the *vita contemplativa*, the contemplative life (p. 152). He, too, is dressed as an ancient Roman, but he sits brooding, propping his head on his arm, lost in deep thought. In fact, his contemporaries called him "the Thoughtful." Michelangelo masterfully translated such personal characteristics into heroic likenesses, turning the mundane into the sublime.

Below the two dukes stand their sarcophagi. On top of Giuliano's recline allegories of Day and Night. Over the tomb of Lorenzo lie Dusk and Dawn. They have long been admired for their graceful poses, but from up close, their bulging muscles are almost too mannered,

and the female figures are clearly male bodies with added, improbable, breasts. The only nearly completed portion of Lorenzo the Magnificent's tomb is the Virgin and Child opposite the altar, carved by Michelangelo. His pupils supplied the sculptures of the Medici saints, Cosmas and Damian, at a later date.

Work on the chapel continued until 1534, but was never finished. Leo X died in 1521. He was succeeded by a Dutch reformist pope, Hadrian VI, who, understandably, cut off funding for the project. In 1523 Giulio de' Medici became pope Clement VII, and work resumed. But by 1526 Clement's political machinations entangled the papacy in hostilities with Emperor Charles V. On May 7, 1527, the imperial troops sacked Rome. Clement fled, ingloriously, and never recovered his prestige. The Florentine historian Francesco Vettori famously remarked that Clement "endured a great hardship to become, from a great and much admired cardinal, a small and little-esteemed pope." When Clement returned to the Vatican in October 1528 he was humiliated and impoverished. The Florentines, taking advantage of his weakness, reestablished the Republic. Naturally, they were not motivated to complete the Medici mausoleum.

Michelangelo, who was both patriotic and republican (in an old sense of the word), turned his attention instead to the needs of his city. He designed fortifications to protect Florence from the combined forces of Charles V and Clement VII, who were poised to retake the city in the summer of 1530. After the Medici returned with the help of Charles V, whom Clement had obligingly crowned Holy Roman Emperor, the pope wanted the chapel to be finished. He offered Michelangelo an amnesty on condition that he resume work, but the artist had by then lost his enthusiasm for the project, and for the Medici, especially after the cruel Alessandro de' Medici came to power and abolished the republican constitution in 1532. In 1534 Michelangelo settled in Rome for good, directing his assistants long-distance in completing the work at San Lorenzo.

While he was still in Florence, and fully engaged with the Medici Chapel, Michelangelo also began the library

MICHELANGELO'S VESTIBULE OF THE BIBLIOTECA LAURENZIANA IN SAN LORENZO.

at San Lorenzo. It was intended to house the Medicean book collection and to be open to public use. The core of the collection consisted of manuscripts gathered by Cosimo de' Medici with the help of leading Florentine humanists. Lorenzo the Magnificent had significantly expanded the family holdings, and it was his wish that the Florentines should have access to these books. His nephew, Pope Clement VII, asked Michelangelo to build the library with a beautiful reading room.

Since space at San Lorenzo was limited, the library was added as a third story over the monastic buildings linked to the church. Michelangelo's work force was already at hand, and he used primarily Florence's local *macigno* stone, rather than Carrara marble, so construction proceeded very quickly. The reading room and the vestibule were largely erected in less than three years, from 1524 to 1527. The flowing staircase that leads up to the reading room, the desks inside it, the carved

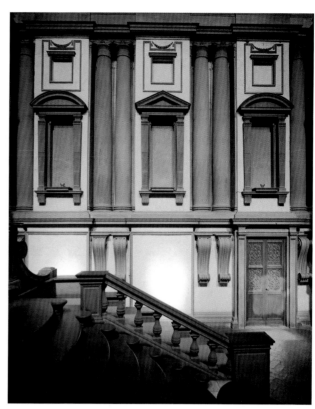

MICHELANGELO'S VESTIBULE OF THE BIBLIOTECCA LAURENZIANA, SIDE WALL.

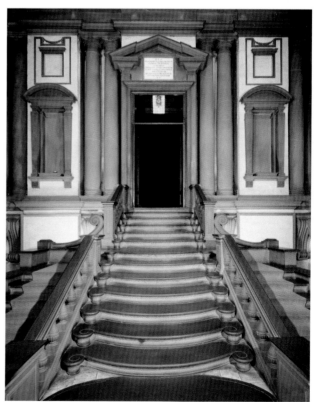

FRONT VIEW, LOOKING INTO THE READING ROOM, MICHELANGELO AND BARTOLOMEO AMMANNATI'S STAIRCASE IN THE BIBLIOTECA LAURENZINA.

ceiling, and the ornate tile floor were installed after Michelangelo had moved to Rome.

Undoubtedly, the most original part of the library is the vestibule (this spread). It is full of visual tricks. From the entryway the space seems tall, but quite confined, for it has a fairly small footprint and is filled by a large stairway. But from the top of the stairs it appears huge. One notices how small people on the floor below seem, and thus realizes how high the space

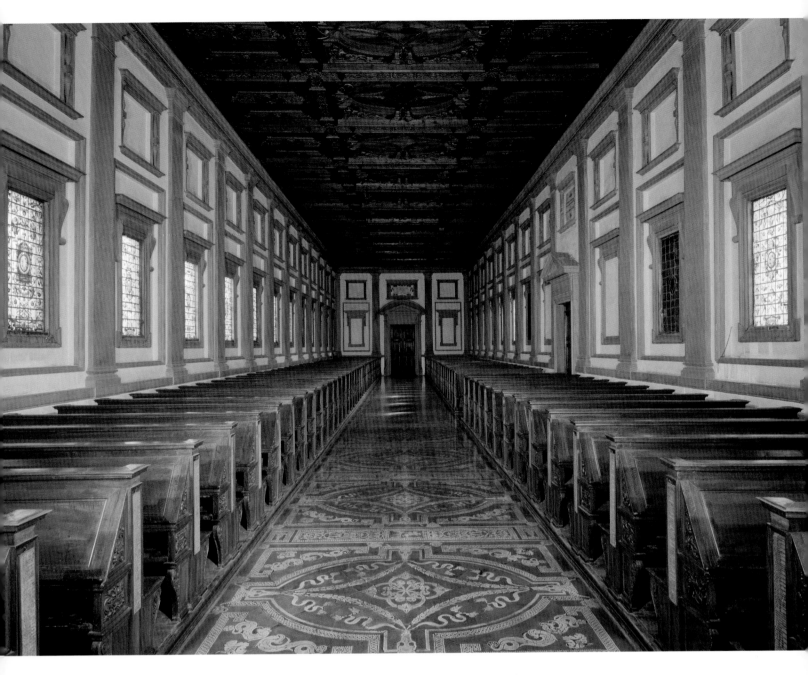

MICHELANGELO'S READING ROOM IN THE BIBLIOTECA LAURENZIANA.

⋖⊹⋖⊹⋖⊹⋖⊹⋖⊹⋖⊹⋖⊹⋖⊹⋖⊹⋖⊹⋖⊹⋖⊹⋖⊹⋖⊹⋖⊹⋖⊹

is. The walls are divided into three tiers. The bottom one is fairly plain, except for consoles floating in their own niches. In the middle tier pairs of Tuscan columns stand slotted tightly into alcoves. Like the consoles, they bear no structural weight. The recessed frieze above the columns emphasizes the undulating movement of the wall. By playing with recessed and projecting elements, Michelangelo has turned architecture into sculpture. He has also reversed the relationship between weight-bearing and free elements, thus exhibiting his engineering skills. The five-meter-high monolithic

columns, uniform in color and shape, testify to his superb knowledge of stone and to his high standards of carving. It was a considerable feat to maneuver the massive shafts into such a narrow and restricted space.

The staircase, too, is a piece of sculpture (p. 157). It occupies most of the entryway—apparently at Clement VII's request—the elliptical stairs cascading through the hall. As the visitor ascends them, they narrow and draw him into the reading room. When he leaves, the widening oval steps seem to spill him back into the vestibule. Michelangelo originally wanted the staircase to be carved

of walnut, to make it seem continuous with the walnut reading desks that begin to appear as one walks up. However, when in 1559 Bartolomeo Ammanati came to execute Michelangelo's design, he carved the stairs out of gray stone. Thus they harmonize with the walls, but have no direct connection to the reading room.

The walls of the reading room pick up the white and gray motif of the vestibule (opposite). But most of the space is made warm and welcoming by the carved linden ceiling, walnut desks, and intricately tiled floor. The sides of the desks facing the aisle still have their old shelf lists, which are fun to peruse. Today the library is a museum. But what a delight it must have been to sit here and read.

Neither Michelangelo nor Clement VII lived to enjoy the library. The pope died in 1534. Michelangelo never returned to Florence. The person who oversaw its unveiling in 1571 was the new absolute ruler of Florence, Cosimo I (right).

Cosimo was a great-grandson of Lorenzo the Magnificent. He came to power at eighteen, and held on to it until 1562, when, ailing, he stepped aside and let his son, Francesco, carry out the business of government. In the course of his rule, Cosimo exercised personal control over the day-to-day affairs in his dominions; under him Tuscany became a tightly run and rapidly expanding state. Cosimo obtained and made the title of Duke of Florence and Grand Duke of Tuscany hereditary. He married Eleonora of Toledo, daughter of Charles V's Viceroy in Naples, and founded his own chivalric order, the Knights of St. Stephen. In other words, he finally made the Medici into true princes, rather than merely pretentious merchants and bankers.

To give his person and court luster, Cosimo employed many talented artists, including the painter and art historian Giorgio Vasari. Vasari was competent and efficient, but by no means a brilliant artist. At one point, he boasted of having painted a vast decorative cycle in the Palazzo dei Conservatori in Rome in a mere 100 days. Michelangelo reputedly grumbled, *Si vede bene*, "so one can well see." Vasari's most lasting achievement was a monumental history of Renaissance art, *Lives of the Most Illustrious Painters, Sculptors and Architects.* He dedicated the second, revised edition to Cosimo, whom he served for some twenty years. Vasari was keen to please his patron and to promote his own career, so he praised the Medici

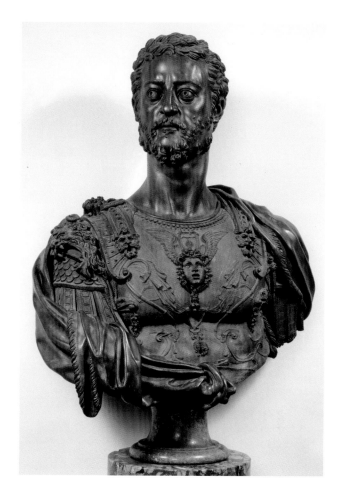

BENVENUTO CELLINI'S *COSIMO I*, 1543–48. MUSEO NAZIONALE DEL BARGELLO, FLORENCE

fulsomely for fostering Tuscan culture and arts. It is to him that we owe the association of the Renaissance with Florence, and of the greatest art patronage with the Medici family. Of course, the Medici did much to promote arts in their city, but they were not the only ones, nor was Florence the cultural epicenter of Europe. But that is another story.

In any event, Cosimo was an avid and shrewd patron who fostered native Florentine crafts and foreign imports. Early in his reign he moved from the ancestral Medici Palace to the Palazzo della Signoria, the traditional seat of Florentine republican government. (This new Medici dwelling acquired the name Palazzo Vecchio, or old palace, after Cosimo left it for the Palazzo Pitti across the Arno.) To remodel the city hall into a princely dwelling, Cosimo put to work a team of gifted men. The competition between them was stiff, and at times vicious, as they jockeyed for power and preference in the

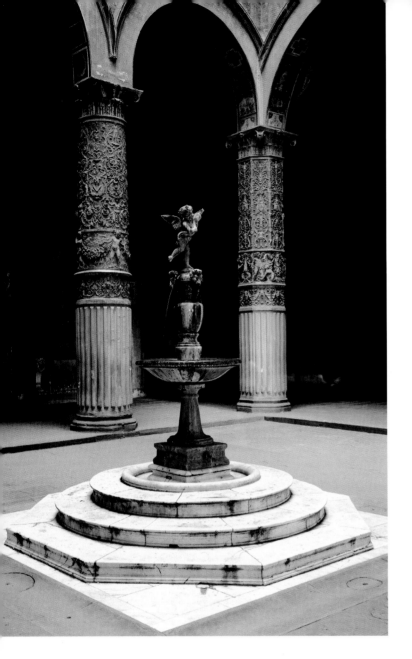

above MICHELOZZO'S COURTYARD FOR THE PALAZZO
VECCHIO, FLORENCE, WITH FRANCESCO FERRUCCI DEL
TADDA'S PORPHYRY FOUNTAIN.

right GIORGIO VASARI AND CRISTOFORO GHERARDI'S *SALA
DEGLI ELEMENTI* IN THE PALAZZO VECCHIO IN FLORENCE.

claustrophobic atmosphere of the court. Vasari, for one,
settled scores with his rivals by excluding them from his
seemingly complete *Lives*, or by mentioning them only
as minor players. Giovanbattista del Tasso, Pierfrancesco
Foschi, and Francesco Bacchiacca, for example, were all
successful and prominent in the 1530s and 1540s, but
they snubbed Vasari when he first came to Cosimo's
court, so now we hardly know their names. Yet as much as
these men may have disliked each other, they had to work
side by side at the behest of the duke.

Cosimo had the Palazzo Vecchio decorated with
elaborate frescoes. In room after room they celebrated the
Medici lineage, military victories, political successes, and
patronage of the arts. Whatever we may think of Vasari's
artistic merits, he was clearly favored by Cosimo and put
in charge of the remodeling campaign. One task was
to spruce up the courtyard of the palazzo, built in the
fifteenth century by Michelozzo. Vasari embellished it by
ornamenting its columns with elaborate stucco reliefs set
against gold background, and painting grotesque figures

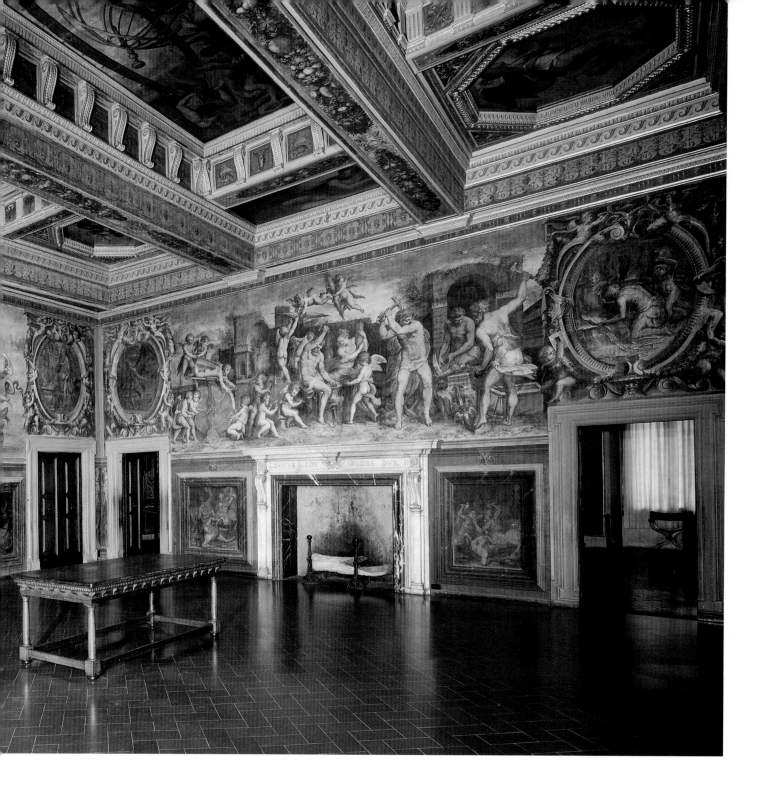

in the vaults. He also designed the fountain for the center of the courtyard (opposite).

The porphyry basin, the main part of the fountain, carved by Francesco Ferrucci del Tadda, was a major technical feat. Porphyry is an extremely dense stone, and very difficult to work, but Cosimo loved it because it had been used by Roman emperors. In antiquity purple was the most expensive and prestigious color. Purple dye, obtained by crushing and processing vast quantities of murex shells, was, unlike other dyes, color-fast. Only the wealthiest and loftiest people could afford and rightfully wear purple garments. Porphyry thus became a prized stone because of its color. But it was also exotic: it could only be obtained from one particular place in Egypt. In the Middle Ages the art of porphyry carving had died out. Cosimo wanted his artists to "conquer" it once again. Many Renaissance sculptors tried with little success, but at last Tadda mastered this craft, and founded a family workshop to capitalize on it.

Inside the Palazzo Vecchio, Vasari supervised the

GIORGIO VASARI'S *COSIMO I SURROUNDED BY ARTISTS*, A CEILING PANEL IN THE ROOM OF
COSIMO I IN THE PALAZZO VECCHIO.

decoration of the rooms. These were grouped into suites dedicated to the most distinguished of the Medici. Cosimo himself resided in the so-called Apartment of the Elements on the upper floor. Frescoes in these rooms celebrated his achievements through allegories of the Olympian gods. The Room of the Elements, for example, portrays the four elements believed by the ancients to form the basis of the universe (pp. 160–161). On the ceiling Saturn, mutilating Uranus, symbolizes Air. He is surrounded by the chariots of the Sun and the Moon, Day and Night, Peace, Fame, Justice, and Truth. It is always fascinating to see how selectively Renaissance rulers interpreted ancient stories. Here Saturn's attack

on his father is cast in a positive light. Meanwhile, on the walls of the room, Earth offers her first fruits to Saturn; the Birth of Venus represents Water; and Vulcan's workshop stands for Fire. In the Room of Cosimo I, the duke appears on the ceiling surrounded by his artists, who look up to him in admiration and offer him their creations (above),

Vasari painted some of these frescoes and supervised others, but he was only one of many artists whom Cosimo patronized. Another very successful court painter was Agnolo Bronzino, entrusted with all the official portraits. His highly polished, detailed, yet idealized style perfectly suited the aloof and grand demeanor of

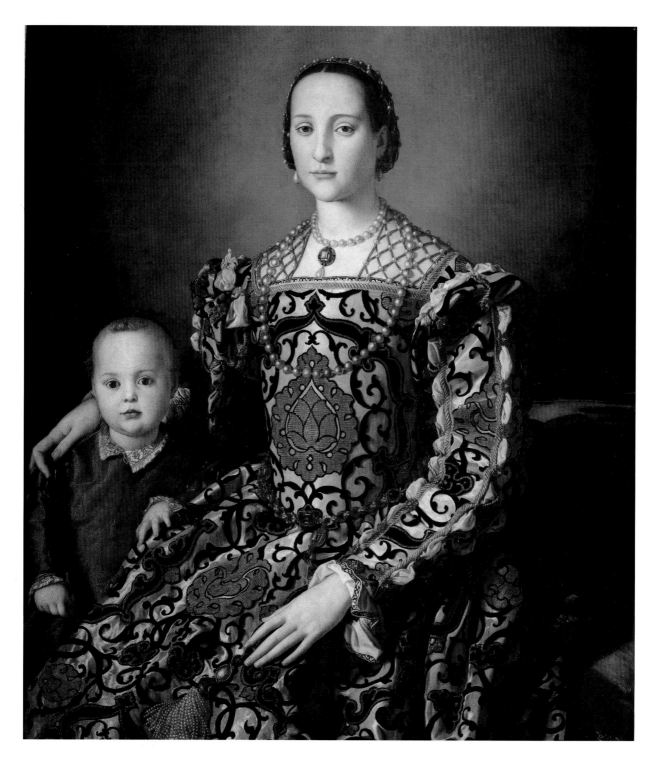

AGNOLO BRONZINO'S *PORTRAIT OF ELEANORA OF TOLEDO WITH HER SON GIOVANNI*, C. 1545.
GALLERIA DEGLI UFFIZI, FLORENCE

Cosimo and his clan. Bronzino's portrait of Eleanora of Toledo, Cosimo's wife, is icily beautiful, her face as meticulously delineated as her clothing (above). She wears a sumptuous dress cut from Florentine figured silk velvet. Pearls hang around her neck, form a mesh on her shoulders, and adorn her hair. Bronzino also painted Eleanora's chapel in her suite of rooms (p. 164). The scenes from the life of Moses and the *Deposition of Christ* are rendered in bright, almost glossy colors. They make the small room appear much larger and fill it with vibrant life.

Eleanora considerably enhanced the splendor of

CHAPEL OF ELEANORA OF TOLEDO IN THE PALAZZO VECCHIO DECORATED BY BRONZINO, 1541–46.

Cosimo's court. Her father, Don Pedro of Toledo, Charles V's viceroy in Naples, maintained a magnificent household. When Jacopo de' Medici visited it in 1539 to perform Cosimo's marriage to Eleanora by proxy, he wrote home that the attire, demeanor, and gifts of the Florentine delegation fell far short of Don Pedro's standard. Once Eleanora came to Florence, Cosimo set to improve the impression produced by his court. The frescoes painted by Vasari, Bronzino, and others certainly embellished his newly refurbished palazzo, but tapestries

JOSEPH PARDONING HIS BROTHERS TAPESTRY DESIGNED
BY AGNOLO BRONZINO AND WOVEN BY NICOLAS
KARCHER, PART OF THE *STORY OF JOSEPH* SERIES IN THE
PALAZZO VECCHIO, 1549–53.

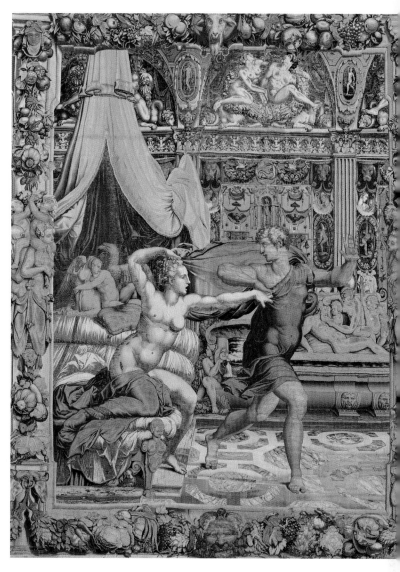

JOSEPH FLEEING FROM THE WIFE OF POTIPHAR TAPESTRY
DESIGNED BY AGNOLO BRONZINO AND WOVEN BY NICOLAS
KARCHER, PART OF THE *STORY OF JOSEPH* SERIES IN THE
PALAZZO VECCHIO, 1549–53.

were princely decoration par excellence. For much of the
fifteenth and sixteenth centuries Flanders had been the
leading region of tapestry manufacture. Now Cosimo
decided to establish a tapestry industry in Florence. He
persuaded two Flemish weavers, Nicholas Karcher and
Jan Rost, who had been working at Ferrara, to set up
two Florentine workshops, and directed them to train
Florentine youths in this art.

Out of this new venture came the twenty-piece
Story of Joseph (above). Bronzino, Pontormo, and Salviati
designed the cartoons from which Karcher and Rost wove
their tapestries. Cosimo intended this set for the Sala dei
Duecento, the former assembly hall of the republican

Council, which he turned into his reception hall. He
chose Joseph as a model Biblical statesman whose life
story could be readily compared with his own. Both
had come from a cadet branch of an extended family,
triumphed over exile, rose to a lofty position despite
adversity, and remained persistently loyal to their clan.
Both had cultivated the virtues of self-control, prudence,
and magnanimity—the themes explored in the tapestry
showing *Joseph Pardoning his Brothers* (above). Cosimo was
also famous for his marital fidelity, and for the rigorous
moral standards he enforced in his city. This aspect of his
rule is suggested by the scene of *Joseph Fleeing from the Wife
of Potiphar* after her attempt to seduce him. Indeed, every

VELERIO BELLI'S CRYSTAL AND ENAMELED SILVER CASKET,
1532. MUSEO DEGLI ARGENTI, FLORENCE

＜＋－＜＋－＜＋－＜＋－＜＋－＜＋－＜＋－＜＋－＜＋－＜＋－＜＋

piece in the tapestry cycle bears some pointed allusion to
Cosimo's life and rule.

The price of the *Story of Joseph* reflected its political
significance. It cost almost as much as the construction
of a good-sized church. Vasari, in his "Life of Pontormo"
commented that

> The Lord Duke then brought to Florence the
> Flemings, Maestro Giovanni Rosso and Maestro
> Niccolò, excellent masters in arras-tapestries, to the
> end that the art might be learned and practiced by the
> Florentines, and he ordered that tapestries in silk and
> gold should be executed for the Council Hall of the
> Two Hundred at a cost of 60,000 crowns.

The tapestries took nearly ten years to manufacture.
They were so large that only half of the ensemble could
fit into the great Sala dei Duecento at one time. But in

GIOVANNI ANTONIO DE' ROSSI'S ONYX CAMEO FEATURING
PORTRAITS OF COSIMO I, ELEANORA, AND THEIR
CHILDREN. MUSEO DEGLI ARGENTI, FLORENCE

＜＋－＜＋－＜＋－＜＋－＜＋－＜＋－＜＋－＜＋－＜＋－＜＋－＜＋

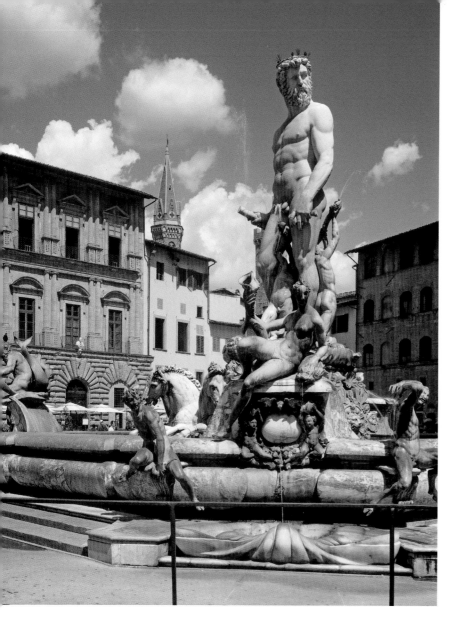

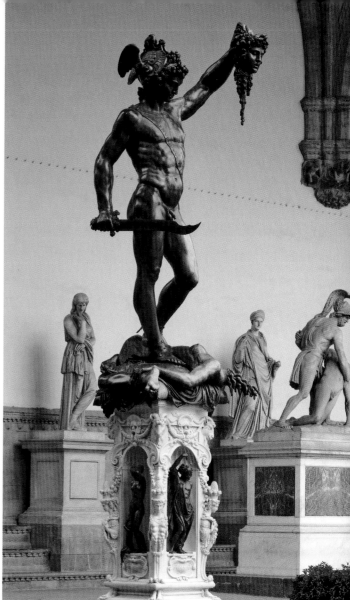

above, left BARTOLOMMEO AMMANATI'S *FOUNTAIN OF NEPTUNE* IN THE PIAZZA DELLA SIGNORIA, FLORENCE, 1560–75.

above, right BENVENUTO CELLINI'S *PERSEUS WITH THE HEAD OF MEDUSA*, 1545–53. LOGGIA DEI LANZI, FLORENCE

any case the weavings were too precious to be hung on a daily basis. Cosimo had them put up only on important state occasions, when he wanted to present himself and his court with particular grandeur.

Despite Cosimo's efforts, tapestry never became a major Florentine industry. Two workshops manned by locally trained craftsmen could not compete with the scores of established weaving businesses in Flanders. But two other art forms that Cosimo imported to his city did take root, and grew into internationally admired Florentine crafts: the carving of semi-precious stones and especially, the art of colored stone inlays.

The Medici had been passionate collectors of stonework since the fifteenth century. Their treasures, accumulated over

generations, fill the Museo degli Argenti in the Palazzo Pitti, and the quality and quantity of these holdings is staggering. Whole rooms are crammed with exquisite vessels of rock crystal and lapis lazuli, agate and amber, turned ivory and carved gems. Prior to Cosimo's reign these objects were imported from elsewhere. Most of Piero the Gouty and Lorenzo the Magnificent's stone objects were either ancient pieces set into contemporary mounts, or had been made in Venice or Milan. When pope Clement VII was courting an alliance with Francis I of France—marrying his kinswoman, Catherine de Medici, to Francis's son, later Henry II—he ordered their wedding present from Valerio Belli of Vicenza. Belli crafted a splendid silver-gilt casket with engraved rock crystal panels showing episodes from the life of Christ

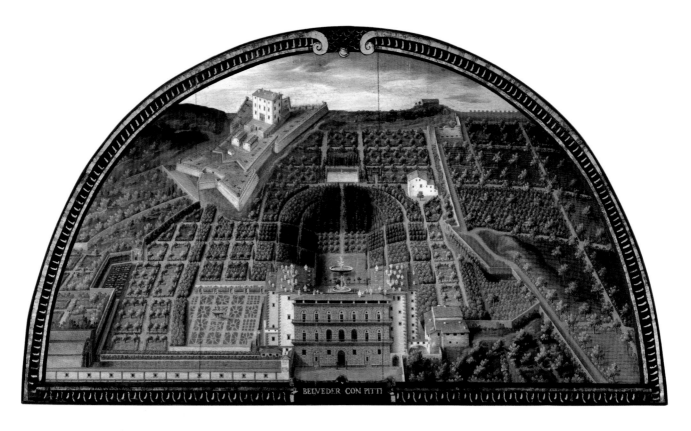

GIUSTO UTENS' LUNETTE WITH PALAZZO PITTI AND THE BOBOLI GARDENS, 1599. MUSEO
DI FIRENZE COM'ERA, FLORENCE

(p. 166, top). Rock crystal is hard to carve, and Belli's extremely detailed and volumetric reliefs are remarkable. He was so pleased with himself that he signed his name on every panel. Cosimo I, and subsequently his sons Francesco and Ferdinando, decided that they ought to have access to such fine stone-carving at home.

Of course they did not stop buying foreign-made creations, but they took active measures to establish the carving of colored stones in Florence. For 200 scudi a year Cosimo retained the Milanese gem-engraver Giovanni Antonio de' Rossi. Rossi carved an onyx portrait of Cosimo, Eleanora, and five of their children in a style that emulated the cameos of Roman emperors (p. 166, bottom).

Cosimo also imported into Florence the ancient art of colored stone inlay. Vasari designed one of the earliest inlaid stone tables in Florence. Its arabesque pattern was translated into mosaic of ebony, jasper, and ivory by the lapidary Bernardino di Porfirio. Ebony and ivory were components of costly ancient Roman tables mentioned by Pliny and Seneca. Sixteenth-century Florentines read these

authors and aspired to revive the best of Roman crafts.

It was Cosimo I who conceived the grandest artwork in hard stones in the city. In a eulogy for his father, Francesco I de' Medici spoke of Cosimo's dream of building yet another family mausoleum at San Lorenzo, one made "of mottled marbles . . . the precious stones of chalcedony, plasm, sardonyx, agate, and jaspers of various colors." Cosimo never realized this ambition, and it fell to Francesco's brother, Ferdinando I, to finally initiate the work at the turn of the seventeenth century, as we shall see in due course.

Cosimo was very savvy in using arts to shore up his power. For the Piazza della Signoria in front of the Palazzo Vecchio, he commissioned the Fountain of Neptune (p. 167, left). At this time it was still a major engineering feat to bring clean water to the city from a distant source, so Cosimo's fountain benefited his subjects and reminded them that they enjoyed fresh water thanks to him. The fountain was extremely important to Cosimo's propaganda, but the sculptural group adorning it is ugly. The figures are coarse and mannered. Far more handsome

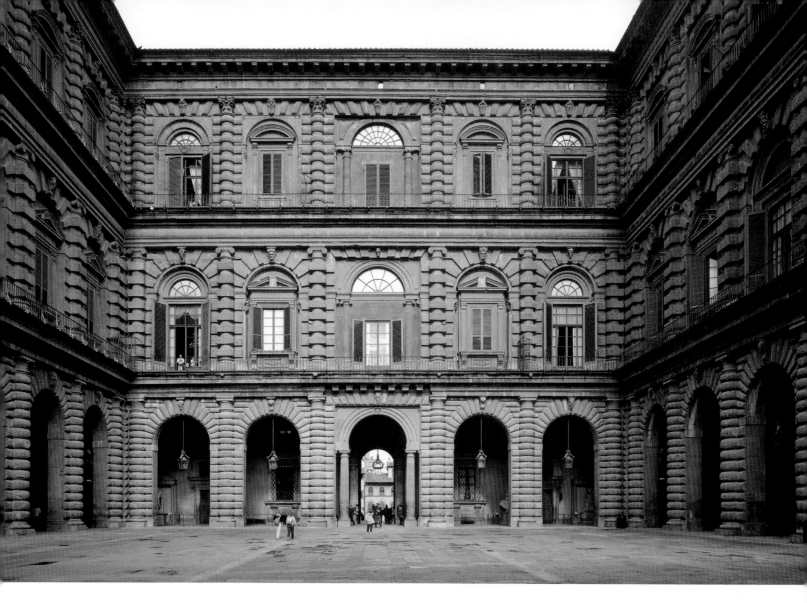

BARTOLOMEO AMMANNATI'S COURTYARD IN THE PALAZZO PITTI, FLORENCE.

is Benvenuto Cellini's bronze *Perseus Slaying Medusa* (p. 167, right). The inscription on the base explains that the group is an allegory of the Medici as saviors who had freed the citizenry from tyrants—a somewhat problematic interpretation, given that Cosimo I was, essentially, the tyrant of Florence.

Cellini was another over-lifesize personality in sixteenth-century Florence. He was an extremely talented artist, and not at all shy in praising his own accomplishments. He wrote an impassioned description of how he had cast the bronze *Perseus*, but then he was passionate about everything in his life, which he described in a colorful autobiography. He had been trained as a goldsmith in his native Florence, but in 1516 he was forced to leave the city following a brawl. He lived for a while in Siena, then in Bologna, Pisa, and Rome. In

the early 1520s he was back in Florence, but had to flee again after being prosecuted for sodomy and quarreling violently with fellow goldsmiths. He spent many years practicing his art in Rome, served Pope Clement VII, was accused of murdering a fellow goldsmith, and pardoned by Pope Paul III. In the 1540s Cellini worked for Francis I in France, and after that for Cosimo I in Florence. He was forever on the move, too restless to stay in one place, work quietly, or leave others in peace. In his autobiography Cellini constantly boasts of how much better his works were compared to those of his competitors, and complains about intrigues and injustices perpetrated against him. His ego was as huge as it was tender, but his creations at least show that his estimate of his merits was not unjustified.

To Cosimo it mattered little what Cellini thought

BERNARDO BUONTALENTI'S *GROTTA GRANDE* IN THE BOBOLI GARDENS.

Lanzi, opposite the Palazzo Vecchio, and next to what would soon rise as the Uffizi.

Cosimo wanted to consolidate his government not only politically, but spatially. So he commissioned Vasari to design a building complex that would house the ducal administration, the city's guilds, and Medici court artists. The building was called the Offices, or the Uffizi. Under Cosimo's son, Francesco I, the second floor became a museum of Medicean paintings and sculptures, and it has retained this function since. The Uffizi imitated an ancient Roman forum in its long U-shape and colonnades on the ground level. To make the building's link with the Roman Empire even more explicit, Cosimo had a statue of himself in the guise of Emperor Augustus placed in a niche in the cross-arm. In addition to the art collection, the most famous part of the Uffizi is a kilometer-long corridor that crosses the Arno above the Ponte Vecchio and leads all the way to the Palazzo Pitti. It gave Cosimo and his family an easy and secure way to move between their two residences, should it be unsafe to walk that distance in plain sight.

Palazzo Pitti originally belonged to the Pitti family of bankers and merchants, who began to construct it in 1458, hoping to outshine the Medici. But the scale of the project was so grand that they ran out of money to complete it. In 1549 Eleonora of Toledo acquired the building and began to transform it into a dwelling befitting her rank. Cosimo transferred his court there a decade later. He put the sculptor and architect Bartolomeo Ammannati in charge of the renovations. Ammannati designed the mannered, rusticated courtyard that faces the gardens on the slope behind the palazzo (p. 169). Niccolò Pericoli, known as Tribolo, a landscape designer and engineer, furnished the initial plans for the Boboli Gardens that now climb up the hill. Bernardo Buontalenti (literally "Bernardo of good talents") devised the fanciful grottoes, alive with statues and paintings, stalactites, and waterfalls (above).

Today the Palazzo Pitti and the Boboli Gardens are a sprawling complex that has been altered over centuries of occupation. The Palazzo houses several museums that are chock-full of furnishings, hard-stone objects,

of himself. What the duke wanted were artworks that combined aesthetic beauty and political potency. For him the *Perseus* symbolized the strength of his leadership, and perhaps also alluded to an Etruscan "revival," for the pose of the Greek hero resembles an Etruscan bronze statuette that the duke seems to have owned. For Cellini, meanwhile, the statue presented an opportunity to show off his skill as a sculptor, and to compete with Michelangelo's *David* and Donatello's *Judith*, both of which were displayed in the Piazza della Signoria. Indeed, the *Perseus* took an honorable place in the Loggia dei

opposite GIORGIO VASARI'S *STUDIOLO* OF FRANCESCO I IN THE PALAZZO VECCHIO.

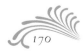

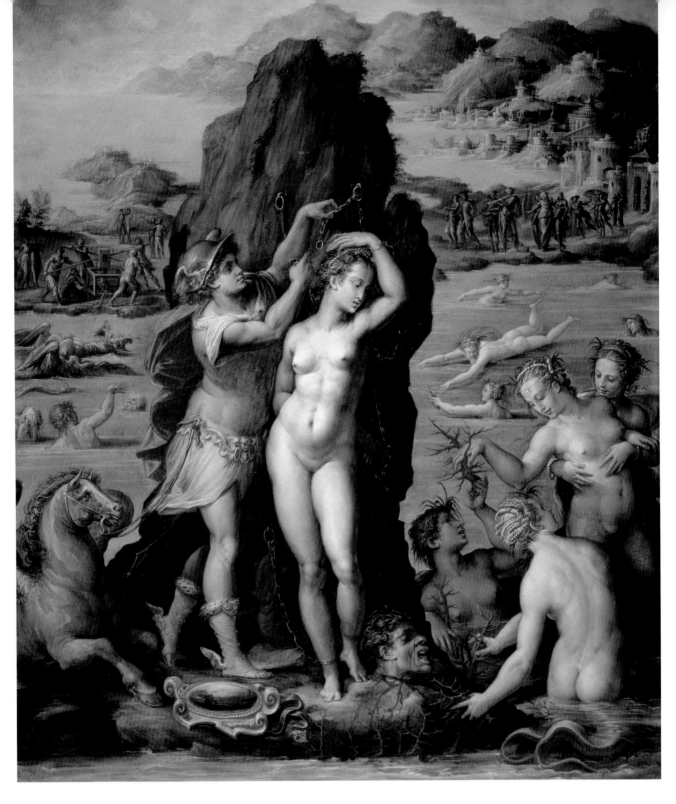

GIORGIO VASARI'S CUPBOARD PANEL DEPICTING THE *STORY OF THE ORIGIN OF CORAL* IN THE *STUDIOLO* OF FRANCESCO I.

paintings, and other treasures of the Medici family, gathered by many generations. From the garden one sees beautiful vistas of Florence and its countryside. It is lovely to escape the summer heat by strolling along the tree-lined avenues, or walk across terraces adorned with pools, fountains, and statues. But the formerly luxuriant plantings are now sparse, the whimsical grottoes seemingly under permanent repair; and crowds of overheated and underdressed tourists do little for the dignity of Cosimo's once opulent villa. Fortunately a late-sixteenth-century painting shows how the palazzo and its grounds looked in Cosimo's era: like a lush and tranquil suburban retreat (p. 168).

Cosimo's son and successor, Francesco I, was less

concerned than his father with consolidating and expanding his state. His was more preoccupied with mediating between his wife, Joan of Austria, and his lover, Bianca Cappello, and with his studies of philosophy, science, and alchemy. To pursue these interests in peace and concentration, he built himself a *studiolo* in the Palazzo Vecchio (p. 171). The room had been an empty space before 1570 when Francesco ordered Vasari to transform it into a sanctuary for learning and contemplation. The room was so private that it could only be reached from Francesco's bedroom by a small concealed door. Francesco asked Vincenzo Borghini, a prelate and scholar, to develop an elaborate program for the *studiolo's* decoration. Playing on Francesco's interests, Borghini devised a cycle of paintings and sculptures that explore the relationship between Nature and Man. In a letter to Vasari, Borghini explained that the room would have a series of cupboards built into the walls,

> in which to keep things that are rare and precious, both in terms of their value and artistic merit, that is to say jewels, medallions, precious stones, cut glass, crystal vases, mechanical devices, and other objects, not too big, placed in their own cupboards and divided according to category.

Each cupboard would have a painted door that would hint at what is stored behind it:

> It seems to me that invention must match the material and the quality of the things to be kept there so that it makes the room pleasant and... serves partly as a sign and almost an inventory of the things, with the figures and the paintings above and around the cupboards indicating in a way what is conserved within them.

Vasari himself painted the door that tells the *Story of the Origin of Coral*, following Ovid's *Metamorphoses* (opposite). As Ovid writes, having killed the Medusa, Perseus

> ... made a bed
> Of leaves and spread the soft weed of the sea
> Above, and on it placed Medusa's head.
> The fresh seaweed, with living spongy cells,
> Absorbed the Gorgon's power and at its touch
> Hardened, its fronds and branches stiff and strange.
> The sea-nymphs tried the magic on more weed

> And found to their delight it worked the same,
> And sowed the changeling seeds back on the waves.
> Coral still keeps that nature; in the air
> It hardens; what beneath the sea has grown
> A swaying plant, above it, turns to stone....
> Then to his heart he took Andromeda,
> Undowered, she herself his valour's prize.

In the Renaissance coral was admired for its beauty and treasured for its medicinal powers. So it was commonly found in princely treasuries. Other cupboard doors in the *studiolo* depicted a diamond mine, gathering of ambergris, pearl fishing, an alchemist's laboratory, and a goldsmith's workshop (p. 174), in which goldsmiths in the foreground assemble Cosimo I's crown. The panel in the center of the ceiling, painted by Francesco Morandini, called Poppi, illustrated the story of Prometheus, who stole the fire of the gods and taught man how to control the elements. Francesco was passionate about alchemy, so it was a perfect image for the room where he came to study this magic art.

Francesco's *studiolo* was typical of the art and curiosity cabinets that became fashionable in the sixteenth century. The germ of such cabinets already existed in the medieval and Renaissance treasuries of princes, where it was customary for rulers to amass objects of precious materials, magical powers, or exotic origins. As Europeans embarked on more frequent voyages of exploration to new and strange lands, they brought back a greater variety of man-made and natural wonders. These imports sparked a more scientific mode of studying nature, and inspired a more encyclopedic style of collecting. Curiosity cabinets became proto-museums in which human crafts mingled with nature's creations, and with strange things that defied categorization. The extent and variety of such compilations reflected the reach and learning of their owners.

Francesco's fascination with nature also prompted him to continue his father's efforts to found a school of hard-stone carving in Florence. He began to search for and amass valuable hard stones from around Tuscany and from distant lands. A huge pile of raw stones he assembled still lies in the courtyard of the Museum of Hard Stones, the Opificio delle Pietre Dure, in Florence. Francesco also enticed from Milan the brothers Ambrogio and Stefano Caroni, both highly esteemed

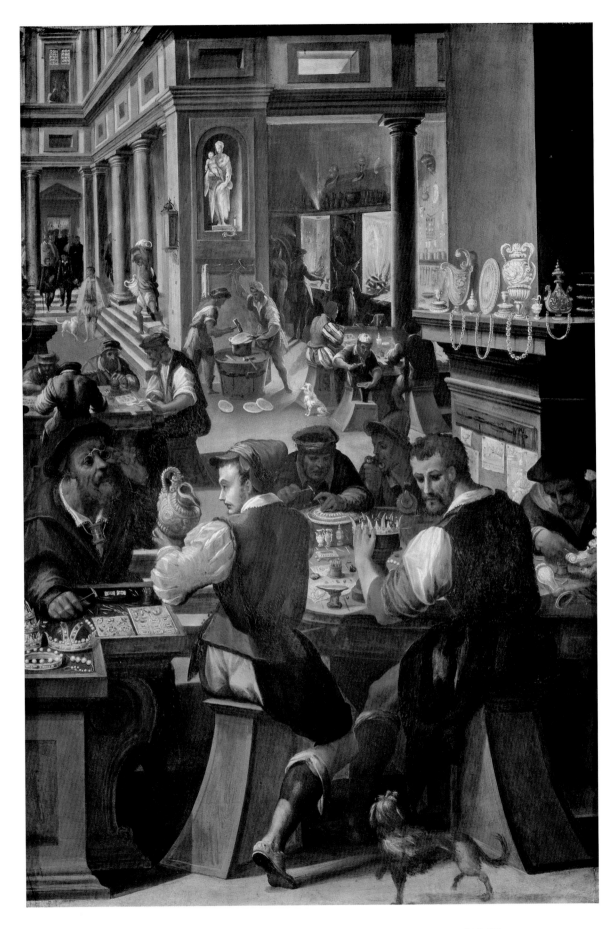

ALESSANDRO FEI'S CUPBOARD PANEL DEPICING *A GOLDSMITH'S SHOP* IN THE *STUDIOLO* OF FRANCESCO I.

above, left LAPIS LAZULI FLASK DESIGNED BY BERNARDO BUONTALENTI'S, CARVED BY MILANESE MASTERS, AND SET INTO A GOLD AND ENAMEL MOUNT BY JACQUES BYLIVELDT, 1581–84. MUSEO DEGLI ARGENTI, FLORENCE

above, right GOLD RELIEF ON AMETHYST DEPICTING *GIAMBOLOGNA PRESENTING FRANCESCO I WITH A FOUNTAIN FOR THE GARDEN AT PRATOLINO*, CREATED BY GIAMBOLOGNA, ANTONIO SUSINI, AND CESARE TARAGONI, 1585–87. MUSEO DEGLI ARGENTI, FLORENCE

carvers, who arrived in Florence in 1572. Three years later they were followed by master Giorgio Gaffurri. The grand duke built a workshop for his new artists in his private residence, the Casino of San Marco, so as to have them close by and closely associated with the court. Soon hard-stone carving and inlay became Florentine arts par excellence. One of the earliest products of Francesco's new workshop was the flask of Persian lapis lazuli carved by his Milanese artisans to a design by the versatile Bernardo Buontalenti (above, left). A Flemish-born court goldsmith, Jacques Byliveldt, set the vessel into a gold and enamel mount. Yet again, Tuscan arts were enriched by co-opting foreign expertise.

To showcase the finest artifacts in his collection, Francesco commissioned Buontalenti to design an octagonal room in the Uffizi called the Tribune. Its

dome was decorated with mother of pearl, and hard stones formed its inlaid pavement. Shelves lining the walls held hard-stone vases, and in the center stood a cabinet built of ebony and precious stones in which Francesco stored the choicest of his treasures. Unfortunately the cabinet, designed by Buontalenti in the shape of an octagonal temple, was dismembered and dispersed in the eighteenth century; but a few pieces that once decorated it survive. Among them is a series of gold reliefs set on a background of amethyst that celebrate Francesco's achievements. One of the scenes shows the sculptor Giambologna presenting the grand duke with a fountain for his favorite country villa at Pratolino (above, right). The relief brings together Francesco's major interests: colored stones, precious metals, and villas with lush parks and elaborate waterworks.

ART AND NATURE AT PLAY: BOBOLI, CASTELLO, PRATOLINO

T HE GREATEST EXCITEMENT WAS CAUSED BY A GARDEN
WHICH, PROPELLED BY INVISIBLE FORCES, MOVED INTO
THE COURTYARD AND UNFOLDED ON ALL SIDES TO THE
TWITTERING OF BIRDS. IN THE GARDEN WERE IMITATIONS OF TOWERS,
FORTRESSES, PYRAMIDS, SHIPS, HORSEMEN, AND ANIMALS, ALL MADE
OUT OF GREENERY. A CLOUD OF BIRDS SWARMED UP BEFORE THE GRAND
DUCHESS AND ONE OF THE ANIMALS LANDED IN THE BRIDE'S LAP, A GOOD
OMEN.

Description of a spectacle at the Medici wedding

The Mannerist age was one of artifice and ingenuity; and of absolute monarchs wielding
natural and man-made wonders as they jostled each other on the political stage. The Medici
grand dukes were still bit players on the international arena, but they did produce two popes
and two queens of France, including Catherine de' Medici, so deft at intrigue and poison. To
maintain their power and status the Medici had to put on a splendid show. The theatricality
of the age was on their side. So were the resources of Tuscany: her natural riches, artistic
traditions, and her talent for converting foreign imports into glorious local arts. In the end,
the Medici may not have significantly enhanced their position, but they played midwife to
three new Tuscan creations: elaborate gardens populated by lively sculptures and clever water

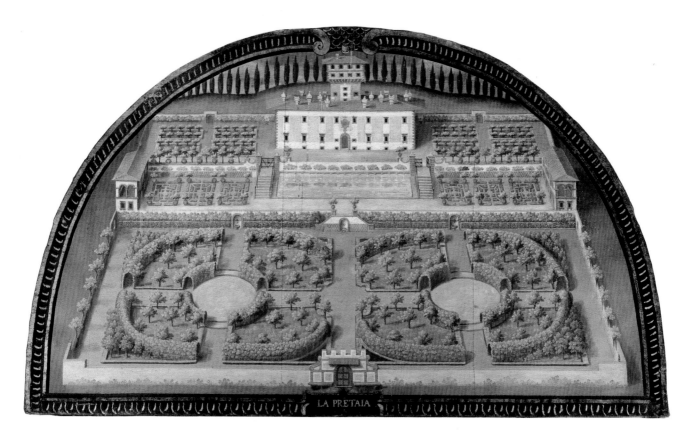

GIUSTO UTENS'S LUNETTE WITH A VIEW OF VILLA LA PETRAIA, 1599. MUSEO DI FIRENZE
COM'ERA, FLORENCE

tricks; stage designs of unprecedented ingenuity and scale; and pictorial inlays of semi-precious stones. A common thread linked these creations: nature and art constantly at play.

Already in the fifteenth century the Medici dotted the Tuscan countryside with their villas. The more power they assumed, the more and grander were the villas they built. Unfortunately, as the centuries progressed, new owners altered the original buildings and their grounds to suit changing needs and tastes, so today many of the Medicean elements are gone. Fortunately a near-contemporary record captures what has been lost. In 1599 Ferdinando I, son of Cosimo I, asked Giusto Utens to paint a series of lunettes showing all the Medici villas (above; p. 180). He hung these pictures in the grand salon of the Villa Artimino, his favorite estate, so that he could see all he owned.

In building their villas the Medici turned to the usual source of inspiration—the wise ancients, who held the golden keys to all life's doors. The foremost authorities on rural retreats were Virgil, whose *Georgics* and *Eclogues* idealized productive and contemplative country life, and Pliny the Younger, whose letters sang the praises of the beauty and fecundity of his Tuscan estate. Lorenzo de' Medici likewise dabbled in verses that exalted the happy peasant existence, although, admittedly, he had little experience of it himself.

The ancients were excellent teachers, walking their readers through every stage of villa construction and other aspects of life as well. Pliny explained how to choose a proper site for the main house, making the best use of the climate and picturesque views. He also indicated each room's particular relation to the garden

previous spread ORAZIO SCARABELLI'S *NAUMACHIA* IN THE COURTYARD OF PITTI PALACE, FLORENCE, 1592.

and the surrounding topography, and the employment of each space as the seasons changed.

Leon Battista Alberti, having absorbed Pliny's prescriptions as well as those of Vitruvius, the most influential Roman writer on architecture, weighed in with his own advice. He dedicated his treatise *On Architecture* to Lorenzo de' Medici, who would appreciate and use its contents. "I do not think it necessary," Alberti wrote, "for the gentleman's house to stand in the most fruitful part of his whole estate, but rather in the most honorable, where he can, uncontrolled, enjoy all the pleasures and conveniences of air, sun, and fine prospects." The main house, he advised, should face the rising sun at the equinox, be open to pleasing vistas, but at the same time be sheltered by surrounding hills. The villa should sit on fertile soil and have nearby woods and streams in which the owner could hunt and fish. And the estate should provide for all its occupants, including the peasants who worked the land, and have sufficient supply of water, olive and wine presses, a mill, a winter garden, stables, and storage sheds. In other words, it should be a self-contained and industrious paradise.

The fifteenth-century Medici followed these basic precepts on a modest scale; but in the sixteenth and seventeenth centuries, as the grand dukes grew more ambitious, their villas developed into splendid mansions in which the family's stature was cultivated as carefully as the land. This was the moment that gardening became a new Tuscan art. As the Medici and their guests strolled through the grounds of different villas, they were awed by the varieties of plantings, amused by capriciously trimmed topiaries, stimulated by fountains shaped into mythological characters, and surprised by grottoes alive with sculptures and water tricks. Nature was turned into art, and rural retreats transformed into theaters of power.

For this was the age of wonder. Princes greedily gathered natural and man-made artifacts to feed their curiosity, display their erudition, and boast of access to the riches of the world. As Europeans ventured further and further to explore, trade, and conquer, sailing to the Levant and Asia, Africa and the New World, they brought back an ever greater array of booty, including exotic plants. Francesco I de' Medici, and his brother Ferdinando I, plunged into this intellectual and scientific commerce. They did so to feed their passion for natural

marvels, and to impress their peers and superiors. They succeeded admirably. The French naturalist Pierre Belon, visiting the Medici garden at Castello, immediately spotted a rare Indian fig tree whose roots grew from every branch of the main body. And the orchard of dwarf fruit trees in the Boboli Gardens was deemed by contemporaries to be suitable for a king. This was precisely the effect the Medici wished to produce.

The choice of plants and their disposition was a serious business. Who better to follow on such matters but the ancients? Pliny's uncle, Pliny the Elder, was full of advice in his exhaustive *Natural History*. Pliny the Younger detailed his own garden designs. Suetonius described the fecund grounds of Nero's Golden House, while Theophrastus, Galen, and Dioscorides discussed the benefits of particular plants. Armed with this information, the Medici planted their trees and orchards in orderly rows, clipped box-hedges into clever geometric and anthropomorphic silhouettes, and cultivated herb and flower beds to enrich their dishes and vases. They populated their gardens with sculpted gods from pagan mythology, and constructed grottoes with intricate automata and waterworks. Even tree houses on Medicean estates were made into stage sets of sorts. At Castello and Pratolino huge oak trees housed pavilions to which guests ascended by spiral staircases. Platforms nestled in the branches were outfitted with marble tables, benches with trellised backs, and fountains gurgling freshly piped water.

Waterworks were the life and spirit of Mannerist and Baroque gardens. Contemporary architectural and agricultural treatises judged the merits of a garden by the quality and quantity of its aquatic displays. But water was an exclusive commodity: an aqueduct had to be built before water could flow freely through a villa and its parks. The seemingly inexhaustible water spurting from the Medici fountains and automata was a miracle of engineering and a princely luxury.

Of course the ancients were also the main muses behind these waterworks. Archimedes, Aristotle, Hero of Alexandria, and Vitruvius all described marvelous Greek and Roman hydraulics, which fired the imagination of Renaissance and Baroque engineers and craftsmen. The automata at the Medici villas drew inspiration from Hero's *Pneumatics*, and from the devices appended to the Italian translation of this text by Giovanni Battista Aleotti. An

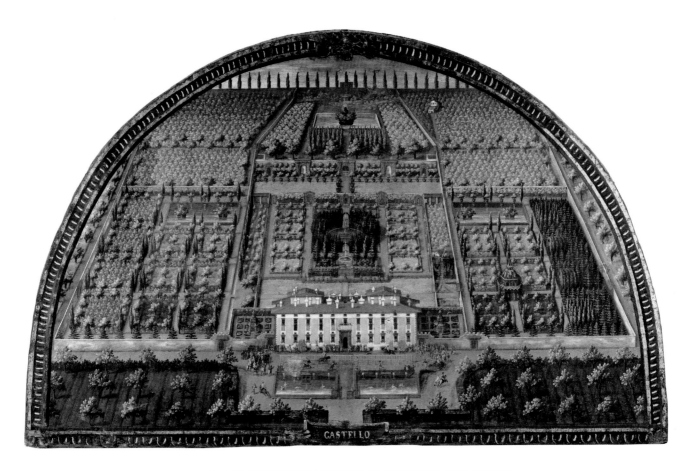

automaton of the woodland god Pan at Pratolino got up and sat down, moved his head and eyes, and played pipes. Enraptured observers said that it surpassed even the works of Daedalus, the legendary ancient Greek sculptor and inventor whose ingenuity cost him his son's life.

Today, most of the marvels that delighted the Medici and awed their visitors have vanished. The gardens have been replanted with less creativity or allowed to overgrow; the fountains have crumbled or been removed; the grottoes are silent for lack of water; and there is not a trace of automata in sight. But imagination, helped by period writings and pictures, is a kind companion. Strolling through the decrepit park at Pratolino, or

standing on a terrace overlooking the villa at Castello (above; opposite), an imaginative visitor can briefly bring them back to life.

Castello sits at the foot of Monte Morello, three and a half miles north west of Florence. It used to be pure countryside, but now the city's sprawling suburbs reach to the villa's gates. Above the estate a slope gradually rises toward the mountain. Below it a plain descends to the Arno. In Cosimo I's day the entrance of the house faced a vast lawn with two large fish ponds filled by a still functioning Roman aqueduct. Beyond the lawn, a long avenue covered by an unbroken vault of mulberry trees ushered the owner and his guests to the main gate, where two fountains spouted water

opposite, top NICCOLÒ DI RAFFAELLO DE' PERICOLI CALLED TRIBOLO'S GARDEN IN THE VILLA MEDICI AT CASTELLO.

opposite, bottom THE MAIN HOUSE OF THE VILLA MEDICI AT CASTELLO.

for the benefit of passers-by and their animals. Magnanimity, including dispensing water to one's subjects, was one of the virtues expected of a prince.

The main house was of no particular distinction, although it had been built in the late fifteenth century by Giovanni and Pier Francesco de' Medici, cousins of Lorenzo the Magnificent, and was the original home of Botticelli's *Birth of Venus*. Cosimo I took possession of Castello soon after becoming the duke of Florence and immediately began to transform it into a lavish retreat worthy of his new rank. He ordered Niccolò Pericoli, nicknamed Tribolo, which means Teaser or Vexer, to

reorganize and expand the building and especially its parks. According to Vasari, Niccolò was a devil among his school friends, incessantly teasing and tormenting everyone, hence his moniker. When he grew up and became an architect, sculptor, hydraulic engineer, and garden designer, he channeled his quick and mischievous mind into ingenious designs for various Medici estates.

At Castello, Tribolo devised for Cosimo a succession of stage sets. As the grand duke stepped out of the north doors of his villa, the ones facing the mountain, he first crossed a lush lawn. Then he entered a garden, described by Vasari:

far left FOUNTAIN OF HERCULES AND ANTAEUS IN THE VILLA MEDICI DI CASTELLO DESIGNED BY NICCOLÒ TRIBOLO C. 1543.

left BARTOLOMEO AMMANNATI'S SCULPTURE FOR THE FOUNTAIN OF HERCULES AND ANTAEUS, 1559–60.

breath. The walkway around the fountain concealed myriad little jets. As guests strolled and admired the fountain, a slyly turned key switched on the jets and drenched them under their jackets and skirts.

Another surprise greeted visitors on the other side of the labyrinth, further up the slope. Traversing the lawn, which you can see in Utens's painting, they arrived at a somber portal supported by two columns and two rusticated pilasters. As soon as they crossed this ordered threshold, they found themselves in a wild realm: a cave bristling with stalactites and mineral accretions. The ceiling grimaced with masks made of shells, and from the three walls emerged what looked like real animals carved from colored stones to convey the markings of their hides (pp. 184–185). In the left niche a mottled brown giraffe towered next to a scaly gray rhinoceros; a spotted beige monkey perched on a rock and looked down on a russet bear who stuck out its tongue. Various hoofed creatures inhabited the right niche: a deer and a goat, a bull, a horse, and a boar, along with a camel with a monkey on its back. But do not think these were mere decorations. The Mannerists loved complex allegories, some of them so arcane as to puzzle even the most learned men. The animals at Castello hinted at Cosimo's virtues and achievements. The duke himself was cast as the white unicorn in the central niche. There he stood rampant, and framed by a shimmering arch of water that sprayed from hidden jets in the floor. Since ancient times the unicorn was admired for being invincible, and for possessing the gift of purifying water by dipping his horn into poisoned springs and making them safe and available to all. Cosimo retrieved the water from its mountain sources, channeled it through his gardens, and brought it to his subjects.

The aqueducts feeding Castello were constructed by Tribolo. He tapped nearby streams, laid a network of elaborate pipes and locks in the ground of the villa, devised the mechanics for fountains and automata, and

... In the middle of this garden is a forest of very tall and thickly planted cypresses, laurels, and myrtles, which laid out in a circular shape, have the form of a labyrinth, all surrounded by box-hedges . . . so even and grown with such beautiful order that they have the appearance of a painting done with the brush.

At the center of the labyrinth stood a fountain sculpted by Ammannati: *Hercules Struggling with Antaeus* (above and opposite), an allusion to Cosimo's triumph over his foes. Hercules squeezed the body of his enemy and water gushed out of his mouth as if it were his last

above, left GROTTO OF THE ANIMALS IN THE VILLA MEDICI DI CASTELLO DESIGNED BY NICCOLÒ TRIBOLO WITH SCULPTURES BY BARTOLOMEO AMMANNATI.

above, right GROTTO OF THE ANIMALS IN THE VILLA MEDICI DI CASTELLO DESIGNED BY NICCOLÒ TRIBOLO AND SHOWING THE CEILING WITH INLAID SHELL MASKS.

led the water out the gate for public use. The Englishman William Thomas, who visited Castello in 1549 while composing his history of Italy, pronounced the gardens "one of the excellentest thynges in all Europe," where "every flower is served with renning water." Clearly contemporaries paid close attention, and were duly impressed by what Cosimo and Tribolo had done.

In Cosimo's day Nature, tamed by the duke and awaiting his pleasure, danced hand in hand with man-made Art. Today the replanted flower beds lack spirit. The labyrinth with its Hercules fountain and sneaky water jets is gone. The fragrant herbs and flowers no longer perfume the hot summer air. Also lost are the lawns that, like intermissions, let the viewer's eyes and mind rest between stage sets. The grotto is dry, and the animals look at an occasional guest with muted eyes. But they are still so vividly crafted that, standing under the portal and peering into the dormant cave, the visitor might well wish to jump over the barrier and touch their flanks and muzzles. It does seem as if the rusty old mechanism might miraculously crank into action, the water jets again sputter and emit their streams, the sleeping beauty of the garden awaken, and all that Cosimo and Tribolo dreamt and created return to life.

The Medici villa at Pratolino (p. 186) is even more of a ghost. Francesco I built it as his favorite retreat to which he withdrew with his Venetian lover, Bianca

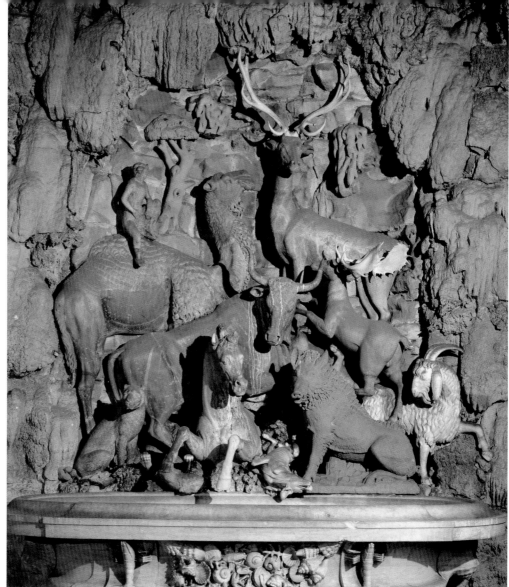

above GROTTO OF THE ANIMALS IN THE VILLA MEDICI DI CASTELLO DESIGNED BY NICCOLÒ TRIBOLO WITH SCULPTURES BY BARTOLOMEO AMMANNATI.

Cappello. After their deaths, the property changed many hands. The last private owners were the Russian Princes Demidoff, who occupied it from the late nineteenth to the mid-twentieth centuries. Then Pratolino was sold to the state. Today, without caring owners or residents, the estate is in dispiriting decline.

It is heartbreaking to wander the grounds now, past crumbling buildings, such as the chapel, under permanent restoration, past decaying sculptures and silent grottoes, some barely visible among wild bushes. From Utens's lunette and period documents we can imagine how the villa looked when Bernardo Buontalenti first built it between 1570 and 1575. Bernardo was as multi-faceted as Tribolo, and similarly served the Medici as an architect,

military engineer, and an inventor of automata and theatrical sets. Utens's painting shows that unlike the typical symmetrical design of Tuscan gardens, Pratolino's grounds resembled a landscaped forest. Wild ravines alternated with geometric hedges, labyrinths mingled with trick waterworks. The play of nature and art was even more inventive than at Castello, and gave Francesco and Bianca more to enjoy.

Pratolino's greatest marvel was its grottoes. Montaigne describes one in his *Voyage in Italy*, written in 1580:

There is an extraordinary grotto composed of numerous niches and rooms, inlaid everywhere with

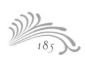

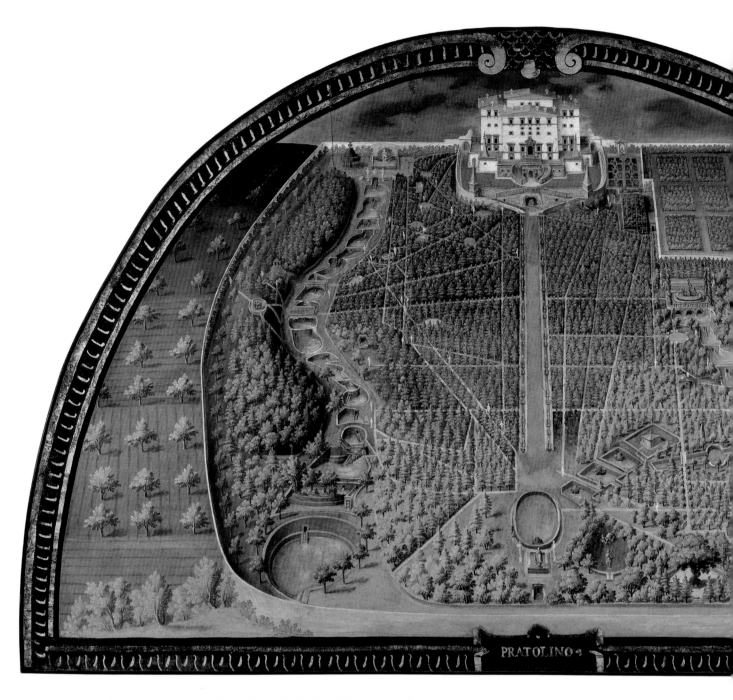

PRATOLINO

a mineral extracted from certain mountains, held together by invisible nails. With the action of the water, not only music and harmonies are created, but various movements are imparted to statues and doors, innumerable animals dive in to drink and other such things. . . . When you move a single device, the whole grotto fills with water: the seats spurt water onto your buttocks, and if you run away up the steps to the castle, every second step squirts out a thousand jets that soak you until you reach the top of the structure.

Water tricks depended to a large measure on surprise. Contemporary writers recommended placing jets where guests might naturally pause to admire some lovely statue, or in an enclosed space where they could not easily escape. Part of the thrill of visiting princely gardens must have lain in anticipating an imminent soaking, but not quite knowing when or where it would come. On a hot summer day, a cool spray was probably a welcome refreshment for the residents of the villas and their guests as they sweltered in long hose and full skirts of satin or brocade.

The abundance of water at Castello was all the more impressive because the site was barren and hard to cultivate. The Medici designers and engineers worked miracles to transform a steep and inhospitable slope into a lush park. It took twelve springs to feed the waterworks. Montaigne quipped that Francesco had selected the location on purpose, to have the honor of bringing water from five miles away. Fynes Moryson, another contemporary traveler, remarked that the Medici spent more on their water than on their wine. Water was the soul of Pratolino. It enlivened statues, delighted the senses, and nourished the encyclopedic grand-ducal collection of plants.

The cleverness with which water and garden design were united was the hallmark of Mannerist villas. Of Pratolino Montaigne wrote that:

At the foot of the castle, there is, among other things, an alley fifty feet long. . . . On both sides, every fifth or tenth step, [are] certain long, most beautiful stone parapets, at whose level some small fountains spurt out of the walls; in this manner, the whole alley becomes a succession of water jets. At the end,

above and left GIUSTO UTENS'S LUNETTE WITH A VIEW OF THE VILLA MEDICI AT PRATOLINO, 1599. MUSEO DI FIRENZE COM'ERA, FLORENCE

a pretty fountain pours its water into a large basin through a marble statue representing a woman doing her washing; she is wringing a towel of white marble, from which water drips down, and underneath, there is a second basin that seems filled with boiling water for the washing.

Utens's lunette shows the washerwoman fountain at the bottom of the hill (p. 186, detail). By tradition and necessity, after water passed through a garden, it was turned to practical ends. At Pratolino, after flowing through the ornamental fountains and automata, and nourishing all the greenery, it was channeled into the poultry pen and the stables, and drove three mills. The statue of the laundress at the bottom of the villa playfully commented on this conversion of pleasure into utility.

Such witty creations sprang up all over Pratolino, even in the substructure of the villa. If guests poked their heads into a grotto underneath the building, they discovered a secret room. In its center stood an octagonal table with holes for bottles and glasses. A cold spring bubbling up from below chilled the drinks—serving as a kind of natural ice bucket. At the entrance to the room a stone waiter greeted visitors, pouring water into a basin so that they could wash their hands. When in 1588 eight French gentlemen visited the villa, a chronicler who accompanied them noted that one should not attempt to dry one's hands on the towel extended by the waiter: it was made of marble, but so convincingly as to fool the eye. Above the waiter, in a niche, a shepherd played the bagpipe to entice a nymph to appear. She emerged from a side door, strolled by with a bucket of water, turned around, and disappeared from sight.

Today, the once magnificent groves and lush plants are shaggy and unkempt. The water-pergola is now a gravel path, and the grottoes that once dotted the property have crumbled. Of mischievous waterworks only a few faint drawings in travelers' notebooks remain. But on my own visit to the villa, as I walked past one small grotto and peered into its damp darkness, a tentative light went on, the water woke up and began to gurgle and spout, and I jumped back in surprise and delight. I was so struck by this discovery that I backed up, waited for the water to die down, and tested whether I imagined it or whether the grotto had in fact come to life when I passed. I approached the entrance again, and again the grotto sprang into action. Thrilled, I continued on my walk. Up on the meadow overlooking the grounds, I had an audience with the old man Apennine (opposite). This colossus, a product of Giambologna's imagination, still looms as tall as the surrounding trees, even though he sits and bends down to crush the head of a monster at his feet. I also greeted the river god Mugnone, who watches over a brackish pool under the terrace where the villa used to stand. Alas, that was all. The rest of Pratolino has reverted to its wild state. Nature has swallowed up the artistry with which it had once been tamed and groomed.

WHILE IN THEIR COUNTRY ESTATES THE Medici showed off Tuscan gardening and engineering, in Florence itself they fostered the equally impressive theater arts. Florentine artists had long prided themselves on their skill at *disegno*—design and drawing. Now they took this art to a new level, producing for the Medici the most dazzling multimedia festivals to date. The grand dukes, eager for international recognition, mounted particularly lavish shows during weddings, when Florence filled with foreign guests. Their ambitions and their artists' talents resulted in the most advanced theater since the ancient stage.

We are lucky that the Medici were such astute self-propagandists. By their very nature theater and other related spectacles are ephemeral arts. Opera and ballet, parades and tournaments, sets and costumes, all last for a few moments and then vanish from life. To publicize the splendor of their dynasty, and to convince the royal houses of Europe of its validity, the Medici produced official descriptions of their festivals. These printed

opposite GIANBOLOGNA'S *APENNINE* IN THE VILLA MEDICI AT PRATOLINO, 1579.

AGOSTINO CARRACCI'S PRINT OF *APOLLO SLAYING THE DRAGON* AFTER STAGE DESIGN BY
BERNARDO BUONTALENTI, 1592.

＜＋

booklets, often illustrated, have preserved the memory
of those events for us. The prints are only black lines
on white paper; they convey no color or sound, no
movement or passion of live events. But without them
we would have nothing, or only the scattered words of
chronicles. Moreover, they are delightful artworks in their
own right.

Even those who witnessed the Medici festivals could
hardly believe their eyes. As one observer wrote, "their
splendor cannot be described, and anyone who did not
see it could not believe it." But perhaps we can try. Let
us travel back to May 1589, when Ferdinando I married
Christine of Lorraine. The month-long celebration had
a packed program. There were plays, a mock naval battle,

chivalric tournaments, and street masquerades. A football
game was scheduled and so was animal baiting. Countless
banquets alternated with parades. The city was crowded.
Ferdinando's image was at stake.

He had become grand duke of Tuscany only two
years earlier, at the death of his brother Francesco I,
whom he detested. Nor had he planned on a political
career. As a second son he had been sent on an
ecclesiastical path. At fourteen he was appointed cardinal.
Since then he had resided in Rome, immersed in religious
affairs and patronage of the arts. But in 1587 Francesco
died, and Ferdinando acted swiftly. He renounced his
vows and sped to Florence to assume control. Now he
had to plan not only his own future, but that of the

dynasty. He scanned the European bridal market for a suitable wife and chose Christine, his distant cousin and the favorite granddaughter of Catherine de' Medici, the queen of France.

Princely weddings were always prime opportunities to show off the groom's power and resources, and to advertise his promise. Ferdinando's festivities were not new in kind, but they took traditional Tuscan arts to new heights. What particularly astonished the observers were the theatrical scenery and machinery. Their chief designer was Bernardo Buontalenti, the versatile genius of Pratolino and countless other Medicean works.

Two spectacles stood out among others. One took place on May 2, in the Medici theater in the Uffizi. This first permanent indoor theater, with a modern proscenium arch, had been designed by Buontalenti three years earlier and updated for this day. On the program was the comedy *La Pellegrina* (The Female Pilgrim), written by Girolamo Bargagli to flatter the bride. But more exciting than the play were its intermezzi, or mini-plays between the acts. The *intermezzi* were the most inventive parts of Florentine theater, combining song, dance, instrumental music, marvelous stage machinery, and movable sets. They are the foundation of theater and opera as we know them, and were miracles to those who saw them for the first time.

The plots of the six intermezzi of *La Pellegrina* derived from Plato, Plutarch, Ovid, and Virgil. Each was a separate story, but all were linked by a common theme: the power of music to influence gods and humans. In the most dramatic episode, Apollo slew the Python by, essentially, dancing him to death. The symbolism of each piece was so complicated that even the most sophisticated viewers were confused. What everybody watched for were clever sets, beautiful costumes, and wondrous special effects.

As the Apollo intermezzo began, the curtains opened onto a forest clearing. At its center rose a large rocky cave. All around it the vegetation was burned and withered. This was the den of the Python, a great dragon who had been terrorizing the island of Delos, Apollo's sacred precinct. Eighteen couples—the harassed Delians—entered the stage and proceeded to narrate their woes in a sung lament. As they recounted the troubles caused by the monster, the Python stuck his head out of the cave and emitted a fiery

plume. The Delians beseeched Apollo to deliver them from the scourge. Suddenly the clouds above parted, and the god himself swooped down, brandishing his bow and arrow (opposite). He alighted on the stage and, to the sound of music, surveyed the burned forest and the quivering Delians before him. The music changed and the god challenged the Python to a duel. He fought the monster first in an iambic rhythm, then pursued him in a spondaic dance. After much thrashing and lunging, and more fiery plumes from the dragon, the Python succumbed, fell to the ground, and spilled a pool of black blood. Triumphant, Apollo executed a swift victory dance, and the delighted and relieved Delians burst into a chorus, praising him with Delphic hymns.

Jaded by the tricks of modern technology and computer graphics, we may think this intermezzo a child's play. But to Ferdinando's guests the rapidly parting clouds, the flying Apollo, and the fire-belching dragon were all marvelous novelties, and to its designers, months of hectic work (p. 192). If we peek behind the scenes of the production—mind you, a small portion of the long and involved play—we discover (in the financial accounts of the purveyor of the Medici household, Girolamo Seriacopi) that the monster's head and paws were made from papier-mâché; the flying Apollo was a mannequin attached to a wire and quickly substituted by a live actor for the battle scene. And since female members of the chorus were played by male singers, they wore masks to conceal their beards and had papier-mâché breasts. These were simple solutions to technical problems. Buontalenti and his team also resolved more tricky challenges. To change sets rapidly, they installed layers of moving panels that could be pulled on and off the stage. They also had to tackle the issue of ventilation. Since open flame was the only available source of light, and hundreds of candles and torches were used to illuminate the theater, their smell, smoke, and heat had to be channeled outside. To air out the space, Buontalenti carved and then concealed holes in the ceiling, camouflaged open windows with artificial foliage, and used the "starlight" perforations in the drop-cloths representing the heavens to release smoke produced by the torches and the fiery effects on stage.

Despite all these measures, the seven-hour-long play with five acts and six intermezzi was trying for the

BERNARDO BUONTALENTI'S DESIGNS FOR THE COSTUMES OF *LA PELEGRINA*, 1589.
BIBLIOTECA NAZIONALE, FLORENCE

◄-

actors, the stage hands, and the assembled guests. The audience, dressed in opulent garments cut from heavy fabrics, sweated profusely in the hot and crowded theater, their perfume barely masking the odor of rarely washed bodies. The heads of the audience swam with sensory overload; their bladders screamed for relief. And this was just the opening week of the wedding festivities. More trials by art lay ahead.

On May 11, the celebrations shifted to the Palazzo Pitti. There a triple program awaited the newlyweds and their over-stimulated guests: a chariot parade, a foot joust, and a *naumachia*, a mock naval battle inspired by ancient Roman combats (p. 176). The day opened with a disaster. Just as the spectators took their seats around the

courtyard—the stage for the upcoming spectacles—the skies opened up and erupted with a torrential rainstorm. Despite the great red awning stretched over the courtyard, the floor was flooded, the viewers drenched, and the proceedings delayed by an hour. But at last the weather cleared, and the spectacle began.

Part One: the parade and joust. The contestants entered the arena in exuberantly playful chariots, each one a work of art. There was a chariot shaped like a smoking volcano; another made into a frightening ship of Death; a third driven by a magician perched atop a mountain full of imprisoned animals; a fourth depicting a huge fountain drawn by satyrs; and so on. The referees of the tournament, Vincenzo Gonzaga of Mantua and Don Pietro de' Medici,

Ferdinando's younger brother, rode in a chariot driven by winged devils and pulled by a large dragon. The front of the carriage gaped with the mouth of Hell; winged Lucifers slithered along its sides; and the wheels had flaming spokes. Once the chariots discharged their passengers, the knights engaged in chivalric combat on foot.

When this show was over, the noble company retired inside the Palazzo Pitti for dinner. The moment they were gone, frantic activity engulfed the courtyard. The floor, caulked with pitch beforehand, was flooded with six feet of water. A fleet of seventeen ships was brought in, scavenged from all over Tuscany over the preceding year. Manned by 120 Christians, the ships stood ready to emerge from the grotto located between the courtyard and the Boboli gardens. The eighteenth ship was occupied by the Turks. Fourteen more Turks (or actors playing their role) guarded the Turkish fortress erected over the fountain on the far side of the courtyard. In the upcoming encounter the Christians would embark on a Crusade against the Infidel—a beloved theme of European kings.

Fortunately, princely banquets were always a lengthy affair, so the spectacle organizers had just enough time to get everything ready for the *naumachia*. As soon as the diners consumed the last dessert and emptied their glasses, fanfares and artillery salvos summoned them back to the courtyard. The admission tickets, incidentally, were made from small pieces of porcelain, a shrewd advertisement for the new industry pioneered by the grand dukes.

A commemorative print of the *naumachia* helps us somewhat to imagine the excitement and the passion of the spectacle (p. 176). We see the audience crowded around the edges of the floor and on the surrounding balconies. Boats jostle on the artificial sea. What we are missing are the deafening gun shots; the smell of gun powder; the screams of wounded Turks uttered in Turkish; the individual struggles of fighters fallen overboard; the cheers of joy at the demise of the Turkish galley; and the triumphal cries of the actors and spectators when the Christians finally climb up on the Infidel fortress and gleefully raise their flag.

The *naumachia* was more than a good show. It groaned under layers of symbolic weight. There was the obvious crusading posture, incumbent on any and all European princes. The maritime theme spoke of Ferdinando's interest in building up the Tuscan fleet. In fact, the actors who enacted the mock battle were his crew of sailors normally stationed in Pisa, as well as foreign seamen on shore leave at Livorno. And then there was the inevitable comparison of the Medici with ancient Romans, who first staged *naumachiae* in the flooded amphitheaters across their realm.

Ferdinando's spectacles initiated his marriage and his reign brilliantly. Although his union with Christine had been an arranged match, it proved loving and harmonious, and Ferdinando's ability to marshal the vast army of people who produced his wedding festivities presaged his success as grand duke. He assembled from all over Tuscany planners and designers, carpenters and tailors, metal smiths, painters, sculptors, actors, singers, and countless other craftsmen. He gathered all the necessary materials from which to build ephemeral displays and huge banquets. Ferdinando would bring equal dedication and vision to his rule, leading Tuscany to the acme of its prestige and power, and enriching its artistic heritage by enthusiastically promoting old arts and new.

Ferdinando's son, Cosimo II, continued the tradition of innovative spectacles when he celebrated his marriage to Maria Magdalena of Austria in November 1608. This time the most dazzling production was the *Argonautica*, staged on the Arno. Bernardo Buontalenti had died shortly before the wedding, and Giulio Parigi, son of his right-hand man in the preparation of the 1589 festivities, became the lead designer. He also produced the commemorative prints.

The *Argonautica* is a somewhat problematic model for a marriage. When Jason arrived in Cholchis to steal the Golden Fleece, Medea was so smitten with him, that she betrayed her family and kingdom to help him conquer all obstacles and abscond with his prize. She then faithfully followed him to Corinth—not that her actions left her many options—and bore him two sons. So far, so good, sort of. The moral seems to be that the bride should support and assist her chosen mate in his valorous deeds, and leave behind her family to become a loyal wife. What Renaissance and Baroque Europeans conveniently disregarded was the troubling end of that romance. Jason, intent on furthering his career, secretly arranged to take a

EVRITO ECHIONE E ETALIDE
Condotti da Mercurio fatta dal Sig.r Cont Alberto e Sig.r Carlo de
Bardi et Agnolo Gucciardini

Battaglia Nauale rapp: Arno per le nosse del
Ser.mo Princ. di Tosc. l'an 1608 Iacopo Ligozz I.

REMIGIO CANTAGALLINA'S PRINT OF THE PEACOCK SHIP FROM THE *ARGONAUTICA*, AFTER
DESIGNS BY JACOPO LIGOZZI, 1608.

more advantageous wife. Medea discovered his betrayal, fell into a jealous rage, killed her children, sent her rival a poisoned garment, and flew out of Corinth in a chariot drawn by dragons. Jason either killed himself in despair at losing two women and two sons or was killed by a plank from his rotting ship *Argo* that fell on him while he slept. Somehow this tragic ending managed to disappear in the mists of time. From the Middle Ages to the Baroque many brides were favorably compared to Medea in love, and their grooms to the brave leader of a famous exploit.

In fact, the *Argonautica* enacted in Florence in 1608 exalted not only Maria Magdalena, but Cosimo II. There was, of course, no mention of Jason's double-dealing, and the grand duke personally performed the part of the Greek hero in the aquatic play. Through the staging of the drama, the age of legendary heroes was reborn on Tuscan soil, and contemporary Tuscans became new and improved Greeks. Since ancient writers saw in this story an echo of the age of colonization and expansion, it also provided an apt metaphor for the ambitions of the grand duke.

The Arno was a perfect stage set for the spectacle. Florentine buildings and surrounding hills provided a beautiful backdrop. The bridge of Carraia became the fortress of Colchis, and that of Santa Trinità the starting point for the Greek fleet. The banks were crowded with spectators. And the theatrical machinery looked all the more impressive for floating while performing complicated maneuvers.

The battle for the Golden Fleece was the centerpiece of the show. After parading before the spectators, the Argonauts landed on the island of Cholchis, set on a float in the middle of the river, and decisively marched on the temple to collect the Golden Fleece. Suddenly two fire-breathing bulls and two warriors blocked Jason/Cosimo's path. He fought them bravely and duly overcame them, only to be challenged by a hissing dragon that vomited another warrior with whom Jason had to fight another duel, which, of course, he won. As Jason stood poised to abscond with the Fleece, the Cholchidian armada arrived at the island. The Greeks and

PERICLEMENE
Fatta Dal Sig.r Michelagnolo Baglioni ∾

Battaglia Navale capp.ta in l'Arno per le notte
Del Ser.mo Princ. di Tosc. l'an: 1608 Iacopo Ligozzi

REMIGIO CANTAGALLINA'S PRINT OF THE GIANT LOBSTER SHIP FROM THE *ARGONAUTICA*,
AFTER DESIGNS BY JACOPO LIGOZZI, 1608.

the Cholchidians engaged in a joust. Next they fought a sea battle, illuminated by countless torches, as by then night had fallen. Victorious at sea, the Argonauts stormed and demolished the enemy fortress. Triumphant, they returned to their ships and sailed in parade to the lodge of honor. There, to the accompaniment of a madrigal, Cosimo presented the Fleece to his bride.

Judging by the commemorative prints, the most impressive aspect of the spectacle were the ships. Each vessel was a marvel, but those designed by Jacopo Ligozzi stood out above the rest. The ship of Eurytus, Echion, and Aethalides, guided by their father Mercury, was shaped like a great peacock (opposite). As the bird sailed along, it fanned its tail, and its mirror-speckled feathers dazzled the onlookers. Ligozzi's other masterpiece was the ship of the grandson of Neptune, Periclymenus, to whom the god gave power to change into any creature at will. The vessel first appeared in the guise of a giant lobster that seemed to move with no external help (above). When it came level with the lodge of honor, the

lobster miraculously changed into a normal boat on which Periclymenus sat in human form, dressed as a knight.

Jacopo Ligozzi was an extremely gifted and prolific artist, and a skillful courtier. Born in Verona, he had been invited to Florence as a young man by Francesco I, and managed to remain in favor under Ferdinando I, Cosimo II, and Ferdinando II. After Giorgio Vasari died, Ligozzi took the post of the first painter to the court and head of the grand-ducal workshop of artists. But his particular strength lay in poetic and intimate depictions of plants and animals. He captured them with exceptional precision and affectionate vividness. He drew the first pineapple shipped to Europe from South America, the American century plant recently imported from Mexico, a fig branch with exotic finches, and countless other creatures. Ligozzi's work was bound to please his patrons, for the Medici were passionate about natural sciences. Ferdinando I dispatched botanists on expeditions throughout Europe to gather and illustrate new plants; and he exchanged seeds, rare plants, and

OVAL MOSAIC OF THE PIAZZA DELLA SIGNORIA WITH PIETRE DURE WORK BY BERNARDINO GAFFURI AND GOLDWORK BY JACQUES BYLIVELDT, 1599–1600. MUSEO DEGLI ARGENTI, FLORENCE

botanical drawings with such leading naturalists as Ulisse Aldrovandi. With Ferdinando's encouragement, Ligozzi's naturalistic sketches were also translated into another art form promoted by the grand duke: *pietre dure,* or mosaics in semi-precious stones and colored marbles, assembled with such precision that no joins were visible to the naked eye—one more instance of nature and art singing a duet.

AS WE HAVE SEEN, THE LOVE OF STONES WAS A Medici family tradition. Lorenzo had collected them and incised them with his name. Cosimo I urged his artists to revive the skill of porphyry carving. Francesco I invited Milanese craftsmen, then the foremost hard-stone carvers, to relocate to Florence and establish a

local school. In 1572 the brothers Ambrogio and Stefano Caroni and Bernardino and Cristofano Gaffuri accepted his invitation. Among their new Florentine creations was a luxurious aedicule depicting Christ and the Samaritan Woman (opposite). Carroni and the Gaffuri made the *pietre dure* figures set in a landscape of hard-stone mosaic. Francesco's goldsmith Jacques Byliveldt fashioned the gold mounts. The piece was prized and passed down for generations as a precious heirloom.

Francesco was most smitten with the beauty of individual minerals. He preferred *pietre dure* mosaics with geometric designs that best showed off the colors and veins of the stones. They also came closer to ancient inlaid floors and marble wall paneling. Such examples of Roman work survived throughout Italy,

opposite CHIST AND THE SAMARITAN WOMAN AEDICULE WITH PIETRE DURE WORK BY CARONI AND GAFFURI AND GOLDWORK BY JACQUES BYLIVELDT, 1591-1600. KUNSTHISTORISCHES MUSEUM, VIENNA

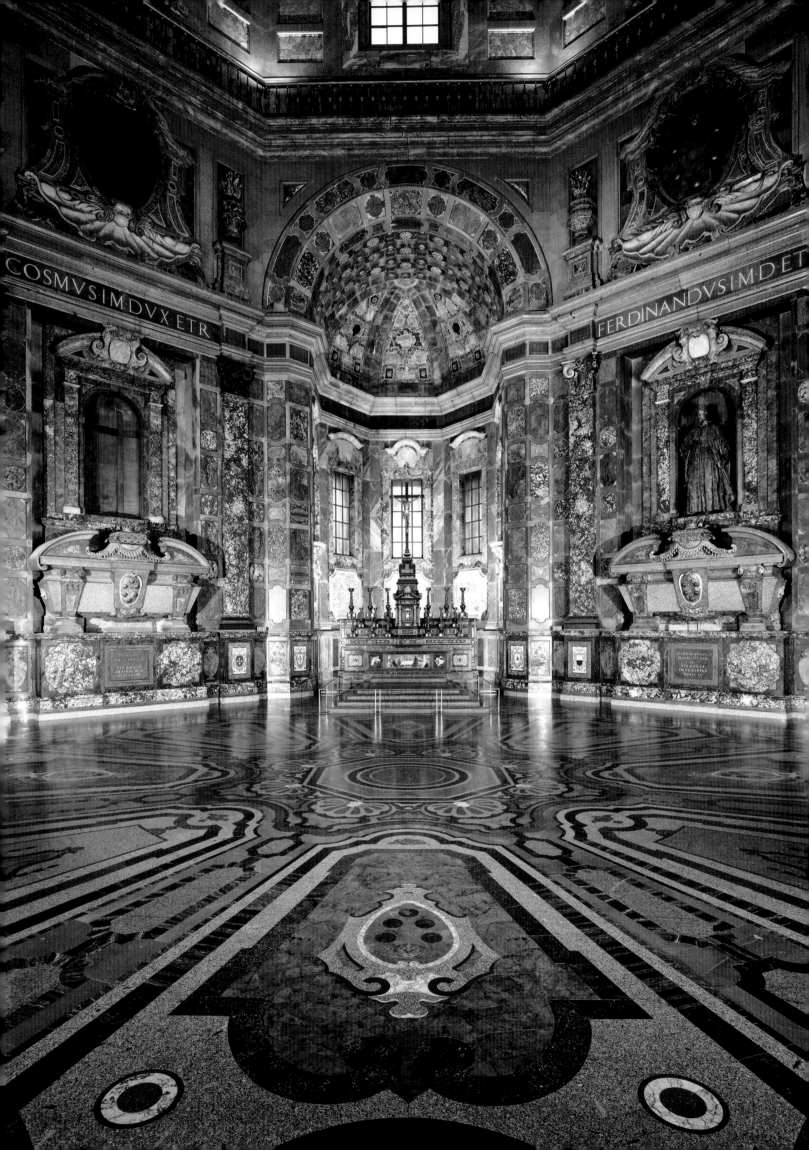

and were greatly admired in the Renaissance and Baroque.

Francesco's brother Ferdinando became infatuated with *pietre dure* in Rome. There, in the luxury-loving milieu of the papal court, he observed the revival of the ancient craft of colored-stone mosaic. As soon as he became grand duke, he established the Galleria dei Lavori in the Uffizi, a court workshop that produced *pietre dure* for the Medici residences and diplomatic gifts. By the early years of the seventeenth century Florence had become world-famous for her stone inlays. This art declined only over the last century, when fewer masters studied and practiced the laborious craft, and fewer clients could afford it. The 1966 flood demolished the workshops by the Arno, but a couple still survive, one located just in front of the Church of Santa Croce. Its showroom is full of superb inlays, and in back is a studio where one can see first hand how this work is done. The museums and churches of Florence are also full of *pietre dure* masterpieces. Once you are attuned to them, you start seeing them everywhere and wonder how you could have missed them before.

Ferdinando I deserves partial credit for the oval cityscape made as an ornament for a cabinet that housed his most precious objects (p. 197). Pieced together by Bernardino Gaffuri, it depicts the Piazza della Signoria. The Palazzo Vecchio stands on the left, the Loggia dei Lanzi on the right, and the Uffizi in the distance between them. In the foreground rises the equestrian monument of Cosimo I, rendered in gold relief by Jacques Byliveldt. The goldsmith also added the *Neptune* fountain and Michelangelo's *David*, and little figures that peer out of the windows of the Palazzo Vecchio. A touch of local color, a man bearing a load on his back emerges from the Palazzo's customs door.

Unlike his brother, Ferdinando loved *pietre dure* with figurative subjects, "painting done not with colors and brushes, but by fitting together various different stones." This technique required consummate patience and skill. To appreciate the complexity of this endeavor, one should visit the Opificio delle Pietre Dure, heir to the Galleria

dei Lavori, to feast the mind and eyes. The ground floor of the museum displays finished pieces. The second story is a magician's workshop. One wall is lined with cases containing cut and polished sections of colored stones from every part of the world. The diversity and beauty of the minerals is breathtaking. Strolling past this vast collection, one can easily understand how an obsession with stones can arise in a flash and burn intensely for life. In the center of the room are cases with different tools for turning raw materials into stone brush strokes. Another series of displays explains how mosaic scenes were pieced. Each little component—a leaf, a beak, a piece of shadow—was cut individually with a wire saw, then slotted into a composition so precisely that the joins disappeared from sight.

Ferdinando promoted the art of *pietre dure* partly because he loved natural sciences and colored stones, and partly to realize a long-cherished family dream: the grand ducal mausoleum at San Lorenzo completely lined with colored marble inlays. The very planning of the huge and opulent Chapel of the Princes (opposite) took several decades. Ferdinando finally laid the foundation stone in 1604. To assure the availability of veined marbles and semi-precious stones, the grand duke issued a proclamation forbidding ordinary citizens to extract, work, and export these materials from his realm. At the same time, a vast organization of naturalists, artists, ambassadors, agents, and influential friends helped Ferdinando discover new quarries, make new acquisitions, and assemble a sufficient supply.

The chapel took more than 250 years to build, and was scaled down repeatedly, although visiting it today you can hardly imagine that any pomp had been diminished. The space is enormous and enormously cold. It projects absolute power and superhuman scale. The grand ducal tombs are sized for giants rather than men. Standing in the middle of the chapel or traversing its frigid and forbidding expanse I felt both mesmerized and repulsed, drawn to examine its details and completely dwarfed. Whole troops of artists and artisans worked to bring it into being: specialist stone carvers and goldsmiths;

opposite MATTEO NIGETTI'S INTERIOR OF THE CHAPEL OF THE PRINCES IN SAN LORENZO, FLORENCE, BEGUN IN 1604.

ART AND NATURE AT PLAY: *Baboli, Castello, Pratolino* 199

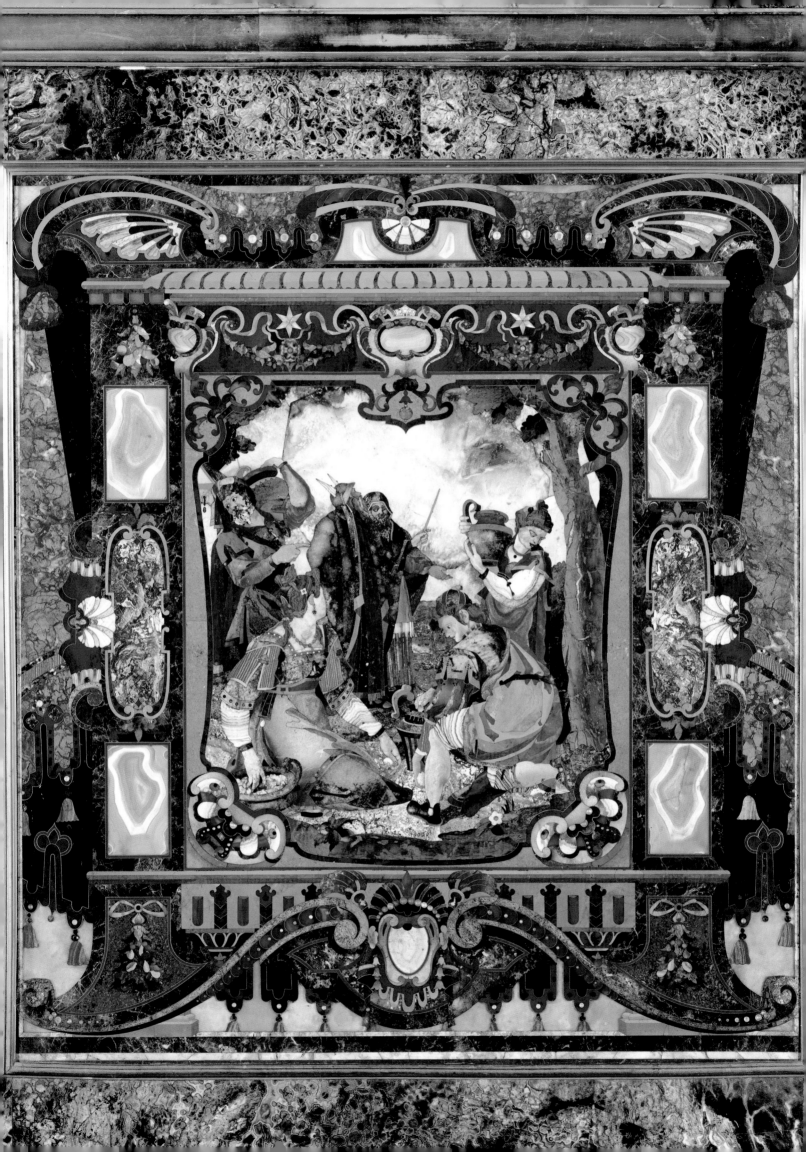

MAHOGANY CABINET WITH *PIETRE DURE* INLAYS IN THE PALAZZO VECCHIO, FLORENCE.

makers of wooden models and carpenters; sculptors and foundry-men who cast bronze ornaments; and painters and designers who drew patterns for the stone mosaics, including Buontalenti and Ligozzi.

Ferdinando had also envisioned a radiant ciborium in the center of the chapel and an altar covered with pictorial stone scenes. By 1653 they were almost finished, but subsequent generations of Florentine rulers fell on hard times, felt less committed to the chapel project, cut its budget, and reduced its scope. The altar panels and the ciborium lingered in the workshop until 1779, when Grand Duke Pietro Leopoldo of Lorraine finally ordered them to be taken apart. In 1787 the *Falling of*

Manna panel (opposite), made for the chapel altar, was placed instead on the front of the high altar of San Lorenzo where it remains to this day. Although you can only see it from a distance that does it little justice, it still speaks of the quality of stone and workmanship that Ferdinando had in mind.

While the chapel project was slowly withering, *pietre dure* mosaics became a vital facet of Florentine artistic life. They were inset into ebony cabinets (above), made into table tops, and turned into small ornaments. They adorned Medicean residences, and spread the fame of the city as presents and souvenirs shipped abroad.

opposite FALLING OF MANNA PIETRE DURE INLAY DESIGNED BY BERNARDINO POCCETTI AND ASSEMBLED BY GIOVAN BATTISTA SASSI, CENTRAL PANEL OF THE HIGH ALTAR OF SAN LORENZO, 1606–1610.

TUSCANY AND THE GRAND TOUR: RELICS FROZEN IN TIME

THERE IS CERTAINLY NO PLACE IN THE WORLD, WHERE A MAN MAY TRAVEL WITH GREATER PLEASURE AND ADVANTAGE, THAN IN *ITALY*. ONE FINDS SOMETHING MORE PARTICULAR IN THE FACE OF THE COUNTRY, AND MORE ASTONISHING IN THE WORKS OF NATURE, THAN CAN BE MET WITH IN ANY OTHER PART OF *EUROPE*. IT IS THE GREAT SCHOOL OF MUSICK AND PAINTING, AND CONTAINS IN IT ALL THE NOBLEST PRODUCTIONS OF STATUARY AND ARCHITECTURE, BOTH ANCIENT AND MODERN.... THERE IS SCARCE ANY PART OF THE NATION THAT IS NOT FAMOUS IN HISTORY, NOR SO MUCH AS A MOUNTAIN OR RIVER, THAT HAS NOT BEEN THE SCENE OF SOME EXTRAORDINARY ACTION.

Joseph Addison, *Remarks on Several Parts of Italy*, 1705

"Such a rabble of English roam now in Italy," Sir Thomas Chaloner wrote in 1596. Over the next three hundred years the crowds only grew larger. In the late seventeenth and eighteenth centuries Northern Europeans made it a fashion to embark on the Grand Tour of Italy. They went to see with their own eyes the land and monuments they had learned to admire by reading ancient texts. This was by and large an aristocratic movement. Young noblemen, accompanied by more or less learned chaperones, came to Italy to polish their

GEORGE COOKE'S *VIEW OF FLORENCE FROM THE CHIESA AL MONTE*, AFTER J. M. W. TURNER, 1829.

knowledge and manners. Under the warm sun, far away from strictures of family and society, they also came of age sexually, enjoying escapades they could not as easily pursue at home.

In the more democratic nineteenth century, Italy in general and Tuscany in particular became popular middle-class destinations. By this time the region was less the site of powerful artistic creations than a place where tourists flocked to experience the glorious past with pleasurable nostalgia. This was the beginning of Tuscan tourism as we know it. To a large extent, the English put the

declining province back on the map through adulation of the old monuments and their splendid afterglow. Byron and Shelley spent several years in Tuscany escaping problems at home, and through their verses popularized the evocative beauty of the land and its history-haunted cities. Turner turned them into picturesque views. Ruskin pioneered the study and preservation of the region's monuments. Whereas in the past Tuscany had imported foreign arts and made them her own, now more than ever, her arts stimulated the creativity of foreigners.

The Grand Tourists visited Tuscany as part of a

previous spread DETAIL OF THOMAS PATCH'S *VIEW OF THE ARNO AND PONTE SANTA TRINITÀ*, C. 1760. GALLERIA DEGLI UFFIZI, FLORENCE

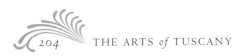

larger circuit that began in northern Italy and led all the way to Naples, whence the more adventurous sailed on to Greece and the Holy Land. As they passed through Florence on their way to Rome, the English in particular were charmed by the picturesque sight of the city. The first glimpse of the town, encircled by hills speckled with white villas, olive groves, and vineyards, captivated William Hazlitt as "a scene of enchantment, a city planted in a garden." Some travelers stopped only for a few days and moved on. Others were impelled to stay longer. "I live in Florence," wrote Toby Mathew in 1608, "in an excellent coole terrene, eate good melons, drink wholesome wines, looke upon excellent devout pictures, heer choyse musique." Horace Walpole, who remained in Florence for over a year during 1740 and 1741, found the city to be by far the most agreeable of all the places he had seen since London. Thus an expatriate community of artists, writers, diplomats, and bon vivants was born.

For the majority of English visitors the attraction of Florence lay in just a handful of monuments. They found the city as a whole rather somber and unpleasant. It was like a dark and forbidding old church, with a few glittering relics on the altar. The most important shrine was, of course, the Uffizi, the repository of the Medici art collection accumulated over centuries of rule. Conditioned by reading ancient authors, the learned tourists headed first for the ancient statues, "to converse with marble gods and petrified emperors." As Joseph Spence reported back home,

> the Duke's gallery has an immense treasure of antiquities, many in age prior to what one generally sees in Rome, for this is the soil of the old Tuscan religious antiquities. There's a figure now in the gallery . . . of the chimera in brass with old Tuscan characters upon it, which are somewhat the more valuable for being unintelligible.

The Etruscan bronze chimera, discovered at Arezzo in 1553, had been instantly appropriated by Cosimo I.

Tourists also came to marvel at the ancient Medici Venus, and at a handful of Renaissance masterpieces: Raphael's Madonnas, Perugino's portraits, Caravaggio's *St. John*, and Titian's *Venus of Urbino*. Johan Zoffany's *The Tribune of the Uffizi* (p. 206, top) vividly captures the

Grand Tourists' reverence towards these icons. The painting was commissioned by Queen Charlotte, who paid for Zoffany's trip to Florence. In return he was to bring the riches of the Medici collection back to the queen and King George IV. Zoffany gave his patrons a virtual tour of Florence's treasures. Although he focused on the Tribune, the holy of holies of the Uffizi, he included not only the artworks housed there, but also those located elsewhere in the museum and even in the Palazzo Pitti. To convey the experience of being in the Tribune on any given day, Zoffany also depicted a boisterous gathering of English residents and visitors to Florence. Sir Horace Mann, the British envoy to the Tuscan court, decked out in the ribbon and star of the Order of the Bath, admires Titian's *Venus of Urbino* in the right foreground, while listening to his seated friend Thomas Patch. To the right of them a group of young men ogles the Medici Venus. Among them is the African explorer Sir James Bruce, whom Zoffany characterized as "the wonder of the age, the terror of married men and a constant lover." Zoffany himself peeks from behind Raphael's Madonna on the far left.

Zoffany's painting is, of course, a piece of flattery: of the Uffizi, its collection, its high-brow connoisseurs. Meanwhile, Thomas Patch poked fun at the pretentiousness of this social scene in his *Gathering of the Dilettanti in a Sculpture Hall* (p. 206, bottom). His gallery is imaginary, but it is filled with Florence's famous masterpieces. In the center Patch himself zealously communes with the Medici Venus. Sir Horace Mann emphatically gestures toward her from the other side. But most other men are indifferent to the great educational opportunities. For them the museum is a social club; they pay more attention to each other than to the art. Patch made his living in Florence by painting such caricatures, as well as pretty tourist views—charming mementos of a delightful Tuscan holiday.

After the Uffizi and the Palazzo Pitti, tourists hurried to the grand ducal mausoleum in San Lorenzo. As Byron described it,

> What is her pyramid of precious stones?
> Of porphyry, jasper, agate, and all hues
> Of gems and marble, to incrust the bones
> Of merchant-dukes?

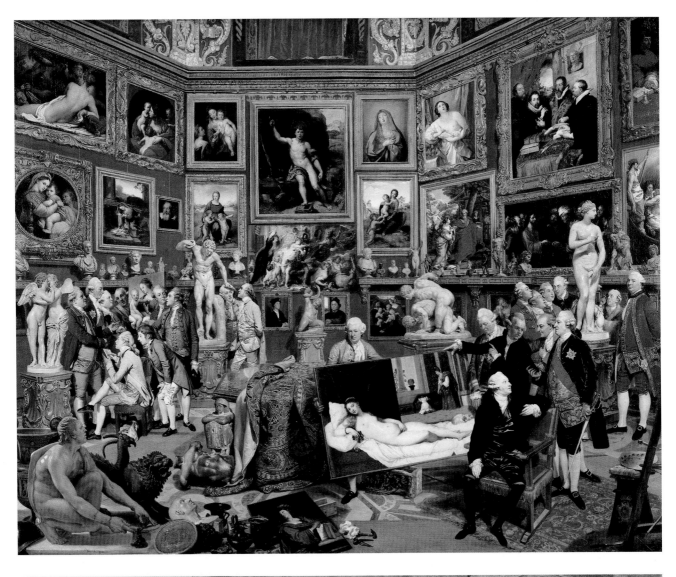

GIUSEPPE ZOCCHI'S *ALLEGORY OF MUSIC*, PART OF THE *FOUR ARTS* SERIES, C. 1750. OPIFICIO DELLE PIETRE DURE, FLORENCE

Although this shrine was one more site to check off on the list of greatest hits, the Grand Tourists were genuinely enthralled by *pietre dure*. As one scholar aptly remarked, "Our century is probably the first in which a man of taste may safely ignore coloured stones in anything but jewelery. Safely for his reputation, that is; but hardly for his sense of beauty, or appreciation of the past." Eighteenth-century visitors to Florence eagerly admired the Medici mausoleum; then they toured the Opificio delle Pietre Dure in quest of their own morsel of this refined Florentine art.

At this time the grand ducal workshop was still edging toward completion of the Chapel of the Princes. As the project was further and further reduced, craftsmen came to rely more and more on the city's international tourists. They produced furniture and decorative items,

opposite, top JOHAN ZOFFANY'S *TRIBUNA DEGLI UFFIZI*, 1772–79. HER MAJESTY THE QUEEN'S COLLECTION, LONDON

opposite, bottom THOMAS PATCH'S *GATHERING OF THE DILETTANTI IN A SCULPTURE HALL*, C. 1760–61. THE COLLECTION OF SIR BRINSLEY FORD, CBE

top ANTONIO CIOCI'S TABLE WITH ETRUSCAN VASES, 1792. MUSEO DEGLI ARGENTI, FLORENCE

bottom ANTONIO CIOCI'S TABLE WITH JAPANESE PORCELAIN AND GINORI CHINA, C. 1797.
MUSEO DEGLI ARGENTI, FLORENCE

and were keenly attuned to current fashions in choosing which scenes to depict. The eighteenth century loved allegories, so Giuseppe Zocchi, lead designer of the Opificio delle Pietre Dure, devised series of tables illustrating the Four Elements and the Four Arts (p. 207). The graceful music panel shows a gathering of musicians in a classicizing architectural setting. Antonio Cioci, who succeeded Zocchi as a "designer and arranger of stones" in the Grand Ducal Workshops, responded to another fad by creating tables laden with illusionistic Etruscan vases on floating marble plinths (opposite, top).

Interest in things Etruscan was part of a larger phenomenon. This was the era of nascent archaeology and of first publications of excavated ancient artifacts. Sir William Hamilton, the British ambassador to Naples, whose beautiful wife Emma gained notoriety as Lord Nelson's mistress, was instrumental in promoting a craze for ancient vases. He was a passionate collector of these vessels, most of them discovered in Etruscan tombs. When he decided to sell his collection, he advertised and enhanced its value by publishing a lavishly illustrated four-volume catalogue. The majority of Hamilton's vases were Greek, imported to the Italian soil by the Etruscans; but because of the limited knowledge of Greek antiquities and the vessels' find spots, they were believed to be Etruscan. So when another enterprising Englishman, the potter Josiah Wedgwood, opened a new ceramics factory, he named it *Etruria*, and emblazed his first edition of vases with the legend "The Arts of Etruria Are Reborn." Wedgwood issued an entire line of decorative vessels that replicated ancient vases in Hamilton's catalogue (right). He also developed several other series of wares more or less loosely inspired by ancient artifacts.

Since *pietre dure* furnishings were such accurate barometers of fashion, we can see through them other popular trends as well. Another series of Cioci's tables presented an array of Asian porcelain and Ginori china (opposite, bottom). European fascination with porcelain began in the sixteenth century, when, as a result of the Portuguese expeditions to the Spice Islands of Molucca, Asian ceramics entered Europe in sufficient quantity to whet the appetite of collectors, yet remain rare and expensive. The Medici grand dukes encouraged Florentine craftsmen to investigate the technique of porcelain and to

JOSIAH WEDGWOOD'S "ETRURIA" POTTERY, 1769. TRUSTEES OF THE WEDGWOOD MUSEUM, BARLESTON, STAFFORDSHIRE

develop cheaper domestic alternatives. Vasari wrote that Buontalenti conducted some experiments, but apparently did not quite succeed. In the 1570s the majolica master Flaminio Fontana, probably assisted by Pier Maria Faenzino, finally produced a few dozen pieces. As we have seen, Ferdinando I advertised this new Florentine art during his wedding when he distributed porcelain tickets to the *naumachia*. Now that the grand duke had this craft at his fingertips, he could collect and exchange with other rulers both imported porcelain and fine samples produced by his own craftsmen. In the eighteenth century the Florentine Ginori family emerged as a chief manufacturer of imitation

GIOVANNI SIGNORINI'S *CARNIVAL IN THE PIAZZA SANTA CROCE*. MUSEO DI FIRENZE COM'ERA, FLORENCE.

Asian ceramics. In their factory, La Manufattura di Doccia, which opened in 1737, the Ginori made particularly fine floral designs. The Cioci *pietre dure* tables, produced for Grand Duke Ferdinando III in the 1790s, depict both Asian and Florentine vessels in the Medici collection.

The translation of Cioci's detailed designs into minutely pieced stone paintings is a testament to the consummate craftsmanship of Florentine *pietre dure* artists. Each little element of the composition—every nuance of color and shading—is individually carved and fitted into a seamless tableau. No piece of stone, however fragmentary, was ever thrown out because its particular hue or veining might come handy for another mosaic, a practice continued to this day.

When visitors to Florence were not paying homage to the city's monuments—or shopping—they could enjoy the opera, the theater, or the carnival. Jonathan Spence, professor of poetry at Oxford, went to Italy as a tutor and chaperone to a young Grand Tourist, Lord Middlesex. The two were in Florence during the February Carnival of 1733 (right). In a letter to his mother Spence wrote:

> We are now in the liveliest part of our carnival, for it is always in most vigour towards its end, and we have now but five or six days of it to come. There's one particular here which we could not have at Venice: the different manner of setting themselves out in their coaches. The vehicle used on this occasion would be like our coaches with their tops off, and the back, before and behind, coming up no higher than your shoulders. In one of these you will sometimes see a Turk and a Christian lady forward, and an Empress and chimney-sweeper backward. Everybody has some disguise or other: the coachman is generally dressed as a harlequin and the footmen as pierrots. The general rendezvous is a place as big as St. James's Square: the coaches go round in a ring, all in masquerade, and the fools on foot have all the middle railed in to walk at their ease and see as great fools as themselves go round in coaches. The inside is always well crowded. I have had a Pharisee there tread upon my toes, and, upon recovering myself, with some confusion, have run my head full into the face of a Roman emperor.

The Napoleonic wars at the turn of the nineteenth century put a temporary end to Britons' study and pleasure tours on the continent. Then, Napoleon himself spent close to a year in Tuscany, exiled to Elba, off the coast of Piombino, in May 1814. He had grown accustomed to action that spanned Europe and Africa. Now, marooned on a single island, he channeled his energy, and boredom, into turning it into a mini-kingdom. He remodeled the Palazzo dei Mulini, a fortification built by Cosimo I de' Medici, into a palace. Its fine garden, full of exotic plants, offered tantalizing prospects of the sea. Napoleon expanded Elba's transport system, improved sanitation, and entrusted his sister, Pauline Bonaparte, to organize a thriving cultural life at their island court, complete with concerts, plays, and

balls. To finance all these activities, Napoleon exploited Elba's iron ore deposits and salt works, well known to the Etruscans and the Romans. He also expanded the tuna-fishing industry that had flourished under the Medici, and imported grapevines and mulberry trees to breed silkworms. But all this flurry of activity was temporary; a little island could not contain the world conqueror. Impatient to regain power, Napoleon sailed from Elba to the mainland and resumed his campaigning. He was finally defeated at the Battle of Waterloo in June 1815, and sent to permanent exile on the island of St. Helena. The English tourists resumed their Tuscan holidays.

The English, and other foreigners, now came in greater numbers. The Italian sojourns of such cultural heroes as Byron and Shelley colored the Tuscan stays of many a visitor. In 1818 Byron published Canto IV of *Childe Harold's Pilgrimage*, and his glowing words affected those who followed:

> ... and now, fair Italy!
> Thou art the garden of the world, the home
> Of all Art yields, and Nature can decree:
> Even in thy desert, what is like to thee?
> Thy very weeds are beautiful, thy waste
> More rich than other climes' fertility;
> Thy wreck a glory, and thy ruin graced
> With an immaculate charm which cannot be defaced.

Byron's verses about Florence made the city more alluring to English visitors:

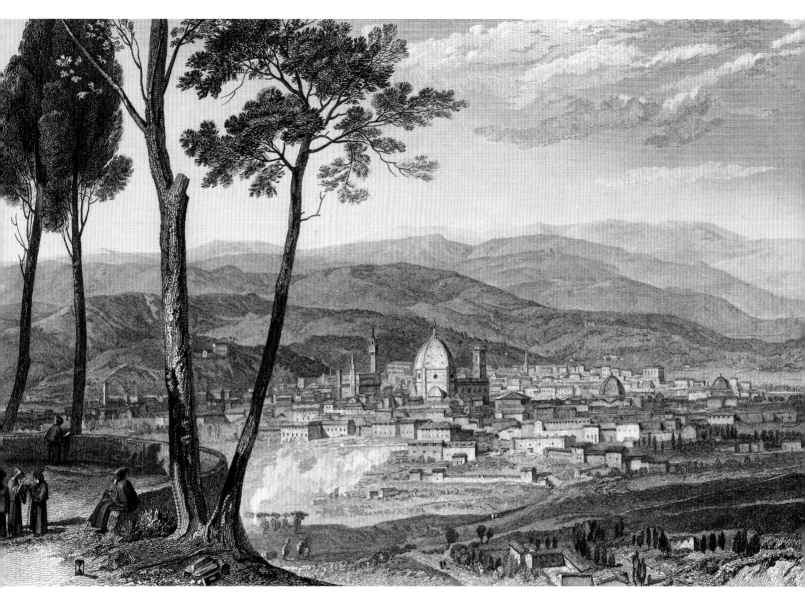

ENGRAVING AFTER J. M. W. TURNER OF *FLORENCE VIEWED FROM THE HILLS OF FIESOLE*, IN
JAMES HAKEWILL'S *PICTURESQUE TOUR OF ITALY*, 1818–20.

But Arno wins us to the fair white walls,
Where the Etrurian Athens claims and keeps
A softer feeling for her fairy halls.
Girt by her theater of hills, she reaps
Her corn, and wine, and oil, and Plenty leaps
To laughing life, with her redundant horn.
Along the banks where smiling Arno sweeps
Was modern Luxury of Commerce born,
And buried Learning rose, redeem'd to a new morn.

Proliferating guidebooks, especially those illustrated
by Joseph Mallord William Turner, also stimulated the
English imagination. Turner visited Italy several times.
In preparation for his first journey in 1819, he read
Select Views in Italy by John "Warwick" Smith and *Tour*
through Italy by John Chetwode Eustace, and copied their
illustrations in his *Italian Guidebook*. As he explored Italy,
he made his own drawings, and these came to illustrate
subsequent guidebooks (above and opposite). James
Hakewill's *Picturesque Tour of Italy*, published in serial
installments between 1818 and 1820, translated Turner's
watercolor views of Florence into engravings. One plate
showed the city from the hills of Fiesole; another from
the Lungarno near the Ponte S. Trinità. This bridge was,
at that time, admired as one of the most beautiful in the
world. (Together with all the other Florentine bridges,
except for the Ponte Vecchio, it was destroyed in World
War II.) This particular view was especially dear to the

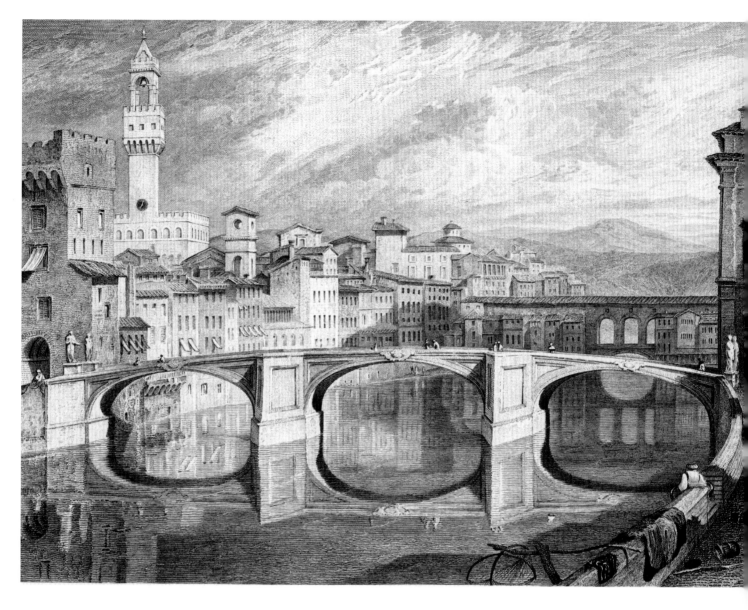

ENGRAVING BY SAMUEL RAWLE OF *FLORENCE, FROM THE PONTE ALLA CARRAIA* AFTER J. M. W. TURNER IN JAMES HAKEWILL'S *PICTURESQUE TOUR OF ITALY*, 1818–20.

British because they saw it from their lodgings. The Schneider's Hotel and the Hôtel des Iles Britaniques on the Lungarno Guicciardini, on the south bank of the Arno, were expensive but reliable English-speaking establishments that the English preferred to patronize.

All the most popular views of Florence showed her from some distance. The English did not actually enjoy the city itself. They promenaded with pleasure along the airy banks of the Arno, but the streets in the center seemed to them too narrow, and the buildings too prison-like. The monuments at the heart of Florence that made it into paintings and into the new medium of photography appeared more on account of their historic associations than their aesthetic appeal. The English photographer Calvert Richard Jones shot the view of Giotto's campanile from the east side next to the south transept of the cathedral because here stood the so-called stone of Dante. The poet, it was said, liked to sit on it on summer evenings in the years before his exile in 1302. Elizabeth Barrett Browning, who lived in Florence with her husband and their cocker spaniel Flush, described it in a poem:

> Called Dante's,—a plain flat stone, scarce discerned
> From others in the pavement,—whereupon
> He used to bring his quiet chair out, turned
> To Brunelleschi's church, and pour alone
> The lava of his spirit when it burned.

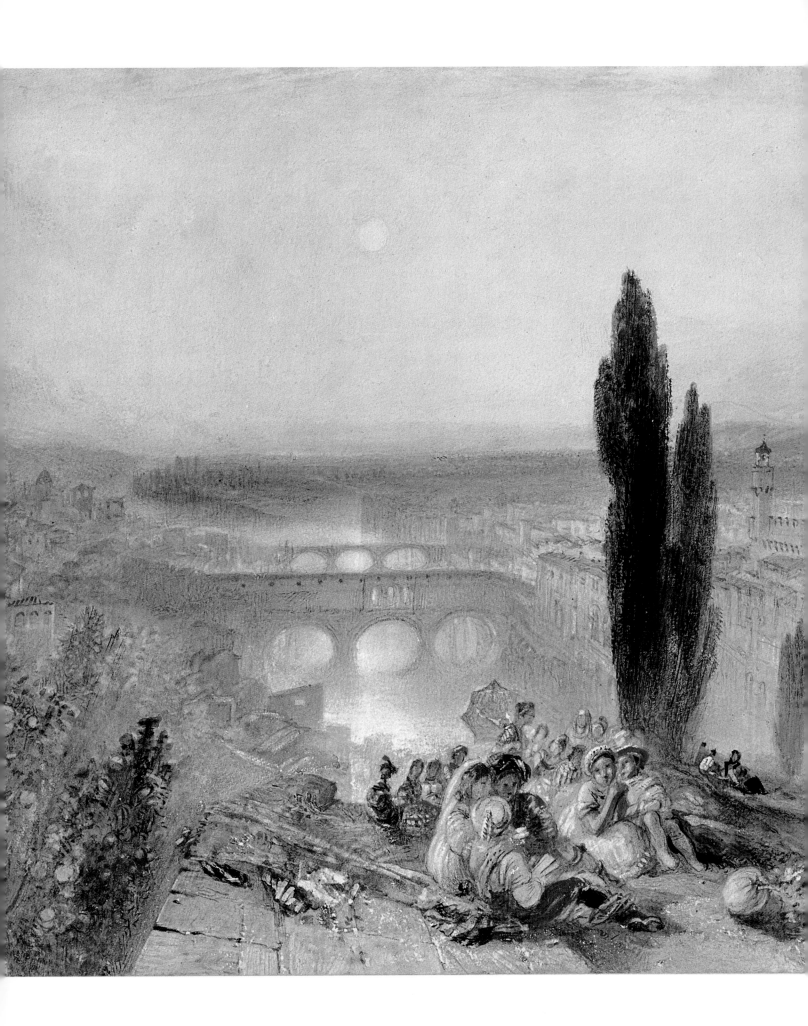

Evocative, but anachronistic. Dante lived a full century before Brunelleschi and his church. The English visitors did admire the Campanile on its own merits. On June 1, 1845 the young John Ruskin ran up the tower "not for the view, but for the love of Giotto, and his heavenly building—God bless him." However, the British considered the cathedral itself—its facade then still unfinished—"awkward, squat, clumsy" and the baptistery "altogether incorrect."

Considering these attitudes, Turner's luminous watercolor vista of Florence, painted during his visit in 1827, captured the city at its best (left). It appears at a distance, from a picturesque vantage point, basking in sunshine. Its inhabitants, or perhaps English tourists, picnic among fruits and flowers, the lush offerings of the Tuscan soil. This view so appealed to the English that Turner produced several more versions to meet the demand. And when between 1821 and 1830 Samuel Rogers published a new edition of his *Italy*, a kind of versified guidebook, he shrewdly commissioned Turner to provide twenty-five illustrations for it. This book became the most successful and influential of the illustrated travel guides in early-nineteenth-century England. Frederick Goodall, the son of one of Turner's engravers, remarked that there was hardly an educated household in the country that did not possess a copy.

John Ruskin received his copy of *Italy* on his thirteenth birthday, in February 1832, and the book profoundly shaped his intellectual career. Young John spent hours pouring over Turner's magical pictures. From those days until the end of his life Ruskin remained the painter's stalwart champion. And he fell in love with Italy. Ruskin first traveled there as a college student, and over the years made repeated journeys to Tuscany. In the course of his studies there he developed the concept of "Etruria" as a place where North and South, East and West, Greek and Gothic, Infidel and Christian met, clashed, interconnected, and gave birth to a truly generative art. He saw Tuscany as the crucible in which

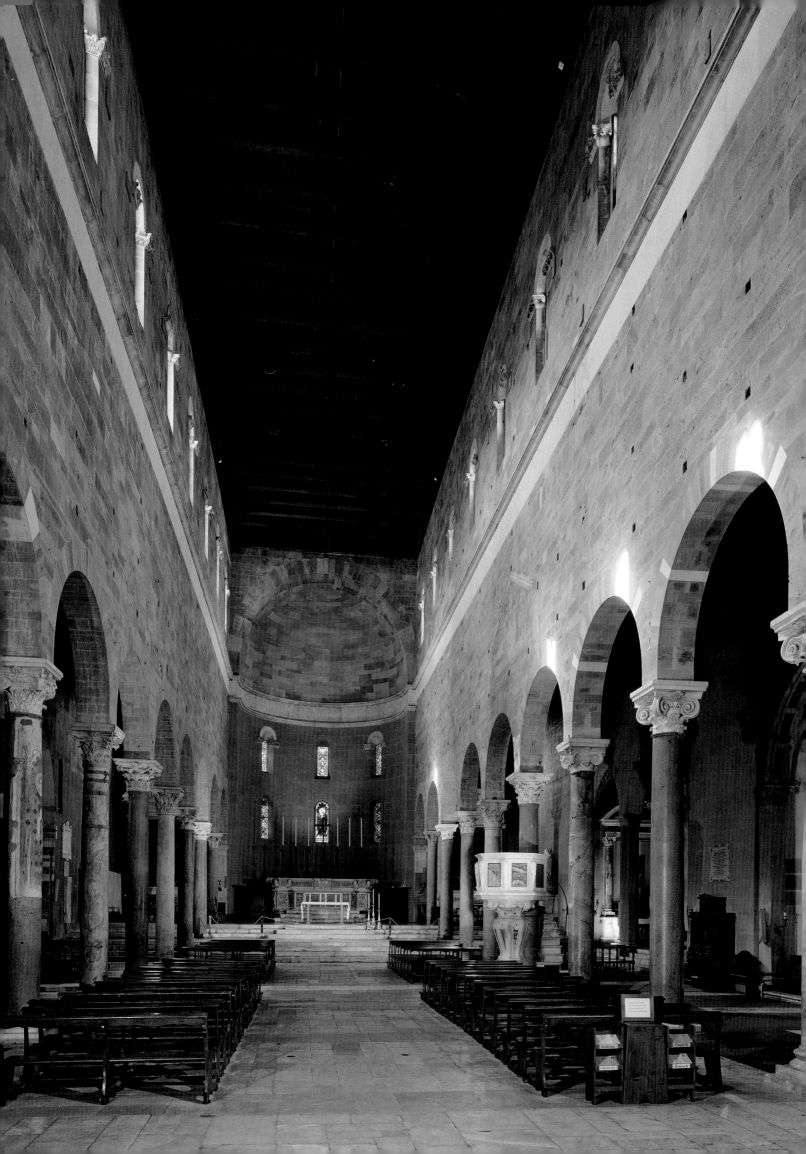

"European" man was formed. In his fundamental books *Modern Painters* and *The Seven Lamps of Architecture*, Ruskin formulated his principles of art based on his Tuscan research.

Ruskin did not love all of Tuscany. He was impressed with Pisa "chiefly in connection with Byron and Shelley." Otherwise he found it flat and shabby, and apart from the cathedral complex, "totally wanting in interest." He did fall in love with Santa Maria della Spina and sketched its intricate Gothic decorations with infinite patience and affection.

His greatest fondness, however, was for Lucca. In a letter to his father, Ruskin described with infectious enthusiasm the city's countryside:

> You cannot conceive what a divine country this is just now; the vines with their young leaves hang as if they were of thin beaten gold—everywhere—the bright green of the young corn sets off the grey purple of the olive hills, and the spring skies have been every one backgrounds of Fra Angelico. Such softness I never saw before.

Within the city he was transfixed by Romanesque architecture. He found it infinitely more beautiful than the "corrupt" Renaissance style:

> Here in Lucca I found myself suddenly in the presence of twelfth century buildings, originally set in such balance of masonry that they could all stand without mortar; and in material so incorruptible that after six hundred years of sunshine and rain, a lancet could not now be put between the joints.
>
> Absolutely for the first time I now saw what medieval builders were and what they meant . . . and thereon literally *began* the study of architecture.

In his letters home Ruskin waxed about Lucca's "church fronts charged with heavenly sculpture and inlaid with whole histories in marble." In his drawings he sketched the city's monuments with dedication and tenderness. Sometimes he captured their lines and ornaments in pencil, at other times he recorded the play

JOHN RUSKIN'S PART OF THE FAÇADE OF SAN MICHELE IN LUCCA, C. 1846. THE ASHMOLEAN MUSEUM, OXFORD

ALINARI'S PORTRAIT OF TWO CHILDREN ON STILTS, LATE NINETEENTH CENTURY.

of light on the buildings in delicate watercolors. In the 1883 epilogue to the second edition of *Modern Painters* he described the interior of San Frediano (p. 216) as an architectural revelation:

> The pure and severe arcades of finely proportioned columns at San Frediano, doing stern duty under vertical walls, as opposed to Gothic shafts with no end, and buttresses with no bearing, struck me with admiration and amazement; and then and there on the instant, I began, in the nave of San Frediano, the course of architectural study which reduced under accurate law the vague enthusiasm of my childish taste, and has been ever since a method with me, guardian of all my other work in natural history and moral philosophy.

Ruskin felt compelled not only to learn the lessons of this glorious past, but also to record them for the future. He viewed with horror how the precious heritage of medieval and early Renaissance Tuscany disintegrated before his eyes. From Pisa he lamented that the workmen hacked away at thirteenth-century frescoes in the Campo Santo to make room for new memorials. He complained that children clambered on the bronze doors of the cathedral, and climbed on the heads of church statues to get a better view on the days of religious processions. Pain at the impending ruin of Santa Maria della Spina urged him to draw the jewel-like chapel with particular care. (At the time of Ruskin's visit the church was about to be dismantled and pieced back together on the higher ground of the quay.) In Lucca, Ruskin observed with misery the flaking of the facade of San Michele:

> …The frost where the details are fine has got underneath the inlaid pieces, and has in many places rent them off, tearing up the intermediate marble together with them, so as to uncoat the building of an inch deep. Fragments of the carved porphyry are lying about everywhere. I have brought away three or four, and restored all I could to their places.

He entitled one of his drawings *Part of the Facade of the Destroyed Church of San Michele at Lucca, as it appeared in 1845* (p. 217). As he later explained, "It was destroyed by having its facade, one of the most precious twelfth-

century works in Italy, thrown down, and rebuilt with modern imitative carving and the heads of the King of Sardinia and Count Cavour instead of its Lombardic ones." In fact, the restoration, conducted by Giuseppe Pardini between 1858 and 1866, around the time of the unification of Italy, replaced some of the original heads with those of Cavour, Napoleon III, Garibaldi, Vittorio Emanuele II, Pius IX, and Dante. Pardini argued that these additions made the building more interesting to his contemporaries.

Ruskin was certainly dogmatic in expressing his views on Tuscany and its monuments. But he was also open to a broader, or a different, range of Tuscan heritage than his predecessors. Unlike typical Englishmen, who exalted only ancient and Renaissance masterpieces, Ruskin decided that Raphael and Michelangelo had been "the ruin of art" and, instead, extolled Romanesque and Gothic arts of the region. He poured over the naturalistic sculpture of Nicola Pisano, and described the font of Pisa as "native Etruscan." In Florence he copied Giotto and Fra Angelico, Filippo Lippi and Botticelli. Writing to Professor Charles Eliot Norton at Harvard University in August 1874, he declared dramatically, "I am more and more crushed every day under the stupendous power of Botticelli. . . . there are no words for his imagination, solemnity of purpose, artistic rapture, in divinely artistic things." He saw Botticelli's Zipporah as "simply the Etruscan Athena, becoming queen of a household in Christian humility."

Just as Ruskin was conducting his Tuscan studies, the new medium of photography was emerging as a vital aid to research. The first photographic process, daguerreotype, was invented by Joseph-Nicéphore Nièpce and Louis-Jacques-Mandé Daguerre and unveiled in 1839. Ruskin began to acquire photographs in the mid-1840s and found them invaluable. They enabled him to record in minutes details the monuments he would otherwise spend months drawing by hand. He called daguerreotypes "certainly the most marvelous invention of the century—given us, I think, just in time to save some evidence from the great public of wreckers." Ruskin did not take his own pictures. His traveling companions did it for him, or he commissioned pictures on the spot.

The Florentines, too, seized the potential of this

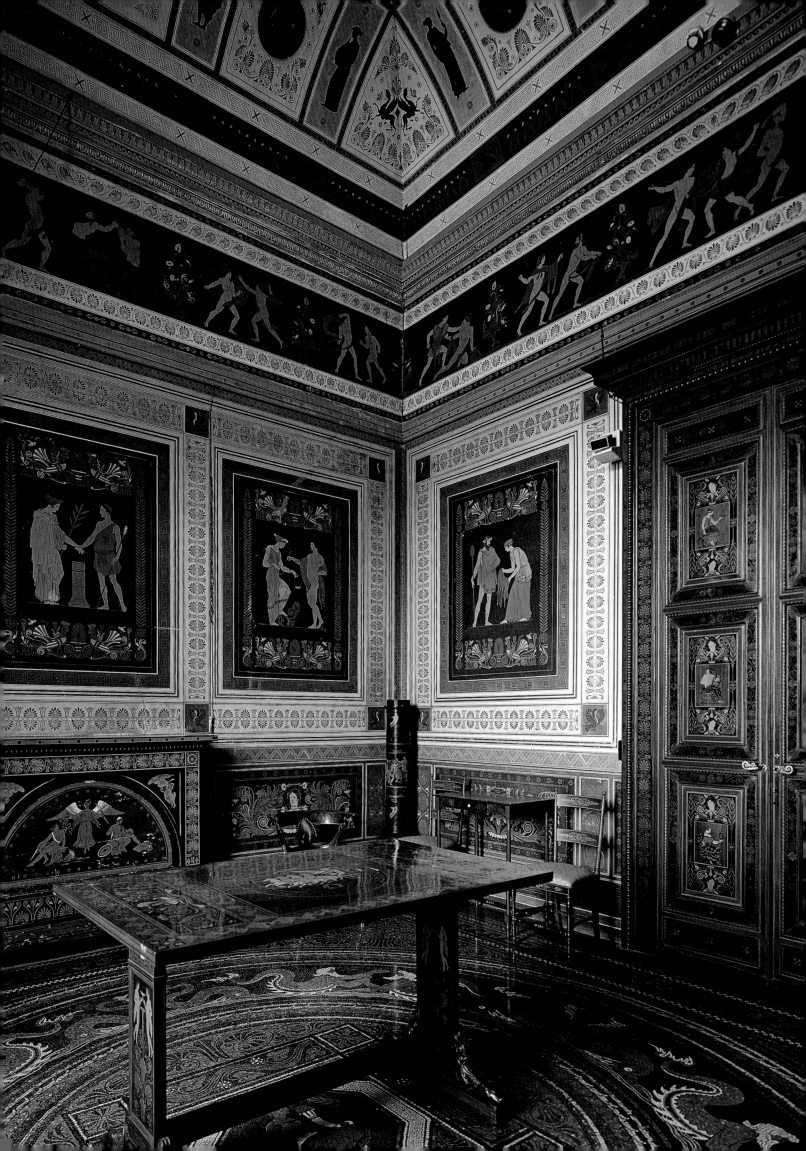

new art. Around 1845 the young Leopoldo Alinari began his apprenticeship with the lithographer Giuseppe Bardi. Coming into contact with photography, he became fascinated with the process and proved so adept at it that in 1852, with Bardi's help, he opened a small photographic studio giving Bardi the rights to distribute his prints (p. 218). Two years later Leopoldo purchased the business from Bardi, and, together with his brothers, Giuseppe and Romualdo, founded the firm Fratelli Alinari, Editori Fotografichi. Leopoldo took the photographs, Giuseppe supervised the printing process, and Romualdo served as administrator. The Alinari brothers were talented and ambitious. They made art reproductions one of their strengths. Their pictures not only captured the original work with precision, but also conveyed its medium and texture. Ruskin admired "their beautiful detail." To meet the demands of tourists as well as to document local heritage, they also shot views of landscape, cities, businesses, and scenes of daily life. Portraits were another of their lines, and their bread and butter.

Unlike most art photographers of their day, Alinari grasped early on the benefits of expanding their work outside their city. Before the advent of railways this was not an easy task. Transporting heavy equipment long-distances was cumbersome and exhausting, but it was a wise business move to photograph such popular tourist cities as Naples, Pompeii, and Venice. Their real success, however, came when Florence became briefly the capital of the Italian Kingdom, between 1861 and 1875. The Alinari shrewdly requested and were granted the right to photograph the king, Vittorio Emanuele, as well as leading politicians and prominent cultural figures, and thus became official photographers in a changing Italy. In all their photographs the Alinari aimed at clarity and a sharp truthfulness to the original subject. It is not coincidental that Prince Albert commissioned them to photograph Raphael's drawings in Florence, Venice, and Vienna. As the firm grew, the brothers aggressively built up catalogues of buildings and monuments across Italy. Although the family sold the company in 1920, it remains in business, and is still a preeminent source for high-quality photographs of Italian works of art.

Whether in Alinari photographs or in Thomas Patch's pretty vistas, in Turner-illustrated guidebooks or in Ruskin's impassioned public lectures, bits of Tuscany came home with visitors to the region, and enriched their world. Those with a particular infatuation with Etruria, and the means to indulge it, constructed entire environments. Robert Adam, who had studied in Italy and Tuscany during his Grand Tour in 1755–58, built Etruscan rooms in Osterley Park (1775–77) and Derby House (1773–74) in London. In Italy, too, the Tuscan heritage, the most ancient on the peninsula, carried major weight. In Piemonte, Pelagio Palagi created for King Carlo Alberto of Savoy a sumptuous *Gabinetto all'etrusca* in the Castello di Racconigi (opposite). The room is, in truth, a mix of elements derived from Etruscan vases and wall paintings, as well as furnishings discovered at Herculaneum and Pompeii. Still, the evocation of Etruria was a fitting choice for a ruler with national ambitions.

opposite PELAGIO PALAGI'S *GABINETTO ALL'ETRUSCA*, 1834. CASTELLO DI RACCONIGI, CUNEO

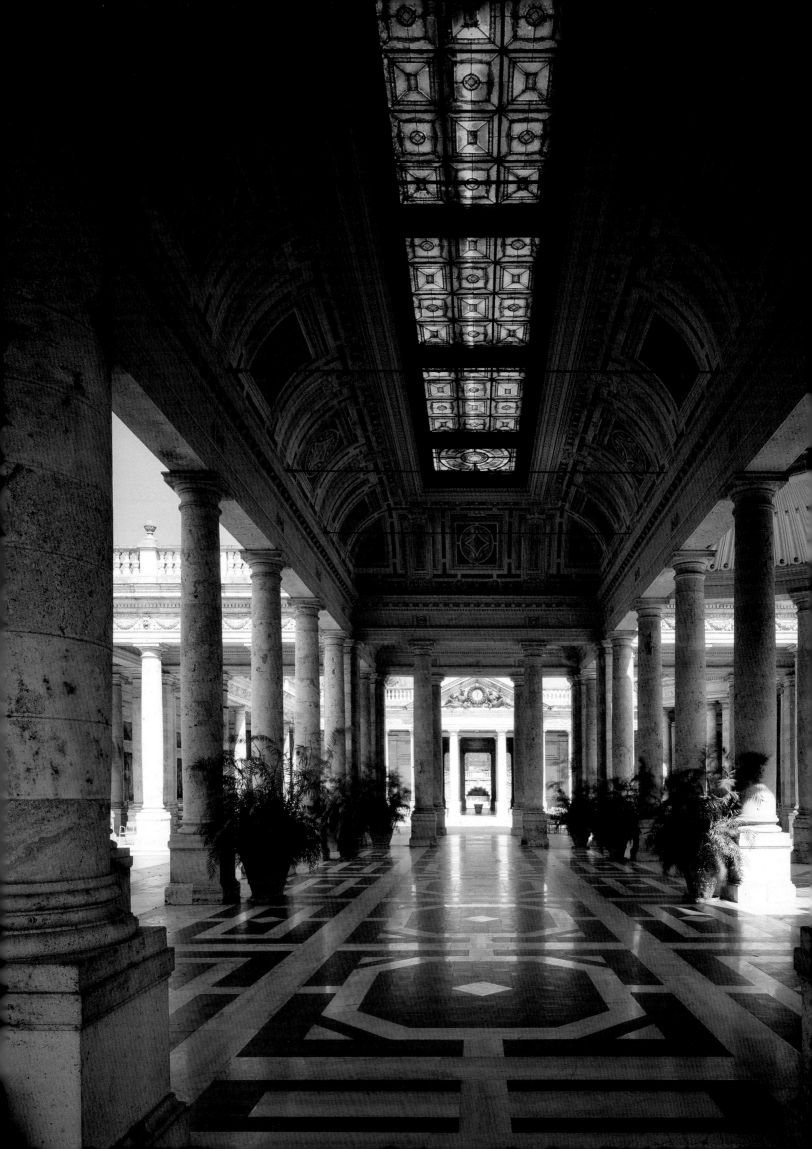

ARCHITECTURE OF PLEASURE: VIAREGGIO AND MONTECATINI

TUSCANY HAS ALWAYS BEEN A LAND OF HEDONISM AS WELL AS ART AND CULTURE. AND IN THE LATE NINETEENTH AND EARLY TWENTIETH CENTURIES THE ART OF BEAUTIFUL LIVING THERE WAS PERFECTED BY THE ESTABLISHMENT OF TWO NEW RESORTS: MONTECATINI, A SPA TOWN SITUATED BETWEEN LUCCA AND PISTOIA, AND VIAREGGIO ON THE SEASIDE BETWEEN CARRARA AND PISA. THESE NEW Tuscan gems were born, once again, out of the combination of marvelous natural resources and the savvy exploitation of international trends.

Bathing and spa culture were, of course, nothing new in Italy. The Romans had been masters of these salubrious and enjoyable pastimes. But as nineteenth-century cities became more and more congested and polluted, medical theorists emphasized the benefits of mineral waters and sea air. Montecatini and Viareggio offered health, plus a variety of aesthetic and cultural diversions. And so they quickly emerged as choice vacation spots for international elites and the well-to-do middle class.

The waters of Montecatini are rich in minerals that heal disorders of the liver and the digestive tract. There are several springs in the area that pump at a rate of 1800 liters per minute from the depths of some 1000 meters. The mineral content and strength vary from source to source. The water of Tamerici spring is the strongest; Toretta and Regina are of medium strength; Tettuccio and Rinfresco are weak. All of these can only be taken

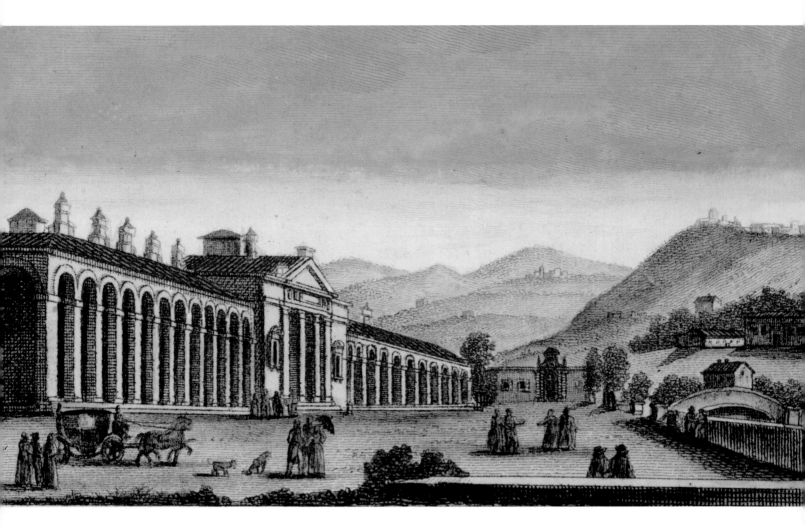

GIUSEPPE MARIA TERRENI'S *MONTECATINI BATHS* IN THE BIBLIOTECA NAZIONALE, FLORENCE

by prescription, as their effects on the body can be powerful indeed.

The springs were probably known in antiquity. But as the area was surrounded by swamps infested with malarial mosquitoes, it was not much used. In the Middle Ages the sources seem to have been forgotten, because when in 1387 Francesco Datini, a prosperous merchant of Prato, consulted his physician about taking Montecatini waters for his stones, they were a novelty. "Many folk," Francesco wrote, "go to the baths of Montecatini and fetch the waters here, wherefore I pray you tell me if I should fetch them here, and both Margherita and I drink it, as is the custom." Still the town did not thrive. The

Medici knew of the springs, but since the dangers of visiting the area outweighed the benefits, they did not develop their potential. Only in the 1770s did the grand duke of Tuscany, Piero Leopoldo I, make a concerted effort to clean up the district and turn Montecatini into a spa (above). An enlightened ruler of the house of Lorraine, with whom the Medici had intermarried, Piero Leopoldo took measures to improve the infrastructure and quality of life throughout his domains. Montecatini was part of his larger vision.

The grand duke began by reclaiming land to rid the area of malaria. Then he commissioned the engineer Francesco Bombicci to lay out the new resort. Bombicci

previous spread THE TERME TETTUCCIO'S COLONNADE, MONTECATINI.

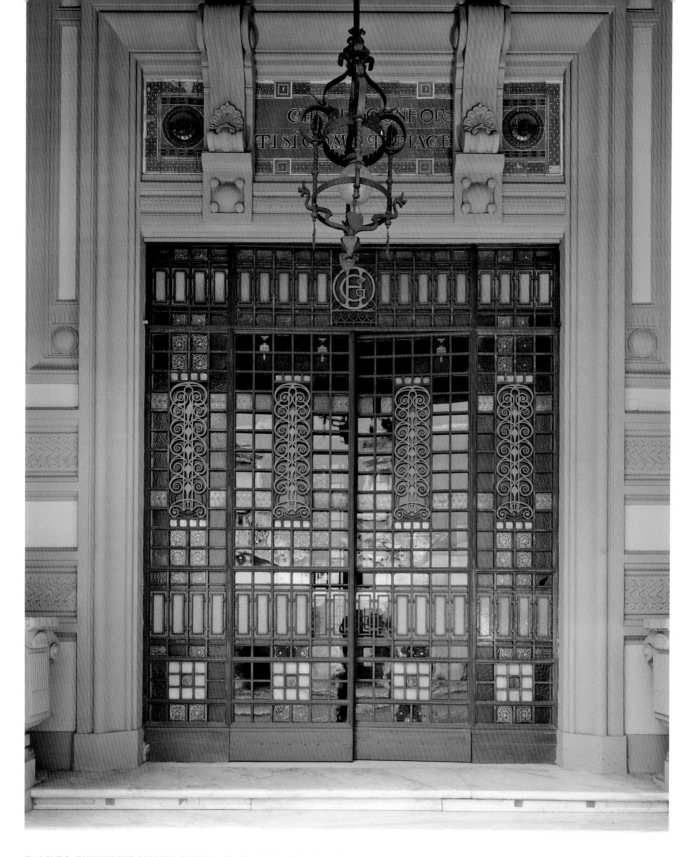

GALILEO CHINI'S WROUGHT IRON AND GLASS DOOR AT THE MAIN ENTRANCE OF THE
GRAND HOTEL & LA PACE, MONTECATINI, C. 1870.

designed the spine of Montecatini, a straight avenue
later renamed after Giuseppe Verdi, who frequented the
town for sixteen years. Viale Verdi was to be flanked by
a series of thermal establishments and elegant parks.
Gaspero Maria Paoletti, then the most prominent Tuscan

architect, was hired to build the bathing complexes. He
constructed the Leopoldine and the Tettuccio baths in
the then current Neoclassical idiom (p. 222). In 1853 a
railroad line was extended to Montecatini, and the town
began to draw a steady clientele. People came partly for

the mineral waters, and partly for sensual gratifications: a beautiful setting, handsome architecture, cultural activities, and vibrant social life.

The real building and visiting boom occurred in the later nineteenth century, when the town realized that it had to compete with other, well established European resorts. Finding itself short of adequate facilities, it undertook a major campaign of expanding its bathing establishments, erecting quality lodgings, refining landscaping, and devising all the amenities required by the capricious spa clientele. The most opulent of the new hotels was Grand Hotel & La Pace, built by 1870 and remodeled in the early twentieth century in the newly fashionable Liberty style (p. 225). The diary of the hotel's director, Luigi Melano, conveys the flavor of the institution and of the town as a whole. In May 1905 Melano jotted down: "It is most important that no guest ever touch a door handle from the moment he arrives to the moment when the door to his room closes behind him." In July 1906 he recorded a very close call:

> The Egyptian delegation led by Ismail Nissan Pacha asked that table places be marked with Egyptian flags made from marzipan. Half an hour before dinner the maitre d' Serafino Brun realized that the flags reproduced by the kitchen were not Egyptian, but Turkish. It was a moment of fury and panic. It was impossible to remedy the marzipan in half an hour. But then the pastry chef used white candle wax and painted it with watercolors, to replace the colors with those of the Egyptian flag. Fortunately it did not occur to anyone in the delegation to taste it.

Two years later, in August 1908, the director found another creative solution to a seemingly intractable problem:

> His Excellency, Prince Lubominski, Ambassador of Russia and Constantinople, did not want to hear any reasons: the cicadas must stop singing during the afternoon hours, otherwise he can not sleep. Unfortunately he could not close the windows, because, he said, and quite rightly, it is too hot. So I sent to his room Lippi and Giunti with their guitars, between 2 and 4 in the afternoon, with orders to play sweetly but without interruption. His Excellency the Prince remained satisfied and did not concern himself with the cicadas any more.

And my favorite entry about the idiosyncratic guests:

> What to do when guests have such bizarre requests? Luckily I am surrounded by the personnel of the highest level and ready to do the impossible...
> Senator R..., now retired, fears draft beyond measure, and asks the waiter to serve him in his apartment slowly, and if possible, on all fours. On foot, the Senator says, one displaces too much air and creates air currents.

The Grand Hotel & La Pace may have gone an extra mile to please its roster of crowned monarchs, world politicians, high society, and artistic clientele, but the entire town of Montecatini was designed to give its guests maximum bliss.

It would be difficult to list those who did not visit Montecatini over the years. It seems to have been a place not to miss. There were many distinguished Italians, such as Giacomo Puccini, who composed here the second and third acts of *La Bohème*. Giuseppe Verdi was a regular for years; while in residence he wrote the music for the final act of *Otello* and began *Falstaff* and *Henry IV.* In August 1916 Marie Curie arrived with a suite of scientists to measure the radioactivity of Montecatini waters. In April 1926 Mary Pickford and Douglas Fairbanks stayed at the Grand Hotel & La Pace. The director wondered whether this was the beginning of an era of actors at the spa. It most certainly was.

The newly built or updated baths and entertainment facilities did their utmost to lure, charm, and amuse their guests with architecture that was grand and playful, fashionable and classy. In 1896 Giulio d'Alessandro Bernardini was hired to develop a blueprint for transforming the town into a well-planned and aesthetically appealing environment. He was also asked to design a number of the baths. Between 1905 and 1909, in collaboration with Ugo Giusti, he constructed the Terme Excelsior (opposite). Initially the building housed the Grand Cafe and Casino; it became a thermal station only in the 1920s. The grand hall, where the visitors first drank coffee and then thermal waters, was decorated in the Liberty style, the Italian incarnation of Art Nouveau. Meanwhile, the loggia outside paid tribute to Tuscan heritage, emulating Renaissance structures, notably

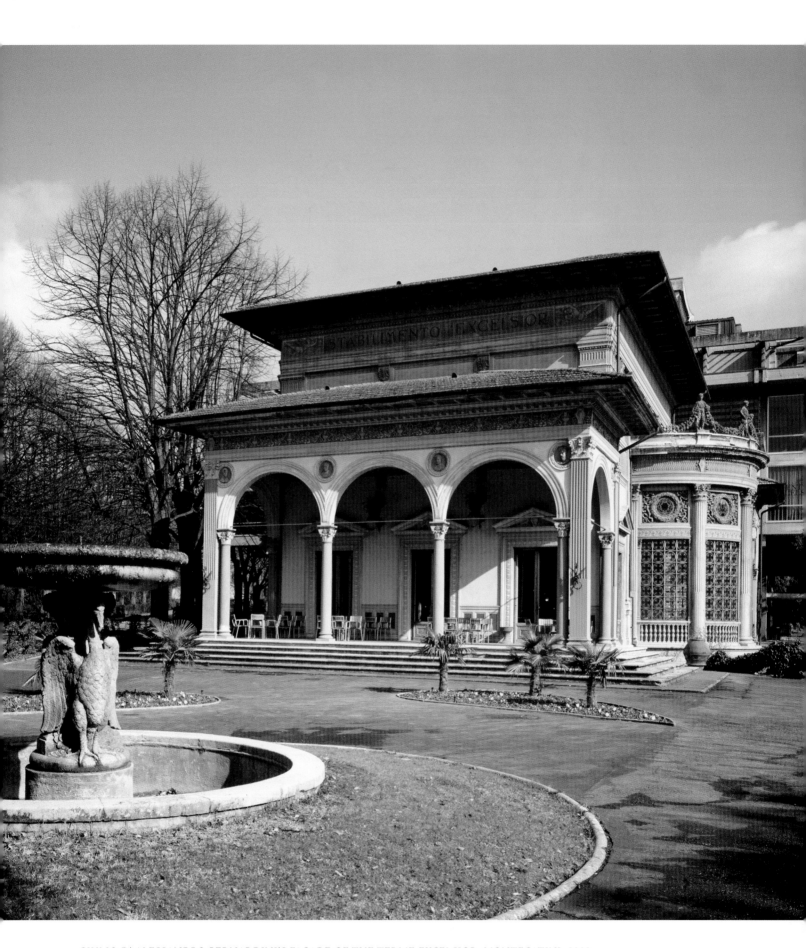

GIULIO D' ALESSANDRO BERNARDINI'S FAÇADE OF THE TERME EXCELSIOR, MONTECATINI, 1909.

VIEW FROM THE COURTYARD OF BERNARDINI, GIUSTI, AND CHINI'S TERME TAMERICI,
MONTECATINI, 1910.

‹‹

Brunelleschi's Ospedale degli Innocenti in Florence. The joyful mixture of period styles characterized Montecatini architecture. It helped create a fantasy atmosphere in which guests could more easily escape the stresses they came to cure.

The Excelsior is subdued compared to the Terme Tamerici (above). This complex is like a piece of costume jewelry: glittery and extravagant. Bernardini and Giusti remodeled it between 1903 and 1910, and let their fantasy fly. The building mixes medieval and Moresque, Renaissance and Liberty elements. No angle of view is the same. What makes it even more exuberant are the decorative flourishes—ceramic tiles and stained-glass panels—added throughout by the designer Galileo

Chini. In the gallery where waters were dispensed, for example, ceramic wall panels in the Liberty style and water-stands modeled on medieval altars turn the room into a playful temple of Montecatini's liquid gold (opposite).

Chini was an astonishingly versatile and prolific artist, and the greatest contributor to the vibrancy of spa architecture in Montecatini, Viareggio, and other Italian resorts. He was born in Florence on December 2, 1873. His parents died when he was young, and he went to live with his uncle Dario, who enrolled him in the Santa Croce School of Art and brought him into his decoration and restoration business. By working as a restorer Galileo gained intimate knowledge of Tuscan artistic traditions,

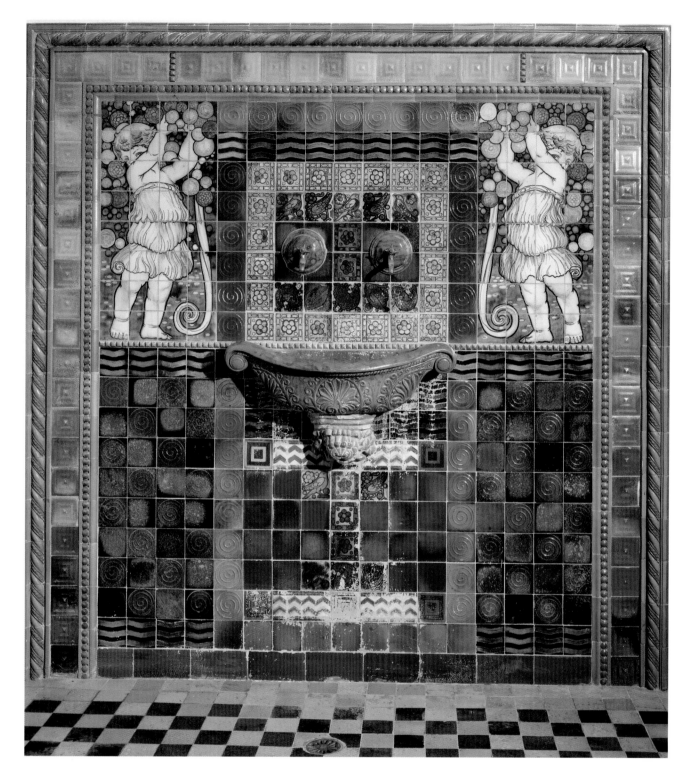

GALILEO CHINI'S MAJOLICA DECORATIONS IN THE TERME TAMERICI.

which served him extremely well when he came into his own. Although his first training was as a painter, he also mastered ceramics. In 1896, with several colleagues, he co-founded the L'Arte della Ceramica factory that quickly gained international esteem. Chini's pottery drew inspiration from Florentine Renaissance artifacts,

Art Nouveau designs, and the English Arts and Crafts movement. Each piece was a fresh and vibrant work of art.

In 1906, together with his cousin Chino, Galileo established his second factory, Fornaci San Lorenzo, located in Borgo San Lorenzo, outside Florence. Much of the Fornaci output, both in ceramics and stained glass,

GALILEO CHINI'S LIBERTY VASE. MUSEO DELLE
CERAMICHE, FAENZA.

<|<|<|<|<|<|<|<|<|<|<|<|<|<|<|<|<|<|<|<|<|<|<|<|<|<|<|

was made as architectural ornament, although the factory
also produced vases for middle-class clientele. Galileo was
extremely busy with projects throughout Italy and did
not personally work at the Fornaci. He developed designs
that his staff turned into beautifully finished works. The
factory continued to operate until 1944, when it was
destroyed in a bombardment.

Today Chini's name is hardly known, and his works
seem a bit derivative. But in his day he was an innovator
and a star. In the traditional Italian artistic milieu, where
distinctions between major and minor arts remained
rigid, he propagated the Arts-and-Crafts notion that
there is no expressive difference between various arts.
In 1917 he published a manifesto entitled *Renewing, Let
Us Renew Ourselves*. He advocated abolishing academies
of fine arts altogether because they sanctioned the
distinction between artistic practices and hampered
creativity. In their place he proposed schools of industrial
arts geared toward reviving all forms of applied arts.
Chini strove to make the "minor" crafts of ceramics,

and mural painting in particular, newly vital. He also
promoted a concept that a work of art should result
from a widely diffused industrial process. His ceramics
were manufactured in large quantities and geared toward
middle-class buyers. As a result, he introduced into
Italian homes the taste for Liberty style, an art language
that was cosmopolitan, sensual, flexible, and inspired (left
and opposite).

Chini quickly became a preeminent decorative artist
of international standing. His works were featured at the
Venice Biennale in 1905 and 1907, to high acclaim. In
1909 he was asked to decorate the Biennale entrance hall.
And two years later the king of Siam, Rama IV, invited
him to fresco the Palace of the Throne in Bangkok. Chini
spent two years in Thailand, and immensely enriched his
artistic vocabulary. He was, in any case—like the best
and most successful artists—a great sponge. He absorbed
and drew nourishment from many sources, and produced
resonant artworks as a result. He could work in neo-
medieval and neo-Renaissance style, in the manner of
Asian art, in Social Realism, and in anything in between.
He was also at ease in the world of theater: he developed
numerous stage and costume designs for his friend
Giacomo Puccini, including the sets for the premier of
Turandot in 1926. At the height of his career Chini was in
huge demand, decorating private and public buildings and
setting trends. His presence at Montecatini transformed
the town. The public rooms of the Grand Hotel & La
Pace, the Tamerici and Tettucci baths, and the town hall
would all be pale and dull without his murals, ceramics,
and stained glass.

World War I wreaked havoc in much of Europe, but
left Montecatini largely intact. The director of the Grand
Hotel & La Pace, Luigi Melano, noted in October 1915
that "it is as if the war belonged to another world. We
have had the same number of clients as last year." Even
two years later the town remained peaceful, although
more directly touched by the war. In October 1917
Melano recorded:

> Now the echoes of the war reach even us. Even
> though the season passed like others, the Government
> asked us (it would be more right to say imposed on
> us) to stay open in the winter period to receive the
> refugees from the regions most tormented by Austrian

GALILEO CHINI'S *PRIMAVERA*. ACCADEMIA D'ARTE D. SCALABRINO, MONTECATINI

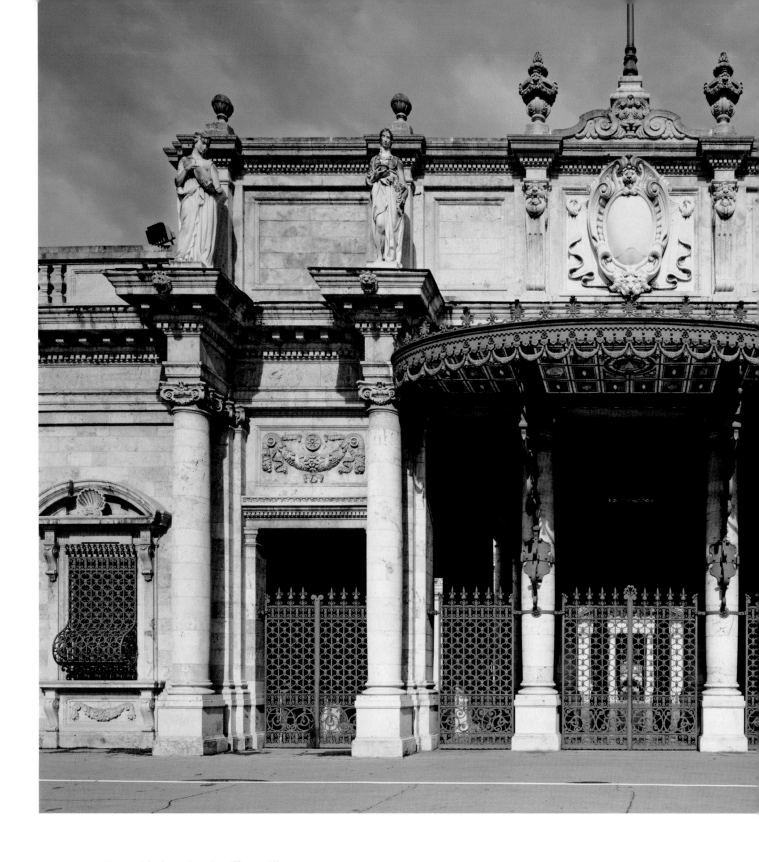

cannons. Even with the reduced staff, we will
nevertheless give our best even to those who in
time of peace could not permit themselves a
stay with us.

When peace returned, everyone was eager to put
behind the suffering and to live life to the fullest.
The Roaring Twenties got under way, and Montecatini
experienced a second construction boom. Its most striking

embodiment was the expansion of the Terme Tettuccio and
the erection of the new town hall. Terme Tettuccio (above)
was the most famous thermal establishment in town and
the culmination of the Viale Verdi. Its waters were already
praised in 1370, and the grand duke Pietro Leopoldo I
erected the first spa building over the source between 1779
and 1781. When the Florentine architect Ugo Giovannozzi
came to remodel the old structure, he decided to preserve the

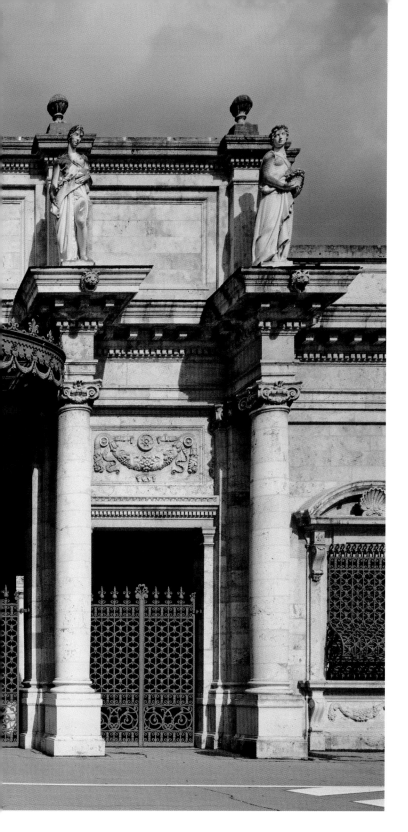

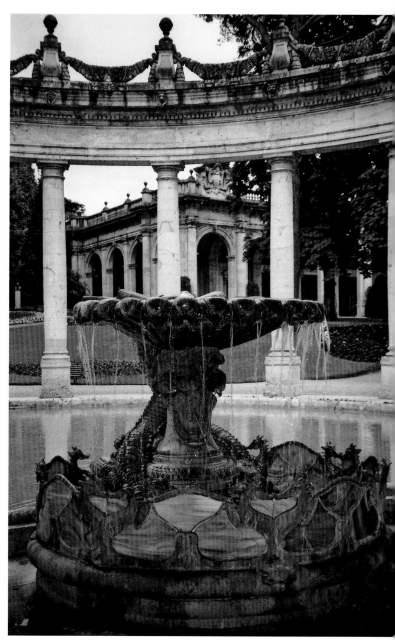

above SIRIO TOFANARI CALLED GOIORANI'S *FOUNTAIN OF THE CROCODILES* IN THE TERME TETTUCCIO.

left THE TERME TETTUCCIO IN MONTECATINI REMODELED BETWEEN 1916 AND 1928 BY UGO GIOVANNOZZI.

original inner facade built by Gaspare Paoletti as a memory to Montecatini's ascent. But for the rest of the building he united the neo-Roman, neo-Renaissance, and Liberty styles on a sweeping, theatrical scale.

The complex is an ongoing play of indoor and outdoor spaces, of cool shadows and bright sunlight. It is a series of elegant courtyards defined and connected by monumental colonnades. You enter the baths through a neo-Renaissance portal overhung by an Art Nouveau iron and stained-glass awning, and step into a grand rectangular hall (p. 222). A veil of stained glass billows overhead, and painted cornices heighten the spring of the vault. Three open-air plazas radiate from the hall. The one on the right is dominated by a round pool. At its edge stands a Liberty-style fountain populated by bronze sea horses and alligators (above, right). The water that

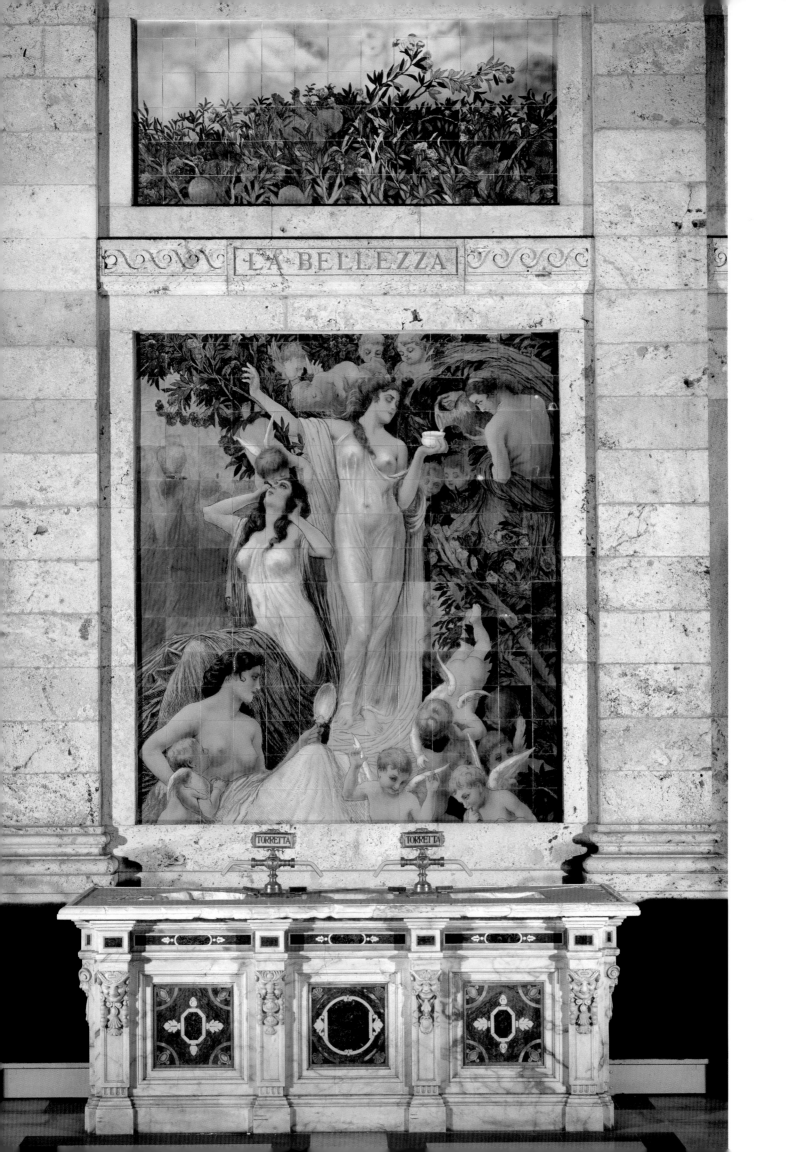

GALILEO CHINI'S SKYLIGHT OVER THE TOWN HALL'S GRAND STAIRCASE, MONTECATINI.

≺≼≺

streams out of it comes from the Tettuccio spring. From here you can either step into the park that surrounds the building, or turn left and enter the domed Rotonda della Musica, the cupola of which is painted with scenes of music-making. Since pleasurable diversions were considered necessary components of the thermal treatment, Tettuccio's guests could assemble for concerts and heal at once their bodies and souls. Beyond the Rotunda is a spacious cafe illuminated by an ornate skylight and frescoed with Tuscan landscapes. If you have

≺≼≺

opposite BASILIO CASCELLA'S *ALLEGORY OF BEAUTY* CERAMIC PANEL IN THE DRINKING GALLERY OF THE TERME TETTUCCIO.

DRAWING ROOM OF PAOLINA BONAPARTE'S VILLA AT VIAREGGIO.

had your fill of salty medicinal waters, here you could enjoy a less healthy drink.

Across the plaza from the Rotunda is perhaps the most spectacular part of the complex: the drinking gallery where altar-like stands dispense the liquid cure. The gallery is built of travertine from nearby Monsummano, a stone of warm, creamy hue. The colors of Basilio Cascella's monumental ceramic panels, depicting the phases of life through scantily clad allegorical figures, complement the stone (p. 234). The overall effect is at once decorative and organic, as if we are watching the scenes through openings in the walls. The gallery, and the whole building, combine stately with playful spirit, grandeur and warmth. It is a perfect setting for promenading in one's resort finery, taking waters and fresh air, and feasting on charming and opulent views.

I visited Terme Tettuccio in the late afternoon, when it is closed to visitors. Walking alone under its majestic colonnades, through grand halls, past monumental

murals, I felt at first intimidated. But as I wove in and out of the pavilions and plazas, past a bikini photo-shoot near the round pool, the complex became more fun and personable. Soon I was under the spell of its alternating spaces—open and covered, sunlit and shadowed—of warm-toned travertine and ceramic visions of *Infancy, Beauty,* and *Source* in the drinking gallery. So when the custodian courteously ushered me out, I was sorry to leave. Or, rather, I would have liked to come back not the next day, but sometime in the 1920s, because today Montecatini spas and hotels seem to take themselves a bit too seriously. I would have preferred to experience them in those more hedonistic days, when stylish, stuffy, relaxed, and self-important visitors frolicked and strolled in the newly created Giovannozzi and Chini fantasy world.

Even the town hall of Montecatini, built in 1919, was made to conform to the cheerful eclecticism of the city's architecture. The building looks like a Florentine

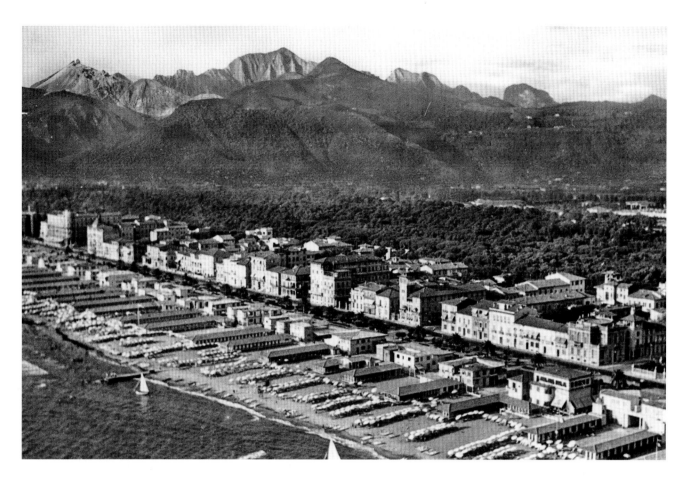

AERIAL VIEW OF VIAREGGIO.

Renaissance palazzo with a triumphal-arch doorway. Inside, the handsomest part is the central staircase, crowned by Galileo Chini's skylight over ceramic lunettes and pendentives (p. 235). The pictures allegorically depict *Building, Knowing, Working,* and *Peace,* themes particularly appropriate at the end of World War I.

The architecture of Montecatini created an atmosphere of enchantment and decadence. It was an ideal stage for therapy and fun. And since Montecatini lies halfway between Florence and Pisa, it was also an alluring stop for culture tourists who may have been overwhelmed by the fare of museums and churches and felt in need of a rest cure. To make sure that no one missed Montecatini, the town printed and distributed fetching posters whose Art Nouveau and Art Deco styles matched the look and feel of the spa.

In the very years when Montecatini was becoming one of the finest thermal spas in Europe, Viareggio enticed vacationers with the sea. "In the month of November, when first frosts begin and the rain cleanses

the air, many Lucchese gentlemen take themselves to Viareggio to enjoy fresh air of the sea." So wrote the traveler Georg Christoph Martini in 1745. It was common at that time for the aristocracy to spend winter months attending balls and carnivals in their villas in the country or by the seashore. Viareggio was then no more than a small town. The fashion for summer vacations there began in the nineteenth century, when new medical theories propounded the benefits of sea air and bathing, almost as an alternative to thermal resorts.

Paolina Bonaparte, sister of Napoleon, initiated the rise of Viareggio when she built her Neoclassical villa here in 1820 (opposite). The town's romantic aura was greatly enhanced by Percy Bysshe Shelley's drowning off its coast on July 8, 1822. (His little schooner *Ariel* sank as he sailed on a pleasure cruise from Livorno to La Spezia.) In 1833 Dr. Giuseppe Giannelli published the first guide book to Viareggio, *Manuale per I bagni di mare.* Gianelli promoted not only the attractions of the town and the benefits of the sea, but the importance of leisure

VIAREGGIO RESIDENCE WITH CHINI CERAMIC DECORATIONS.

and diversion to health. Cafes and comfortable hotels, music and theater, sports and dances were all necessary complements to the water therapy, in his view. The book was dedicated to the governor Alfonso Cittadella, and was intended to sustain the political program of the Bourbons. With its publication, the resort's reputation and popularity were launched.

What made it all possible is the incomparable natural setting of the town on the Versilia coast (p. 237). It sits right by a warm and nearly straight stretch of the sea and has an extremely wide beach with fine, powdery sand. Behind it grow thick pine groves, and beyond them rise the Apuane Alps. Again, the natural resources of Tuscany inspired and nourished the flowering of life and art.

Once the Bourbons made the commitment to the town, they hired the architect Lorenzo Nottolini to plan its overall design. He projected long avenues parallel to the coast, parks that provided cooling shade, and a palm-lined esplanade by the sea where the ritual of seeing and being seen could take place. In 1902 Viale Regina Margherita was inaugurated between the esplanade and the beach. Along it rose cheerful pavilions built of wood, embellished with lacy carvings, and housing shops, cafes, and bathing establishments. The only surviving structure from this era is the Martini bathing chalet that looks like a house out of children's fairy tales.

When, in the 1860s, train lines linked Viareggio to Lucca and Pisa, the town became easily accessible to both

DETAIL OF THE ENTRANCE OF HOTEL EXCELSIOR AT VIAREGGIO DESIGNED BY ALFREDO BELLUOMINI AND GALILEO CHINI IN THE 1920S.

Italians and foreigners, and advertisements lured them with multiple charms: "Viareggio . . . the most beautiful beach in Italy, most effective for the development and strengthening of children. A constant mild and healthy climate. Close to the regal estates of S. Rossore, the duchess of Madrid, and the duke of Parma. A Railroad center." Another ad proclaimed: ". . . flanked by two majestic and thick pine forests, where one breathes resinous and healthy air. Delightful walks, picturesque views, grand bathing establishments with ample halls for balls and concerts." The efforts paid off. Viareggio became a trendy cosmopolitan resort.

The era of wooden pavilions on the waterfront came to an abrupt end on the night of October 17, 1917.

A fire swept along the promenade and devoured all the wooden structures, wiping out the entire waterfront; only the *Martini* miraculously survived (p. 240, at left). The seaside was quickly rebuilt, but in a new manner. Now the buildings were constructed of cement and in the current Art Nouveau and Art Deco styles. Here again Galileo Chini was a force of inspiration and change. After he returned from Siam, he built himself a villa in Lido di Camaiore, near Viareggio, and introduced the region to the charm and beauty of buildings decorated with bright ceramic tiles (opposite). Post–World War I Viareggio owes much of its festive look to Chini, as well as to his leading collaborator, Alfredo Belluomini, a young local architect.

 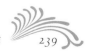

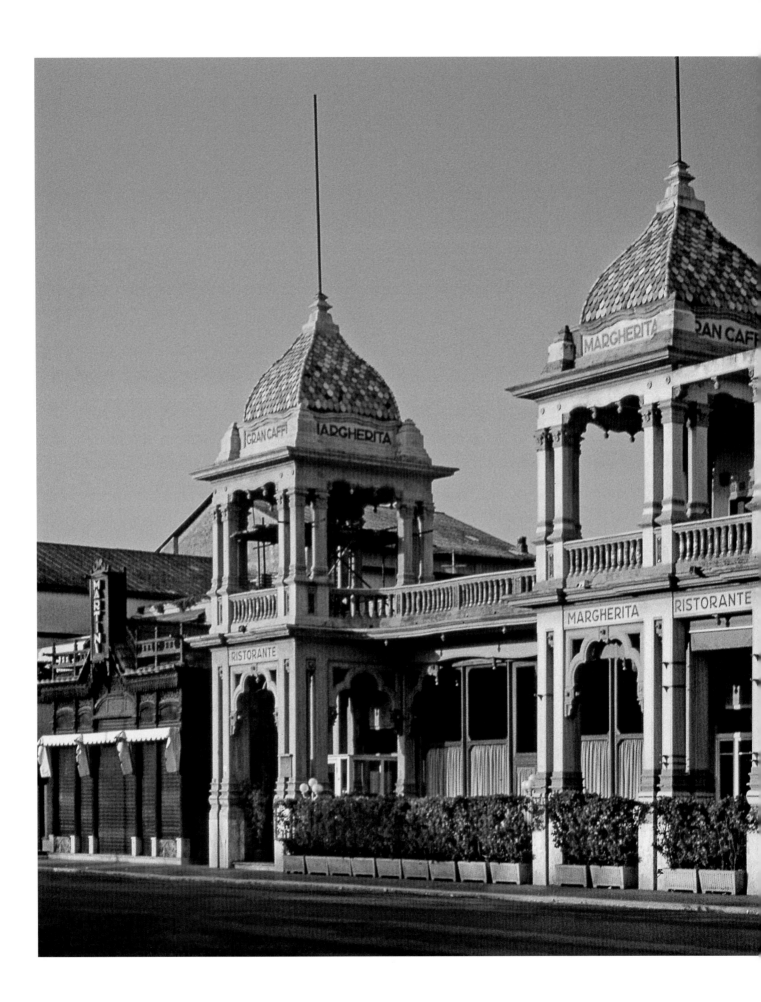

From left: MARTINI CHALET;
ALFREDO BELLUOMINI AND
GALILEO CHINI'S GRAND
CAFFE MARGARITA, 1929;
AND ALFREDO BELLUOMINI'S
GALLERIA DEL LIBRO, C. 1930.

In 1924 the maritime administration, which previously had jurisdiction over the beach, handed it over to Viareggio's town council. Endowed with new authority, the town moved swiftly to refurbish the waterfront. The commission appointed to oversee the work included Galileo Chini; Ugo Giusti, with whom Chini previously worked at Montecatini; and Alfredo Belluomini. Giusti soon died, but Chini and Belluomini designed and embellished most of the new buildings, immeasurably ennobling and ornamenting the town. Belluomini was a match for Chini in his eclecticism. He is probably the author of the Art Nouveau gem Magazzini Duilio 48, a store built with curvy, sensuous lines (left). He also designed Galleria del Libro, inspired by the more severe Viennese Secessionist style (p. 241). He rebuilt the entrance to the Balena bathing establishment in a style that blends Secessionist and Eastern idioms, ornamented by Chini's ceramic tiles. Chini's hand is more apparent in Belluomini's Gran Caffe Margherita, the most exclusive meeting place along the promenade (pp. 240–41). The airy pavilion pays tribute to the wooden chalets that used to line the waterfront of Viareggio. At the same time, the twin cupolas, clad in bright ceramic tiles, draw inspiration from the architecture Chini saw during his sojourn in Siam.

All these buildings gave a more sophisticated look to Viale Regina Margherita. The street parallel to it, across the esplanade, was also built in grand style. Here rose fancy hotels and noble villas that looked onto the open-air "drawing room" of Viareggio and at the sea. The Grand Hotel & Royal, erected by Belluomini in 1925, advertised itself in a poster as "the Pearl of the Tyrrhenian sea." It was the most exclusive hotel in town, whose habitués included members of the royal family of Savoy, the princess of Belgium, and other European nobility. The Grand Hotel Excelsior, further along the street, again married Belluomini's and Chini's talents (p. 239). Its cupola echoed the Gran Caffé Margherita, and its entrance glowed with Chini's ceramic seascape. Many of the villas on the street likewise sported friezes by Chini, manufactured in the Fornaci San Lorenzo. Some showed boats and sea scenes, others putti with festoons and vases with flowers. The ornaments made every building more expressive, and gave the city as a whole a spirit of refinement and fun.

EVENING COSTUMES FOR VIAREGGIO'S GUESTS.

The hotels and bathing establishments, cafes and boulevards, theater and music, literary events and art shows, sporting competitions and horse races furnished visitors with an array of leisure activities recommended for a healthy rest. A journal entitled "Viareggio" promoted the attractions of the town with enticing covers showing chic vacationers framed by the city and the sea (opposite, top). And since shopping was already then part of holiday relaxation, Viareggio hosted a wide range of designer boutiques eager to clothe their clients in anything from beach costumes to evening-wear (above). In the 1930s the Grand Hotel & Royal even organized fashion balls to show the latest collections of such couturiers as Chanel.

Viareggio's attractions did not dim with the summer season. Its winters blazed with the February Carnival (pp. 244–45). What distinguished Viareggio's carnival was the tradition of imaginative floats sailing along the waterfront. Initially the floats were made of wood, metal, and gesso, and drawn by horses or oxen. Viareggio was a sea town, and its men were shipbuilders who readily adapted their skills from the shipyards to the construction of carnival floats (as well as wooden bathing establishments). From the start, float decorations were topical: they caricatured politicians, to the displeasure of the police, and commemorated notable events, whether the invention of the bicycle or the first space voyage of the Soviet cosmonaut Yuri Gagarin. Having begun as a local

diversion in 1873, the Viareggio Carnival evolved into a huge tourist attraction that fed the city's economy in the winter months. As the Commune declared in 1911, "The Carnival signals the beginning of the season of winter celebrations which must continue and prosper greatly so as to make a winter sojourn at Viareggio one most preferred by the vagabond colony of foreigners."

Suspended during World War I, the carnival resumed with new zeal, and new commercial awareness in 1921. It was now operating under the auspices of a carnival committee whose mission was "to draw the whole world to see and enjoy the beauties of this marvelous place," and to make Viareggio into Eden. To further this goal, the committee launched the magazine "Viareggio in Mask," an official publication issued annually and devoted to the year's carnival preparations and highlights. That year the floats also featured bands of musicians who sang specially composed songs, adding another dimension to the festivities. But the real revolution came in 1923, when papier-mâché figures replaced wood, gesso, and metal float decorations. From then on floats became much more ambitious: bigger, bolder, with moving components and more intricate imagery every year.

To this day the carnival animates Viareggio from late January until mid-February. Street bands, entertainment groups, district celebrations, and masked balls keep the city abuzz, but the high point, of course, is the procession of massive papier-mâché floats along the esplanade that takes place over several days.

The carnival at Viareggio brings up to date the tradition of Tuscan grand spectacles. Born of local resources and traditions, and of the creativity of native craftsmen, it affectionately tends its roots, feeds on the present, and looks to the future, as Tuscan arts have always done.

OLD ROOTS, NEW SHOOTS

EVERY LOVER OF TUSCANY PROBABLY HAS A LIST OF HIS OR HER OWN FAVORITE MODERN ARTISTS. THE REGION REMAINS A VIBRANT AND MAGICAL PLACE, AND ARTS OF ALL KINDS CONTINUOUSLY GROW FROM ITS SOIL. THE STORIES OF SALVATORE FERRAGAMO, EMILIO PUCCI, AND FABIO PICCHI, THE HEROES OF THIS CHAPTER, REPRESENT THE ARTS OF TWENTIETH-CENTURY TUSCANY PARTICULARLY WELL.

Salvatore Ferragamo was not actually a Tuscan, but it was Florence that brought him success, and that re-blossomed thanks to him. He was born in 1898 in Bonito, a small village in southern Italy, the eleventh of fourteen children in a family of poor farmers. After third grade, Salvatore had to begin working for a living. He decided to learn a cobbler's trade. His father was not pleased, feeling that a more decorous profession would be preferable: tailor, barber, or carpenter. But Salvatore was already strong-willed and decisive, and he defended his choice in a fairy-tale way.

His little sisters, Giuseppina and Rosina, were getting ready for their first Communion. But their parents had no money to buy them pretty white shoes to match their Communion dresses. To wear their usual wooden clogs would be a disgrace. So the family considered pretending that the girls were ill and could not attend the ceremony. On the eve of the big day Salvatore stayed up all night and made two pairs of shoes, having

borrowed lasts, nails, glue, cardboard, and some thick white canvas from the local cobbler, Luigi Festa. In the morning, seeing Salvatore's creations, his father relented and gave him permission to train under Festa.

The boy learned the craft very quickly and with ease. By age eleven he borrowed money from his uncle, a priest, and set up his own tiny shop between the entrance door and the kitchen of the family home. Soon he won the patronage of the wives of local dignitaries. Formerly these ladies had bought the latest fashions in Naples, Bari, or Foggia, but now they hurried to Salvatore for his one-of-a-kind shoes.

Salvatore could have perfectly well continued his business in Bonito, but he wanted to achieve more. As was common in poverty-stricken Italy, his brothers had emigrated to America. In 1914 Salvatore decided to go there as well. He left not out of necessity, but out of restlessness. As he later said, "I have had the good fortune of being permanently dissatisfied, always searching for something." He bought a third-class ticket on a transatlantic liner, and spent much of his savings on a gabardine coat with a fur collar and a fashionable umbrella: "I was determined," he said, "that no one was going to call me a provincial, a country bumpkin." His luggage was a cardboard suitcase stuffed with cheese, salami, and bread, to sustain him during the crossing. He had only one American dollar, and to enter the United States he needed $20. He wrapped his dollar around a wad of paper, and the customs' official did not notice.

Salvatore arrived in Boston, where his brother got him a job at the Queen Quality Shoe Company. He took one look at the machine-operated factory and the "heavy, clumsy, and graceless" shoes produced there, "with points shaped like potatoes and heels like lead," and said "No, thanks." He did not wish to produce such ugly work. Instead Salvatore went on to California. Most of his sisters and brothers were living in Santa Barbara and doing various jobs around a local movie studio, the American Film Company. Salvatore convinced his brothers to pool their resources and open a shoe-repair

and custom work shop. Very soon they hit luck. A prop man was searching for good boots for Westerns. Salvatore made a few pairs, and Cecil B. De Mille is said to have exclaimed: "The West would have been conquered earlier, if they had boots like these." Ferragamo's career was launched. He made period shoes for *The Birth of a Nation*, *The Ten Commandments*, *The Thief of Bagdad*, and *The King of Kings*, among other films. Movie stars began to frequent his shop. Among his earliest patrons were Mary Pickford and her sister Lottie, Douglas Fairbanks, Pola Negri, and Rodolfo Valentino, who also came over to share some real Italian meals.

Ferragamo was fortunate to be in the right place at the right time and smart enough to make the most of it. In the first decades of the twentieth century a French designer, Paul Poiret, had responded to the emancipation of women by offering them, in place of long and corseted garments, loose and flowing dresses with raised hemlines. This called attention to women's feet and legs, previously deemed unseemly for exposure, and made shoes a crucial part of an outfit. During World War I women left their homes to take men's jobs in offices and factories, and began to drive automobiles. Easy and comfortable dresses became essential to their lives. As hemlines continued to rise, shoes became more and more significant. The demand for handsome pairs rose dramatically and reached its peak in the 1920s. New styles, colors, materials, and decorations emerged to meet mounting expectations. To satisfy the extravagant desires of his customers, Ferragamo made shoes out of python, ostrich, lizard, and water-snake, but what lay at the heart of his success was the comfort of his creations.

Ferragamo strove to construct shoes that did not hurt the feet. He enrolled in an evening anatomy course at the University of Southern California in Los Angeles and realized that when a person stands, her weight rests on her arches. To be truly comfortable, shoes must provide arch support, allow the metatarsus and heel to flex freely with the weight of the body, and help the person balance

previous spread EMILIO PUCCI POSES WITH A MODEL WEARING ONE OF HIS DESIGNS ON THE ROOF OF THE FAMILY PALAZZO, FLORENCE, 1950S.

as she walks. This was a revolutionary concept in shoe design.

In his 1957 autobiography *Shoemaker of Dreams*, Ferragamo wrote:

> I love feet. They talk to me. As I take them in my hands, I feel their strengths, their weaknesses, their vitality or their failings. A good foot, its muscles firm, its arch strong, is a delight to touch, a masterpiece of divine workmanship. A bad foot—crooked toes, ugly joints, loose ligaments moving under the skin—is an agony. As I take these feet in my hands I am consumed with anger and compassion: anger that I cannot shoe all the feet in the world, compassion for all those who walk in torment.

To accommodate the particular anatomy of his customers, Ferragamo studied their feet closely and made wooden lasts around which he built their shoes. He retained the lasts so that the client could order more pairs in the future and be assured of a perfect fit. Photographs from the 1950s show walls of his atelier with rows of lasts. Over them are such identifying plaques as "Diplomatic Corps" or "Royal Houses."

Ferragamo's clientele grew exponentially. To cope with the demand, he tried to use machines, since stitching every pair by hand took such a long time. The machine-made shoes sold like hotcakes. But Ferragamo felt ashamed of them. They did not live up to his standards of quality. Driven to do better, he envisioned a factory in which fine craftsmen would produce handmade shoes in a succession of stages, in a kind of human assembly line. They would follow not only his models, but also the techniques born of his anatomical studies.

In 1927 Ferragamo returned to Italy and spent months traveling around, trying to sell his vision to craftsmen in Naples, Rome, Milan, Turin, and smaller towns in between. All to no avail. Most cobblers were not interested in working to a standardized design imposed by Ferragamo rather than their own models; nor in creating novelty shoes made according to his strange concepts. Florence was his last stop and his last hope. The city maintained its superb artistic and artisanal traditions. Clustered around the cathedral and the Piazza Santa Maria Novella were numerous shops of skilled

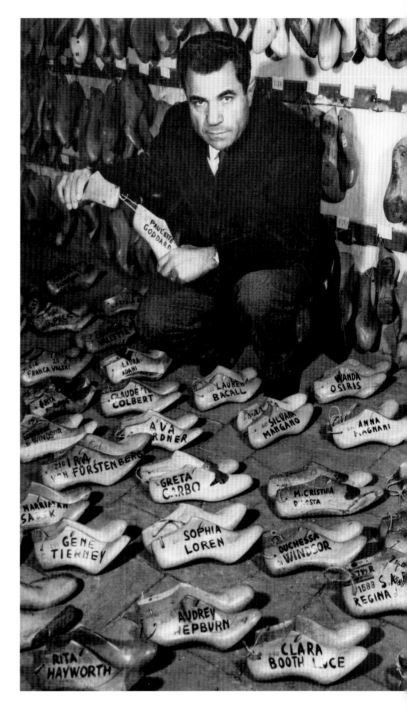

SALVATORE FERRAGAMO WITH WOODEN LASTS OF HIS FAMOUS CLIENTS' FEET, LOCCHI, 1950.

craftsmen processing leather for shoes, handbags, and other accessories. They listened to Ferragamo and agreed to his proposal. In a workshop at 57 Via Mannelli some sixty workers formed his first factory of handmade shoes. With a sample of their work, Ferragamo went back to America to negotiate sales to prominent stores. The response was wonderful. But in his absence his workmen

reverted to their traditional and idiosyncratic ways of shoemaking. Ferragamo dismissed them and hired young apprentices who would learn his art of the shoe from the start.

When the Depression hit, Ferragamo's financing, which had come from America, evaporated. At this stage his energy and persistence are reminiscent of Michelangelo at San Lorenzo. All at the same time he created new models, supervised his workers, traveled to the States to deal with marketing and distribution. To keep his company afloat, he borrowed money at usurious interest rates. After all this work he still could not remain afloat, and in 1933 he went bankrupt. Like Michelangelo, Ferragamo refused to be defeated. Several of his faithful employees stayed on, willing to weather the difficulties, and Ferragamo began to call on his loyal clients and ask them to keep the orders coming so that he could get back on his feet with their advance payments. Since bankruptcy laws forbade him to be in business, he reopened his workshop under his sister's name. In a few months he was working as before. He moved his atelier to the ancient Palazzo Spini Feroni, and by 1937, having repaid his debts, bought the Palazzo for his headquarters. New Ferragamo boutiques opened in Rome, Milan, Venice, Naples, Turin, Genoa, and Viareggio, the favorite resort of the elite.

The war years, when resources became scarce, only spurred Ferragamo's imagination. Traditional materials, such as leather and steel, which he used for arch support, were reserved for the war effort. Salvatore resorted to alternatives. For his shoe uppers he employed braided cellophane (used in candy wrappers), rope, or raffia—a traditional Florentine craft. For the soles and arch support he made use of cork platforms and wedged heels (opposite). The Wedge became a huge hit.

To get a sense of Ferragamo's creativity, visit the museum on the top floor of the Palazzo Spini Feroni. The shoes on display are a record of his dialogue with international fashion as well as artistic and cultural trends. There are patchwork shoes inspired by American needlework and clothes designed by Sonia Delaunay, and a marvelous pair of gold sandals with pyramid-shaped heels that echo the discovery of King Tutankhamen's tomb in 1922–1923 (opposite). No less spectacular are the sandals with cork platforms covered in colored suede, probably designed for Judy Garland in 1938, in response to the glitter of American film musicals (opposite).

Ferragamo brought shoemaking to the level of haute couture. *Vogue, Harper's Bazaar, Annabella*, and *Grazia* continuously showed his creations. In 1947 he received the Oscar of fashion, the Neiman Marcus Award, alongside Christian Dior. The award was for his Invisibile sandal that used fishing line for the upper portion (opposite). The idea came to Ferragamo when, leaning out of the window of the Palazzo Spini Feroni one day, he watched fishermen on the Arno. The ethereal design of the sandal, with its almost invisible upper and dynamically curved heel made it seem dreamy and carefree, a welcome sensation just after the war. A less enchanted article in *Look* pointed out that the price— $29.75 per pair—would buy four tons of coal. The greater significance of the award, however, was that it was the first time an Italian designer garnered a major prize and recognition.

In the late 1940s and throughout the 1950s Ferragamo continued to think up new shoes, and to tap into postwar euphoria and consumerism. The parade of ladies into his stores was as impressive as the number of shoes with which they walked out. The "divine" Greta Garbo visited the Palazzo Spini Feroni on September 15, 1949, and bought seventy pairs. She loved his flat-heeled brogues. The Ferragamo museum preserves sales receipts from vast purchases by Marilyn Monroe, who would buy stilettos in every conceivable color. In her famous skirt-blowing scene in *The Seven Year Itch* she wears Ferragamos. In 1954, just after shooting *Roman Holiday*, Audrey Hepburn spent a day shopping under Ferragamo's care in the company of Anita Loos, the author of the novel

opposite
top left FERRAGAMO CELLOPHANE SHOE WITH LEATHER-COVERED CORK WEDGE, 1941–42. *top right* FERRAGAMO SANDAL INSPIRED BY THE DISCOVERY OF TUTANKHAMUN'S TOMB, 1930. *bottom left* FERRAGAMO SUEDE SANDAL, LIKELY MADE FOR JUDY GARLAND, 1938. *bottom right* FERRAGAMO'S INVISIBILE SANDAL, FOR WHICH HE RECEIVED THE NEIMAN MARCUS AWARD IN 1947.

OLD ROOTS, NEW SHOOTS 251

Gentlemen Prefer Blondes, which she completed at the Grand Hotel & La Pace at Montecatini. (In July 1952, as he was preparing a quiet writing corner for Loos in the hotel's garden, the hotel director remarked, "Let's hope it will be a success.")

During the 1950s Ferragamo took an active part in the publicity campaign for the "Italian look." He felt proud of his contribution:

> It gives me great satisfaction, that from the time of my return from Hollywood almost thirty years ago, I have increased the export of Italian shoes all over the world. I am very happy to have made the humble trade of shoemaker respectable, raising it to a position of eminence in the fashion industry, and to have awakened in women the desire for good shoes, like a beautiful hat, dress, or fur. Above all I am proud that Italian shoes are everywhere in great demand.
>
> I do not care if foreign shoemakers steal my ideas, copy my designs and even the materials I use. They have copied everything, but the principle of "comfort" which has been the foundation of my success. Women must be persuaded that luxury shoes need not be painful to walk in. They must be convinced that they can wear the most refined and exotic shoes, but only if they know how to choose the form which sustains the shape of their foot correctly. Elegance and comfort are not incompatible, and whoever maintains the contrary simply does not know what he is talking about.

Unfortunately, for those who were born after Ferragamo's death and those without the means to have their shoes handmade to their precise measurements, today's Ferragamo creations are not as divine on the foot. But in Ferragamo's day, his shoes undeniably turned Florence into the fashion center of Italy, and he could not have achieved this without skilled Florentine craftsmen.

Another crucial figure in the ascent of Florentine fashion was Emilio Pucci, Marchese di Barsento, a man as captivating as his dazzling clothes. Pucci came from an ancient Florentine family. His ancestors did well by supporting the Medici. In the Sassetti chapel frescoes painted by Ghirlandaio in the 1480s, Antonio Pucci stands to the right of Lorenzo de' Medici. Antonio's son, Alessandro, married Sibilla Sassetti, the daughter of Francesco, as the frescoes were being painted.

Emilio Pucci spent his childhood between palaces, villas, tutors, and religious schools. An avid skier, he was a member of the Italian Olympic ski team in 1934. During World War II he flew as a fighter pilot in the Italian air force, was wounded, decorated for bravery several times, and often mentioned in war bulletins. After the war he served as an Air Force pilot for fourteen years, until he became a designer.

Pucci was an adventurer, a gallant ladies' man, and a loyal friend. One of his lovers was Edda Ciano, favorite daughter of Benito Mussolini. At the risk to his own life, Pucci tried to help Edda save her husband, Count Galeazzo Ciano, Mussolini's Minister of Foreign Affairs. Ciano had advocated the alliance with Germany, but became wary when Hitler invaded Poland without notifying Rome, as was required by an agreement between Italy and Germany. After several Axis defeats, Ciano and other top officials began to urge a peace with the Allies, whereupon Mussolini dismissed his entire cabinet. Ciano and other leading Fascists were powerful enough to force Mussolini's resignation in July of 1943. But within a few months Hitler reinstated Mussolini as a puppet head of Italy, and Ciano was arrested and brought to trial for treason. In the course of his stellar career as a diplomat and high-ranking Italian Fascist Party official, Ciano had kept a diary in which he detailed the Axis war efforts and painted vivid and devastating portraits of the principal Nazis and Fascists. When he was arrested, Edda, at his urging, threatened to publish his diary if he were harmed. Pucci spirited her, her children, and the vital papers to the Swiss border, away from the Germans. Upon his return to Italy he was arrested by the Gestapo and tortured, but did not reveal Edda's whereabouts. Ciano was executed. Edda made contact with Allen Dulles, who was then an agent of the Office of Strategic Services, as well as with a reporter for the *Chicago Daily News*, and the diary was published in America in June of 1945. Meanwhile, an SS agent who had been a lover of Galeazzo Ciano's secured Pucci's release.

Pucci's fashion career began two years later, quite by chance. In the winter of 1947 he was skiing at St. Moritz. On the slopes he met Toni Frissel, a fashion photographer from *Harper's Bazaar*. Frissel loved the ski outfit Pucci was wearing, and wanted to photograph it. When she discovered that Pucci designed it himself, she asked him to create some women's ski clothes for her

AN
ITALIAN SKIER
DESIGNS

• Visitors to the Alps report that the smartest women on the ski slopes are the Italians. The ski clothes on these pages were designed in Italy by Emilio, himself an expert and passionate skier, and photographed in Zermatt. They have been reproduced by White Stag for Lord and Taylor.

1. Miss Sally Booth in a poplin parka with a zippered pouch placed in the front like a yoke. Chamois, white, navy, gray. $19.95.

2. Emilio and Mme. Poppi de Salis. Emilio's "Streamliners," heavy worsted gabardine with a gathered cuff fitted *over* the boot top and battened down with leather straps under the arches. Black or gray. $39.95. With them, a matching shirt tailored to a skier's dream—its wing collar buttoned over a separate hood. $35.

3. Emerging from between the layers of Miss Booth's sweaters, another glimpse of Emilio's remarkable wing collar—here in blue and white striped cotton, the wing tips standing out sharply. $12.95.

• Opposite: Mme. de Salis in a yellow tie silk version of the ——▶ poplin parka. $45. The pants, in lightweight worsted gabardine, cut with extra fullness but not an ounce of bulk in their whittled grace. Emilio makes a point of pre-shrinking the fabric of his ski pants so that they keep their shape though soaked day in, day out. Navy, beige, gray. $35. For skier's tan: Elizabeth Arden's "Sun Gelée."

TONI FRISSELL

PUCCI'S SKI OUTFITS, IN A FEATURE PHOTOGRAPHED BY TONI FRISSEL, MAKE THEIR DEBUT IN THE DECEMBER 1948 ISSUE OF *HARPER'S BAZAAR* (EMILIO PUCCI IS SEEN IN THE UPPER RIGHT PHOTOGRAPH).

story on European winter fashions. Her photographs ran in the December 1948 issue of *Harper's Bazaar* (above). The American fashion world was smitten. White Stag and Lord & Taylor commissioned Pucci to put together collections for them, and so his new career took off. (He needed the work badly, as he was, along with the rest of Italy, completely impoverished after the war.) In January 1950 *Harper's Bazaar* called Pucci's clothes "the neatest thing on two skis."

This was, actually, not Pucci's first foray into ski-wear design. In the 1930s he came to America on a kind of reverse Grand Tour. He won a skiing scholarship to Reed College in Portland, Oregon. While pursuing his master's degree in political science, he designed the uniform for the college ski team. Throughout the 1940s he continued

to invent stylish ski suits for his friends and girlfriends. Whereas contemporary ski clothes were heavy, unisex, and monotone, Pucci made his in lively colors and prints, and tailored them into flattering shapes.

Immediately after his first success in America, Pucci began to develop a summer holiday collection. As he was vacationing on Capri in the summer of 1949, he designed pirate-style pants, now popularly known as Capri pants, as well as masculine-looking shirts to be worn with upturned collars, bright sundresses, straw hats, and thong sandals. He used local fabrics and tailors to turn his ideas into beautiful clothes. Since Capri was a very trendy resort, the American press instantly noticed the new Pucci outfits. They were so fresh and fun, relaxed and chic, and suffused with Mediterranean sunshine.

SKETCH FOR PUCCI'S PALIO COLLECTION, 1957.

◄◄-◄

Despite the reservations of his family and his banker, Pucci opened a boutique on Capri, and then others in Rome, Elba, and Montecatini. He also began to export his collections to prestigious American department stores.

Pucci was amused by the idea of being the first in his noble lineage to work. But in fact, the family's involvement with the textile industry was quite long-standing. Many leading Florentine families made their money by manufacturing and selling cloth, the city's chief commodity. In the seventeenth century the Pucci were among several families who pooled their resources and formed a factory, Antico Setificio Fiorentino, that would generate silk on a larger commercial scale. The factory grew famous across Europe for the quality of its products

and remains in operation to this day. After World War II Emilio Pucci became a majority shareholder in the factory, and in 1987 his son, Alessandro, took over the business and restored many antique looms. Emilio Pucci ran his business out of the family palazzo, one of the largest in the city, located one block north of the cathedral on the street that bears the family name (p. 246 and opposite). He used the ground floor for production and stock, while the Baroque ballroom on the first floor served as a perfect stage for showing his collections.

Pucci was not only a fabulous designer, but a savvy businessman. As he said in one interview, "If a designer is good, he senses new trends in living before they become apparent and he is ready with the answers." He foresaw and supplied what would appeal to American women in the prosperous postwar era: the era of country-club social life and nascent air travel. Up until the 1950s American fashion was dominated by Parisian couture, which presumed a more or less static and stately matron. Structured and sewn from heavy fabrics, French garments did not encourage active movement or lounging, nor were they easy to pack for travel. Pucci designed sporty outfits in which a woman could feel free and spirited, be able to drive and travel with ease, and be relaxed yet always chic. He was a great traveler himself, so he welcomed and capitalized on the boom in commercial aviation and the rise of the jet set. His clothes were perfect for flying: they were light, wrinkle-free, and stylish anywhere, at any time. His famous tunic dresses were made of a feather-light silk jersey he especially developed. They weighed only three to four ounces. Diana Vreeland said that "the silk jersey was like wearing nothing." It was a very different feel from the weighty French couture.

Pucci clothes were also spectacular and joyful to look at. His fabrics were a riot of colors, patterns, and allusions. Many of their designs sprang from his Tuscan heritage: the Sienese *contrade* (left), Brunelleschi's dome, and the paintings of Botticelli and Leonardo. The ski outfit that appeared on the *Harper's Bazaar* Christmas cover in 1963 was infused with color that recalled light filtering through the stained-glass windows of Florentine churches (opposite). Through his travels and general curiosity Pucci also brought Balinese and African motifs into his fabrics, as well as Pop and Op art. But whatever

his inspirations, his colors and patterns were always
clearly his own. Somehow he managed to achieve a subtle
balance between discipline and exuberance, extravagance
and class.

Pucci's fabrics were so winning because they evoked
strong sensations. The German poet and novelist Johann
Wolfgang von Goethe had written an extensive treatise,
The Theory of Colors, in which he argued, among many
things, that colors have the power to provoke emotions
and ideas, and to make us dream. (Goethe's scientific
interest in color was inspired by his experience of
Renaissance paintings during his Grand Tour of Italy
between 1786 and 1788.) Pucci, too, felt that, "Color
is a language by itself, it excites you or soothes you." His
fabrics and clothes do precisely that, although their effect
is more stimulating than calming.

above, left FABRICS CREATED FOR PUCCI'S "FANTASIOSA"
COLLECTION ARE DRAPED FROM A WINDOW OF THE
FAMILY PALAZZO, FLORENCE, 1963.

above, right FOLD-OUT CHRISTMAS COVER FOR *HARPER'S
BAZAAR*, DECEMBER 1963, FEATURING SKIWEAR DESIGNED
BY PUCCI AND PHOTOGRAPHED BY MELVIN SOKOLSKY.

As Puccimania swept the world in the 1960s and 1970s, all fashionable women who could afford to wore Pucci clothes with abandon. The Kennedys sported them during annual family holidays at Antibes. Marilyn Monroe was buried in her chartreuse Pucci dress. Those who could not pay for real Pucci bought knock-offs, or even painted their own for Pucci-themed toga parties. They were simply the rage. Pucci's personal charm and urbanity enhanced the popularity of his creations, as did his friendship with his glamorous clientele. The director of the Grand Hotel & La Pace, Vittorio Mariottini, wrote in his diary in August 1954 (the year Pucci received the Neiman Marcus Award):

> The Marchese Emilio Pucci and Audrey Hepburn seem to be old friends, even if they eat at separate tables.
>
> Last night the Marchese substituted a soup spoon at the seat of the most elegant Audrey with a different one whose hollow was covered with an invisible crystal. The trick spoon was dipped in the soup, guided by the slender hand of the beautiful Audrey, but she did not manage to bring it to her mouth. She tried two or three times; there was a moment of worried hesitation and then she burst out laughing, taking with herself the better part of the present guests. Among whom was the Marchese, naturally.

Pucci was a great marketer. In the course of his career, he designed outerwear, lingerie, shoes, bags, bath towels, sheets, rugs, ceramics, a Vespa, a Lincoln Continental interior, police uniforms for the city of Florence, matching jewelry for pets and owners, and much more. Starting in 1965 he decorated airplanes, ticket counters, VIP lounges, and uniforms for Braniff International Airlines (opposite). The hostesses' wardrobe could take them from the North Pole to South America, from Europe to the Orient—all in a single suitcase. "It's the way all women will travel in the future," said Pucci. (If all women could afford it, that is.) The Braniff uniforms consisted of several layered components. Hostesses greeted passengers in wool coats in such delicious colors as apricot or absinthe. Underneath they wore gabardine suits of compatible and equally vibrant colors. And under those, removed during the flight to let them move with ease, were gaily patterned tunic-culottes. Braniff dubbed this series of clothing the "Air Strip."

It doubtless made the flight quite a spectacle, and, one would hope, put the hostesses in a most cheerful mood. In 1971 Pucci even designed the emblem for Apollo 15. Thus a Pucci flag was carried to the Moon.

Pucci made Italian fashion into a hot commodity. He did not, of course, accomplish this single-handedly. The greatest credit for launching and promoting the "made in Italy" concept belongs to another Florentine, Giovanni Battista Giorgini, or "Bista" to his friends.

Giorgini was born in 1898 to a noble Lucchese family. As a young man he wanted to travel and see the world. He combined his curiosity with his business instincts: in 1923 he opened a buying office and went to the United States to investigate the tastes and needs of the American market. What he offered was "made in Italy" merchandise: clothing, shoes, leather and straw goods, glass, and ceramics. He pitched them well and delivered high-quality products. The business rapidly grew, until the 1929 crash. Not until after World War II was Giorgini able to return to his early success. Nonetheless, even during the war he found, or made, opportunities to turn his marketing skills to profit. When the Allied army came to Florence, the Giorgini family, all fluent in English, hosted the Allied Command Headquarters in their house on Bellosguardo, a hill in the southern part of the city. In 1944 Giorgini was appointed director of the Allied Force Gift Shop. After the war he traveled back to the United States to reestablish old contacts, and within a few years was representing the largest American and Canadian importers of quality Italian merchandise: I. Magnin, B. Altman, Bergdorf Goodman, and Tiffany among them. Giorgini was genuinely committed to promoting Italian handcrafts and fashions. Throughout the 1940s Italian clothing designers were still largely copying Parisian models. After a great deal of work and cajoling, in February 1951 Giorgini organized the first Italian fashion show, in which Pucci took part.

Guccio Gucci, the son of a Florentine craftsman, meanwhile, built an empire of fine bags. He began with a saddlery shop in 1906. By 1938 he had opened a chic boutique on the prestigious Via Condotti in Rome, and by the 1950s his sons and successors had expanded all over the world. Like Ferragamo, Gucci made art out of hardship. When leather was not available during the

Fascist era and World War II, he turned lowly hemp, linen, jute, and bamboo into sartorial masterpieces. His bag with a bamboo handle became a classic (right). Ingrid Bergman carried it in Roberto Rossellini's film *Viaggio in Italia* in 1953. The elegantly designed and skillfully crafted Gucci products remain symbols of prestige to this day, despite family scandals that rocked the firm in the 1980s.

For the first half of the twentieth century Italy was an underdeveloped and poor nation. It was transformed in the 1950s by an "economic miracle"—the hard and creative work of the likes of Ferragamo and Gucci, Giorgini and Pucci. Through their efforts and imagination Italy rose again as a major international economic power, and Florence as a font of prestigious arts. Fashion was a major contributor to the renewal of Italy and remains its most identifiable export.

To do justice to the richness of contemporary Tuscan artistry, we should also consider local cuisine, one of the major arts of the province. One always eats well in Italy, but in Florence, a particularly fine meal can be found at Cibrèo, located near the church of Sant'Ambrogio, where Renaissance artists Andrea del Verocchio and Mina da Fiesole are buried.

Cibrèo is more than a restaurant. It is a mini galaxy composed of a fine dining establishment, a cozy trattoria, a cafe, and a theater, all rotating around a central star—the owner and chef Fabio Picchi, a man as complex, juicy, and memorable as his offerings. In his elegant restaurant and adjacent trattoria Picchi serves such delicacies as tomato aspic flavored with herbs and spices, yellow pepper soup (p. 259), calamari stew with spinach and tomatoes, and stuffed chicken neck—an entire head of a rooster presiding over a plate with slices of a succulent mixture of chicken, bread, and herbs (p. 258). In the Renaissance, stuffed fowl was a delicacy set before royalty, although then it was presented fully plumed and re-stuffed with the bird's own meat flavored with vegetables and spices. Cibrèo's bird seems to look back to such feasts. Picchi is devoted to understanding the history of what he makes, though he also transforms rustic classics into subtle or bold

top PUCCI'S UNIFORM COLLECTION FOR BRANIFF INTERNATIONAL AIRLINES, 1965.

bottom GUCCI LEATHER BAG WITH BAMBOO HANDLES.

concoctions and marries them to foreign elements. This kind of borrowing and transformation has been a Tuscan characteristic since antiquity.

Picchi offers more than sumptuous food. He is a hereditary Communist; His grandfather was one, which kept him from getting jobs and left him time to become a great cook and to teach Picchi's mother, who passed on the love of food to her son. And he is a cheerful idealist

top FABIO PICCHI, CHEF AND OWNER OF THE CIBRÈO, FLORENCE.

bottom CIBRÈO'S STUFFED CHICKEN NECK.

who relishes providing people from all walks of life with deeply satisfying nourishment for both the stomach and the mind. Hence his Teatro del Sale (Theater of the Salt), across the street from the restaurant. The Teatro is a private club, but anyone can join it for just 5 Euros. It offers breakfast, lunch, and dinner, all served as a buffet, for a modest fixed price. The atmosphere is informal and communal, as strangers—students, professionals, older people, Florentines, Italians from Bologna to Syracuse, foreigners from all over—share tables and serve themselves, but the food is the refined product of Picchi's artistry. At dinner, some twenty dishes—various lentils and roasted vegetables, pasta or risotto, mussels and fish, meat or tripe with caramelized onions—are set out on one big table to which the diners flock excitedly, loading up their plates and taking them back to simple wooden tables and folding chairs. Every few minutes the chef—Picchi himself, if he is in—calls out in a bright voice the arrival of another course: black sepia or spicy clam soup, bollito misto, salted fish, or ice cream made just two hours earlier. In response, there is a happy crush to get to the kitchen window and sample new treats.

At 9:15 PM the kitchen closes with the fall of its own curtains, and members turn their chairs to face the stage and partake of the next course of the evening—a concert, a play, a reading; there are 240 different performances presented every year. Picchi's wife, Maria Cassi, a distinguished actress and the Teatro's artistic director, brings in a wide range of talent, inviting famous as well as little-known performers whose careers she fosters. This makes the Teatro not merely a dinner theater, but a setting for experimentation and the advancement of culture.

The Teatro's mission seems to be rooted in the very space it occupies. The building was once a monastery, and in the Renaissance it shared a wall with the workshop where Ghiberti's *Gates of Paradise* were cast. As a convent, it sheltered the Mal Maritate—women who sought refuge from bad marriages. In World War II, when the building was occupied by a textile factory, it hid members of the neighboring Jewish community (Florence's synagogue stands on an adjacent street), safeguarding them from deportation. Now the Teatro warmly welcomes both local and foreign guests in unique ways.

Picchi's philosophy of food applies to his Teatro.

CIBRÈO'S YELLOW PEPPER SOUP.

❦❦❦❦❦❦❦❦❦❦❦❦❦❦❦

"There are two kinds of cuisines," he says, "the additive and the alchemical. My cuisine is alchemical." It is not a collection of sauces spooned over meat, fowl, or snails. Every recipe is a combination of the best Tuscan resources and traditions, foreign encounters, and new ambitions simmered together with passion and impeccable craftsmanship. The same is true of the theater, which brings together a democratic setting and superb food, pleasure for the stomach and for the soul. Picchi's restaurant and Teatro are quintessential arts of Tuscany—deeply immersed in history, nourished by the region's rich resources, cosmopolitan, and uniquely imaginative. As all these ingredients are steeped together, they are alchemically transformed into inimitable gems. This is the magic of Tuscany, the secret of its ongoing vitality, and the root of its undying appeal.

SUGGESTIONS FOR FURTHER READING

CHAPTER 1. THE ETRUSCANS, SHAPERS OF TUSCANY: CERVETERI, TARQUINIA, VOLTERRA

Bonfante, L. *Etruscan Life and Afterlife: A Handbook of Etruscan Studies*. Detroit, 1986.

Bonfante, L., and J. Swaddling. *Etruscan Myths*. London, 2006.

Haynes, S. *Etruscan Civilization. A Cultural History*. Los Angeles, 2000.

Sprenger, M., and G. Bartoloni. *The Etruscans. Their History, Art, and Architecture*. New York, 1983.

CHAPTER 2. CHRISTIANITY AND PROSPERITY IN MEDIEVAL TUSCANY: LUCCA AND PISA

Del Beccaro, R. *Lucca: History and Legends*. Lucca, 1999.

De Roover, F. E. "From the History of Lucca: Political Background." *Ciba Review* 80 (1950), pp. 2902–30.

De Roover, F. E. *Le sete lucchesi*. Lucca, 1993.

Jones, J. *History of Lucca. Storia di Lucca*. Lucca, 2000.

Muller von der Haegen, A., and R. Strasser. *Tuscany, Art and Architecture*. Cologne, 2000.

CHAPTER 3. THE CIVILIZATION OF SPACE: SIENA

Christiansen, K., et al. *Painting in Renaissance Siena, 1420–1500*. New York, 1988.

Dundes, A., and A. Falassi. *La Terra in Piazza. An Interpretation of the Palio of Siena*. Berkeley and Los Angeles, 1975.

Norman, D., ed. *Siena, Florence and Padua. Art, Society and Religion 1280–1400*. 2 vols. New Haven and London, 1995.

CHAPTERS 4 AND 5. SURPASSING THE ANCIENTS AND ONE ANOTHER: QUATTROCENTO FLORENCE AND FLORENCE OF THE POPES AND THE GRAND DUKES

Baxandall, M. *Painting and Experience in Fifteenth-Century Italy*. Oxford, 1983, 1972.

Crum, R. J., and J. T. Paoletti. *Renaissance Florence: A Social History*. Cambridge, 2006.

Hartt, F., and D. G. Wilkins. *History of Italian Renaissance Art. Painting, Sculpture, Architecture*. Upper Saddle River, N.J., 2007.

Levey, M. *Florence. A Portrait*. Cambridge, Mass., 1996.

Rubin, P. L. *Images and Identity in Fifteenth-Century Florence*. New Haven, 2007.

Turner, R. A. *Renaissance Florence. The Invention of a New Art*. New York, 1997.

Wallace, W. E. *Michelangelo at San Lorenzo. The Genius as Entrepreneur*. Cambridge, 1994.

CHAPTER 6. ART AND NATURE AT PLAY: BOBOLI, CASTELLO, PRATOLINO

Blumenthal, A. R. *Theater Art of the Medici*. Hanover, N.H., 1980.

Giusti, A. M. *Pietre Dure. Hardstone in Furniture and Decorations*. London, 1992.

Lazzaro, C., and R. Lieberman. *The Italian Renaissance Garden: From the Conventions of Planting, Design, and Ornament to the Grand Gardens of Sixteenth-Century Italy.* New Haven, 1990.

Nagler, A. M. *Theatre Festivals of the Medici 1539–1637.* New Haven, 1964.

Saslow, J. M. *The Medici Wedding of 1589. Florentine Festival as* Theatrum Mundi. New Haven, 1996.

CHAPTER 7. RELICS FROZEN IN TIME: TUSCANY AND THE GRAND TOUR

Clegg, J., and P. Tucker. *Ruskin and Tuscany.* London, 1993.

Klima, S., ed. *Joseph Spence: Letters from the Grand Tour.* Montreal, 1977.

Powell, C. *Turner in the South. Rome, Naples, Florence.* New Haven, 1987.

Powell, C. *Italy in the Age of Turner. "The Garden of the World."* London, 1998.

Zevi, F., ed. *Alinari, Photographers of Florence 1852–1920.* Florence, 1978.

CHAPTER 8. ARCHITECTURE OF PLEASURE: VIAREGGIO AND MONTECATINI

Benzi, F., and G. Cefarello Grosso eds. *Galileo Chini. Dipinti, Decorazioni, Ceramiche. Opere 1895–1952.* Milan, 1988.

Cresti, C. *Montecatini. 1771-1940: Nascita e Sviluppo di una Citta Termale.* Milan, 1984.

Giusti, A. M. *Viareggio 1828–1938. Villeggiatura, Moda, Architettura.* Milan, 1989.

Giusti, A. M., ed. *Montecatini, citta giardino delle Terme.* Milan, 2001.

Grand Hotel & La Pace, *Montecatini Terme,* n.d.

Pardi, G., et al. *La passagiata, architetture. Le architetture storiche dei Viali a Mare di Viareggio tra il tardo Ottocento e il secondo dopoguerra.* Viareggio, 1997.

Suppressa, A. *Itinerari di Architettura Moderna. Pistoia, Pescia, Montecatini.* Florence, 1990.

CHAPTER 9. OLD ROOTS, NEW SHOOTS

Aschengreen Piacenti, K., et al. *I protagonisti della moda: Salvatore Ferragamo, 1898–1960.* Florence, 1985.

Ferragamo, S. *Shoemaker of Dreams; the Autobiography of Salvatore Ferragamo.* London, 1957.

Gentile, G., and N. Pescarolo, eds. *La Stanza delle meraviglie. Vane del commercio a Firenze: dagli sporti medioevali al negozio virtuale.* Florence, 1998.

Le Bourhis, K., et al. *Emilio Pucci. Biennale di Firenze. Il Tempo e la Moda.* Treviso, 1996.

Mannucci, E. *Il Marchese Rampante: Emilio Pucci, avventure, illusioni, successi di un inventore della moda Italiana.* Milan, 1998.

Ricci, S., ed. *Palazzo Spini Feroni e il suo museo.* Milan, 1995.

INDEX

ACKNOWLEDGMENTS

IT IS A PLEASURE to thank people who have contributed to this book: Diana Murphy initially invited me to undertake this project; Eric Himmel helped shape it; Elaine Stainton thoughtfully edited the manuscript; Judith Abbate and Michelle Ishay designed, respectively, the handsome interior and jacket; Alvise Passigli and Vera Silvani of the Scala Group helped to secure the illustrations; Rob McQuilkin lent encouragement along the way; and Hazel Rowley offered valuable lessons on the writing craft. In Florence, Fabio Picchi welcomed me generously into his Cibrèo world; at the Lensini studio in Siena, Fabio, Franca, and Francesca showered me with Tuscan warmth and hospitality; Lucio Ghilardi, whose luminous personality is in perfect accord with that of his Lucca, gave depth to my stay in that city; and numerous other Tuscans helped to make my research both joyful and personal. Alexandre Tissot Demidoff shared information on his family history. My parents and grandparents provided affectionate support. Ken Lapatin, as always, has been a keen editor, a sharp pair of eyes, the source of most useful ideas, and a loving companion. Finally, Audrey, napping cozily in my lap, filled me with peace and inspiration as the book was taking its final form.

Editor: Elaine Stainton
Art Director: Michelle Ishay-Cohen
Designer: Judith Stagnitto Abbate
Production Manager: Anet Sirna-Bruder

Library of Congress Cataloging-in-Publication Data:

Belozerskaya, Marina, 1966–
 The arts of Tuscany : from the Etruscans to Ferragamo / by Marina Belozerskaya.
 p. cm.
 ISBN-13: 978-0-8109-9378-5 (Abrams)
 1. Art, Italian—Italy—Tuscany. 2. Tuscany (Italy)—Civilization. I. Title.
 N6919.T9B45 2008
 709.45'5—dc22
 2008014065

Published in 2008 by Abrams, an imprint of Harry N. Abrams, Inc. All rights reserved. No portion of this book may be reproduced, stored in a retrieval system, or transmitted in any form or by any means, mechanical, electronic, photocopying, recording, or otherwise, without written permission from the publisher.

Printed and bound in China
10 9 8 7 6 5 4 3 2 1

Abrams books are available at special discounts when purchased in quantity for premiums and promotions as well as fundraising or educational use. Special editions can also be created to specification. For details, contact specialmarkets@hnabooks.com or the address below.

HNA ▪▪▪▪
harry n. abrams, inc.
a subsidiary of La Martinière Groupe

115 West 18th Street
New York, NY 10011
www.hnabooks.com